EYEWITNESS 1917

EYEWITNESS 1917

The Russian Revolution as it happened

Published with the support of the Future of
Russia Foundation and Pushkin House Trust

Introduction © Craig Kennedy 2019
Chapter introductions and biographies
© Fontanka 2019

All images © individual copyright holders
listed on pp. 302–3

Editors: Frank Althaus, Mark Sutcliffe
Translation and editorial assistance: Nina
 Sampson
Design: Christoph Stolberg
Repro: Martin Chapman
Print: Balto print, Lithuania

ISBN 978-1-906257-27-9

First published in 2019

Fontanka
5A Bloomsbury Square
London WC1A 2TA
www.fontanka.co.uk

Project 1917
Editor-in-chief: Mikhail Zygar
Project director: Karen Shainyan
Executive producer: Daria Ivanova
English version producer: Vera Makarenko
Senior editor: Andrey Borzenko
Editor: Mikhail Degtyarev
Editors: Yuriy Saprykin-junior, Serafim
 Orekhanov
Director of photography: Rashel
 Zemlinskaya
Photo editor: Natalia Vasilieva
Research: Pavel Krasovitsky, Daulet
 Zhanaidarov
Video production manager: Anna Bocharova
Video editor: Julia Zakrevskaya
Product director: Olga Avstreyh
Web designer: Alyona Tokareva
Art director: Alexey Ivanovsky
Assistants: Elizaveta Podkolzina, Aleksandra
 Grishina

Pushkin House
English language partner for Project 1917
Coordinators: Clem Cecil, Alina Grigorjan,
 Rebecca Ostrovsky
Translation: Rose France, Leo Shtutin

F

PROJECT 1917
THE FUTURE OF HISTORY

It's rare nowadays for a book to appear on the Russian Revolution that offers a startlingly fresh perspective on that fateful year. The February Revolution and the Bolsheviks' seizure of power have been among the most widely scrutinised and recounted events of all time. And, of course, for good reason: what happened in 1917 profoundly shaped our modern world. So when a new work comes along that not only offers a highly original approach to retelling the revolutionary saga, but also manages to appeal to a younger generation, it's something to be celebrated. In this book and *Project 1917: Free History*, the website on which it is based, we have such a work.

Project 1917 began life as a year-long, internet-based drama that unfolded over the course of 2017, the centenary of the Russian Revolution. It seeks to recount, day by day, the events of a hundred years earlier through the written testimony of hundreds of people who lived through Russia's revolutionary year. The genius of the project is its innovative use of social media platforms as the stage on which the drama unfolds – an historical re-enactment of the Revolution via Twitter and Facebook.

During the centenary year, anyone with an internet connection could subscribe to *Project 1917*, just as you might follow your favourite celebrity chef or political pundit. Each day, you would receive brief posts from your selection of the people who made up this unusual social network.

And herein lies the twist: the people making these daily posts were not our twenty-first-century contemporaries. Rather, they were actual historical figures who lived through the events of 1917 – their names and photos appearing alongside their posts, just as they might in a normal social media feed. As for the content itself, each post was a verbatim extract from their letters, diaries or memoirs relating to that particular day in 1917.

The community of historical figures whose posts appeared during 2017 numbers more than five hundred. Its membership runs the gamut from firebrand revolutionaries like Trotsky and Lenin to reactionary ministers, from bohemian poets like Zinaida Gippius to crusading liberals, from the French ambassador Maurice Paléologue to the peasant diarist Alexander Zamaraev. Even Nicholas and Alexandra frequently chime into the conversation. Some figures are prolific contributors, others appear seldom. By the end of the centenary year, between them they had generated several thousand posts.

Many posts are commentaries on the events of the day. But over time, certain storylines and themes naturally emerge: the revolutionary events of February and March, the struggle to form a new government, the scourge of famine, the sovereign aspirations of national minorities, the war, the rise of the Bolsheviks, the suppression of the press, the first arrests, the role of cinema, love and longing, Kerensky's meteoric career, the death of Rasputin and the fate of the royal family. *Project 1917*'s tools allow users to group posts both chronologically and by theme, to follow conversations between characters, even to locate events on an interactive map of Petrograd.

Such an innovative approach provides fresh insights into familiar events. The central drama of the decades leading up to 1917 was a struggle between state and society. Following the Great Reforms of Alexander II, new social groups emerged in Russia – professionals, industrial entrepreneurs, factory workers, yeoman farmers. These new groups were growing increasingly independent of state control and support (something similar has occurred in post-Soviet Russia). In time, many began to demand a say in how they were governed, only to encounter fierce resistance from a reactionary state.

Project 1917 allows us to eavesdrop, as never before, on intimate conversations, trenchant commentary and ferocious debates on all sides of this struggle. What's new here is not the source material itself: virtually everything published in the project has previously appeared in print. Where *Project 1917*'s originality lies is in the sheer breadth of voices it brings together and in their artful juxtaposition.

This is made possible by the project team's inspired decision to adopt a social media format for their creation. Social media excel at gathering input from a broad community and distilling it into a steady stream of brief, thematically linked posts. Using this format, the project's curators have been able to create dense streams of posts reflecting a broad range of views on the events of the day. The views are sometimes droll, sometimes tragic, often in violent contradiction, but always revealing. And they help us appreciate anew the vast, discordant polyphony of revolutionary Russia.

Project 1917's approach also helps lay bare the utter confusion of the period. By taking us day by day, week by week through the cogitations of major figures, we become acutely aware of just how hard it was to divine what lay ahead. This is something often lost in traditional approaches to the period, where order is imposed by the all-seeing retrospective eye of the historian. In the fog of this protracted crisis, no one had clairvoyance. Nothing was preordained: many people could alter the fundamental course of events; all they needed was the nerve to act.

Project 1917 is the brainchild of the Russian writer and journalist Mikhail Zygar and a talented team of historians and technical wizards. In the years leading up to the project, they had observed how certain ideas about Russia's past were being used to help shape the country's national identity. Despite the important role history was playing, however, they found that when it came to epochal events like the Russian Revolution, public knowledge was often simplistic, tendentious or even non-existent.

Therein lay the inspiration for *Project 1917*. They wanted to create a public resource that was easy to use, appealed to young people, and provided direct access to a diverse selection of primary source materials. This could help lead users to a deeper appreciation of the complexity of the revolution. They also hoped that by engaging directly with primary sources, users would be encouraged to draw conclusions for themselves, rather than rely on a prescribed interpretation.

Preparing the project for launch in late 2016 was a daunting task. They pored over thousands of pages of source material left by hundreds of historical witnesses. They decided who would make the cut for the cast of characters, which passages to post and in which daily stream to include them. In the balance and the range of views presented, they have shown great integrity, giving ample air time to monarchists, anarchists and every voice in between.

While the original *Project 1917* is now archived on the web at www.project1917.ru, it is enjoying a new incarnation in book form. The publishing professionals at Fontanka have done a remarkable job in transplanting it from the digital realm to the world of print. They have succeeded in keeping alive the spirit and narrative surge of the original project. Some of the social media format remains, with streams of posts flowing chronologically throughout the year and a liberal use of period photographs and visual cues. The editorial voice remains muted, with primary source material comprising the vast majority of the book. And although the constraints of print required a reduction in the number of posts, the spirit, sweep and drama of the internet original remain.

We at Pushkin House have felt fortunate to be able to help make *Project 1917* accessible to the anglophone world, both through an abridged, English-language version of the original internet project (archived at www.project1917.com), and now with this beautifully produced volume from Fontanka. We are an independent, UK-registered cultural charity founded 65 years ago by Russian émigrés in London – some of them refugees from the revolution itself and friends of various 'contributors' to *Project 1917*. Our mission now as then is to help the public – Russian and non-Russian alike – to engage with Russia's rich culture and gain a deeper understanding of Russian society. For us, *Project 1917* ticks all the boxes.

Perhaps the most heartening thing about *Project 1917* has been its success in engaging the public. Its postings have enjoyed a massive following; they've been 'liked' and 'retweeted' by thousands. What's more, some postings have prompted direct responses from readers, as if hoping to strike up a direct conversation with long-dead figures from the past. Teachers of history can only look on with awe and admiration, and with a hope that *Project 1917* spawns many imitators in the future.

Craig Kennedy
Co-chair of the Board of Trustees
Pushkin House

SHADES OF REVOLUTION

The two hundred and thirty or so characters whose words are reproduced in this book have been sorted into five broad categories – 'royalists', 'early reformers', 'progressive revolutionaries', 'radical revolutionaries' and 'observers'. Each category is given a different text colour. The aim is to give readers a simple means of orientation, to show which characters are writing from a broadly similar perspective, and which are in opposition.

Inevitably – given that all five colours could happily have been used to convey the shades of opinion within the Bolshevik faction alone – there are characters of the same colour who do not represent the same constituency or share exactly the same views. At the same time, certain characters changed their position over the year – or the context within which they found themselves changed. In March 1917 Alexander Kerensky, for example, was a member of both the Provisional Government and the Petrograd Soviet, and therefore at the radical end of the first wave of reformers. By October, however, he was amongst the most reactionary of revolutionaries, despised by progressives and radicals alike.

Our hope, however, is that by relieving readers of some of the burden of trying to remember exactly what a Menshevik Defencist was, we will allow them to concentrate on the narrative flow of events through the year.

The five groups are listed below. A short biography of each character is given at the beginning of the first chapter in which he or she appears. Some chapters have more new characters than others, and unsurprisingly the predominant colour changes as the year progresses: very few radical revolutionaries contribute to the story at the beginning of the year, and by December the royalist voice has been virtually silenced.

Royalists
Members of the imperial family and their immediate circle, along with a few die-hard monarchists.

Early Reformers
This grouping comprises those who actively sought to overthrow the monarchy, and the more reluctant reformers who felt the abdication of Nicholas II was the only way to prevent extreme elements seizing power. Included in this category are most of the generals, who may not actively have sought the February Revolution, but who pledged allegiance to the Provisional Government immediately after it. The political party most closely identified with this grouping were the Constitutional Democrats, or Kadets.

Progressive Revolutionaries
The smallest group, the oranges are generally members of the Petrograd Soviet, mostly Mensheviks and Socialist Revolutionaries (SRs), who believed in the creation of a socialist state but did not support the Bolsheviks' sudden power grab in October.

Radical Revolutionaries
The Bolsheviks and their supporters.

Observers
The largest category, the greens are essentially those who witnessed the revolutionary year without being clearly identified with one political movement or another. This does not, of course, mean that their voices are objective: they include some of the old regime's most trenchant opponents as well as others who were appalled by the prospect of a Bolshevik government.

Dates

Extracts in the book are given a date if they were written on the day in question (e.g. a diary entry or newspaper article), or if it is known that they refer to a particular day. If the extract is from a memoir and does not refer to a specific date, then it is left undated.

Up until 14 February 1918 Russia used the Julian calendar ('Old Style'), which ran thirteen days behind the Gregorian calendar ('New Style') used by most of the rest of the world. For most countries outside Russia, therefore, the October Revolution actually started on 7 November 1917, not 25 October.

This book uses 'Old Style' dates throughout. To avoid conflicts in chronology, foreign sources (e.g. the *New York Times*) have been re-dated to Old Style. For example, an article published on 15 March 1917 is dated 2 March 1917. The actual date of publication is given in the bibliographical reference.

In February 1918 Russia changed from the Julian calendar to the Gregorian: people went to bed on 31 January and woke up on 14 February.

Footnotes and references

All extracts are fully referenced at the back of the book. Alongside bibliographical references, some extracts may have an additional explanatory note designated by an asterisk in the main text. Notes have been kept to an absolute minimum to avoid diverting attention away from the sequence of events of the year; generally they are confined to explanations of characters or events that appear nowhere else in the book.

Transliteration

Russian names are transliterated using a system based on the British Standard 2979, simplified for improved readability and ease of pronunciation. Commonly accepted spellings have been used where they exist.

Original punctuation and capitalisation have generally been retained in texts first published in English, as well as certain spellings: for example, *Miliukoff* for *Milyukov* in the memoirs of British ambassador Sir George Buchanan.

Editorial omissions are shown by ellipses in parentheses; ellipses without parentheses are part of the original text.

Grigory Rasputin

1
DARK
FORCES

"Russia, my Russia. She's so wretched now,
has become so rotten, so near to death."

ROYALISTS

Empress Alexandra Feodorovna (1872–1918), granddaughter of Queen Victoria, cousin of Kaiser Wilhelm II; fell under influence of Rasputin, who she believed had the power to cure her son of haemophilia; murdered by Bolsheviks in Ekaterinburg in July 1918.

Grand Duke Andrei Vladimirovich (1879–1956), grandson of Emperor Alexander II, first cousin of Nicholas II; arrested in August 1917, escaped; settled in south of France, married the ballerina Matilda Kshesinskaya in 1921.

Grand Duchess Maria (1899–1918), third daughter of Nicholas and Alexandra, nicknamed 'fat little bow-wow' by her sisters; murdered by Bolsheviks in Ekaterinburg in July 1918.

Grand Duke Mikhail Alexandrovich (1878–1918), younger brother of Nicholas II; named heir in Nicholas's abdication proclamation, an accession he refused; arrested and sent to Perm in March 1918; murdered with his secretary Nicholas Johnson on night of 12–13 June.

Emperor Nicholas II (1868–1918), anointed tsar in 1896, nicknamed 'Bloody Nicholas' after suppression of 1905 Revolution; appointed himself army commander-in-chief in September 1915; abdicated on 2 March 1917; murdered by Bolsheviks on 17 July 1918; canonised by Russian Orthodox Church in 2000.

Vladimir Purishkevich (1870–1920), monarchist member of the Duma, anti-Semite, one of Rasputin's assassins; arrested in November 1917, later released; fought with White Army, died of typhus.

Grigory Rasputin (1869–1916), self-proclaimed holy man, adviser to imperial family; earned devotion of the empress through apparent ability to alleviate tsarevich's haemophilia; murdered in gruesome fashion by conservative royalists.

Anna Vyrubova (1884–1964), confidante of Empress Alexandra; severely injured in train accident in 1915; devoted follower of Rasputin; fled to Finland in 1920, took monastic orders.

Felix Yusupov (1887–1967), husband of Nicholas II's niece, ringleader of plot to assassinate Rasputin; emigrated to Paris after October Revolution.

Princess Irina Yusupova (1895–1970), niece of Nicholas II, married to Felix Yusupov; successfully sued MGM after 1932 film *Rasputin and the Empress* portrayed a character clearly based on her being seduced by Rasputin.

EARLY REFORMERS

General Alexei Brusilov (1853–1926), commander, South-Western front from 1916, appointed army commander-in-chief in May 1917, replaced by General Kornilov in July; published a call to former officers to join Red Army in *Pravda* in 1920; given state funeral by Soviet regime.

Pavel Milyukov (1859–1943), founder of Kadet Party in 1905; favoured constitutional monarchy; foreign minister in Provisional Government; emigrated to France in 1921, where he edited anti-Bolshevik émigré newspaper *Poslednie novosti* ('Latest News'), but supported USSR in Second World War.

Mikhail Rodzyanko (1859–1924), chairman of Provisional Committee of the Duma, forerunnner of Provisional Government; active in White movement in Crimea from 1917, emigrated to Serbia in 1920, died in poverty.

Vasily Shulgin (1878–1976), monarchist member of Provisional Committee of the Duma; active in White movement, emigrated to Serbia in 1920; arrested by Red Army in 1944, imprisoned for 12 years in Vladimir, where he lived for 20 years after his release; attended the XXII Congress of the Communist Party in 1962.

PROGRESSIVE REVOLUTIONARIES

Maxim Gorky (1868–1936), novelist, playwright and political commentator; opposed Bolsheviks after October Revolution; moved to Italy in 1923 to alleviate tuberculosis; feted by Stalin on return to USSR in 1933; proponent of Socialist Realism.

RADICAL REVOLUTIONARIES

Vladimir Lenin (1879–1924), founder of Russian Social Democratic Labour Party in 1898, leader of Bolshevik faction from 1903; chairman of Soviet of People's Commissars and leader of Communist Party Politburo; suffered a stroke in 1922.

OBSERVERS

Zinaida Gippius (1869–1945), poet, novelist and critic, the latter under male pseudonyms; anti-Bolshevik, left Russia in 1920 with her husband, the writer Dmitry Merezhkovsky, finally settling in Paris.

Ryurik Ivnev (1891–1981), poet, novelist and translator; Lunacharsky's secretary after October Revolution; travelled the country in 'agit-train' in summer 1919; published translations of Georgian and South Ossetian poetry.

New York Times, American newspaper, founded in 1851.

Maurice Paléologue (1859–1944), French ambassador to Russia 1914–17; his published works included novels and biographies of Alexandra Feodorovna and her sister Grand Duchess Elizaveta Feodorovna.

Lev Tikhomirov (1852–1923), leading member of radical group Narodnaya volya ('People's Will'), but in 1888 published 'Why I have ceased to be a revolutionary'; thereafter monarchist and conservative writer and thinker.

Sergei Vavilov (1891–1951), volunteered in 1914; eminent physicist specialising in optics; president of USSR Academy of Sciences from 1945; editor of *Great Soviet Encyclopaedia* from 1948.

In the fourth year of a world war that is sapping public morale, Nicholas II, Emperor and Autocrat of all the Russias, is now also commander-in-chief of the Russian imperial army. Much of his time is spent at Army Headquarters at Mogilev, some 500 miles from the capital, Petrograd. With every military setback, the aura of the 'tsar batyuskha', the father of the country, is becoming increasingly tarnished. By early 1917 there are many in Russia's political circles who talk openly of the urgent need for more representative government.

Throughout the country conditions are deteriorating fast. Blizzards and plummeting temperatures cut supplies and drive prices higher every week. 'Children are starving,' a secret police agent reports. 'A revolution, if it takes place, [...] will be spontaneous, quite likely a hunger riot [...] Every day the masses are becoming more and more embittered.'

Confidence in the monarchy – the Romanov dynasty that only four years earlier triumphantly marked three hundred years as rulers of Russia – is further undermined by rumours surrounding the German-born Empress Alexandra, a first cousin of German Kaiser Wilhelm, and the self-professed holy man, Grigory Rasputin. While the imperial family and their circle consider Rasputin to be a man of God, others see him as the devil incarnate – a malign influence at the very centre of power.

LEV TIKHOMIROV
Conservative writer and thinker, former revolutionary

They're saying the most bizarre things about the empress herself: that she's in constant communication with Kaiser Wilhelm and sends him messages about military matters. And of course there are even more rumours about Grigory Rasputin. *11 November 1916*

PAVEL MILYUKOV
Leader of the opposition in the Duma; speech to the Duma

As long ago as 13 June 1916 I stood on this platform and warned that the 'poisonous seed of suspicion is already yielding abundant fruit' and that 'from one end of the Russian land to the other dark rumours of treason and betrayal are spreading'. Alas, gentlemen, that warning, like all the others, was not heeded. Gentlemen, I should not like to dwell on those perhaps exaggerated, abnormal suspicions with which the alarmed conscience of the Russian patriot reacts to all that is taking place here. But how are you going to deny the possibility of such suspicions, when a handful of sinister individuals, from personal and base motives, direct the most important affairs of state? *1 November 1916*

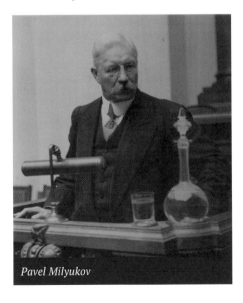

Pavel Milyukov

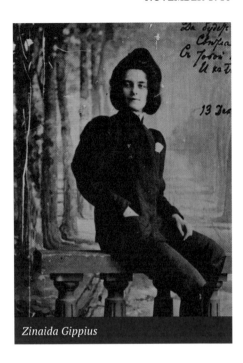

Zinaida Gippius

ZINAIDA GIPPIUS
Poet, novelist and journalist

The Duma opened on the first. Milyukov gave a long speech, for him extremely hard-hitting. He spoke of 'treason' in the palace and ruling circles, about Empress Alexandra's role and that of Rasputin (yes, he talked about Grisha too!), and Stürmer, Manasevich, Pitirim – the whole cabal of idiots, spies, extortionists and plain scoundrels.* He mentioned cases and extracts from German papers. But for me the crux of his speech were the following key words: 'Today we see and we understand that with this government we cannot legislate, any more than we can lead Russia to victory.' *4 November 1916*

GRIGORY RASPUTIN
Self-proclaimed holy man, adviser to the imperial family; letter to Empress Alexandra

Wise counsel leads to pious ways, the people did not seek what is good, wisdom in everything is from high. Nobody will escape. What is said is said. God is with us. *17 November 1916*

MAXIM GORKY
Writer and political commentator

We're taking it 'day by day'. For the most part we've put our bets on Nicholas the Sainted One. We're doing nothing ourselves. The more intelligent people think that history, rather than Nicky, will put things to rights. But for them history is also a kind of miracle-worker, unaffected by human thought and volition. So they too are doing nothing. On the whole it's pretty dull, although unsettling too. But we've got used to it. The main thing is to do nothing and not make mistakes, because increasingly Russia is being subjected to mistakes. *1 November 1916*

EMPRESS ALEXANDRA FEODOROVNA
Letter to her husband, Nicholas II

Ah Lovy, I pray so hard to God to make you feel & realize, that He is our caring, were He not here, I don't know what might not have happened. He saves us by His prayers and wise counsils & is our rock of faith & help. Once more, remember that for your reign, Baby & us you need the strenght prayers & advice of our Friend.* *11 November 1916*

GRIGORY RASPUTIN
Self-proclaimed holy man, adviser to the imperial family; letter to Empress Alexandra

Aspire for peace, seek the truth, God will fortify you. *15 November 1916*

FELIX YUSUPOV
Husband of Nicholas II's niece

There was no hope that the emperor and empress would understand the full truth about Rasputin and keep him at arm's length. After all my encounters with Rasputin, after all I saw and heard, I was utterly convinced that he embodied all the evil and was the main reason for all of Russia's misfortunes: if there was no Rasputin, there would no longer be that satanic force which the emperor and empress had fallen prey to.

MAURICE PALÉOLOGUE
French ambassador

I forget who it was said of Caesar that he had 'all the vices and not one fault'. Nicholas II has not a single vice, but he has the worst fault an autocratic sovereign could possibly have – a want of personality. He is always following the lead of others. His wishes are always being evaded, surprised or over-ridden; it never makes itself felt by any direct and spontaneous action. In this respect he in many ways resembles Louis XV, whom the consciousness of his innate weakness of character always kept in constant fear of subjection to others. Hence the love of subterfuge, which is a characteristic of both of them. *14 November 1916*

SERGEI VAVILOV
Soldier, later eminent physicist

The papers are littered with intimations of 'a dark force'. The result is a lurid and absurd picture. An owl's nest comprising Empress Alexandra Feodorovna, Pitirim, Rasputin, Frederiks and Stürmer in pride of place – the mainspring of Russia's 'fate'.* And this could only be dreamt up by the crazy Russian imagination. It's straight out of Dostoevsky and horror stories. Behind the owl there are sorcerers, in front, pigs with hackles raised; while here is the naïve, good-hearted and decent army, which never gets worked up about much and takes everything as it comes. I've said this before – the army is made up of the righteous and the young. In which case, Lord give us war to the end of our days. Everyone is fated to die, but it's better to die honestly and simply. Russia, my Russia. She's so wretched now, has become so rotten, so near to death. *26 November 1916*

'Dark forces' on the eve of the Russian Revolution:
Rasputin and his court of women

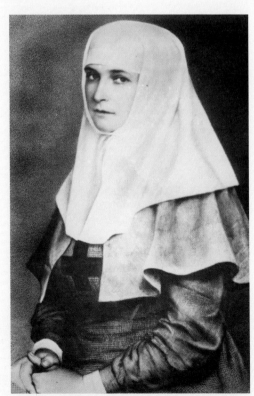

Empress Alexandra; along with her elder daughters
Olga and Tatyana she trained as a nurse and
assisted with surgical operations during the war

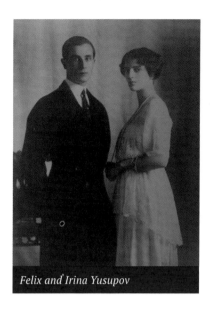

Felix and Irina Yusupov

FELIX YUSUPOV
Husband of Nicholas II's niece; letter to his wife Irina

My darling, I miss you so much, I need your warmth, comfort and advice so badly. I have to resolve a whole lot of problems that have landed on me. I'm terribly busy working out a plan to destroy Rasputin. It's now simply imperative, or else all is lost [...] You must also play a part in it. Dmitry Pavlovich knows about everything and is helping.* It will all take place in the middle of December [...] Not a word about this to anyone. *20 November 1916*

PRINCESS IRINA YUSUPOVA
Niece of Nicholas II; letter to her husband Felix

Thank you for your mad letter. I didn't understand half of it, but I can see that you are preparing to do something wild. Please be careful and don't get caught up in any dirty business... The dirtiest trick is that you've decided to do it all without me. I can't see how I can play a part in it now, since it's all already arranged. [...]
 In a word, be careful. I can see from your letter that you are wildly enthusiastic and ready to climb up the wall. *25 November 1916*

EMPRESS ALEXANDRA FEODOROVNA
Letter to her husband, Nicholas II

Sleep so little when you are not there [...] Our Friend & Kalinin entreat you to close the Duma not later than the 14-th Feb., 1-st or 15-th even, otherwise there will be no peace for you & no works got through.* In the Duma they only fear this, a longer intermission [...] all who love you think aright [...] Be the Master. *9 December 1916*

LEV TIKHOMIROV
Conservative writer and thinker, former revolutionary

Revolution is brewing and staring us in the face. For now it's the upper echelons and officials who are bringing it into being, but later it will be the workers and peasants who will take it their own way. God only knows who will be left alive. But it's entirely likely that the main culprit, the 'dark force' in the form of Grishka Rasputin, will conveniently scamper off somewhere abroad at the critical moment. *9 December 1916*

EMPRESS ALEXANDRA FEODOROVNA
Letter to her husband, Nicholas II

My Angel, we dined yesterday at Ania's with our Friend [...] He entreats you to be firm, to be the Master & not always to give in to Tr. – you know much better than that man (still let him lead you) – & why not our Friend who leads through God?* [...] We must give a strong country to Baby, & dare not be weak for his sake, else he will have a yet harder reign, setting our faults to right & drawing the reins in tightly which you let loose. *13 December 1916*

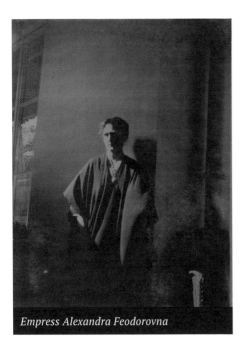
Empress Alexandra Feodorovna

EMPRESS ALEXANDRA FEODOROVNA
Letter to her husband, Nicholas II

My beloved Sweetheart, Scarcely slept this night again [...] Trepov was very wrong in putting off the Duma now & wishing to call it beginning of January again, the result being that nobody goes home & all will remain, fomenting boiling in Petrograd [...] Lovy, our Friend begged you to shut it 14-th – Ania and I wrote it to you – & you see, they have time to make trouble [...] I cld. hang Tr. for his bad counsels. *14 December 1916*

EMPEROR NICHOLAS II
Letter to his wife, Alexandra Feodorovna

My own dearest Sweetheart, Loving thanks for your strong reprimanding letter. I read it with a smile because you speak like to a child. – It is a rotten business to have a man whom one dislikes & distrusts like Trep. But first of all one must choose a new successor & then kick him out after he has done his dirty business. I mean send him away, when he has shut up the Duma [...] I kiss you and the girlies ever so tenderly & remain your poor little huzy with no will Nicky. *14 December 1916*

NEW YORK TIMES
American newspaper; report

Sergius Michailow Trufanoff, better known as 'Illiodor, the Mad Monk of Russia,' who up to the beginning of the war was a chaplain of the imperial court in Petrograd, and an intimate of Gregory Rasputin, the Siberian peasant priest and court confessor, made his first public statement last night. He said that Rasputin was now the strongest 'separate peace' advocate in Russia, and that in his efforts to take Russia away from the Allies he had the support of the Czarina and other powerful influences in Petrograd. Furthermore Illiodor said that there was no reason to doubt but that German money had something to do with the change of front on the part of Rasputin. In Illiodor's opinion Rasputin stands a good chance to win in the fight for supremacy between the pro-German and allied adherents, which he says is now being fought out in the Russian capital. *14 December 1916*

FELIX YUSUPOV
Husband of Nicholas II's niece

Everyone came to the following conclusion: Rasputin had to be done away with, using poison as the best means of concealing all trace of the murder. Our house on the Moika was chosen as the place where the murder would be carried out.

GRIGORY RASPUTIN
Self-proclaimed holy man, adviser to the imperial family

I'm protected against ill fortune [...] Disaster will befall anyone who lifts a finger against me. *16 December 1916*

FELIX YUSUPOV
Husband of Nicholas II's niece

I pulled the trigger. Rasputin gave a wild scream and crumpled up on the bearskin.* *16 December 1916*

VLADIMIR PURISHKEVICH
Monarchist member of the Duma

Rasputin was already at the gates, when I stopped and bit myself hard on the left wrist, to force myself to concentrate, and this third time hit him in the back. He stopped; carefully taking aim I fired a fourth time, apparently hitting him in the head, for he collapsed face down onto the ground in the snow, tearing at his head. I ran up to him and kicked him as hard as I could in the temple. He was lying with his hands stretched out in front of him, clawing at the snow as if he wanted to crawl forward on his stomach; but he was already unable to move and just lay there grinding and gnashing his teeth. *16 December 1916*

FELIX YUSUPOV
Husband of Nicholas II's niece

I pounced on the body and began to beat him with the rubber club. At that moment I was thinking neither of God's law, nor man's. *16 December 1916*

GRAND DUCHESS MARIA
Third daughter of Nicholas and Alexandra

Bad news. Grigory has disappeared since last night. No one knows where he is. *17 December 1916*

RYURIK IVNEV
Poet, novelist and translator

Everyone is rejoicing over Rasputin's murder, celebrating, but I couldn't sleep all night. I cannot, cannot rejoice at murder. Maybe he was harmful, maybe Russia is saved, but I cannot, cannot rejoice at murder. *20 December 1916*

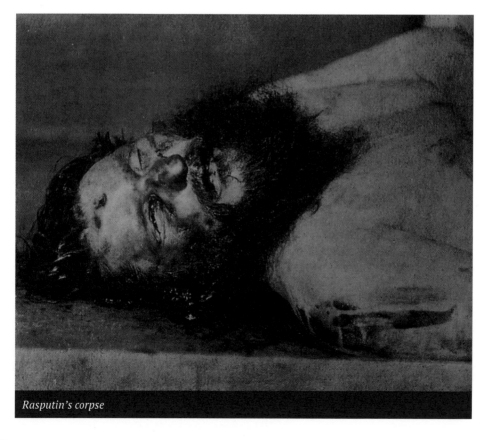

Rasputin's corpse

GRAND DUKE ANDREI VLADIMIROVICH
First cousin of Nicholas II

According to the rumours, Rasputin was buried yesterday night at Tsarskoe Selo, in the presence of Nicky, Alix, their daughters (except Olga), Protopopov [...] and Anya Vyrubova, next to the shelter, where they are intending to erect a church over his grave. It's so touching, further comment is superfluous. *22 December 1916*

MAXIM GORKY
Writer and political commentator

Things are going on here that could make you go mad: every day brings something 'new' that stinks of the fifteenth century. *19 December 1916*

MAURICE PALÉOLOGUE
French ambassador

The empress was praying at the tomb of Rasputin. Every day she goes there with Madame Vyrubova, and spends hours absorbed in prayer. *4 January 1917*

GRAND DUKE MIKHAIL ALEXANDROVICH
MIKHAIL RODZYANKO
Younger brother of Nicholas II; conversation with the chairman of the Duma, recorded in the latter's memoirs

MA: I would like to speak to you about what is happening and know your thoughts on what to do... We understand the situation completely.
MR: Yes, Your Highness, the situation is so serious that not a minute must be lost, and we need to save Russia fast.
MA: Do you think there will be a revolution?
MR: While there is war, the people realise that a revolt would mean the destruction of the army, but the danger lies elsewhere. The government and Empress Alexandra Feodorovna will lead Russia into a separate peace and infamy, they will hand us over to the

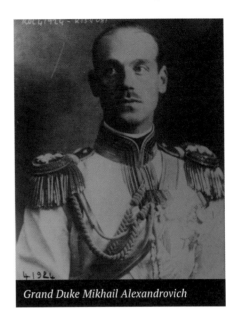

Grand Duke Mikhail Alexandrovich

Germans. This is something the nation will not stomach, and if it were proved true – and the rumours going around are enough – it would cause the most terrible revolution which would wipe out the throne, the dynasty and all of us. There is still time to save the situation and save Russia, and even now your brother's reign can attain unprecedented achievements and greatness in history. But for that to happen, the entire direction of the government must change. Ministers need to be appointed who have the confidence of the country, who do not offend the people. Unfortunately I have to say to you that this can only be achieved by the removal of the empress. She has a harmful influence on everything, even the army. She and the emperor are surrounded by dark, useless mediocrities. Alexandra Feodorovna is ferociously hated; everywhere, in all circles, her removal is demanded. While she is in power, we're heading towards certain destruction [...] As his only brother, Your Highness, you must tell the emperor the truth, you must open his eyes to the harmful interference of Alexandra Feodorovna whom the people regard as a Germanophile and inimical to the interests of Russia. *8 January 1917*

PAVEL MILYUKOV
Leader of the opposition in the Duma

In Moscow I found a more definite mood. Prince Lvov had only just returned from Petersburg and confidentially informed us of the latest news from the capital. A palace coup was to be expected in the nearest future. The idea was being explored in military circles, and by the grand dukes, and by politicians. They're talking, apparently, of disposing of Nicholas II and Alexandra Feodorovna. We have to be ready for the consequences. A few of those present agreed that it befell Lvov himself to become head of the government. Nobody's thinking about it seriously, but the general talk was that it would be good if somebody brought it about.

GENERAL ALEXEI BRUSILOV
Commander, South-Western front

I received information that a palace coup was being considered, that they were proposing to declare the heir, Alexei Nikolaevich, emperor under the regency of Grand Duke Mikhail Alexandrovich [...] But these were all dark rumours, there was nothing credible about them. The reason I didn't believe them was that the central role was assigned to [Chief of Staff] Alexeev, who had apparently agreed to arrest Nicholas II and Alexandra Feodorovna. Knowing Alexeev's character, I was convinced that he would not carry this out.

ZINAIDA GIPPIUS
Poet, novelist and journalist

Grishka's murder I still consider a wretched thing. The conspirators and murderers, the 'jealous relations', have been packed off to their estates, and the whole imperial family has buried Grishka at Tsarskoe Selo. Now we just await some graveside miracle. It's almost inevitable. He is a martyr, after all. They want to put a halo on that piece of scum. But as long as we are in a swamp, there will always be devils, you can't get rid of all of them. *2 February 1917*

EMPRESS ALEXANDRA FEODOROVNA
Letter to her husband, Nicholas II

The sun shines so brightly – I felt such peace & calm on this dear place. He died to save us. *26 February 1917*

VASILY SHULGIN
Member of the Duma, right-wing Progressive bloc

It became even worse when Rasputin was killed. Before, everyone just blamed him. But now they've realised that it's not about Rasputin at all. They killed him, and nothing has changed. And now all the arrows hit home directly, instead of being intercepted by Rasputin. So it's a question of biding time. Two to three months. *17 February 1917*

ANNA VYRUBOVA
Confidante of Empress Alexandra

In the morning when I went to the empress I found her in tears. She told me that the emperor was leaving.* I bid farewell to him, as usual, in the empress's green drawing room. The empress was very upset. The emperor informed me that he was not saying goodbye for long, that in about ten days he would be back [...] On that day I became very ill [...] After seeing the emperor off, I lay down in my bedroom, after writing to the empress excusing myself from tea. In the evening Tatyana Nikolaevna came in to tell me that Alexei Nikolaevich and Olga Nikolaevna had measles. They had caught it from a small cadet who had come to play with the heir a couple of weeks before.

EMPRESS ALEXANDRA FEODOROVNA
Letter to her husband, Nicholas II

My own angel love, Well, now Olga & Aleksei have the measle – Olga's face all covered, & Baby has more in the mouth & he coughs very much & eyes ache. They lie in the dark – we lunched still together in the playroom [...] Oh

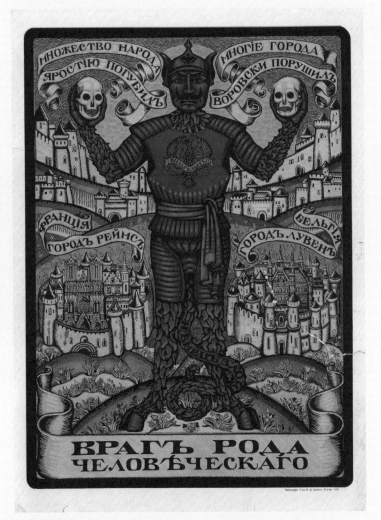

Kaiser Wilhelm is depicted as the 'enemy of the human race' and the
destroyer of Rheims and Louvain: 'many people has he cruelly killed';
'many cities has he dishonestly destroyed'

my love – how sad its without you – how lonely, how I yearn for yr. love & kisses, precious treasure, think of you without end. *23 February 1917*

EMPRESS ALEXANDRA FEODOROVNA
Letter to her husband, Nicholas II

One must play with the reins, let them loose & draw them in, always let the master-hand be felt, then they also far more value kindness – only gentleness they do not understand. – Russian hearts are strange & not tender or susceptible in the higher classes, strange to say. They need decided treatment, especially now. *22 February 1917*

LEV TIKHOMIROV
Conservative writer and thinker, former revolutionary

Rumours are going round to the effect that Protopopov has been recently engaging in spiritualism, summoning the spirit of Rasputin, and has convinced the empress that Rasputin's spirit has taken root in him, Protopopov, and consequently the empress has total faith in him. *28 February 1917*

EMPRESS ALEXANDRA FEODOROVNA
Letter to her husband, Nicholas II

Such a hard time as the one we are going through now. – Being apart makes everything so much harder to bear – no possibility of giving you a gentle caress when you look so weary, tormented [...] I do so long to help you to carry the burden! You are brave & patient, but my soul feels & suffers with you far more than I can say. I can do nothing but pray & pray & Our dear Friend does so in yonder world for you – there he is yet nearer to us – Tho' one longs to hear his voice of comfort and encouragement. – God will help, I feel convinced, & send yet the great recompense for all you go through. *22 February 1917*

EMPRESS ALEXANDRA FEODOROVNA
Letter to her husband, Nicholas II

Yr. wall wify remains guarding here in the rear, tho' she can do but little, but the good ones know she is yr. staunch upholder. – My eyes ache fr. crying. *22 February 1917*

Vladimir Ilyich Lenin

VLADIMIR LENIN
Bolshevik leader; speech given in Zurich

We of the older generation may not live to see the decisive battles of this coming revolution. But I can, I believe, express the confident hope that the young, who are working so splendidly in the socialist movement of the whole world, will be fortunate enough not only to fight, but also to win, in the coming proletarian revolution. *9 January 1917*

EMPRESS ALEXANDRA FEODOROVNA
In conversation with her friend, Lili Dehn

Veronal is keeping me up. I'm literally saturated with it.*

Leaflets being distributed on Tverskaya Street,
Moscow, during the February Revolution

2
THIS IS REVOLUTION

"They are not sick, nothing particular has happened to them, but the organism is worn out, it is no longer capable of living."

ROYALISTS

Pyotr Bark (1869–1937), last minister of finance under tsar; emigrated to England where he became managing director of Anglo-International Bank; knighted as Sir Peter Bark by George V in 1935.

General Mikhail Belyaev (1863–1918), last minister of war under tsar; arrested after February Revolution and then released; arrested again in 1918 and shot.

Lili Dehn (1888–1963), friend of Empress Alexandra, settled in England after revolution, then moved to family estate in Poland until 1939; emigrated to Venezuela in 1947, died in Rome.

George V (1865–1936), first cousin of Nicholas II, king of England from 1910; widely blamed for failing to offer asylum to imperial family after February Revolution.

Pierre Gilliard (1879–1962), French tutor to imperial family; travelled with family to Ekaterinburg but was released on arrival; remained in Siberia after their murder, eventually leaving Russia in 1920.

Konstantin Globachev (1870–1941), head of Okhrana, tsarist secret police in Petrograd; emigrated to New York, where he worked as a commercial artist.

General Nikolai Ivanov (1851–1919), replaced General Khabalov as commander of Petrograd Military District on 28 February, relieved of duties two days later; commander in White Army from October 1918, died of typhoid in Odessa.

Grand Duke Kirill Vladimirovich (1876–1938), first cousin of Nicholas II, pledged allegiance to Provisional Government; left Russia in 1917, recognised as sole heir to throne on death of his cousin Nikolai Nikolaevich in 1929.

General Sergei Khabalov (1858–1924), commander of Petrograd Military District at start of February Revolution, replaced by Ivanov; imprisoned then released after October Revolution; emigrated to Greece in 1920.

Colonel Alexander Kutepov (1882–1930), commander of Preobrazhensky Regiment, general in White Army; emigrated to Paris, organised anti-Bolshevik sabotage; kidnapped by Soviet secret agents in 1930, may have died of heart attack en route from Marseilles to Russia.

Grand Duke Nikolai Nikolaevich (1856–1929), supreme commander-in-chief of Russian army at beginning of war, replaced by Nicholas II in August 1915; evacuated from Crimea on board British ship *HMS Marlborough* in 1919.

Princess Olga Paley (1865–1929), confidante of Empress Alexandra, morganatic second wife of Grand Duke Paul Alexandrovich, Nicholas II's uncle, who was executed with three other grand dukes in Peter and Paul Fortress in January 1919; Princess Paley died in exile in Paris.

Nikolai Pokrovsky (1865–1930), last minister of foreign affairs under tsar; emigrated to Lithuania, where he lectured at Kaunas University.

Alexander Protopopov (1866–1918), minister of internal affairs before February Revolution; close ally of Empress Alexandra, suspected of working for reconciliation with Germany; executed in 1918.

General Nikolai Ruzsky (1854–1918), present when Nicholas II was persuaded to abdicate; retired for health reasons to Pyatigorsk, where he was arrested and shot by Red Army the following year.

Vladimir Voeikov (1867–1947), commandant of the court; feigned madness in 1918 and hid in psychiatric hospital before escaping to Odessa; settled in Finland, moved to Sweden in 1940 when Finland was annexed by USSR.

EARLY REFORMERS

General Mikhail Alexeev (1857–1918), Nicholas II's chief of staff until abdication; then commander-in-chief under Provisional Government; became Kerensky's

chief of staff after Kornilov rebellion; after revolution one of the founders of Volunteer Army; died of heart attack in 1918.

Alexander Bublikov (1874–1941), transport commissioner of Provisional Committee of the Duma; emigrated to France and then New York.

Alexander Guchkov (1862–1936), minister of war in Provisional Government; captured by British after fighting for Boers in 1899; active in White movement after revolution; emigrated to Paris.

Vladimir Nabokov (1869–1922), leading Kadet, father of writer Vladimir Nabokov; killed by far-right Russian activists in failed attempt to assassinate Milyukov in Berlin in 1922.

Russkoe slovo, 'Russian Word', newspaper published in Moscow 1895–1918, supportive of Provisional Government.

General Vladimir Sakharov (1853–1920), made commander of the Eleventh Army in 1915; from December 1916 second-in-command to Ferdinand I on Romanian front; dismissed after February Revolution; lived in Romania, then Crimea where he was shot by local militia.

PROGRESSIVE REVOLUTIONARIES

Alexander Kerensky (1881–1970), lawyer, minister in Provisional Government, prime minister from July to October 1917; in hiding till May 1918 before emigrating; died in New York.

Petrograd Soviet, Petrograd Soviet of Workers' and Soldiers' Deputies, created in March 1917.

Nikolai Sukhanov (1882–1940), Menshevik, founder member of Petrograd Soviet Executive Committee; broke with Mensheviks in 1920, arrested in 1930, exiled to Tobolsk for ten years; accused of being German spy in 1937, executed in 1940; author of seven-volume memoir of the revolution.

OBSERVERS

Alexander Benois (1870–1960), artist, writer and journalist; editor of *Mir iskusstva* ('World of Art') magazine; designed sets and costumes for Diaghilev's Ballets Russes; head of picture galleries at Hermitage Museum from 1919 until emigrating to Paris in 1926.

Sir George Buchanan (1854–1924), British ambassador to Russia from 1910 to January 1918; after his departure diplomatic relations between UK and USSR were only restored in 1924.

Dmitry Filosofov (1872–1940), author, critic and religious thinker; literary editor of *Mir Iskusstva* ('World of Art') magazine; emigrated to Poland where he led émigré anti-Bolshevik activities.

Ivan Pavlov (1849–1936), physiologist, creator of science of conditioned reflexes, awarded Nobel prize in 1904; after revolution continued to work in his own laboratory outside Petrograd.

Mikhail Prishvin (1873–1954), writer whose short stories depict the natural world encountered in extensive travels around Russia; his published diaries cover 1905 to 1954.

Sergei Prokofiev (1891–1953), composer; after the revolution spent several years composing and performing in Europe and USA, returning to USSR in 1936; denounced for 'formalism' by Andrei Zhdanov in 1948.

Konstantin Somov (1869–1939), artist and illustrator; member of the World of Art movement; after revolution taught at Petrograd Free Art Educational Studios; travelled to New York in 1923 and two years later settled in Paris.

The Times, London newspaper first published in 1785.

Baron Nikolai Wrangel (1847–1923), memoirist and businessman, interests included gold and oil; emigrated to Serbia after October Revolution; his son Pyotr was leading figure in White Army.

On 22 February Nicholas leaves Petrograd for Mogilev, and security is left to General Belyaev, known to his colleagues as 'dead head', and the city's military commander General Khabalov. On 23 February – International Women's Day – disorders break out in Petrograd. Large groups of workers go on strike to protest against food shortages.

Violent skirmishes continue over the next two days, and on the evening of 25 February Nicholas sends Khabalov a telegram demanding the suppression of the protests by military force. By nightfall the authorities are losing control of the workers' quarters. Mayor of Petrograd, Alexander Balk, describes this day as 'a total defeat for us'.

Sunday morning, 26 February: a curfew is imposed; the bridges over the Neva are raised but thousands of workers cross the frozen river. Later that day, in Znamenskaya Square near the statue of Alexander III, a company of the Volynsky Guards Regiment is forced by their commanding officer to shoot into the crowd. An American pastor describes the 'rat-tat-tat of a machine gun. The people could hardly believe their ears, but there was no doubting the evidence of eyes as they saw people falling [...] Then something extraordinary happened: the troop of Cossacks positioned in the square turned and fired at the gunners on the house tops [...] The crowd scattered behind buildings and courtyards, from where some of them began firing at the military and police. Forty or so were killed and hundreds wounded.'

That same day, Chairman of the Duma Rodzyanko sends Nicholas a telegram: 'Situation serious. In the capital anarchy. Government paralysed.' He begs the tsar to allow for a new government with the power to appoint a new cabinet.

MAURICE PALÉOLOGUE
French ambassador

I heard a strange and prolonged din which seemed to come from the Alexander Bridge. I looked out: there was no one on the bridge, which usually presents such a busy scene. But, almost immediately, a disorderly mob carrying red flags appeared at the end which is on the right bank of the Neva, and a regiment came towards it from the opposite side. It looked as if there would be a violent collision, but in fact both crowds merged into one. The soldiers began to fraternise with the insurgents. *27 February 1917*

DMITRY FILOSOFOV
Author, critic and religious thinker

From my window I can see three or four soldiers with guns. They're smoking. Nervy. A small crowd surrounds them. A car drives past with some young ladies on board. The soldiers stop it, order them out. They get into the car and fire into the air. The crowd approaches. They say that the whole of Shpalernaya Street is overflowing with soldiers of the Volynsky Regiment. *27 February 1917*

MIKHAIL RODZYANKO
Chairman of the Duma; telegram to Nicholas II

The government is utterly powerless to crush the rebellion. The garrison forces cannot be relied upon. Reserve battalions of the guards' regiments are in revolt. Officers are being killed. Civil war has begun and is spreading. Order the immediate creation of a new government on the basis outlined to Your Majesty in my telegram of yesterday. Your Majesty, do not delay. If the unrest spreads to the army, it is the Germans who will prevail; Russia's destruction, and that of the dynasty, is inevitable. In the name of the whole of Russia I beg Your Majesty to do this. The hour that will decide Your fate and that of the country has come. Tomorrow may already be too late. *27 February 1917*

Mikhail Rodzyanko

EMPEROR NICHOLAS II
To Count Frederiks, minister of the household

That fat old fool Rodzyanko has again written me all sorts of rubbish to which I won't even bother to respond. *27 February 1917*

GENERAL SERGEI KHABALOV
Commander of the Petrograd Military District; telegram to Nicholas II

I will take all measures available to me to put down the rebellion. I believe it essential to send reliable troops from the front immediately. *27 February 1917*

EMPRESS ALEXANDRA FEODOROVNA
Telegram to her husband, Nicholas II

Concessions unavoidable. Strikes continuing. Many troops gone over to side of revolution. *27 February 1917*

PRINCESS OLGA PALEY
Confidante of Empress Alexandra

Towards two o'clock there arrived from Petrograd a certain Ivanoff, a notary's clerk, a young man of great intelligence, brave and ambitious [...] 'All is not lost,' he declared. 'If the emperor would but

mount a white horse at the Narva Gate and make a triumphant return into the town, the situation would be saved.'
27 February 1917

NIKOLAI POKROVSKY
Minister of foreign affairs of the Russian Empire

Khabalov was completely bewildered and stood open-mouthed as Golitsyn berated him for his lack of organisational abilities.* General Belyaev has taken over direct control of the military, expressing his conviction that the disturbances can definitely be brought under control. Protopopov also arrived, saying that he had come on foot from his home on the Fontanka without any hindrance. When Bark arrived he had managed to change his view radically overnight: he told me that Protopopov must be dismissed directly. *27 February 1917*

ALEXANDER PROTOPOPOV
Minister of internal affairs of the Russian Empire

The ministers decided to send the sovereign a despatch on the state of affairs, with a request to appoint an authorised chairman of the council of ministers and a military dictator in order to bring the military under control. Then Golitsyn asked me on behalf of the council to 'sacrifice myself', as he put it, and leave my position, since my name 'infuriated the crowd', and news of my departure would lead to 'calm'. I replied that I would willingly have gone long ago and, as he well knew, had asked as much on more than one occasion.

GENERAL MIKHAIL BELYAEV
Minister of war of the Russian Empire; telegram to General Alexeev

The disturbances which began in the morning in some military units are being harshly and energetically suppressed by companies and battalions that remain faithful to their duties. At present we have not yet managed to put down the revolt, but I am quite

certain of the early imposition of peace, to which end ruthless measures are being taken. The authorities are staying completely calm. *27 February 1917*

Alexander Benois

ALEXANDER BENOIS
Artist, writer and journalist

It appears certain that the Arsenal on Liteiny has been taken by mutinous regiments (which ones?), and that prisoners have been freed from the Kresty prison. Among those liberated is the recently incarcerated Manasevich-Manuilov, the minister's right-hand man and Paléologue's police informer; the liberating crowd accompanied him home with great celebrations, while the man himself walked through the snow in his pale pyjamas.* The district court is on fire. *27 February 1917*

PAVEL MILYUKOV
Leader of the Kadets in the Duma

I proposed that we wait until the situation had become clearer, and meanwhile create a Provisional Committee of members of the Duma 'to impose order and to communicate with individuals and organisations'.

KONSTANTIN GLOBACHEV
Head of the Okhrana, the tsarist secret police in Petrograd

In order not to expose people to needless violence and to avoid wasteful loss of life, I ordered all present to leave their posts immediately and return home. When this was done I took the precaution of locking all entrances to the building and then left the department myself with my closest advisers. *27 February 1917*

COLONEL ALEXANDER KUTEPOV
Commander of the Preobrazhensky Regiment

The whole of Liteiny was crammed with people who had surged in from the side streets, and were shouting as they extinguished and smashed streetlamps. Among the cries I heard my own name accompanied by foul abuse. The majority of my detachment began to mingle with the crowd, and I realised that they were no longer able to put up resistance. *27 February 1917*

SERGEI PROKOFIEV
Composer

On the bridge over the Fontanka I halted because I could hear the lively rattle of small-arms fire coming from Liteiny Prospect [...] I approached a little knot of people at a corner. A student was telling of his experiences: '... so they thrust a rifle into my hands. I haven't a clue what to do with it, I'm scared stiff it might go off. But you have no choice, you can't not take it, because if you don't they'll beat you up. So, anyhow, I took it, went round the corner and dumped it there.' *27 February 1917*

GENERAL SERGEI KHABALOV
Commander of the Petrograd Military District; to General Mikhail Alexeev

Please convey to His Imperial Majesty that I have been unable to carry out the instruction to impose order in the capital. Most of the units, one after the other, have betrayed their duty, refus-

General Sergei Khabalov

ing to take up arms against the mutineers. Other units have gone over to the mutineers' side, turning their weapons against forces loyal to His Majesty. Those that have remained loyal have been fighting the mutineers all day, sustaining considerable losses. By evening the mutineers had seized control of most of the capital. *27 February 1917*

GENERAL NIKOLAI IVANOV
Commander of the Petrograd Military District

After lunch the sovereign said to me: 'I appoint you commander-in-chief of the Petrograd district. There are disturbances in the reserve battalions there, and the factories are on strike.' *27 February 1917*

GRAND DUKE MIKHAIL ALEXANDROVICH
Younger brother of Nicholas II; direct wire conversation with General Alexeev

Please convey the following to His Majesty the Emperor on my behalf:
 It is my profound conviction that the entire Cabinet of Ministers must

be dismissed; Prince Golitsyn has confirmed the same. At the same time it is essential that replacements be nominated. Given today's situation, I suggest that the choice should fall on someone who enjoys the trust of Your Imperial Majesty and who is widely respected. This person should be entrusted with the duties of chairman of the Council of Ministers, answerable only to Your Imperial Majesty. He must be charged with the formation of a cabinet at his own discretion [...] For my part I suggest that this person could be Prince Lvov. *27 February 1917*

GENERAL MIKHAIL ALEXEEV
Chief of staff, Army Headquarters; direct wire conversation with Grand Duke Mikhail Alexandrovich

First. In view of the extreme circumstances the sovereign emperor believes it impossible to put off his departure and will leave tomorrow at half past two in the afternoon. Second. His Imperial Majesty will put off all decisions relating to changes in government until his arrival at Tsarskoe Selo. Third. General Ivanov will depart for Petrograd tomorrow as commander of the Petrograd District, accompanied by a loyal battalion. Fourth. From tomorrow four infantry regiments and four cavalry regiments, drawn from the most trustworthy companies, will set off from the Northern and Western fronts for Petrograd. *27 February 1917*

GRAND DUKE MIKHAIL ALEXANDROVICH
Younger brother of Nicholas II; diary entry

After this failed attempt to help matters I decided to return to Gatchina, but it was impossible to get out of the city, what with machine-gun fire going off and hand grenades exploding. *27 February 1917*

ZINAIDA GIPPIUS
Poet, novelist and journalist

Yesterday evening [...] there was talk of the government wavering between the dictatorship of Protopopov and some kind of administration of 'confidence', with General Alexeev at its head. But then late at night came the order dissolving the Duma before 1 April. It seems the Duma is resolved not to be dissolved. And so there, in fact, it continues to sit. All the streets around us are crammed with soldiers who have obviously joined the movement. *27 February 1917*

MIKHAIL RODZYANKO
Chairman of the Provisional Committee of the Duma; committee's declaration on the need to take power

In these grave times of internal disorder, brought about by the measures of the old government, the Provisional Committee of members of the State Duma has found itself compelled to take into its own hands the restitution of state and social order. While conscious that it is entirely responsible for this decision, the committee expresses its conviction that the population and the army will help it in the difficult task of establishing a new government, one that is in accordance with the wishes of the population and able to enjoy its confidence. *27 February 1917*

EMPEROR NICHOLAS II
Letter to his wife, Alexandra Feodorovna

Serious disturbances started in Petrograd several days ago; to make things worse, the troops have also joined in. It's a revolting sensation to be so far away and to receive only scraps of bad news! *27 February 1917*

NIKOLAI POKROVSKY
Minister of foreign affairs of the Russian Empire

We were informed that the revolutionaries had got into the Mariinsky Palace and moved on to the State Chancellery, where they were in charge; they would

soon move on to the Chancellery of the Council of Ministers. Kriger and I sat in the room, initially with the light on, but then we put out the light and even decided to hide under the table in the hope that people coming into the room might not notice us.*

SERGEI PROKOFIEV
Composer

That afternoon Mama and I went out to look at revolutionary Petrograd, which had a distinctly holiday air about it. At Gostiny Dvor there was another incident with a policeman: I saw two students dragging off a stout, grey-haired man in civilian clothes pursued by a furious mob screaming: 'A plain-clothes policeman!' People came running up from all directions, and I could see that it was a poor lookout for him. But then someone shouted: 'No mob rule!' and I immediately chimed in with 'No mob rule!' Some people supported me, calling for the same thing, but others cried: 'Kill him!' and thrust their fists right in his face [...] The policeman was on quite a high section of pavement a few paces from me; I pressed backwards as hard as I could and forced a few people back off the pavement, while some of the soldiers rushed into the space thus created and succeeded in isolating the policeman from the crowd, rendering him more or less safe. *28 February 1917*

MIKHAIL RODZYANKO
Chairman of the Duma; appeal from the Executive Committee of the Duma

Assaults on the life and health of private individuals, and equally on their property, are unacceptable. The spilling of blood and the destruction of property will be a stain on the conscience of the people who have committed such acts and, what is more, may lead to incalculable misery for the whole population of the capital. *27 February 1917*

ALEXANDER BENOIS
Artist, writer and journalist

So I suppose this is it – REVOLUTION! Even I am feeling worried, shown by the fact that I awoke at 6 a.m. This worry (which I am trying with all my strength to conceal) reveals itself in a heightened sense of irritation. Our daughters are annoying me, their reaction to events too careless, noisy and cheerful. Over coffee Dunya was getting everyone excited by announcing that she had just leant out of the window to see cars with red flags, one after another, turning off Sredny Prospect towards Tuchkov Bridge. The crowd (and the presence of a crowd at this early hour already seems to me of great significance) was accompanying them with cries. *28 February 1917*

GENERAL SERGEI KHABALOV
Commander of the Petrograd Military District; telegram to Army Headquarters

The number of those remaining loyal has shrunk to 600 infantrymen and 500 cavalry with 15 machine guns, 12 cannons and only 80 cartridges. The situation is difficult in the extreme. *28 February 1917*

MIKHAIL RODZYANKO
Chairman of the Provisional Committee of the Duma

In order to bring the telephone exchange back into operation we must send one or two cars with students or whoever, so they can fetch the frightened young ladies from their homes. Furthermore, we must remove the corpse lying in the exchange room. *28 February 1917*

ALEXANDER BUBLIKOV
Transport commissioner of the Provisional Committee of the Duma

Railway workers! The old order, which brought about the destruction of all branches of state government, is now impotent. The State Duma has taken into its hands the creation of a new power. I appeal to you on behalf of our

country: the salvation of the Motherland now depends on you. Your country expects more than that you fulfil your duty: she expects heroism. The train services must be uninterrupted and must be conducted with redoubled energy. *1 March 1917*

VLADIMIR NABOKOV
Leading member of the Kadets, head of the Provisional Government's secretariat

Whether under the influence of shots fired (if there were any) or for some other reason, the crowd began to loot the Astoria. Some 'refugees' from the hotel began to turn up at our house: my sister and her husband, Admiral Kolomeitsev, then a whole family with small children brought here by English officer acquaintances, then another family of distant Nabokov relatives. Somehow or other we accommodated them all in our house. *28 February 1917*

IVAN PAVLOV
Physiologist, Nobel prize winner; to his assistant

Why are you late, Sir? [...] What difference does a revolution make when you have work in the laboratory to do!

Ivan Pavlov

ALEXANDER BENOIS
Artist, writer and journalist

Two younger soldiers would usually lie down on the wheel arches of the trucks, posing as if taking aim. It's more picturesque that way, more of a daredevil effect. The crowd welcomes each such truck by raising their hats and shouting 'Hurrah!' *28 February 1917*

KONSTANTIN SOMOV
Artist

There are lots of armed hooligans, here and there they're shooting, and there are enormous queues for sugar on Angliisky Embankment. Cars go past with red flags, carrying people in shabby outfits, and some soldiers. The crowd is generally good-humoured, but I think there will be carnage. *28 February 1917*

MAURICE PALÉOLOGUE
French ambassador

During a day which has been prolific in grave events and may perhaps have determined the future of Russia for a century to come, I have made a note of one episode which seems trivial at first sight, but in reality is highly significant. The town house of Kshesinskaya [...] was occupied by the insurgents today and sacked from top to bottom [...]* The ballerina, once the beloved of the tsarevich and subsequently courted by two grand dukes at once, has become as it were a symbol of the imperial order. It is that symbol which has been attacked by the plebs today. A revolution is always more or less a summary and a sanction. *28 February 1917*

VASILY SHULGIN
Member of the Provisional Committee of the Duma

The Duma has turned into an almighty police station. With one difference: whereas before the police used to drag people in, now it's the people who are dragging in the police. *28 February 1917*

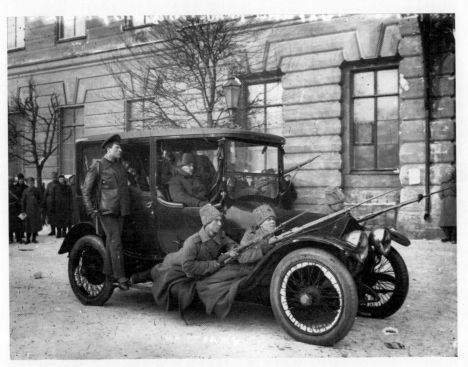

Duma messengers protected by armed guards. In his book From Czar to Kaiser *the American photographer Donald Thompson wrote: 'These motors were driven at a terrific speed through the streets. One ran even more risk of being killed by them than by the bullets that were flying in all directions'*

MIKHAIL PRISHVIN
Writer and ethnographer

Two women go past carrying pokers with lead balls on the end – to smash policemen's heads in. *28 February 1917*

SIR GEORGE BUCHANAN
British ambassador

Thanks to the efforts of the Executive Committee, the situation in the town showed signs of improvement on Tuesday [...] Though shooting continued the whole day, it was for the most part confined to the firing by the police of the machine guns, which Protopopoff had had placed on the roofs of the houses, and to the attempts made by the soldiers to dislodge the police by rifle fire.

ALEXANDER BUBLIKOV
Transport commissioner of the Provisional Committee of the Duma; telegram to railway authorities

Immediately despatch two goods trains from Dno station to Bologoe, one after the other, and position them in a siding to the east of Dno so as to make it physically impossible for any train whatsoever to pass from Bologoe to Dno. Any delay or failure to execute this order will be treated as a betrayal of the fatherland. *28 February 1917*

EMPEROR NICHOLAS II
Diary entry, written on the train

Shame and dishonour! It isn't possible to get to Tsarskoe, although all my thoughts and feelings are constantly there! How difficult it must be for poor Alix to have to go through all this alone! *1 March 1917*

LILI DEHN
Friend of Empress Alexandra

Her Majesty still thought that the train would arrive at ten. 'Maybe it has been held up by snow drifts,' she let slip.

GRAND DUKE KIRILL VLADIMIROVICH
First cousin of Nicholas II; address to Mikhail Rodzyanko in the Duma

I have the honour to appear before Your Excellency. I am at your service, like the whole nation. I wish the best for Russia. This morning I addressed the men of the Naval Guards, explained to them the significance of what was going on, and can now declare that the whole Naval Guard is at the complete disposal of the State Duma. *1 March 1917*

ZINAIDA GIPPIUS
Poet, novelist and journalist

All morning regiments have been flowing, flowing past our house towards the Duma. And in fairly orderly fashion, with flags, banners and music [...] We went out onto the street at around one o'clock and turned the corner towards the Duma. We saw a tidal wave of soldiers, shimmering with patches of crimson, not just on our street, but on all the surrounding ones too. *1 March 1917*

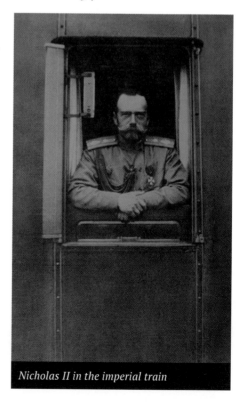

Nicholas II in the imperial train

PETROGRAD SOVIET
Order no. 1 on the democratisation of the army

To be immediately and fully executed by all men in the guards, army, artillery and navy and to be made known to the Petrograd workers.

The Soviet of Workers' and Soldiers' Deputies has resolved:

1. In all companies, battalions, regiments, batteries, squadrons and separate services of various military departments and on board naval ships committees shall be immediately elected from among representatives of the rankers of the foregoing units.

2. In all units which have not yet elected their representatives to the Soviet of Workers' Deputies, one representative from each company shall be elected. All representatives, carrying appropriate identity cards, are to arrive at the building of the State Duma by 10 a.m. on 2 March 1917.

3. In all their political actions, units are subordinated to the Soviet of Workers' and Soldiers' Deputies and their own committees.

4. All orders issued by the Military Commission of the State Duma shall be carried out, except those which run counter to the orders and decrees issued by the Soviet of Workers' and Soldiers' Deputies.

5. All kinds of weapons, namely rifles, machine guns, armoured cars and so forth, shall be placed at the disposal and under the control of the company and battalion committees and shall by no means be issued to the officers, not even at their insistence.

6. In formation and on duty, soldiers shall strictly observe military discipline; however, off duty and formation, in their political, civic and private life, soldiers shall fully enjoy the rights granted to all citizens. In particular, standing to attention and obligatory saluting off duty shall be cancelled.

7. Likewise, officers shall be addressed as Mr General, Mr Colonel, etc., instead of Your Excellency, Your Honour, etc. Rudeness towards soldiers of all ranks and, in particular, addressing them as 'thou' shall be forbidden. Any violation of this rule

The Preobrazhensky Regiment demonstrating on Nevsky Prospect, March 1917

and all cases of misunderstanding between officers and soldiers shall be reported by the latter to the company committees.

This order shall be read out in all companies, battalions, regiments, ship crews, batteries and other combat and non-combat detachments. *1 March 1917*

ZINAIDA GIPPIUS
Poet, novelist and journalist

The soldiers are now arresting officers, now setting them free, evidently they don't know themselves what they are supposed to do or what they want. On the streets the attitude to officers is clearly hostile [...] And the last issue of the Soviet paper *Izvestia* (yes, it's no longer the 'Soviet of Workers' Deputies' but the 'Soviet of Workers' and Soldiers' Deputies') printed a completely bizarre 'Garrison Order no. 1'. This directed amongst other things to 'obey only those orders which do not contradict the orders of the Soviet of Workers' and Soldiers' Deputies.' *2 March 1917*

PYOTR BARK
Minister of finance of the Russian Empire

The leader of the gang was a drunken reservist who had spent several years in our house as a servant. When I saw that he was the ringleader of the mob that had broken in, I asked him what he needed. He replied that he and his comrades had come to arrest the minister of finance on the orders of the military authorities, and he gave a sign to the soldiers and sailors accompanying him to surround me.

When my wife came out of her sitting-room and wanted to say goodbye to me, he held a revolver to her temple and declared that if she took another step he would fire. He went on to say: 'When I asked you for bread, you gave me stone.' My wife looked at him in amazement and asked: 'When was this, Nikifor? I thought we gave you everything you asked for, and your appearance here now – is that how you thank us for our kind conduct towards

you?' He replied, 'We do not have time to talk to you, the military authorities are waiting for us.'

NIKOLAI SUKHANOV
Member of the Executive Committee of the Petrograd Soviet; address to the Provisional Committee of the Duma

The Provisional Committee of the State Duma, having taken executive power into its hands, is still not a government, not even a 'provisional' one; it must create that government. The Soviet of Workers' Deputies, [...] as the organisational and ideological centre of the popular movement, as the only body [...] with real strength in the capital today, wishes to [...] set out the demands which it makes in the name of all democracy to the government formed by the revolution. *1 March 1917*

SERGEI PROKOFIEV
Composer

Somewhere in the bowels of the Duma an immense work was in progress that would determine the fate of Russia. High up on the roofs of the city the old regime had its police snipers firing on opponents in the crowds, while below on the streets people continued to mill about in such a monotonously aimless manner that very soon it began to irritate me. With relief I sat at home and took up my work again. I finished the Sonata No. 3, sketched out some pieces for Op. 22 (including the penultimate one, which reflected my mood brought on by the events of the time). And I settled down to work further on the Violin Concerto.

MAXIM GORKY
Writer and political commentator; letter to his wife Ekaterina Peshkova

The events taking place may appear grandiose, even moving at times, but their meaning is not so profound and sublime as everyone imagines. I am filled with scepticism, even though I am also moved to tears at the sight of soldiers marching to the State Duma to the sound of music. I don't believe in a

Tsarist policemen under arrest

revolutionary army; I think that many people are mistaking an absence of organisation and discipline for revolutionary activity.

All the forces in Petersburg have gone over to the Duma, that's true; so have the units coming from Oranienbaum, Pavlovsk and Tsarskoe. But the officers will, of course, side with Rodzyanko and

Maxim Gorky

Milyukov up to a certain point, and only the wildest dreamer would expect the army to stand together with the Soviet of Workers' Deputies.

The police, ensconced in attics, spray the public and soldiers with machine-gun fire. Cars packed with soldiers and bearing red flags drive around the city in the search for policemen in disguise, and these are then placed under arrest. In some cases they are killed, but for the most part they are brought to the Duma, where about 200 policemen out of 35,000 have already been rounded up.

There's a great deal of the absurd – more than there is of the grandiose. Looting has begun. What will happen next? I don't know. But I see clearly that the Kadets and the Octobrists are turning the revolution into a military coup. Will they succeed? It seems they

already have. We won't turn back, but we won't go very far ahead either – perhaps only a sparrow's step. And of course a lot of blood, an unprecedented amount, will be shed. *1 March 1917*

BARON NIKOLAI WRANGEL
Businessman and memoirist

Rumours abound that Ivanov is on his way with a battalion of the Georgievsky Cavalry, that numerous forces have been directed towards Petersburg, and some have already arrived. But these are only rumours. *1 March 1917*

GENERAL NIKOLAI IVANOV
Commander of the Petrograd Military District

Walking past one carriage I swung round – and a soldier made a jump at me, literally at point blank range. He had a sabre in his left hand [...] I pushed him away. My hand slid along his sabre. I cut my hand slightly and then stopped him in his tracks by shouting: 'On your knees!' My hand was on his right shoulder: 'On your knees!' At this point I don't know what he thought, but as I grabbed him with my left hand suddenly, whether deliberately or not, he bit me. Then they took him away and he calmed down.

GENERAL MIKHAIL ALEXEEV
Chief of staff, Army Headquarters; telegram to Nicholas II

For the moment the State Duma is trying to bring back some order, but if there is no decree forthcoming from Your Majesty allowing the general situation to calm down, then tomorrow power will pass into the hands of extreme elements, and Russia will undergo all the horrors of revolution. I beg Your Majesty, for the salvation of Russia and the dynasty, to place at the head of the government a person in whom Russia can believe, and instruct him to form a cabinet. At this moment that is the only way out. There must be no delay. *1 March 1917*

EMPEROR NICHOLAS II
Letter to his wife Alexandra Feodorovna

Seeing what is being done by ministers to the detriment of Russia, I shall never be able to agree with them, finding solace in the thought that this is out of my hands, not my responsibility.
1 March 1917

EMPRESS ALEXANDRA FEODOROVNA
Letter to her husband Nicholas

Beloved, precious light of my Life [...] Its more than madening not being together – but soul & heart are more than ever – nothing can tear us apart, tho they just wish this, thats why wont let you see me until you have signed a paper of theirs about otv. min. or constitution.* The nightmare is that having no army behind you, you may be forced into it. But such a promise is 'null' once in power again. – They meanly caught you like a mouse in the trap – unheard of in history. *2 March 1917*

MIKHAIL RODZYANKO
GENERAL NIKOLAI RUZSKY
Direct wire conversation between the chairman of the Provisional Committee and General Ruzsky in Pskov, after Nicholas II's arrival

NR: His Majesty has come to a final decision and has requested that I inform you of it – that is, to grant an administration that is answerable to the elected bodies, with a cabinet selected by you. If you are favourable to His Majesty's wish, then a proclamation has been drafted which I could send to you now. [...]
MR: It is clear that His Majesty and you are unaware of what is going on here. A most terrible revolution is taking place, which will not be easily overcome [...] Unfortunately the popular mood has been so inflamed that it will almost certainly be impossible to contain it, and the troops are utterly demoralised. Not only are they disobeying orders, they are killing their officers. Hatred for the sovereign empress has reached extreme levels [...] I must inform you that what you are suggesting is

no longer enough and that the dynastic issue is being raised directly. I doubt that this is something we can resolve.
NR: Your comments, Mikhail Vladimirovich, certainly cast a different light on the matter [...] Before sending you the proclamation, would you be kind enough to tell me in what way the dynastic issue is being discussed?
MR: I will answer you now, Nikolai Vladimirovich, with pain in my heart [...] a forceful demand that he abdicate in favour of his son under the regency of Mikhail Alexandrovich is becoming an explicit demand. I repeat, I'm telling you this with pain in my heart, but what can be done? While our brave army was shedding its blood and making countless sacrifices, the government was literally riding roughshod over it. The order to despatch the Georgievsky Battalion under General Ivanov has only poured oil on the fire [...] Halt the despatch of the troops, since they will not engage against the people.
NR: The crisis we're going through must be ended as soon as possible in order that the army can once again focus on the enemy. Troops were sent from the front towards Petrograd, [...] but now this order has been rescinded.
MR: Anarchy has reached such a level that I am compelled this night to appoint a Provisional Government. Unfortunately the proclamation is too late [...] The moment has been missed and there is no going back. *2 March 1917*

GENERAL MIKHAIL ALEXEEV
Chief of staff, Army Headquarters; telegram to the generals in command of Russian armies at the fronts

His Majesty is in Pskov where he expressed his agreement to a proclamation meeting the popular demand for the establishment of an administration answerable to parliament, having charged the chairman of the State Duma with the formation of a cabinet.
 The chairman of the Duma responded that such a proclamation would have been timely on 27 February. It is now too late [...] The dynastic issue is now

being raised directly, and the war can only be continued by meeting the demands for his abdication in favour of his son under the regency of Mikhail Alexandrovich.

If you share this view, please be so kind as to telegraph your loyal request to His Majesty via C.-in-C. Northern front with all due haste, notifying me of the same. *2 March 1917*

GENERAL ALEXEI BRUSILOV
Commander, South-Western front; telegram to General Alexeev

No hesitation. Time does not allow. I concur completely. Will send telegram via C.-in-C. Northern front with most humble request to His Majesty the Emperor. Completely share your views. There can be no alternative. End. *2 March 1917*

GENERAL VLADIMIR SAKHAROV
Commander, Romanian front; direct wire conversation with General Lukomsky

Evidently, and however sorrowful it may be, I must agree that this is the only way out. I will compose a telegram, but it might be better to send it after a final decision has been received from you, based on the views of everyone else. But it would be extremely desirable, nay necessary, to know the response from the Caucasus. *2 March 1917*

EMPRESS ALEXANDRA FEODOROVNA
Letter to her husband, Nicholas II

We all kiss & kiss & bless you without end. God will help & yr glory will come. This is at the climax of the bad, the horror before our allies!! & the enemies joy!! Can advise nothing, be only yr precious self. If you have to give into things, God will help you to get out of them. Ah, my suffering saint, I am one with you, inseparably one, old Wify. May this image I have blessed bring you my fervent blessings, strength, help. Wear [Rasputin's] cross the whole time even if uncomfortable for my peace's sake. *2 March 1917*

GENERAL MIKHAIL ALEXEEV
Chief of staff, Army Headquarters; telegram to Nicholas II

Your Imperial Majesty, who loves the motherland fervently, for the sake of

General Mikhail Alexeev

her integrity and independence, in order to achieve victory, be pleased to take a decision which may bring about a peaceful and favourable exit from the more than grievous situation that has developed. *2 March 1917*

EMPEROR NICHOLAS II
Telegram to General Alexeev

For the well-being, peace and salvation of our dearly beloved Russia, I am ready to abdicate in favour of my son. I ask all to serve him loyally and sincerely. *2 March 1917*

VLADIMIR VOEIKOV
Commandant of the court

I ran into the sovereign's carriage, entered his compartment unannounced

and asked, 'Can it really be true, as the count says, that Your Majesty has signed his abdication? And where is it?' The sovereign handed me a packet of telegrams lying on his table, and replied, 'What else was there for me to do, when everyone had betrayed me? Starting with Nikolasha.* Read this.'
2 March 1917

GRAND DUKE NIKOLAI NIKOLAEVICH
Former supreme commander-in-chief of the Russian army; telegram to his nephew Nicholas II

A victorious conclusion to the war, so necessary for the good and destiny of Russia and the salvation of the dynasty, calls for EXTREME MEASURES TO BE TAKEN. I, your loyal subject, consider it necessary under my oath of allegiance and my bounden duty to IMPLORE ON BENDED KNEE Your Imperial Majesty to save Russia and Your Successor, knowing Your feeling of sacred love to Russia and to him. Having blessed yourself, PASS ONTO HIM YOUR THRONE. THERE IS NO OTHER WAY. 2 March 1917

VLADIMIR VOEIKOV
Commandant of the court

To my repeated question 'Where is the abdication?', the sovereign replied that he had given it to Ruzsky to send to Alexeev, to which I told the sovereign that in my opinion no final decision could be taken until he had heard from Guchkov and Shulgin, now en route to see him. The sovereign agreed to demand his abdication back from Ruzsky. 2 March 1917

PIERRE GILLIARD
French tutor to the imperial family

Nicholas II did not hesitate, and on the morning of the 2nd he handed General Ruzsky a telegram informing the chairman of the Duma of his intention to abdicate in favour of his son.

A few hours later he summoned Professor Fyodorov to his carriage and said:

'Tell me frankly, Sergei Petrovich, is Alexei's malady incurable?' Professor Fyodorov, fully aware of the significance of what he was going to say, replied: 'Sire, science teaches us that it is an incurable disease. Yet those who are afflicted with it sometimes live to an advanced old age. However, Alexei Nikolaevich is at the mercy of an accident.'

The emperor lowered his head sadly and murmured: 'That's just what the empress said to me... Ah well, since it is so, since Alexei is unable to be of use to his country in the way I would like, we are entitled to keep him.'

ALEXANDER GUCHKOV
Minister of war in the Provisional Government

The sovereign responded that he had considered the question over the last few days (he heard me out calmly) and that he had himself reached a decision on abdication, that he had considered abdicating in favour of his son, but now had resolved that he could not be parted from his son and had therefore decided to abdicate in favour of Grand Duke Mikhail Alexandrovich. 2 March 1917

EMPEROR NICHOLAS II
Diary entry, Pskov

In the evening Guchkov and Shulgin arrived from Petrograd and, after talking to them, I handed over the signed and recopied proclamation. I left Pskov at one o'clock at night with a heavy heart. All around is betrayal, cowardice and deceit! 2 March 1917

PAVEL MILYUKOV
Leader of the Kadets in the Duma; speech reported in Izvestia Petrogradskogo soveta

I have been asked, who elected you? No one elected us, for if we had waited for a popular election, we would not have been able to seize power from the hands of our enemies. While we argued about whom to elect, the enemy would have succeeded in organising itself and conquering both you and us. We were

elected by the Russian Revolution. (*Loud prolonged applause.*) […] We will not hold on to power for a single minute after we are told by the freely elected representatives of the people that they wish to see other people in our places, more deserving of their trust. (*Applause.*) […]

You ask about the dynasty. I know in advance that my reply will not satisfy all of you, but I will give it nonetheless. The old despot who brought Russia to its knees will give up the throne voluntarily, or will be dethroned. Power will pass to the regent, Grand Duke Mikhail Alexandrovich. (*Prolonged indignant shouting, cries of 'Long live the republic!', 'Down with the dynasty!' Faint applause, drowned out by a new wave of indignation.*)

The heir will be Alexei. *2 March 1917*

GENERAL MIKHAIL ALEXEEV
Chief of staff, Army Headquarters; telegram to Nicholas II

The military is subject to the new government, not excepting those members of the royal family present in Petrograd who are serving in the military, and all levels of the population recognise only the new authorities. For the imposition of complete order, to save the capital from anarchy, it is essential to summon here to the post of commander of the Petrograd Military District a gallant battlefield general whose name will be popular and have authority in the eyes of the people. The Committee of the State Duma recognises that that person is the gallant hero, famed throughout Russia, commander of the 25th Army Corps, Lieutenant-General Kornilov. *2 March 1917*

EMPEROR NICHOLAS II
Abdication proclamation

The fate of Russia, the honour of Our heroic army, the welfare of the nation and the whole future of Our dear country require that the war shall be continued, cost what it may, to a victorious end.

Our cruel enemy is making his final effort and the day is at hand when Our brave army, with the help of Our glorious allies, will overthrow him once and for all. At this moment, a moment so decisive for the existence of Russia, Our conscience bids Us to facilitate the closest union of Our subjects and the organisation of all their forces for the speedy attainment of victory. For that reason We think it right – and the State Duma shares Our view – to abdicate the crown of the Russian State and resign the supreme power.

As we do not desire to be separated from Our beloved son, We bequeath Our inheritance to Our brother, the Grand Duke Mikhail Alexandrovich, and give him Our blessing on his accession to the throne. *2 March 1917*

GEORGE V
King of England, first cousin of Nicholas II

I fear Alicky is the cause of it all and Nicky has been weak. Heard from Buchanan that the Duma had forced Nicky to sign his abdication and Misha had been appointed regent, and after he has been 23 years emperor, I am in despair. *2 March 1917*

MIKHAIL RODZYANKO
Chairman of the Provisional Committee of the Duma; direct wire conversation with General Ruzsky

It is vital that the abdication manifesto and transfer of power to Grand Duke Mikhail Alexandrovich should not be published until I inform you to do so. The fact is, revolutionary activity has been kept more or less within reasonable limits, but the situation is not yet back to normal and civil war remains a distinct possibility. The grand duke's regency and accession of the tsarevich-heir would perhaps keep things calm, but the accession of the grand duke as emperor is absolutely unacceptable. I would ask you to take all possible measures to delay publication. *3 March 1917*

Высочайшій Манифестъ.

БОЖІЕЮ МИЛОСТІЮ

МЫ, НИКОЛАЙ ВТОРЫЙ,

ИМПЕРАТОРЪ И САМОДЕРЖЕЦЪ
ВСЕРОССІЙСКІЙ,

ЦАРЬ ПОЛЬСКІЙ, ВЕЛИКІЙ КНЯЗЬ ФИНЛЯНДСКІЙ,
И ПРОЧАЯ, И ПРОЧАЯ, И ПРОЧАЯ.

Объявляемъ всѣмъ вѣрнымъ Нашимъ подданнымъ:

„Въ дни великой борьбы съ внѣшнимъ врагомъ, стремящимся почти три года пора-ботить Нашу Родину, Господу Богу угодно было ниспослать Россіи новое тяжкое испы-таніе. Начавшіяся народныя внутреннія волненія грозятъ бѣдственно отразиться на дальнѣйшемъ веденіи упорной войны.

Судьба Россіи, честь геройской Нашей Арміи, благо народа, все будущее дорогого Нашего Отечества требуютъ доведенія войны во что бы то ни стало до побѣднаго конца. Жестокій врагъ напрягаетъ послѣднія силы и уже близокъ часъ, когда доблест-ная Армія Наша, совмѣстно со славными Нашими Союзниками, сможетъ окончательно сломить врага. Въ эти рѣшительные дни въ жизни Россіи почли мы долгомъ совѣсти облегчить Народу Нашему тѣсное единеніе и сплоченіе всѣхъ силъ народныхъ для ско-рѣйшаго достиженія побѣды и, въ согласіи съ Государственною Думою, признали мы за благо отречься отъ Престола Государства Россійскаго и сложить съ Себя Верховную Власть. Не желая разставаться съ любимымъ сыномъ Нашимъ, Мы передаемъ наслѣдіе Наше брату Нашему ВЕЛИКОМУ КНЯЗЮ МИХАИЛУ АЛЕКСАНДРОВИЧУ и благосло-вляемъ Его на вступленіе на престолъ Государства Россійскаго. Заповѣдуемъ Брату Нашему править дѣлами государственными въ полномъ и ненарушимомъ единеніи съ представителями народа въ законодательныхъ учрежденіяхъ на тѣхъ началахъ, кои бу-дутъ ими установлены. Принеся въ томъ ненарушимую присягу въ имя горячо люби-мой Родины, призываемъ всѣхъ вѣрныхъ сыновъ Отечества къ исполненію своего свя-того долга передъ нимъ, повиновеніемъ Царю въ тяжелую минуту всенародныхъ испы-таній и помочь Ему вмѣстѣ съ представителями народа вывести Государство Россійское на путь побѣды, благоденствія и славы.

Да поможетъ Господь Богъ Россіи.

На подлинномъ Собственною Его Императорскаго Величества рукою написано:

„НИКОЛАЙ".

Данъ 2 марта 15 часовъ 1917 г.
Городъ Псковъ.

Скрѣпилъ Министръ Императорскаго Двора Генералъ-Адъютантъ Графъ Фредериксъ.

Nicholas II's abdication proclamation. The document opens: 'By God's grace, We, Nicholas the Second, Emperor and Autocrat of All the Russias, Tsar of Poland, Grand Duke of Finland, et cetera, et cetera, et cetera'

THE TIMES
London newspaper; report

There has been a revolution in Russia. The Emperor Nicholas II has abdicated. His brother, the Grand Duke Michael, has been appointed Regent. The Parliamentary leaders, with the people and the Army at their back, have carried out a coup d'Etat. While the bulk of the Petrograd garrison held the city for the parliamentary cause, M. Rodzianko, the president of the Duma, demanded of the tsar a new government. Failing to receive satisfaction, M. Rodzianko placed himself at the head of a Provisional Government of 12 members. The new government has dispersed the old ministry, and has arrested many of its leading members [...] In Petrograd order is now being rapidly restored after considerable street fighting on Sunday and Monday. There is every indication that the revolution has completely succeeded. *3 March 1917*

GRAND DUKE MIKHAIL ALEXANDROVICH
Younger brother of Nicholas II

At 6 a.m. we were woken by a telephone call. The new Minister of Justice Kerensky told me that the Council of Ministers in its full complement would call on me in an hour. In fact they only arrived at 9.30. *3 March 1917*

PAVEL MILYUKOV
Leader of the Kadets in the Duma

As I entered the apartment I bumped into the grand duke, and he addressed me with a rather clumsily improvised joke: 'So it's not such a bad thing to be in the position of the English king. Very convenient and straightforward, is it not?' I replied, 'Yes, Your Majesty, ruling can be quite peaceful if the constitution is observed.' With that we both went into the meeting room.

ZINAIDA GIPPIUS
Poet, novelist and journalist

And so with Mik. Alex. it's all become clear. On leaving, Kerensky shook the gr. duke warmly by the hand and said, 'You are an honourable man.' *3 March 1917*

FORMER EMPEROR NICHOLAS II
Diary entry

It appears that Misha has abdicated. His manifesto concludes with a call for elections to a Constituent Assembly within six months. God knows who advised him to sign such a vile document! In Petrograd the disturbances have stopped – long may it remain that way. *3 March 1917*

GRAND DUKE MIKHAIL ALEXANDROVICH
Younger brother of Nicholas II

In Petrograd the mood is improving and order is being restored, the cabs are back on the streets and the trams will start working tomorrow; but there's still practically no discipline in the military, which is more than regrettable. *6 March 1917*

RUSSKOE SLOVO
'Russian Word', newspaper supportive of the Provisional Government; article titled 'Citizen Mikhail Romanov'

Today the Soviet of Workers' Deputies was informed that Grand Duke Mikhail Alexandrovich had demanded a special train from Gatchina to travel to Petrograd. The Soviet of Workers' Deputies, having discussed the matter, instructed one of the members of the Executive Committee to telephone Varshavsky Train Station and convey the following resolution of the Soviet of Workers' Deputies: 'Citizen Mikhail Romanov, like any other citizen of the Russian Empire, has no rights to any privileges,

be it a special train or carriage, but may buy a ticket from any ticket office, and even any number of tickets, and the Soviet of Workers' Deputies further guarantees his safe passage to Petrograd.'
5 March 1917

BARON NIKOLAI WRANGEL
Businessman and memoirist

Absolute monarchy has breathed its last. It departed quietly, almost unnoticed, without a struggle, not clinging onto life, not even trying to resist death. Only very old, utterly exhausted organisms die in that way; they are not sick, nothing particular has happened to them, but the organism is worn out, it is no longer capable of living. The firewood has burnt, the fire has gone out. 'Died from weakness,' as the saying has it.

The last rites have been read. The successors, Milyukov, Kerensky and Co., have set about building a new, free Russia. *5 March 1917*

ALEXANDER KERENSKY
Minister of justice in the Provisional Government; speech to the Soviet of Workers' Deputies

I cannot live without the people, and the moment you begin to doubt me, kill me. *2 March 1917*

Removal of imperial regalia from a building on
Voskresensky Prospect in Petrograd

3
EUPHORIA

"Today is one of the greatest and most joyous days for Russia. What a day!"

ROYALISTS

Elizaveta Naryshkina (1838–1928), lady-in-waiting to Empress Alexandra and before her to Nicholas II's mother Empress Maria Feodorovna; known as 'Madame Zizi'; emigrated to Germany and then France after the revolution.

PROGRESSIVE REVOLUTIONARIES

Nikolai Chkheidze (1864–1926), Menshevik, first chairman of Petrograd Soviet; left Petrograd for native Georgia before October Revolution; chairman of Constituent Assembly in Georgia; fled to Paris when Red Army invaded in 1921; committed suicide.

RADICAL REVOLUTIONARIES

Leon Trotsky (1879–1940), revolutionary and Marxist theorist, chairman of Petrograd Soviet from September 1917; first commissar of foreign affairs; led negotiations at Brest-Litovsk but abstained in vote on final treaty; appointed commissar of war, led Red Army against Whites; expelled from Communist Party in 1927, exiled to Kazakhstan in 1928, then Turkey in 1929, expelled from France in 1933, from Norway in 1936; settled in Mexico where murdered by a Spanish communist on Stalin's orders.

OBSERVERS

Alexander Blok (1880–1921), poet, secretary to commission that interrogated former members of tsarist government; died disillusioned with the revolution.

Andrew Bonar Law (1858–1923), British Conservative chancellor of the exchequer in Lloyd George's war coalition; succeeded Lloyd George as prime minister when coalition collapsed in 1922.

Marc Chagall (1887–1985), modernist artist, founded Vitebsk Art School; left Russia in 1922, fled Nazi-occupied France to USA in 1941, returning to France in 1948.

James L. Houghteling, Jr (1883–1962), attaché at American Embassy, author of *A Diary of the Russian Revolution*; later director of *Chicago Times*, then US commissioner of immigration.

David Lloyd George (1863–1945), British Liberal prime minister 1916–22; welcomed February Revolution, but Britain and the Allies supported White Army after October Revolution; represented Britain at Paris Peace Conference; led Liberal Party until 1931.

Stinton Jones (1884–1979), English engineer and businessman who spent twelve years in Russia; left immediately after February Revolution.

Manchester Guardian, British newspaper founded in 1821; changed masthead to *The Guardian* in 1959.

Niva, illustrated Petersburg weekly 1870–1918, subtitled 'Journal of literature, politics and contemporary life'.

Louis de Robien (1888–1958), French count, career diplomat; attaché at French Embassy from 1914; moved with mission to Arkhangelsk in July 1918, returned to France in 1919; appointed ambassador to China in 1941.

Bertie Stopford (1860–1939), English antiques dealer, lived in Petrograd 1915–17; rescued Grand Duchess Maria Pavlovna's jewels from Vladimir Palace and smuggled them to England in September 1917; left England in 1920 following imprisonment on charges of gross impropriety; died in France.

Igor Stravinsky (1882–1971), composer first renowned for ballets written for Diaghilev's Ballets Russes; lived in Western Europe from 1915, moving to USA in 1939, settling in Hollywood; visited USSR in 1962.

Donald Thompson (1885–1947), American war photographer and film-maker; published several books on revolution and a film titled *The German Curse in Russia*.

Harold Williams (1876–1928), New Zealand journalist; foreign editor of *The Times*, knew 58 languages; married Ariadna Tyrkova, leader of Kadet Party in the Duma.

Zhurnal dlya khozyaek, 'Housewife Magazine', illustrated women's monthly magazine published in Moscow 1912–26.

For many, there is a lingering sense of disbelief and euphoria during the days and weeks after the revolution. The old order has gone, the new seems full of possibility. Although Prince Georgy Lvov is nominally head of the Provisional Government, it is Milyukov, as minister of foreign affairs, and Kerensky, as minister of justice, who take the lead.

Kerensky quickly moves to minimise reprisals against the old regime. 'The Duma sheds no blood' is the slogan. Before the month is out he confirms a decree abolishing the death penalty. The police and gendarmerie are dissolved. Political amnesty sees the return of thousands of Russian émigrés after long years of exile.

The new Provisional Government enjoys extraordinary support – even grand dukes and generals swear allegiance to it. Foreign powers quickly recognise the new regime, speeches are made in London 'to welcome the Russian Revolution', which is referred to as 'a revolution in thought, a revolution in way of life'. In Petrograd the euphoria is infectious. The journalist Arthur Ransome celebrates the freedom of the press: 'Every paper seems to be executing a war-dance of joy [...] It is as if all Russia had spat out the gags forced in mouths by the old regime of oppression.'

Already, however, the government is starting to worry about what to do with the former imperial family, while Nicholas is still in Pskov, separated from his family at Tsarskoe Selo.

PRINCE GEORGY LVOV
Prime minister in the Provisional Government

Honour and glory to the Russian people! The sun of freedom is shining over Russia and has immediately illuminated the deep bed of that lake which is the genius of the Russian people. And this genius tells us of generosity towards the past and forceful energy in the future [...] We are all supremely happy that we have managed to live to see this great moment, that we can create a new life for our nation – not for the people but with the people [...] What an extraordinary joy it is to live in these great days. *7 March 1917*

Prince Georgy Lvov

JAMES L. HOUGHTELING, JR
Attaché at the American Embassy

We stopped to laugh at some clumsy men trying to take down a Romanoff coat-of-arms from above the shop of the apothecary Goldberg; they perched on the roof tree and struggled to detach it from numerous wires and to lower it without breakage. Goldberg evidently thought that he might need it again. The women in a breadline right below smiled as if they knew better. *3 March 1917*

FORMER EMPRESS ALEXANDRA FEODOROVNA
Letter to her husband Nicholas

Paul just came – told me all.* I fully understand yr. action, my own heroe! I know that could not sign against what you swore at yr. coronation. We know each other through & through – need no words –, as I live, we shall see you back on yr. throne, brought back by your people, to the glory of your reign. You have saved yr. son's reign & the country & yr. saintly purity & Judas Ruzsky, you will be crowned by God on this earth – in yr. country. *3 March 1917*

LILI DEHN
Friend of Empress Alexandra

She staggered rather than walked, and I rushed forward to support the empress until she reached the desk between the windows. She leant heavily against it and, taking my hands in hers, said in an agonised voice:
 'Abdiqué! Poor darling... completely alone there... My God! How much he has had to endure! And without me at his side to comfort him. Oh my God, how terrible it is to think of him all on his own! *3 March 1917*

THE TIMES
London newspaper; proceedings of the House of Commons

Mr. Devlin (Belfast, W., Nat.) said that all who believed in the triumphant vindication of democratic principles and democratic government in all countries in Europe must rejoice at what they believed to be a successful blow struck for democratic government in Russia. He was very glad to hear that the attitude of those who had taken part in the revolution had been an attitude that would tend to a further strengthening of all those great elements in Russia that were associated with the Allies in the successful prosecution of the war. (*Cheers.*) *3 March 1917*

ALEXANDER KERENSKY
Minister of justice in the Provisional Government; speech to the Petrograd Soviet

Citizens! I am A.F. Kerensky, member of the State Duma and minister of justice (*wild applause and cries of 'hurrah'*). The first act of the new government will be the immediate issuance of an act of total amnesty. Comrades, all the former presidents of the Council of Ministers and all the ministers of the old regime come under my jurisdiction. They will answer, comrades, for all crimes against the people, according to the law (*shouts of 'No mercy!'*). Free Russia will not resort to the shameful methods of enforcement employed by the old regime. *2 March 1917*

PRINCE GEORGY LVOV
Prime minister in the Provisional Government

The government has dismissed the old governors and will not replace them. The provinces will elect. These matters must be resolved by the population itself rather than at the centre. *6 March 1917*

MARC CHAGALL
Artist

The revolution moved me with an absolute force that takes hold of a person, of an individual human, of his being, surging through the borders of imagination and bursting into the most intimate world of images, which themselves become part of the revolution.

IGOR STRAVINSKY
Composer; letter to his mother Anna

All my thoughts are with you in these unforgettable days of happiness, which our beloved and liberated Russia is going through. Send a telegram with your news. *2 March 1917*

BERTIE STOPFORD
Anonymous author of *The Russian Diary of an Englishman*

I went this evening to the first representation of the ballet under the new order [...] The great imperial box in the centre of the grand tier was unoccupied until the second entr'acte, when a man

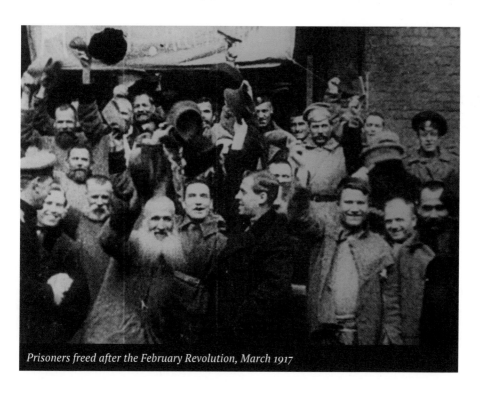

Prisoners freed after the February Revolution, March 1917

and woman of the people came and sat in it. It disgusted me. The 'Marseillaise' was played at the beginning of the second act and encored [...] I was told that at the end a man with long hair and a red tie and a soldier harangued the house from the imperial stage box on the first floor. *15 March 1917*

ALEXANDER KERENSKY
Minister of justice in the Provisional Government; speech to the Petrograd Soviet

Nobody will be subjected to punishment without trial. A public court of the people will pass judgement in every case. Comrade soldiers and citizens, every measure taken by the new government will be published. Soldiers, I ask you to assist us. A free Russia has been born, and nobody must be allowed to tear this freedom from the people's grasp. *2 March 1917*

Maurice Paléologue

MAURICE PALÉOLOGUE
French ambassador

Last night Rasputin's coffin was secretly exhumed from its resting-place in the chapel at Tsarskoe Selo and taken away to the Forest of Pargolovo, fifteen *versts* north of Petrograd. In the midst of a clearing there, a number of soldiers, commanded by an engineer officer, had

piled up a large quantity of pine logs. After forcing off the coffin lid they drew the corpse out with sticks; they dare not touch it with their hands, owing to its putrefying condition, and they hoisted it, not without difficulty, on to the heap of logs. Then they drenched it in petrol and set it on fire. The process of cremation lasted until dawn, more than six hours. In spite of the icy wind, the appalling length of the operation and the clouds of pungent and fetid smoke which rose from the pyre, several hundred *muzhiks* crowded round the fire all night; silent and motionless, they gazed in horror-stricken stupor at the sacrilegious holocaust which was slowly devouring the martyred *starets*, friend of the tsar and tsaritsa, the *Bozhy chelovek*, 'Man of God'.* When the flames had done their work, the soldiers collected the ashes of the corpse and buried them under the snow. *10 March 1917*

JAMES L. HOUGHTELING, JR
Attaché at the American Embassy

Pettit arrived from Moscow at noon.* He says that the revolution in that city was very quiet, and that he only heard of four deaths: two policemen, an officer, and a civilian. On Tuesday, when the news arrived, one regiment remained loyal and, withdrawing to the Kremlin, prepared to defend itself; but on Wednesday the soldiers thought better of it and gave up without a struggle. The tsarevich is reported to have died of measles this morning – that boy has as many lives as old Franz Joseph had. *3 March 1917*

ELIZAVETA NARYSHKINA
Lady-in-waiting to Empress Alexandra

Everybody is very sad. All the telegrams which the empress has sent to the tsar during the last weeks have been made public. The empress is indignant and, I believe, scared. The antagonistic spirit toward her is increasing. It would be horrible if it ended in condemnation. I had been wishing ardently that they might let her go away. *19 March 1917*

LOUIS DE ROBIEN
Attaché at the French Embassy

People say that the emperor is asking to be taken to Tsarskoe Selo, to be near the grand duchesses, who are ill. From there he would go to England by way of Murmansk. *6 March 1917*

Vladimir Nabokov

VLADIMIR NABOKOV
Leading member of the Kadets, head of the Provisional Government's secretariat

There can be no doubt that in the circumstances the problem of what to do with Nicholas II was a very difficult one. In more normal circumstances there would probably have been no objection to his leaving Russia for England, with whom our ties as Allies would have guaranteed that no conspiratorial attempts to put Nicholas back on the throne would be permitted [...] In the circumstances the government obviously had a right to take steps to see that Nicholas II could not cause trouble, and it could come to an agreement with him about a fixed place of residence and decree the protection of his person. Going to England would probably have also been the most desirable course of action for Nicholas himself. Meanwhile, the warrant for arrest produced a knot that to this day has not yet been untied.*

MANCHESTER GUARDIAN
British newspaper; report

M. Kerensky, one of the Russian socialist leaders and the new Minister of Justice, in an interview with the *Daily Chronicle*'s Petrograd correspondent, said: – 'I must tell you frankly that we Russian Democrats have been latterly rather worried about England, because of the close relations between your Government and the corrupt Government we had. But now, thank God, that is over, and our deep, strong feeling for England as the champion of liberty will come into its own again.' *9 March 1917*

PRINCESS OLGA PALEY
Confidante of Empress Alexandra

The Embassy of England, on the orders of Lloyd George, had become a centre of propaganda. The liberals, Prince Lvoff, Miliukoff, Rodzianko, Maklakoff, Guchkoff etc., were constantly there.* It was at the English Embassy that it was decided to abandon legal avenues and follow the path of revolution. It should be added that in all of this Sir George Buchanan, the English ambassador to Petrograd, was satisfying a personal grudge. The emperor didn't like him and he was increasingly cool towards him.

SIR GEORGE BUCHANAN
British ambassador

That Princess Paley is gifted with a vivid imagination is no secret to me, and I can but congratulate her on this chef-d'oeuvre [...] Needless to say, I never engaged in any revolutionary propaganda, and Mr Lloyd George had our national interests far too much at heart ever to have authorised me to promote a revolution in Russia in the middle of a world war [...] Princess Paley, unlike my other critics, has rendered me one service for which I am grateful. I have often wondered what was the motive that prompted me to start the Russian Revolution, and she is good enough to tell me. The emperor did not like me – he has received me at my last audience standing – he had never offered

Princess Olga Paley

me a chair. What more natural than that after such treatment I should [...] try to bring about a palace revolution?

DAVID LLOYD GEORGE
British prime minister; telegram to Prince Lvov, Russian prime minister

It is with sentiments of the most profound satisfaction that the peoples of Great Britain and of the British dominions across the seas have learned that their great ally Russia now stands with the nations which base their institution upon responsible government. Much as we appreciate the loyal and steadfast cooperation which we have received from the late emperor and the armies of Russia during the past two and a half years, yet I believe that the revolution whereby the Russian people have based their destinies on the sure foundation of freedom is the greatest service which they have yet made to the cause for which the allied peoples have been fighting since August 1914. *10 March 1917*

LEON TROTSKY
Revolutionary and Marxist theorist

What is now happening in Russia will go down in history forever as one of its greatest events. Our grandsons and great-grandsons will speak of these days as of the beginning of a new era in the history of humanity. *3 March 1917*

HOLY SYNOD OF THE RUSSIAN ORTHODOX CHURCH
Pronouncement on the abdication of Nicholas II

God's will has been done. Russia has embarked on a new form of government. May God bestow happiness and glory on our great country as she sets out on this new path. The Provisional Government has come to power at a most difficult historical moment. The enemy remains on our soil, and our glorious army faces great challenges in the days to come. At this time all true sons of the motherland must show renewed spirit. *9 March 1917*

JAMES L. HOUGHTELING, JR
Attaché at the American Embassy

The church services today finished early, for the priests in omitting all reference to the imperial family had to cut out a full third of the service. *5 March 1917*

MAURICE PALÉOLOGUE
French ambassador

I went out to see some of the churches: I was curious to know how the faithful would behave at the Sunday mass now that the name of the emperor has been deleted from public prayers [...] The same scene met me everywhere; a grave and silent congregation exchanging amazed and melancholy glances. Some of the *muzhiks* looked bewildered and horrified and several had tears in their eyes. Yet even among those who seemed the most moved I could not find one who did not sport a red cockade or armband. They had all been working for the revolution; all of them were with it, body and soul.

But that did not prevent them from shedding tears for their little Father, the tsar, *Tsar batiushka!* *5 March 1917*

NIVA
Illustrated weekly

Kerensky, as minister of justice, addressed those around him as he handed over this historic document and said, with tears in his eyes: 'I am thankful that it has fallen to me to abolish the death penalty in Russia forever.'

ALEXANDER BLOK
Poet

All will be well, Russia will be great. But how long the wait is and how hard it is to wait. *22 April 1917*

ZHURNAL DLYA KHOZYAEK
'Housewife Magazine', published in Moscow

Days of great freedom in Russia are here, and bright red is now encountered in many aspects of women's lives. The colour red, which was avoided as too garish, has become a staple in the Russian woman's wardrobe.

Light dresses, blouses and shirts pulled on over the head and which do not impede movement, and straight skirts – these are the fashion staples of our day. Now that women are becoming enthused by the new possibilities and wide opportunities for work, and have no time to think about endless fastenings and buckles, what is needed are simple dresses, overcoats, skirts, blouses and cardigans that can be put on quickly and without the assistance of others. Our new slogan will be: 'We are not beholden to anyone and can do everything for ourselves.' *2 March 1917*

DONALD THOMPSON
American photographer; letter to his wife Dot

The servants are beginning to get stuck up with this new-born freedom. You have to call them 'comrade' or 'friend'. The servant in my room notified me today that from now on I will have to shine my own shoes. *8 March 1917*

NIKOLAI SUKHANOV
Member of the Executive Committee of the Petrograd Soviet, writer and editor

These were days when the revolution, freedom and especially the Soviet were just empty sounds for the great mass of the soldiery. This mass, only yesterday the blind instrument of tsarism, had now thrown off the yoke and was threatening tomorrow to turn into just as blind and arbitrary a 'master of the situation', capable of wreaking the most dreadful havoc. At that time it was necessary to treat the garrison with the utmost delicacy, and vital to create at all costs an indisputable authority that it could believe in, consider its own and therefore obey.

LOUIS DE ROBIEN
Attaché at the French Embassy

This morning I went [...] to the Duma, which is open to everyone. The Palace looks like an immense guardroom. Soldiers are everywhere, all unbuttoned and eating at dirty wooden tables or sprawling on the floor round a samovar [...] The portrait of the emperor has been removed, but they have left a bust of Alexander and given it a red cravat. Outside the entrance is one of the court motor cars, from which the coronets have been roughly scratched off and on top of which a red cloth has been hoisted. *7 March 1917*

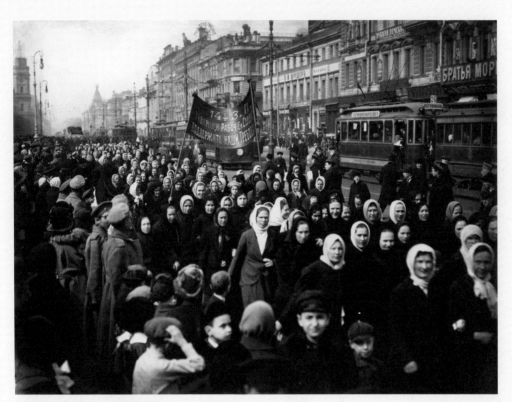

Women's demonstration, March 1917

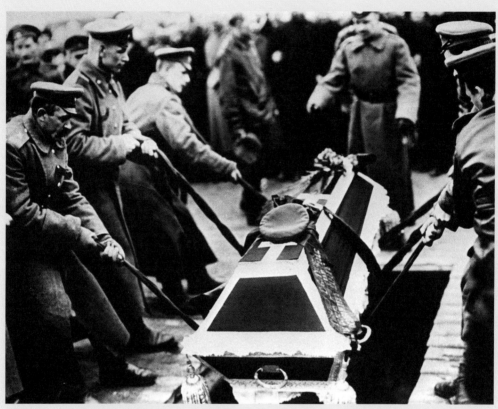

The burial of those who died during the February Revolution took place on Marsovo pole on 23 March 1917

MAURICE PALÉOLOGUE
French ambassador

Today there has been a great ceremony on the Champ-de-Mars, where the victims of the revolutionary rising, the 'nation's heroes' and 'martyrs to liberty', have been given a state burial. A long grave has been dug in the transverse axis of the parade-ground. In the centre a platform, draped in red, was raised to serve as vantage-point for members of the Government [...] What struck me most was the absence of one element from the ceremony – the clergy. No priests, no icons, no prayers, no crosses. The only anthem was the *Workmen's Marseillaise* [...] As I returned to the embassy by the solitary paths of the Summer Garden, I reflected that I had perhaps witnessed one of the most considerable events in modern history. For what has been buried in the red coffins is the Byzantine and Muscovite tradition of the Russian people, nay the whole past of Orthodox Russia. *23 March 1917*

NIKOLAI SUKHANOV
Member of the Executive Committee of the Petrograd Soviet, writer and editor

To say that the funeral went off brilliantly is an understatement. It was a magnificent and enthralling triumphal procession of the revolution and of the people who made it. As for its size, it surpassed anything ever seen. The British ambassador Buchanan, watching it from his embassy (which looks onto Marsovo pole and the Neva Embankment), stated categorically that Europe had never seen anything like it.

SOLDIERS OF TRANSPORT REPAIR WORKSHOP NO. 2
Letter from troops in Uman, Kiev Province to Nikolai Chkheidze, leading Menshevik in the Petrograd Soviet

We, the soldiers of Transport Repair Workshop No. 2, sincerely sympathise with the Great Cause and are walking hand in hand with the proletariat towards the attainment of a better future life. After years of struggle with the Romanov tyrants, the foul throne of Nicholas II was overthrown by a powerful hand; the tyrants' nest came crashing down and all the slaves of Nicholas II are sitting under lock and key [...] Tsar Nikolasha and Sasha the libertine started mocking Russia, filled the whole palace with various and sundry sorcerers and horse thieves, and made a funeral feast of lies and debauchery on the warm blood of the workers and soldiers [...] Lately the revolution has chewed up thousands of the lives of our best freedom fighters. Eternal memory to you, dear comrades [...] In light of all this, we are enclosing the money we have collected for victims of the revolution and ask Comrade Chkheidze in the name of the entire detachment, numbering four hundred men, to accept this money, FORTY-TWO roubles. *3 April 1917*

HAROLD WILLIAMS
New Zealand journalist; article in the British *Daily Chronicle*

It is a wonderful thing to see the birth of freedom. With freedom comes brotherhood, and in Petrograd today there is a flow of brotherly feeling everywhere [...] The police have gone, but discipline is marvellous [...] The soldiers with all their freedom are displaying a sense of order and discipline that would hardly be conceivable in any other nation. Throughout the revolution when the city was actually under control of thousands of soldiers they behaved, with few exceptions, like thorough gentlemen. We heard of no cases of cold-blooded murder [...] Never was any country in the world so interesting as Russia is now. Old men are saying 'Nunc dimittis', young men singing in the dawn, and I have met many men and women who seemed to be walking in a hushed sense of benediction. *8 March 1917*

DONALD THOMPSON
American photographer; letter to his wife Dot

They say that everyone is to be equal. Well, this is all very well to say. I think I know Russia better than I did a few weeks ago, and when it comes to all Russians being free and equal, nothing doing! It will never work, and personally I think they are starting out wrong. The members of this Council [the Soviet] are the orneriest bunch of devils I have ever met. I will bet $1,000 to a cent that 90 per cent of them cannot read or write, but they are being led by some pretty smart people. *6 March 1917*

JAMES L. HOUGHTELING, JR
Attaché at the American Embassy

We have heard that at Kronstadt the sailors revolted with much bloodshed, killing 170 officers, including a very efficient and popular admiral who had been put in command at the request of the British.* The sailors seem to be responsible for the few excesses of the revolution. *19 March 1917*

HAROLD WILLIAMS
New Zealand journalist; article in the *New York Times*

I have just glanced through a number of non-Russian newspapers containing the first news of liberation. The Armenians are exuberant. In the Georgian papers there is a note of restrained joy and warm sympathy for Russia, which of late years rarely found expression among the Georgians. The Mohammedan national leaders have joined the cadet party. The Esthonians have held joyful meetings to celebrate the new freedom, but with their characteristic practical sense have set seriously to work on the food problem. Ukrainian and Jewish papers which have been suppressed during the last two years are renewing publication. There is no need to dwell on the manifold stirring of the new life in Finland. *15 March 1917*

ANDREW BONAR LAW
British chancellor of the exchequer; on moving a House of Commons resolution of greeting to the Russian Duma

The events in Russia, which have followed each other with such startling rapidity during the last thirteen days, have arrested the attention of the world even in the midst of the greatest convulsion that has ever been wrought upon earth by man. What has happened in Russia reminds us of the earlier days of the French Revolution [...] It is too soon to say that all danger is over in Russia [...] But it is not too soon for the Mother of Parliaments to send a friendly greeting to the Parliament of an Allied country, and it is not too soon for us to send a message of good will to the new Government, a Government which has been formed with the declared intention of carrying this War to a successful conclusion, and a Government which has undertaken a task as arduous as has ever fallen to the lot of any Administration – the task at once of driving out a foreign aggressor and of establishing freedom and order at home. It is not, I think, for us to judge, much less to condemn, those who have taken part in the government of an Allied country, but I hope I may be permitted to express a feeling which I believe will be shared by the vast majority of the Members of this House, and which I, at least, hold strongly, a feeling of compassion for the late Czar, who was for three years, or nearly three years, as I believe, our loyal Ally, and who had laid upon him by his birth a burden which has proved too heavy for him. *8 March 1917*

NEW YORK TIMES
American newspaper; report

Twenty Russian exiles sailed for Petrograd on the first steamship leaving this country after the revolution and will offer their services to their country for the war. This little band was headed by General Alexis Korvanov, who for fifteen years has been earning his living as Ivan Korostony, cobbler, in Hester

Street, and waiting for a time when he could return to his native land [...] General Korvanov, a man of medium height and build, with a trim black beard, is about 53 years old [...] He entered political life and in 1888 was made Chief of Police of Moscow. Two years later he was promoted by the Czar to be Governor of Kiev. In the Spring of 1892 the Grand Duke Michael became jealous of the recognition of his services by the emperor and brought political charges against him which resulted in his being exiled to Siberia. In July, 1896, General Korvanov was sent in charge of a company of prisoners to work on the new railroad in Manchuria. He escaped, and at Shanghai got a chance to work his way on a freighter to Yokahama. While the vessel was anchored in the harbor of Nagasaki the crew mutinied. General Korvanov took the part of the officers, and in the fighting received a gash from a belaying pin which left a scar from his left eye to his left ear, a scar he still bears. *15 March 1917*

PRINCE GEORGY LVOV
Prime minister in the Provisional Government

The great Russian Revolution is a thing of genuine wonder in its sublime, peaceful procession [...] The essence of its guiding idea is in itself wonderful. The soul of the Russian people has become the democratic soul of the world by its very nature. It is ready not just to join forces with democracy worldwide but to stand in the vanguard and lead it on the path of mankind's progress towards the great principles of freedom, equality and fraternity. *27 April 1917*

NIKOLAI CHKHEIDZE
Menshevik chairman of the Petrograd Soviet; address to a delegation of students

I see on your banner the slogan 'Greetings to the Provisional Government', but for you it can be no secret that many of its members, on the eve of the revolution, were trembling and lacked faith in the revolution. You extend greetings to it. You seem to believe that it will carry high the new standard. If this is so, remain in your belief. As for us, we will support it for as long as it realises democratic principles. We know, however, that our government is not democratic, but bourgeois. Follow carefully its activity. We shall support all of its measures which tend towards the common good, but all else we shall unmask because at stake is the fate of Russia. *24 March 1917*

THE TIMES
London newspaper; editorial

The great danger was that the tsar might fail to realise the position with sufficient promptitude, and that he might either resist the Revolution or defer his decision. He has had enough of wisdom and of unselfish patriotism not to take either of these courses. By laying down the supreme authority of his own free will, he has saved his people, we may trust, from civil war and his capital from an outbreak of social anarchy. *3 March 1917*

VLADIMIR LENIN
Bolshevik leader; letter to Alexandra Kollontai

Well! This 'first stage of the first revolution (of those born out of the war)' will not be the last, nor will it be just Russian. *3 March 1917*

STINTON JONES
English businessman

It will take time for Russia to realise what she wants. There is no cohesion, no common ideal to inspire her people. She is conscious of having killed a dragon; that is all.

ALEXANDER BLOK
Poet

The most striking thing was the utter unexpectedness of it, like a train crash in the night, like a bridge crumbling beneath your feet, like a house falling down. *25 May 2017*

Former Emperor Nicholas II and his son
Alexei in the garden of the Alexander Palace,
Tsarskoe Selo, spring 1917

4
FORMER PEOPLE

"My general impression: worn down, exhausted people who looked unwell, some in tears."

CHAPTER 4

ROYALISTS

OBSERVERS

Grand Duke Dmitry Pavlovich (1891–1942), first cousin of Nicholas II, exiled to Persia after involvement in Rasputin's murder; moved to England in 1918, then settled in France.

Dowager Empress Maria Feodorovna (1847–1928), Nicholas II's mother, born Princess Dagmar of Denmark; sister of Queen Alexandra of England, George V's mother; after February Revolution moved to Crimea; left Russia in 1919, died in native Denmark, having never publicly accepted that her son Nicholas II was dead.

Grand Duchess Maria Pavlovna (1890–1958), first cousin of Nicholas II, sister of Dmitry, one of Rasputin's murderers; established embroidery workshop in Paris after emigrating in 1919; moved to New York in 1928, worked for department store Bergdorf Goodman; moved to Argentina in 1941 to set up cosmetics business; spent final years with her son in Germany.

Grand Duchess Olga (1895–1918), eldest daughter of Nicholas and Alexandra, worked as Red Cross nurse at Tsarskoe Selo during the war, murdered by Bolsheviks in Ekaterinburg in July 1918.

Boris Stürmer (1848–1917), prime minister, ally of Empress Alexandra and Rasputin, dismissed in November 1916 after accusations of being a German spy; arrested after February Revolution, died in captivity.

Vladimir Telyakovsky (1860–1924), director of the imperial theatres; after revolution worked as financial inspector on Nikolaevsky railway, refused appointment as administrator of Petrograd academic theatres.

Arthur Balfour (1848–1930), British foreign secretary 1916–19, previously Conservative prime minister 1902–5.

Kievlyanin, 'The Kievan', conservative newspaper published 1864–1919, supported monarchy and, later, White movement.

Kazimir Malevich (1878–1935), avant-garde artist, founder of Suprematism; after revolution taught in Vitebsk and Kiev; briefly imprisoned in 1930, his final works were realist in style.

Ivan Manukhin (1882–1952), prison doctor at Peter and Paul Fortress; known for curing Maxim Gorky of tuberculosis; allowed to emigrate to France in 1920 after Gorky appealed personally to Lenin.

Lord Stamfordham (1849–1931), private secretary to George V and previously to Queen Victoria; died while still in office.

H.G. Wells (1866–1946), English writer best known for science fiction novels; supporter of Bolsheviks although anti-Marxist; interviewed Lenin in 1924 and Stalin in 1934.

Zapretnoe slovo, 'Forbidden Word', one of the names under which *Narodnoe slovo*, official newspaper of Popular Socialist Party, appeared in November–December 1917; published under slogan 'Everything for the people, everything through the people'.

What to do about Nicholas II – now addressed as 'Colonel Romanov' – and his family preoccupies both the Provisional Government and the government of his cousin, King George V of England. Nicholas asks Prime Minister Lvov if he can be allowed back to Tsarskoe Selo while his children recover from measles, hoping then to move to Port Romanov on the Murmansk Coast and eventually, when the war is over, to the Crimean resort of Livadia. General Lavr Kornilov, the new commander of the Petrograd Military District, informs Alexandra at Tsarskoe Selo that she is under arrest and hints at arrangements for the family's exile. The British, Danish and Swiss governments are all involved in potential asylum negotiations for the former imperial family, while the Soviet is determined to keep them under close guard.

Other 'former people', who only weeks previously have been running the country, are now in custody or trying to find ways to leave, or else reach accommodation with the new regime. Investigative committees are set up to interrogate former statesmen and courtiers. Those with German-sounding names, such as Boris Stürmer, former prime minister, are under particular scrutiny. As spring turns to summer, and early euphoria to a sense of disillusionment with the Provisional Government, the mood against potential 'reactionary' forces hardens.

KAZIMIR MALEVICH
Artist

Political prisoners who suffered at the hands of the anointed tsarist government have been released from all prisons and from Siberia. The expectation is that they will be replaced by new, more contemporary prisoners. Or so rumour has it... *6 March 1917*

DONALD THOMPSON
American photographer; letter to his wife Dot

B.V. Stürmer, the former president of the Council of Ministers, has also been arrested, and Protopopoff, who, I am told, was the real cause of the Russian trouble, came himself to the Duma and was in the building before anyone realised he was there. At that time the cry was on all lips, 'Kill Protopopoff!' How he was able to get to the Duma without being arrested is beyond me. *6 March 1917*

ALEXANDER PROTOPOPOV
Former minister of internal affairs of the Russian Empire

In the morning, at 9 o'clock, I got up – I hadn't undressed – drank tea with black bread, and as the doorman was very worried that they might start tracking me down, I headed off to my brother on Kalashnikov Embankment. However, it was very difficult getting there: the crowds filled the street, cars with soldiers and workers were going by, I could hear artillery fire somewhere; it was a very dangerous journey – I could have been recognised and then who knows if I would have made it.

I went to a poor tradesman I knew and liked. He couldn't believe his eyes when he saw me; he took me in, looked after me as best he could, reassured me; my presence didn't make him feel in the least nervous. There is great soul in the body of the common man.

In the paper I read that the Duma had formed an Executive Committee to which former members of the government were being summoned, and that I could not be found anywhere. After

some thought I decided to go voluntarily to the Duma. Am I really any more to blame than anyone else? But, my God, my feelings as I headed – now an alien and an outcast – towards a building I had known so well for almost nine years. Lord, no one knows your ways, we are not judges of our own lives, of our sins.

There was a mass of troops, guns and people by the Duma. I asked a student to take me to the Executive Committee. Realising who I was, he grabbed my arm: 'There's no need,' I said. 'I'm not going to run off, I came here of my own accord.' He let me go. They began calling for Kerensky. He arrived, and sternly commanding that he alone was to be obeyed, since soldiers, citizens and officers were yelling all around, he led me to the ministers' hall, where I was placed under arrest. I was sick and exhausted, nonetheless I was touched to the core and will never forget his kindness on this our first, painful meeting.

I spent the night on the couch, covered by my overcoat. *28 February 1917*

MAURICE PALÉOLOGUE
French ambassador

Nicholas Romanov, as the emperor is now styled in official documents and the papers, has asked the Provisional Government for: (1) a free pass from Mogilev to Tsarskoe Selo; (2) permission to reside at the Alexander Palace until his children have recovered from the measles; (3) a free pass from Tsarskoe Selo to Port Romanov on the Murman coast. The government has granted his requests.

Milyukov, who is my authority for this information, presumes that the emperor intends to ask the king of England for a place of refuge. 'He should lose no time in getting away,' I said. 'Otherwise the Soviet extremists might quote some awkward precedents against him.' Milyukov, who is rather of the Rousseau school and, being the soul of kindness himself, only too prone to believe in the innate goodness of the human race, does not think that the lives of the sovereigns are in danger. *6 March 1917*

VLADIMIR NABOKOV
Leading member of the Kadets, head of the Provisional Government's secretariat

The Provisional Government decided to imprison Nicholas II and transfer him to Tsarskoe Selo. It was also decided to imprison the Empress Alexandra Feodorovna. I was instructed to draw up an appropriate telegram in the name of General Alexeev, who was at that time the supreme commander's chief of staff. This was the Provisional Government's first decree countersigned by me and published over my signature.

ARTHUR BALFOUR
British foreign secretary; cable to the British Embassy in Petrograd

After further consideration it has been decided that it would be better for the emperor to come to England during the war rather than to a country contiguous to Germany. Apprehension is felt lest, through the influence of the empress, the residence of the emperor in Denmark or Switzerland might become a focus of intrigue, and that in the hands of disaffected Russian generals the emperor might become the possible head of a counter-revolution. This would be to play into the hands of Germany, and a risk that must be avoided at all costs. *9 March 1917*

VASILY SHULGIN
Member of the Provisional Committee of the Duma

To abolish the death penalty at a time of war, when people are dying in their thousands and there is no other punishment, is something hitherto unheard of in the annals of history. Napoleon used to say: 'If an army mutinies, you have to shoot half of it in order to save the rest.' We were then facing the prospect of mutiny. But nobody, including myself, objected. I just asked Kerensky: 'Alexander Feodorovich, by proposing the abolition of the death penalty, do you mean for everyone? You understand what I'm referring to?' He replied: 'I understand and my answer is: yes, for everyone.'

I was referring to the family of Romanovs, having a vague presentiment of the fate that lay ahead. Following Kerensky's reply I said: 'I have no more questions.' And the abolition of the death penalty was passed unanimously.

LILI DEHN
Friend of Empress Alexandra

The sovereign would now take a daily walk in the park, and every time he would come back upset by some new show of disrespect. 'But in fact it's stupid', he would say, 'to think that this kind of behaviour can cripple my soul. How petty it all is. They try to humiliate me by calling me "colonel". Ultimately, this is a very honourable title.'

SIR GEORGE BUCHANAN
British ambassador; letter to British Foreign Secretary Arthur Balfour

Nothing has yet been decided about the emperor's journey to England. He is living with the empress and his children at Tsarskoe Selo under a strong guard, and is allowed to walk in the park but is always kept under observation. From a private and confidential source I hear he is perfectly happy and takes exercise by clearing the paths in the park of snow. He does not yet realise that he will not be allowed to go as he had hoped to Livadia, but the loss of his throne does not seem to have depressed him. The empress, on the other hand, is said to feel the humiliation of her present position deeply. She is, I hear, averse to the idea of going to England. Some telegrams have just been published in the Press, which were sent by her to the emperor before and after Rasputin's murder, which show clearly that he did everything she told him to. There was also published a hysterical letter from the empress to Rasputin, in which she wrote as if she were addressing a saint, saying that she only found comfort when leaning on his shoulder, and praying him to bless 'thy child'. She has been the emperor's evil genius ever since they married, and nobody pities her. *21 March 1917*

ARTHUR BALFOUR
British foreign secretary; minute to Prime Minister David Lloyd George

I think the king is placed in an awkward position. If the czar is to come here we are bound publicly to state that we (the government) have invited him – and to add (for our own protection) that we did so on the initiative of the Russian government (who will not like it).

I still think that we may have to suggest Spain or the South of France as a more suitable residence than England for the czar. *25 March 1917*

H.G. WELLS
English writer; letter to *The Times*

Sir, Will you permit me to suggest to your readers that the time is now ripe, and that it would be a thing agreeable to our friends and allies, the republican democracies of France, Russia, the United States, and Portugal, to give some clear expression to the great volume of republican feeling that has always existed in the British community? *8 April 1917*

LORD STAMFORDHAM
Private secretary to George V; letter to Foreign Secretary Arthur Balfour

He must beg you to represent to the prime minister that from all [His Majesty] hears and reads in the press, the residence in this country of the ex-emperor and empress would be strongly resented by the public, and would undoubtedly compromise the position of the king and queen [...] Buchanan ought to be instructed to tell Milyukov that the opposition to the emperor and empress coming here is so strong that we must be allowed to withdraw from the consent previously given to the Russian government's proposal. *24 March 1917*

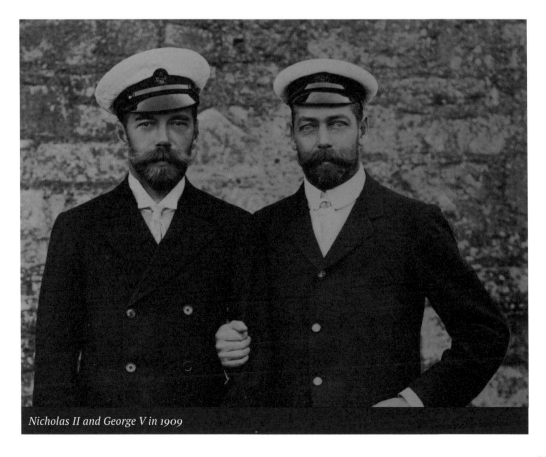

Nicholas II and George V in 1909

THE TIMES
London newspaper; editorial titled 'The Tsar a Poor Man'

M. Titoff, the commissary appointed by the Provisional Government to take charge of the affairs of the ex-tsar and his family, has applied for a grant to cover their immediate expenses. According to a rough estimate of their private fortunes, it appears that Nicholas II owns not more than £100,000 in cash and securities. His wife's fortune amounts to about £110,000. Young Alexis is much wealthier, as his allowance has been accumulating. He possesses about £550,000. The fortunes of his sisters are estimated as follows: Olga, £530,000; Tatiana, £400,000; Marie, £370,000; Anastasia, £330,000 [...] enormous revenues were derived from mines, forests, and lands belonging to the emperor's Cabinet. The expenditure of the Court swallowed up these vast sums on the maintenance of Imperial residences, shooting boxes, and a whole host of retainers. Hence, in spite of his great possessions, the tsar appears to be a poor man, inasmuch as the real estate belonging to the Cabinet will become state property. *23 March 2017*

ALEXANDER KERENSKY
Minister of justice in the Provisional Government

The whole family was standing huddled in confusion around a small table near a window in the adjoining room. A small man in uniform detached himself from the group and moved forward to meet me, hesitating and smiling weakly. It was the emperor [...] He shook my hand firmly, smiled, seemed encouraged and led me at once to his family [...] Alexandra Feodorovna, stiff, proud and haughty, extended her hand reluctantly, as if under compulsion. Nor was I particularly eager to shake hands with her, our palms barely touching. This was typical of the difference in character and temperament between the husband and his wife. I felt at once that Alexandra Feodorovna, though broken and angry, was a clever woman with a strong

will. In those few seconds I understood the psychology of the whole tragedy that had been going on for many years behind the palace walls.

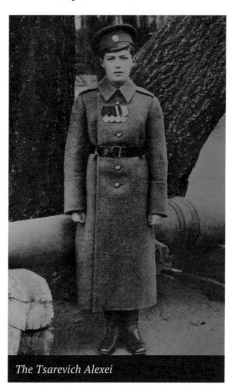

The Tsarevich Alexei

PIERRE GILLIARD
French tutor to the imperial family

In the evening a long conversation with Their Majesties on the subject of Alexei's lessons. We must find a way out since we no longer have any tutors. The tsar is going to make himself responsible for history and geography, the tsarina will take charge of his religious instruction. The other subjects will be shared between Baroness Buxhoeveden (English), Mlle. Schneider (arithmetic), Dr Botkin (Russian) and me. *16 April 1917*

GRAND DUCHESS MARIA PAVLOVNA
First cousin of Nicholas II

Our daily life changed very little. We followed our previously accepted routine; in many ways, one could say, our life became more peaceful. We now

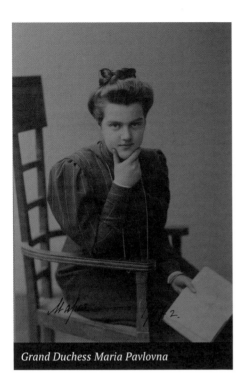

Grand Duchess Maria Pavlovna

found ourselves in a situation where it had become a risk for people to be friendly with us. It was highly likely that anyone who visited our house or the houses of any of the other members of the former imperial family would subsequently experience difficulties. Those who still came believed that the best way was to keep the visit secret. For example, when the French ambassador Paléologue came to bid farewell, the visit was very carefully disguised. But my father preferred not to put his friends in an awkward situation, and so we saw less and less of people.*

BERTIE STOPFORD
Anonymous author of *The Russian Diary of an Englishman*

Yalta. All round and everywhere there is only anxiety. Countess Betsy Schuvalov has just arrived from Kislovodsk, where she saw the Grand Duchess Vladimir most days, and has brought me a piteous letter from her in which she complains most bitterly of her lot.* She has not been out of her house for more than

two months. As she has moved into a smaller house, she lives entirely in one bed-sitting room. What can I do? Surely the best thing is to do nothing; but how can she be expected to take this view, never in her life having been denied anything? *19 May 1917*

THE TIMES
London newspaper; report by a 'competent observer, who witnessed the Revolution in Russia, and has just returned to Western Europe'

The most astonishing feature of the whole revolution was the revelation of the weakness of the tsar's hold upon the people, peasants and workmen alike. He was nothing to them, hardly even a name. I have visited several parts of the country since the revolution, and have nowhere found regret at the abdication of the tsar [...] It is true that one peasant woman whom I saw wept on hearing of the abdication of the tsar. 'How shall we now say our prayers?' she asked tearfully. It was explained to her that she could now pray for the Duma. This substitution of the name of the Duma for that of the tsar is now widespread in Russia: and prayers are daily offered for the welfare and health of the Duma. *8 April 1917*

LOUIS DE ROBIEN
Attaché at the French Embassy

After lunch I went to see Countess Kleinmichel. The poor woman arouses one's pity. She has been guarded for forty days by a gang of soldiers who stole things from her house, made holes in the pictures, ruined the tapestries, and so on. There were sixty of them who behaved as complete masters in her house and penetrated even to her bedroom. They let no one into the house and they did not even allow her to see her doctor. They stole part of her silver, and the arms which were in the smoking room, and so on. And now, the big drawing room has been turned into a meeting-place for the area section

of the Workers' and Soldiers' Committee, with wooden trestle tables set up, beside which the little pink chairs are arranged...

The Countess received me in her bedroom. She is very brave, and views the events calmly... She told me that she has the wherewithal to kill herself, rather than be murdered if fresh troubles arise. 'After all,' she said, 'I have lived for seventy years; it's not everyone who reaches this age: one must know how to die.'* *24 April 1917*

DONALD THOMPSON
American photographer; letter to his wife Dot

The chief of police of Petrograd, Major General Balk, has also been arrested, as have Admiral Giers and Vice-Admiral Kartzeff.* These are only a few of several thousand. Some of them have been taken from their homes by force, and others have given themselves up. They are brought before the Duma, where they are all held a short time, questioned, and then told that they must stand trial before the courts of free Russia, which are being established. The Peter Paul Fortress is now the home of many a member of the old regime and the royal family. *6 March 1917*

ANNA VYRUBOVA
Confidante of former Empress Alexandra

Black, relentless sorrow and despair. Weak, I fell onto the iron bed; there were puddles all around the stone floor, water was coming in through the panes. It was dark and cold; the tiny window high up in the wall let in neither light nor air, it smelt damp and fetid. In the corner was a toilet and sink. The iron table and bed were fixed to the wall. A thin, horsehair mattress and two dirty pillows lay on the bed. After a few minutes I heard keys being turned in the double or triple locks of the huge iron door and a terrifying man with a black beard, dirty hands and an evil-looking,

criminal face came in; he was surrounded by a crowd of insolent, revolting soldiers. On his command the soldiers tore off the mattress from the bed, took one of the pillows and then began to pull off my icon pendants and gold rings.

This specimen informed me that he was representing the minister of justice and that he was in charge of the prisoners' regime. Later he announced his surname – Kuzmin, a former convict who had done fifteen years' hard labour in Siberia. I tried to forgive him, realising that he was avenging the ills of all those years on me; but how hard it was to endure his cruelty on this first evening! [...]

When the soldiers tore the gold chain off my cross, they cut my neck badly. The cross and some of the pendants fell onto my knees. I cried out in pain; one of the soldiers then punched me, and, spitting in my face, they left, slamming the iron door behind them. I lay on the bare bed, hungry and cold, covered myself with my coat and from exhaustion and weeping began to fall asleep, still the butt of jokes and jeers from the soldiers gathered at the door, watching me through the aperture.

BORIS STÜRMER
Former prime minister of the Russian Empire; interrogation by the chairman of the Extraordinary Investigative Commission

CHAIRMAN: Please sit down. You are appearing before the Extraordinary, previously Supreme, Investigative Commission [...] Under what circumstances were you appointed prime minister?
BORIS STÜRMER: Forgive me, I do not recall all the details [...] The conversation was very long, on many subjects. [...]
CH: You say it was a long conversation. I'm sure it was. After all, you were about to assume the leading position in the Russian government – no doubt the conversation was about your programme?
BS: Yes.
CH: So what was your programme? How did you set it out to the former emperor?

The Trubetskoi Rampart, Peter and Paul Fortress

Cell inside the Trubetskoi Rampart

Boris Stürmer

BS: The programme was this, that I believed the State Duma could work and was necessary… I never was and never will be one of those people who would say that the State Duma is ineffective, that it was not necessary and so forth. This was the general thrust […] I don't remember the details – because it was so unexpected, I was so surprised, in no way could I have thought about a programme… But we touched on a whole series of issues. […]

CH: What was your programme as minister of the interior?
BS: What can I say?… The programme… I can tell you that the programme I drew up, that I outlined… I was minister of the interior for four months, and during that time it was just day-to-day business…
CH: I'm sorry, I'm not asking what programme you subsequently drew up, but what you put at the head of the programme which you set out to the sovereign when you were appointed minister of the interior?
BS: It's very hard to say what exactly… One thing followed another…

CH: Well maybe tell us one thing, then, that followed another…
BS: Please believe me, I'm speaking frankly!… I felt that it was necessary to maintain the status quo – to try to support what there was without conflicts and arguments… And tomorrow would be another day…
CH: With whom were you avoiding conflicts and arguments?
BS: So that the Ministry of the Interior didn't provoke any conflicts or arguments with the Duma. This was the point…
CH: So not to have conflicts and arguments with the State Duma? This, essentially, was what your programme was all about?
BS: Yes. […]
CH: But did you have any idea, occupying such an important position in such a huge state at such a difficult moment in the life of this state, what the minister of the interior of the Russian state should be doing?
BS: A whole series of reforms… For example, urban and land reform, *volost* reform and so forth.* A whole series of issues which came up, and these issues were what I had to deal with…
CH: So these were the issues you brought up?
BS: No, they were brought up by life. […]

BS: You were kind enough to ask this question about the programme: 'Did you have some kind of programme, what was the programme you set out?' That was how the question was put. Let me say this. When I considered your question, I thought, well this is not Western Europe, this is not a constitutional state where public opinion penetrates all institutions when there is a change of government system, where the government is supported when it's approved of and not supported when it is not approved of. In the end there are other groups who have their own defined programme. When the monarch summons new people to take the reins of government, then of course there is no programme…

CH: You mean that here, thank God, there was no constitution?

BS: No, I'm not talking about that. You asked me whether I had a programme. I mean that I could not have had a programme, not because we don't have a constitution but because we do not do things the way they are done in Europe.

CH: If we had raised this question, I would have put it to you like this: Europe is Europe and Russia is Russia, but life goes on both there and here, and it's a requirement of life that the person who takes upon himself the administration of the state should have a specific view on the central issues facing the country [...] The fact that we had no constitution did not mean that life stopped presenting issues that had to be dealt with. We did not raise this purely as a formality, but because it is crucial. It would seem to us that when in 1916 you were successively appointed to the highest offices in the land, you should have had a view on the central issues facing the government of Russia at such a critical time as war. This was what lay behind our questions. Our questions were essential and highly relevant. And now you talk about the way we do things in Russia not being the same as in European countries.

BS: There is only one programme: the authority to which each one of us at some point swore allegiance – that of the tsar, and the instructions which he gave. The alternative is something new, for which I do not consider myself qualified. I served the old regime, I believed that this regime needed to be supported or at least not attacked. I could not join a regime that would essentially refute this. That is my opinion. *22 and 31 March 1917*

ALEXANDER BLOK
Poet, secretary to the Extraordinary Investigative Commission

Today I was twice in the Winter Palace and became an editor. Muravyov will send a telegram to Lodyzhensky (i.e. my main superior in Minsk), and since he is a comrade of the minister of justice, I hope that I'll be assigned. I don't know whether for long, but I'll try. For the moment I've taken on Maklakov and will next ask for Vyrubova, and on Friday I want to attend the interrogation

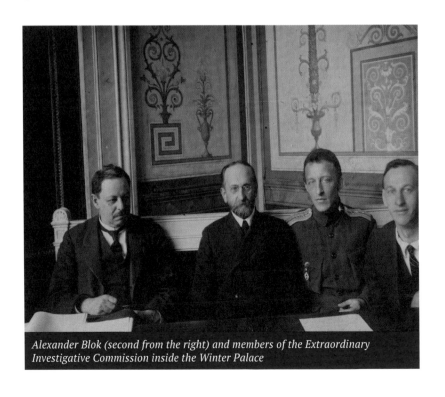

Alexander Blok (second from the right) and members of the Extraordinary Investigative Commission inside the Winter Palace

of Goremykin.* My salary will be 600 roubles a month. I have just read Nicholas II's handwritten note to Voeikov, in which he demands that the newspapers stop writing 'about the late R'. The handwriting is pretty feminine – weak; written in December. A telegram of his, too, to stop the Manasevich-Manuilov case. Boring gentleman. *8 May 1917*

VLADIMIR VOEIKOV
Former commandant of the court

On 28 April I was summoned to a meeting of the Extraordinary Investigative Commission. Sitting behind a long table along the windows of a large room were four people I didn't know, as well as the chairman Muravyov.

When I entered I automatically bowed to the assembled company, which I felt put the 'Council of the Areopagus' in a very awkward position: they didn't know how to react [...] But what was the aim of the interrogation? What were they interested in? They seemed interested above all in gossip about the personal life of the sovereign and empress, about life at court.

In my opinion the whole interrogation was a complete farce, and the members of the commission no doubt realised this themselves. *28 April 1917*

ANNA VYRUBOVA
Confidante of former Empress Alexandra; interrogation by the chairman of the Extraordinary Investigative Commission

CHAIRMAN: So you knew what Rasputin believed himself to be?
ANNA VYRUBOVA: What he believed himself to be? He always said that he was one of the itinerant holy men; he preached the word of God.
CH: What form did this preaching take?
AV: It could be quite interesting. I even made a few notes. I don't know... He explained Holy Scripture.
CH: Are you saying he was well versed in Holy Scripture?

AV: He knew all of Holy Scripture, the Bible, everything...
CH: But was he not illiterate?
AV: He knew it all, told it, explained it all.
CH: Did you happen to hear from him that his vocation was ridding people of passion, calming them down?
AV: I never heard this. He never said anything of the sort to me. He would tell me a great deal about all his travels; to Jerusalem, I don't know where else, he walked throughout Russia in chains, on foot. It was very interesting for me. I would listen.
CH: That was earlier; later he began going around in silk shirts and not wearing chains.
AV: Yes, all the ladies would sew him clothes. I think he would wear something like that.
CH: Why do you think this was?
AV: He used to say that his whole body hurt from what he wore.
CH: What did he call you?
AV: Annushka... Anna Alexandrovna, he addressed me in various ways.
6 May 1917

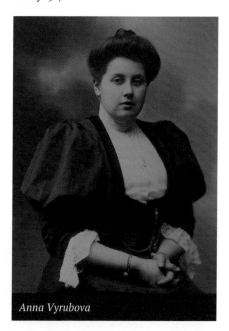

Anna Vyrubova

IVAN MANUKHIN
Prison doctor at the Peter and Paul Fortress

Almost two months after February, I visited the fortress for the first time. The detainees were held in a special area deep inside the building, known as the Trubetskoi Rampart. It was not easy to gain access. One had to go past the guard at the entrance to the fortress, across the courtyard, past another guard at the second entrance, and then through the iron door of the rampart entrance, followed by a short flight of stone steps that led to a room from which one made one's way down a long corridor accompanied by soldiers of the guard. It felt like a dungeon... Along one of the walls was a series of doors – the cells.

On that day I met my patients. There was no possibility that first day of doing a detailed medical examination or even asking questions that could elicit a frank response, because of the presence of the soldiers – just a cursory first acquaintance. There were two women among the prisoners: A.A. Vyrubova and E.V. Sukhomlinova.* My general impression: worn down, exhausted people who looked unwell, some in tears.

ANNA VYRUBOVA
Confidante of former Empress Alexandra

Twice a day they brought me a half-empty bowl of a revolting kind of soup which the soldiers would spit and put glass into. It often reeked so badly of rotten fish that I had to hold my nose, swallowing just enough not to die of hunger; the rest I poured down the toilet. I did this because on one occasion the guards noticed that I hadn't eaten it all, and threatened to kill me if it happened again. Not once in all the months I was there was I allowed to have food brought in from home. For the first month we were completely in the hands of the guards. Warders patrolled the corridors the whole time. The keys were kept by the head guard. Several men would always enter the cell at the same time. Every activity was forbidden in the prison. 'Activities are not what you're banged up for', the commandant said when I asked to be allowed to sew.

I did not undress. I had two woollen scarves; one I wore on my head, the other on my shoulders, and I slept under my coat. The wet floor and walls made it cold. I would sleep for four hours. Then I would hear every quarter chime of the cathedral clock [...] Waking up, I would warm myself in the only warm corner of the cell, where there was a stove on the outside. I used to stand there for hours on my crutches, leaning against the dry wall.

VLADIMIR TELYAKOVSKY
Director of the imperial theatres

Doctor Brunner told me that he saw Grand Duke Nikolai Mikhailovich today, who told him that the soldiers in the Peter and Paul Fortress wanted to do away with the political prisoners, who were only saved by the skin of their teeth after it was explained that all these detainees were protected people until their trial. *3 April 1917*

FORMER EMPEROR NICHOLAS II
Diary entry, Tsarskoe Selo

Forgot to mention that yesterday we said goodbye to 46 of our servants who were finally released from the Alexander Palace to their families in Petrograd. *1 April 1917*

GRAND DUKE DMITRY PAVLOVICH
First cousin of Nicholas II; letter to Felix Yusupov from Qazvin, Iran

My dear old friend!

Yes! It has happened! The thing you and I so believed was possible has taken place. Because of the empty-headed and short-sighted stubbornness of one woman the final catastrophe has happened – a catastrophe which of course has swept away both the tsarist system and all of us at the same time,

since the very name Romanov is now synonymous with every kind of filth, nastiness and dishonesty. [...]

As for me, well of course my first reaction was to go back. But then I changed my mind as I realised that my immediate return would be too hasty a decision, even as regards the Prov. Gov., whose thoughts on this question were completely unknown to me. And as regards Tsarskoe Selo, I felt that it would be morally repugnant to go hurtling back as soon as I knew of the fall of the regime that had exiled me.

All the newspaper reports about Kerensky apparently informing me that there would be no obstacle to my returning to Petrograd are a complete lie – I have received no such communications. In fact quite the opposite: the reply I received to a telegram I sent to Prince Lvov saying that I was willing to support the Prov. Gov., and were the newspaper reports about my return based on fact, left me in a quandary, because it read thus: 'Prov. Gov. has not taken any decisions as to your return to Russia'. [...]

Goodbye. I don't know when we'll see each other. In what circumstances, I wonder, and where?

Your very affectionate friend
23 April 1917

ALEXANDER BLOK
Poet, secretary to the Extraordinary Investigative Commission

On Saturday I attended a press conference at which the commission gave details of its work... On Monday the lordly wreck that is Goremykin was interrogated in the palace; the old man's eyes are staring at death, but he continues to lie in that soft, sinewy, affected voice of his; the shadow of a smile crosses his face – a mixture of old-man bonhomie (children, family, home, tiredness) and iron cunning (Venetian fresco, porphyry column, throne steps, steering wheel of state) – and still the eyes gaze on death. After this we went again to the fortress, listened again to

Ivan Goremykin, prime minister until February 1916

Beletsky. Yesterday for the third time Beletsky spread liberally some of the secrets of the art of which he was a magician, so on Monday we will listen to him again; we're already a bit bored with him – he is so obliging and talkative. However, during the break Muravyov took me to the cells, under the pretext of my secretarial role. We went visiting – first Voeikov (I'll now be working on him); he's a fairly insignificant creature, not at all how you imagine a former commanding officer of the Hussars, but his testimony is extremely interesting; then we called in on Prince Andronikov – a nasty piece of work, piggy face, pot-bellied, new little jacket (everyone says the same thing: 'ugh, that Andronikov who used to leech off everyone'). The prince jumped up ingratiatingly to close the ventilation window, but you'll never reach a cell window by jumping. It was right out of Dostoevsky (incidentally, it was only in Andronikov's cell that I noticed a large Bible on the table). Then we went to see Vyrubova (I've just handed over her interrogation report); the holy harlot and half-wit was sitting with her crutches

on the bed. She's 32, could almost have been pretty but there is something awful about her... Carried on to Makarov (minister of the interior) – a clever bureaucrat. Then to Kafafov (director of the police department) – this unfortunate oriental gentleman with his ovine profile was shaking and crying that he would go mad: it was stupid and pitiful. Then to Klimovich (director of the police department), very clever, a striking young gendarme general, very brave, an inveterate sceptic.* All this together makes a strong impression [...] I read some of the Rasputin documents; just wall-to-wall pornography. *18 May 1917*

IVAN MANUKHIN
Prison doctor at the Peter and Paul Fortress

The patients were all weakening before my eyes, growing old, disintegrating, wasting away, some were suffering from nerves and insomnia, losing heart... True, there were some (like Shcheglovitov and General Sukhomlinov) who showed extraordinary, unshakeable strength and imperturbable calm in the face of such physical trials.* The impression Vyrubova gave was of a very unfortunate woman who found herself unexpectedly in nightmare conditions – conditions that she could never have thought she would experience and which she doubtless never even imagined existed. Believing that I was ready to help her in her misfortune, she was very open with me. She categorically denied her liaison with Rasputin, and that was undoubtedly how it was: she was telling the truth. But she always avoided talking about Rasputin. *10 May 1917*

ANNA VYRUBOVA
Confidante of former Empress Alexandra

On three occasions drunken soldiers burst into my chamber threatening to rape me, and I only escaped by a miracle. The first time I fell to my knees, holding the icon of the Virgin Mary to my chest, and begged them to spare me, for the sake of their mothers, and my elderly parents. They left. The second time, in my fear I threw myself against the wall, hammering and shouting. Ek. V. [Sukhomlinova] heard me and also shouted, until soldiers from some of the other corridors came running... The third time a sentry officer came in on his own. I pleaded with him tearfully and he spat at me and left. *10 May 1917*

IVAN MANUKHIN
Prison doctor at the Peter and Paul Fortress

It's worth mentioning that not one of the imprisoned monarchists has renounced their past or their beliefs or acknowledged to themselves (as far as I could see) their guilt before the people who have risen up, nor do they see themselves as responsible for the revolution that has swept over them. They haven't taken the uprising seriously: it's just a spontaneous rebellion which will somehow or other blow itself out. Nobody believed that the old regime had collapsed, but all of them were fretting over their fate, realising that they were completely in the soldiers' hands. They seized on my idea of getting them out as a lifeline. I warned them that I would be objective and would try to get them out on the basis of each person's state of health. *17 May 1917*

FORMER EMPEROR NICHOLAS II
Diary entry, Tsarskoe Selo

I am 49 years old. Almost a half century! My thoughts are particularly with dear Mama. It's terrible not even being able to correspond. I know nothing of her, except from stupid or revolting newspaper articles. The day passed like a Sunday – mass, lunch upstairs, then a puzzle! Our congenial work in the orchard, where we started to dig flower beds, after tea mass, dinner and in the evening reading – much more with my dear family than in normal years. *6 May 1917*

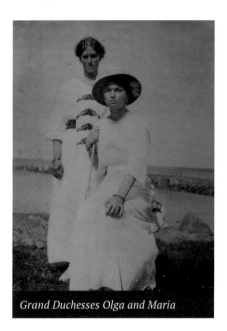
Grand Duchesses Olga and Maria

GRAND DUCHESS OLGA
Eldest daughter of Nicholas and Alexandra; letter to her tutor Pyotr Petrov from Tsarskoe Selo

We go for a walk in the afternoons from 2 o'clock until 5. We each do something in the garden. If it's not too close, Mama also comes out, and lies on a couch under the tree by the water. Papa goes (with several others) deep into the garden where he fells and saws up dead trees. Alexei plays on the 'children's island', runs around barefoot and sometimes swims [...] Lessons continue as normal. Maria and I are studying English together. She reads aloud to me, and if it's not too hot, will do a dictation [...] Twice a week Anastasia and I study medieval history. It is much more difficult, as I have a terrible memory for all those events, though she isn't any better.

Your pupil no. 1, Olga *19 June 1917*

GEORGE V
King of England, first cousin of Nicholas II

I own that I feel very anxious for the safety of the emperor [...] If he once gets inside the walls of the prison of St Peter and St Paul, I doubt he will ever come out alive. *22 May 1917*

YAKOVLEVSKY WORKERS' SOVIET
To the Petrograd Soviet of Workers' and Soldiers' Deputies

The Yakovlevsky Workers' Soviet comprising six thousand people has resolved to demand the imprisonment in the fortress of Nikolai Romanov. *31 May 1917*

NIKOLAI SUKHANOV
Member of the Executive Committee of the Petrograd Soviet, writer and editor

Around this time Dr Manukhin turned up in the Military Academy and sought me out among the throng on urgent business [...] The mood in the garrison was finally turning in favour of dealing with the prisoners arbitrarily. A plot of some kind had been discovered, and it seemed the first victim was to be Vyrubova [...] A massacre was expected at any moment.

Manukhin fervently insisted that I go off with him to the Peter and Paul Fortress at once. As an Ex. Com. member I should be able personally to conduct Vyrubova out of the fortress. [...]

In awe and trepidation I passed through the gates of the Russian Bastille, past stalwart sentries who spent a long time studying our papers. [...]

While waiting for the supervisor, I expressed a strong desire to go into the cells themselves and see deep inside the bowels of the prison. I remember that Protopopov was sound asleep with his back to the door. Stürmer was sitting on a bunk holding a small book. [...]

Then we heard that Vyrubova was now ready to go. We went to her cell. A pretty young woman, with a simple, typically Russian face, got up to meet us, very excited at the imminent change, as is always the case in prisons. She was on crutches, I think as a result of a railway accident.

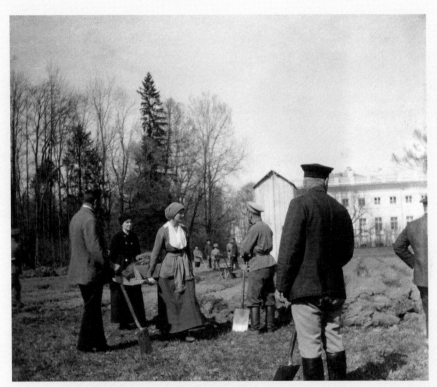

Grand Duchess Tatyana at Tsarskoe Selo after the imperial family's arrest

ANNA VYRUBOVA
Confidante of Empress Alexandra

At 6 o'clock, as I was standing barefoot, pressed against the cold wall, the door suddenly burst open and in came Chkani. First he asked me whether I had had hysterics after the meeting with mother. Then he continued that he was to inform me that tomorrow I might be brought out. My head spun and I didn't see the hands the soldiers were proffering me, congratulating me. I almost couldn't take it in when I suddenly heard the voice of the young wardress who rushed into the cell, saying: 'Quick, quick, get ready! The doctor and deputies of the Central Soviet are coming for you!' I had nothing except a torn grey woollen blouse and some wretched belongings which she hastily tied up in a kerchief. Meanwhile poor Sukhomlinova started knocking on the wall, asking if she could say goodbye to me, but this was forbidden. Soldiers came in and surrounded me, and practically carried me through the long corridors. At the stairs a fair-haired rifleman who used to escort me to visits nodded to me. We went downstairs, through the refectory – the door opened in front of us... and we went out... to freedom. *12 June 1917*

ALEXANDER BLOK
Poet, secretary to the Extraordinary Investigative Commission; letter to Alexandra Kublitskaya-Piottukh

Yesterday was a big day: Muravyov, Manukhin and I made the rounds of our clients in the fortress. We witnessed some 'heart-rending' scenes. Protopopov gave me his notes. Someday I'll tell you who this talented and contemptible person really reminds me of. Among them are unfaltering individuals whom I respect (Makarov, Klimovich), but for the most part they're utter rabble! Whenever they're spluttering with tears or saying something they regard as very important, I look at them and experience a particular sensation: a revolutionary one. [...]

I myself am immersed in the secrets of the police department; my Beletsky, who I'm working on, is scribbling away himself – sweaty, lardy, in tears, with relish, saying that it's the only thing left for his soul. There's something childlike about this rough swine. *11 June 1917*

Grand Duchesses Olga, Tatyana, Maria and Anastasia and the Tsarevich Alexei at Tsarskoe Selo

PIERRE GILLIARD
French tutor to the imperial family

As the grand duchesses have been losing all their hair as a result of their illness, their heads have been shaved. When they go out in the park they wear scarves arranged so as to conceal the fact. Just as I was going to take their photographs, at a sign from Olga Nikolaevna they all suddenly removed their headdress. I protested, but they insisted, much amused at the idea of seeing themselves photographed like this, and looking forward to seeing the indignant surprise of their parents. Their good spirits reappear from time to time in spite of everything. It is their exuberant youth. *9 June 1917*

FORMER EMPEROR NICHOLAS II
Diary entry, Tsarskoe Selo

A wonderful day; enjoyed our walk. After lunch we learned from Benckendorff that we are not being sent to the Crimea, but to some remote provincial town three or four days' journey to the east! Where exactly they haven't said – even the commandant doesn't know. And we were all counting on a long stay in Livadia!! *28 July 1917*

GRAND DUKE MIKHAIL ALEXANDROVICH
Younger brother of Nicholas II

The palace commandant came for me at noon, and together we went to the Alexander Palace. We left by the kitchen and through a basement walked to the palace, the fourth entrance, and Nicky's ante-chamber. From there I entered the cabinet, where I met Nicky in the presence of Kerensky and an ensign in charge of guard duty.

I found that Nicky looked rather well. I was with him for ten minutes and then went back to Gatchina. The meeting was organised for me by Kerensky, after I accidentally found out this afternoon that Nicky and the family were to leave for Tobolsk tonight. *31 July 1917*

ALEXANDER KERENSKY
Minister of justice in the Provisional Government

As I sat in the room near the tsar's study giving the final orders and awaiting news of the arrival of the train, I could hear the young heir apparent Alexei running about noisily in the corridor [...] For the first time I saw the former tsarina simply as a mother, anxious and weeping. Her son and daughters did not seem to mind the departure so much, though they too were upset and nervous at the last moment.

FORMER EMPEROR NICHOLAS II
Diary entry, on board a steamer on the River Tobol

Got up late, having slept badly because of the general noise, whistles, stops etc.; during the night we came out of the Tura into the Tobol. The river is wider, the banks higher. The morning was cool, but the afternoon got quite warm when the sun came out. I forgot to mention that yesterday before dinner we went past the village of Pokrovskoe – Grigory's home.

At 6.30 we arrived in Tobolsk, although we had been able to see it for over an hour. There were a lot of people standing on the bank – which means they knew of our arrival. [...]

As soon as the steamer docked, they started to unload our baggage. Valya, the commissar and the commandant went off to inspect the houses, which have been assigned for us and our suite.* When the former returned, we learnt that the buildings are empty, dirty, without any furniture, and that it was impossible to move into them. For this reason we stayed on the boat and waited for them to bring back the luggage that we needed for the night. We had supper and joked about the surprising inability of people to even arrange accommodation, then went to bed early. *6 August 1917*

ELIZAVETA NARYSHKINA
Lady-in-waiting to Empress Alexandra

I invited over a kind old priest with whom I want to prepare for holy communion. He read me extracts from his diary in which he described his meetings with our prisoners – it moved me a great deal [...] How many wretched things have befallen them in recent times, how many deprivations! The sovereign has borne it all with the angelic humility of a saint, while the young grand duke at one point asked: 'If Papa is no longer tsar, will I be able to serve in the Guards?' When it was explained to him that this was unlikely, he added: 'So what will I do? I don't want to wander around England in a bowler hat.' No vanity whatsoever. *8 August 1917*

RUSSKOE SLOVO
'Russian Word', newspaper supportive of the Provisional Government

On the evening of 20 August, at 10 o'clock, former Prime Minister Stürmer died in hospital. For the last few days the patient had been unconscious and fed by artificial means.

As has been noted in these pages, Stürmer was arrested in the first days of the revolution and then, after being detained for a week in the Tauride Palace, was transferred to the Peter and Paul Fortress, where he spent around four months.

Owing to the increasingly severe nature of his illness (kidney disease), a few weeks ago Stürmer was released from the Peter and Paul Fortress and placed in the private clinic of Dr Gerzoni under police guard. His wife was allowed to visit him there, and he died in her arms.

The investigation into the actions of the former prime minister, which began almost immediately after the fall of the old regime, is almost completely finished. The former prime minister is accused of handing over diplomatic secrets to agents of hostile powers, as well as bribery.

Stürmer died in his 77th year. The funeral will take place on 23 August. *20 August 1917*

ANNA VYRUBOVA
Confidante of former Empress Alexandra

It's been reported in all the papers that I am to be sent abroad; the date and time were given. My family is worried, saying that this is a provocation. Last night my parents stayed with me, none of us could sleep. *25 August 1917*

IVAN MANUKHIN
Prison doctor at the Peter and Paul Fortress

I was constantly having to deal with the soldiers, trying to win them over and use every possible argument and blandishment to get them to agree to my removing one or other of the prisoners. When the soldiers displayed insuperable stubbornness, I would seek help again from the Soviet of Workers' and Soldiers' Deputies. At that time the Soviet was still the supreme revolutionary authority. But this authority soon lost its relevance. When a leading member of the Socialist Revolutionary Party, Gots, came from the Soviet to try to remove someone else, and appeared at the garrison meeting in the role of 'persuader', he was shouted down and the soldiers didn't give their permission. Assistance had to be sought from one of the prominent Bolsheviks. Lunacharsky turned up. The garrison quietened down and gave way.

KIEVLYANIN
'The Kievan', conservative newspaper; report

An attempt was made yesterday to exercise mob justice on Protopopov, who has been transferred from the fortress to Nikolaevsky Hospital on account of his poor state of health. The sentry of the Volynsky Regiment, which was mounting guard at the hospital, burst into the ward and demanded that Protopopov be handed over for examination and trial.

Protopopov did not lose courage and began to calm the soldiers down, calling them comrades and dear friends, persuading them that his case had not been terminated but would be scheduled for

trial in court. The hospital administration quickly informed the district headquarters and the Extraordinary Investigative Commission about the Volynsky Guards' behaviour. Thanks to the swift action of the medical personnel, mob justice was successfully avoided. The sentry of the Volynsky Regiment was recalled. The hospital administration has enquired about transferring Protopopov to different, more secure premises. *17 October 1917*

ZAPRETNOE SLOVO
'Forbidden Word', official newspaper of the Popular Socialist Party; report

Yesterday Protopopov, who is unwell, was arrested and escorted to the Nikolaevsky Military Hospital. On the way to the hospital Protopopov expressed surprise that he was not to be appointed commissar anywhere. *24 November 1917*

PETROGRADSKAYA GAZETA
Newspaper report

The family of the Romanovs has been issued with food vouchers by the Vyborg Food Committee. Only those members of the former royal family who are unwell will receive flour. *6 October 1917*

DOWAGER EMPRESS MARIA FEODOROVNA
Nicholas II's mother; letter to her son from Cape Ai-Todor, Crimea

My dear darling Nicky!
 You know that my thoughts and prayers never leave you – day and night I think of you all, sometimes it is so painful, that I can almost bear it no longer [...] I live only by remembering the past and try, if possible, to forget the present nightmare. *22 November 1917*

Vladimir Lenin

5
NEW
PEOPLE

"Seems crazy, but dreadfully convincing."

EARLY REFORMERS

Nikolai Nekrasov (1879–1940), minister of transport, then finance, in Provisional Government; active in White movement after October Revolution; arrested then freed on Lenin's orders; worked for Central Union of Consumer Cooperatives 1921–30; sentenced to ten years for counter-revolutionary activity, worked on White Sea Canal construction; released early, arrested again and shot in 1940.

PROGRESSIVE REVOLUTIONARIES

Edinstvo, 'Unity', daily newspaper of Menshevik faction within Russian Social Democratic Labour Party, edited by Georgy Plekhanov; closed in January 1918.

Yuly Martov (1873–1923), leader of anti-war Menshevik Internationalists; after 1917 vocal critic of Lenin, Bolsheviks and the bloodshed of civil war; emigrated to Berlin in 1920, already suffering from tuberculosis.

Georgy Plekhanov (1856–1918), Marxist theorist, one of the founders of Russian Social Democratic Labour Party; sided with Mensheviks against Lenin and Bolsheviks; went to Finland in January 1918 for treatment of long-term effects of turberculosis, died in May.

RADICAL REVOLUTIONARIES

Jakub Hanecki (1879–1937), Polish communist, helped finance Bolsheviks in exile; chairman of State Bank 1918–20, then held positions in foreign and trade ministries; director of Museum of the Revolution from 1935; arrested and executed in December 1937, his wife and son suffering same fate shortly afterwards.

Lev Kamenev (1883–1936), leading Bolshevik, exiled to Siberia under tsar; member of Bolshevik Central Committee and Politburo; formed United Opposition against Stalin with Zinoviev and Trotsky, his brother-in-law; arrested in 1934, put on show trial in 1936 and executed.

Alexandra Kollontai (1872–1952), Marxist feminist, Bolshevik Central Committee member, first head of party's women's department Zhenotdel; opposition to party led to diplomatic appointments in Norway, Mexico and Sweden.

Nadezhda Krupskaya (1869–1939), Bolshevik revolutionary and wife of Lenin; educational activist, early pioneer of Communist youth organisations, set out in article 'Komsomol i boiskautizm'; Central Committee member from 1927, deputy commissar for enlightenment from 1929.

Anatoly Lunacharsky (1875–1933), leading Bolshevik, writer; people's commissar for enlightenment 1917–29; died en route to take up appointment as ambassador to Spain in 1933; early advocate of introducing rugby to USSR.

Karl Radek (1885–1939), revolutionary activist, travelled with Lenin on sealed train through Germany, but refused entry to Russia; active in establishing German Communist Party; exiled to Urals in 1927 for support of Trotsky, recanted 1929; sentenced to ten years at 1937 show trial, died in prison.

Joseph Stalin (1878–1953), Bolshevik Central Committee member, Communist Party general secretary 1922–52, USSR premier 1941–53; denounced by his successor Nikita Khrushchev.

David Suliashvili (1884–1964), Georgian communist writer; travelled with Lenin on sealed train to Petrograd; as a child attended Gori Church School with Stalin; recounted revolutionary events in short stories.

Grigory Zinoviev (1883–1936), leading Bolshevik, chairman of Communist International (Comintern) 1919–26; initially allied with Stalin against Trotsky, later turned on by Stalin; sentenced to ten years for complicity in murder of Kirov in 1935; agreed to plead guilty at show trial in 1936 on condition of avoiding death penalty; found guilty and executed the next day.

OBSERVERS

Osip Brik (1888–1945), writer and literary critic; co-founder of avant-garde journal *LEF* with Vladimir Mayakovsky, who was Brik's wife Lili's long-term lover.

Winston Churchill (1874–1965), minister in Liberal governments from 1906; home secretary 1910–11; first lord of the Admiralty 1911–15; blamed for Gallipoli debacle in 1915; returned to office as minister of munitions in 1917 and from 1919 secretary of state for war and air; feared rise of Bolshevism in Germany as well as Russia, strong advocate of supporting Whites.

Elena Lakier (1899–?), diarist, student at Odessa Conservatoire; left Odessa on board English ship bound for Constantinople as Bolsheviks approached city in 1920.

Romain Rolland (1866–1944), French writer, awarded Nobel prize for literature in 1915; visited Moscow in 1935 and known for uncritical support of Stalin.

Sir Horace Rumbold (1869–1941), British ambassador to Switzerland, Poland and Spain between 1916 and 1924; ambassador to Germany 1928–33, where he issued stark warnings about Hitler's rise.

Out with the old, in with the new. Except that for émigré Russian dissidents, getting in to Russia from war-torn Europe proves to be no easy task. Most of the leading members of the Russian Bureau of the Bolsheviks' Petersburg Committee – Lenin, Zinoviev, Stalin, Kamenev and others – are abroad or in Siberia.

Within a week of the tsar's abdication, Lenin's so-called 'Letters from Afar', giving his views on the Bolshevik position vis-à-vis the new regime, are being circulated from his base in Zurich. Communications fly between Petrograd and other cities in an attempt to coordinate the return. Trotsky is in New York, Yuly Martov in transit from Paris to Zurich, Alexandra Kollontai in Oslo, Zinoviev is with Lenin in Zurich, Kamenev and Stalin are making their way back to Petrograd from exile in Siberia.

In Petrograd the Soviet issues a manifesto calling for 'the peoples of the world [...] to take into their own hands the question of war and peace'. Revolutionary Defencism – calling for peace while maintaining Russia's right to self-defence – seems to leave the door open to continuing and even stepping up the war effort. Irakly Tsereteli, Menshevik leader of the Petrograd Soviet, praises the workers for their moderation. The Bolsheviks talk up the need to export the revolution, seeing it as a 'prologue for the uprising of the peoples of all the warring countries'. Strongly-held positions multiply, some in support of the Provisional Government, others in opposition. Lenin, meanwhile, is still lodging with his cobbler landlord in Zurich, pent up, in Trotsky's description, 'like a caged animal'...

NADEZHDA KRUPSKAYA
Bolshevik revolutionary and wife of Lenin;
in Zurich

When Ilyich was about to head off to
the library and I'd finished clearing
away the dishes, Bronski came in,
saying, 'What, you don't know what's
happened?! There's a revolution in
Russia!' And he told us about the latest
reports in the special editions of the
newspapers. After he'd left, we went
down to the lake, where all the papers
were posted up as soon as they came
out. We read the reports several times.
A revolution really had happened in
Russia. Ilyich was all activity.

He asked Bronski to find out whether
it might be possible to get back to
Russia through Germany with the help
of a smuggler. It soon transpired that
the smuggler could only get us as far as
Berlin. Furthermore, the smuggler was
somehow connected with Parvus, and
as Parvus had profited from the war and
turned into a 'socialist chauvinist', V.I.
wanted nothing to do with him.* The
journey could be made by plane – no
matter that the plane could be downed.
But where to find the magic aeroplane
that could transport us to revolution-
making Russia? *1 March 1917*

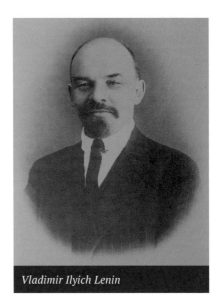
Vladimir Ilyich Lenin

NADEZHDA KRUPSKAYA
Bolshevik revolutionary and wife of Lenin;
in Zurich

Ilyich has not slept for days. Tonight he
said: 'You know, I can travel under the
passport of a mute Swede.' I laughed.
'It won't work; you might start speak-
ing in your sleep. If you dream of the
Kadets, you'll start mumbling: bastards,
bastards. Everyone will realise that
you're not a Swede.' For all that, the
idea of travelling as a mute Swede was
more realistic than flying over in some
aeroplane. Ilyich wrote about his plan
to Hanecki in Sweden. *2 March 1917*

JAKUB HANECKI
Polish communist, associate of Lenin

Receiving a book in the post from Swit-
zerland, I guessed I'd find a letter inside
the cover... And so it proved. A little
note penned by Ilyich [...] as well as his
photograph. The note said something
along the lines of: 'We cannot wait any
longer, there's no hope of getting there
by legal means. But we must get to Rus-
sia at once – whatever the cost. The only
possible plan is as follows: find a Swede
who looks like me. And since I don't
know Swedish, the Swede will have to
be deaf and dumb. I enclose my photo-
graph just in case.' *10 March 1917*

Nadezhda Krupskaya

VLADIMIR LENIN
Bolshevik leader; letter to journalist
Vyacheslav Karpinsky

Dear Vyach. Al.,

I'm thinking through every possible
way of making the journey. What I'm
about to say is a deadly secret. I ask
you to reply immediately, preferably by
express (I reckon we won't bankrupt the
party with a few express messages), to
be sure that nobody reads the letters.

Take out papers in your name for
travelling to France and England, and
I will travel on them through England
(and Holland) to Russia. I will wear a
wig. A photograph will be taken of me in
the wig, and I will go to the consulate in
Berne with your papers, wearing the wig.
You should then disappear from Geneva
for several weeks at least (until you get
a telegram from me from Scandinavia):
spend the time hiding extra carefully in
the mountains, where we'll pay for your
lodging, of course.* *6 March 1917*

NADEZHDA KRUPSKAYA
Bolshevik revolutionary and wife of Lenin;
in Zurich

Various political groups of Russian
émigré internationalists living in
Switzerland gathered to discuss how
to get to Russia. Martov put forward a
proposal that would involve exchanging
German and Austrian internees for a
pass for émigrés to cross Germany. Best
of all would be to start negotiations
initiated by the Swiss government.
Grimm was assigned to lead talks with
the Swiss government.* *6 March 1917*

ALEXANDRA KOLLONTAI
Bolshevik Central Committee member;
in Holmenkollen, Norway

'Amnesty!' A telegram from Petrograd,
from a member of the Soviet Execu-
tive Committee: all political émigrés
have been granted an amnesty. We can
return to Russia immediately. But I have
another telegram on the table: from
Lenin in Switzerland, an instruction to
wait for his letters to the Russian Bureau
of the Central Committee... So I'll have

Alexandra Kollontai

to delay my departure for five or six days.
An amnesty! An amnesty! And still Rus-
sian freedoms are questioned.

What is this Provisional Government?
Kadets, the wealthy bourgeoisie! The
question of passports is troubling be-
cause everyone has false ones. But isn't
it better just to go without documents,
on the off chance? One or two of the
émigrés even went to the Russian consu-
late, which led to a farcical performance.
The consulate officials, seeing two tall
and determined Russian émigrés (in
Christiania everyone knows each other
by sight), were frightened to death: it
seems they thought that the Russian
political émigrés had come to arrest
them. They didn't know anything at the
consulate and gave out no information.

Our comrades from Copenhagen and
Stockholm came over to discuss who
should go and who for the moment
should stay as a link between Switzer-
land and Russia. The foreign Central
Committee of the party, and important-
ly Lenin, are still in Berne. But nobody
wants to stay as the contact, so we're
asking Berne. All of us are dying to join
the celebration of the revolution, Russia
is calling us. *6 March 1917*

VLADIMIR LENIN
Bolshevik leader; telegram from Zurich to Bolsheviks returning to Russia

Our tactics: no trust in and no support for the new government; Kerensky is especially suspect; arming of the proletariat is the only guarantee; immediate elections to the Petrograd Duma; no rapprochement with other parties. Telegraph this to Petrograd. *6 March 1917*

JOSEPH STALIN
Leading Bolshevik; communication from Perm

Fraternal greetings. We leave for Petrograd today. Kamenev, Muranov, Stalin. *8 March 1917*

LEON TROTSKY
Revolutionary and Marxist theorist; in New York

I called at the office of the Russian consul general in New York. The portrait of Nicholas II had already been removed from the wall, but the oppressive atmosphere of a Russian police station under the old regime still hung about the place. After the usual delays and arguments, the consul general ordered that I be issued with papers for passage to Russia. In the British Consulate, as well, they told me, when I filled out the questionnaire, that the British authorities would put no obstacles in the way of my return to Russia. So everything was in good order.

GEORGY PLEKHANOV
Marxist theorist; in London

I have a feeling that I will not live in Russia for long. But I cannot not go. An old soldier of the revolution must be at his post when he is called. *22 March 1917*

VLADIMIR LENIN
Bolshevik leader; letter to Inessa Armand

Dear Friend,
 You must be in an excessively nervous state, which explains a number of theoretical 'oddities' in your letters.

No need, you say, to distinguish between the first and the second revolution, or the first and the second stage?? That's exactly what we have to do. Marxism requires that we should distinguish between the classes that are active. In Russia a different class is in power than before. Consequently, the revolution that lies ahead is quite, quite different. [...]
 Probably we won't manage to get to Russia!! Britain will not let us through. It can't be done through Germany.* *13 March 1917*

Inessa Armand

VLADIMIR LENIN
Bolshevik leader; letter from Zurich to Jakub Hanecki

Please let me know in the greatest possible detail, first, whether the British Government will allow passage to Russia for me and a number of members of our Party, the Russian Social Democratic Workers' Party (Central Committee), on the following conditions: (a) the Swiss socialist Fritz Platten receives permission from the British Government to conduct any number of persons through England irrespective of their political allegiances and their views on war and peace;* (b) Platten alone answers both for the composition of the conducted

groups and for maintaining proper order, and receives a railway coach for travelling through England, which he, Platten, is to keep locked. No one can enter this coach without the consent of Platten. This coach shall have extraterritorial rights; (c) from a port in England Platten conveys the group by steamer of any neutral country, with the right to notify all countries of the sailing time of this special ship; (d) railway fares shall be paid by Platten according to the tariff and the number of seats occupied; (e) the British Government undertakes not to place obstacles to the chartering and sailing of a special steamer with Russian political emigrants and not to detain the steamer in England, enabling the passage to be made in the quickest possible way.

Secondly, in the event of agreement, what guarantees will England give that these conditions will be observed, and that she has no objection to them being published. If telegraphic enquiries have to be made in London we agree to bear the expenses of the telegram and a prepaid reply. *15 March 1917*

YULY MARTOV
Leader of the Menshevik Internationalists; letter to Nadezhda Kristi, Russian émigré in Zurich

The question of returning to Russia is now entirely a practical one. Everyone is asking about it. In Berne, Zinoviev and I discussed the prospects with others. We learned from *Les Temps* that Gorky has responded to the request of the volunteer Agafonov and others with a telegram: *revenez tous*, to which they replied with a telegram to Kerensky and Chkheidze to 'make all arrangements' for transportation. And today a telegram from St Petersburg has been published in *Les Temps*: 'Bankers have handed Kerensky 5 million francs collected to finance the transportation of emigrants.' I begin to think that my idea is not a fantasy: to charter a steamer,

and to be delivered from England under the escort of a Russian torpedo boat, which more or less guarantees against an attack. *15 March 1917*

DAVID SULIASHVILI
Georgian communist writer; travelled on the train to Petrograd with Lenin

Our assumption that the Allies would not let us through their territory was justified. At that time it was not in their interests for revolutionaries to return to Russia. [...]

Day and night we thought only of how we could get back to our homeland. That was all we talked about when we met up.

After many years in exile the possibility of returning to our homeland had suddenly opened up before us, but the road of return was blocked. Dejected, we wandered the familiar streets.

Helpless, bewildered, reconciled to the situation, suddenly we heard a clarion call: 'There is a way! [...] I will teach you how to get to the revolution! Follow me, those who are willing, and I will lead you to Russia, I will show you the revolution!'

It was the voice of the great émigré, it was the voice of Comrade Lenin.

His call threw the émigré community into disarray. Astonished, almost resentful, socialists of all persuasions considered such audacity unacceptable.

'What?! Surely we cannot be allowed to travel to Russia through the territory of Germany, which is fighting against us? What will our fellow countrymen say? Surely this is treachery? What will we reply to them? And will the Provisional Government really let us in, if we have arrived from Germany? Will they not ask why Germany let us through? No, no! To return that way is madness.'

Practically the whole émigré community made the same argument.

But Lenin was Lenin, and no amount of obstacles could force him to change his mind once the decision had been taken.

Karl Radek

KARL RADEK
Revolutionary activist, associate of Lenin

When [...] Vladimir Ilyich became convinced that it was a fantasy even to think that the Allies would allow him and his comrades to make the journey to Russia, one of two possibilities remained: either we could try to travel through Germany illegally, or we could travel with the knowledge of the authorities.

JAKUB HANECKI
Polish communist, associate of Lenin

When all hope that the Provisional Government would help ensure passage through England turned out to be in vain, the émigrés in Switzerland decided to enter into negotiations with the German government. Swiss Comrade Platten led the negotiations. [...]

The conditions were as follows.

1. All émigrés are to travel regardless of their views on the war.

2. The railway carriage in which the émigrés are to travel will enjoy extraterritorial rights. Nobody has the right to enter the carriage without the permission of Comrade Platten. There shall be no inspection of passports or luggage.
3. Those who travel to Russia are obliged, once there, to campaign for the exchange of a corresponding number of Austrian and German internees. *17 March 1917*

KARL RADEK
Revolutionary activist, associate of Lenin

We then sent the Swiss socialist deputy Robert Grimm [...] and Comrade Platten to see [German ambassador] Romberg with these conditions. We met them in the town hall after their meeting with the German ambassador. Grimm related how surprised the ambassador had been when they had read out to him our conditions for the journey through Germany. 'Forgive me,' said the German ambassador, 'but it seems to me that it is not I who am requesting permission to travel through Russia, but Mr Ulyanov and the others who are asking me for permission to travel through Germany. We are the ones who have the right to impose conditions.'

ROMAIN ROLLAND
French writer and Nobel prize winner; from the Grand Hôtel Château Bellevue, Switzerland

They have signed (or will sign) an agreement, under which they are obliged, once they have returned to Russia, to demand the release of all civilian German prisoners of war. In return, Germany undertakes to let them pass through their territory into Russia, from one border to the other, in sealed train carriages [...] I am vehemently against this plan. I do not doubt the clear conscience of the Russian revolutionaries and I understand very well the impatience that gnaws at them, at the

thought of the struggle which is taking place at the moment in Petrograd, from which they are absent. But I cannot condone that they have gone to the Germans for help, not only because they are the enemy (although they do not recognise them as such), but because the German government is the worst supporter of militant imperialism, and it is clear that they are only granting them this favour because it serves their interest. Whatever they do in the future and however honest their intentions, in the eyes of Europe and their own people they will be the enemy's accomplices.
24 March 1917

VLADIMIR LENIN
Bolshevik leader; letter from Zurich to Robert Grimm

Our Party has decided to accept without reservations the proposal that the Russian émigrés should travel through Germany, and to organise this journey at once. We already expect to have more than ten participants in the journey.

We absolutely cannot be responsible for any further delay, resolutely protest against it and are going alone. We earnestly request you to make the arrangements immediately and, if possible, to let us know the decision tomorrow.
18 March 1917

ANATOLY LUNACHARSKY
Leading Bolshevik; in Zurich

Lenin made a wonderful, even grandiose impression on me – albeit at the same time there was something tragic, almost gloomy, about him. Our real discussion will only take place tomorrow. However, I cannot agree with him. He is too hasty in his desire to travel, and I believe his unconditional agreement to travel with the approval of Germany but not Russia to be a mistake that may have negative consequences for his future.

But Lenin is grandiose. He is like a yearning lion making his way towards a desperate battle. *21 March 1917*

VLADIMIR LENIN
Bolshevik leader; letter to Inessa Armand in Clarens, Switzerland

I hope we shall be starting out on Wednesday – together with you, I hope.

We have more money for the journey than I thought, enough for ten to twelve people. The comrades in Stockholm have been a great help. [...]

It is quite possible that the majority of the workers in Petrograd are now Social Patriots... We'll do a bit of fighting – and the war will agitate for us.

A thousand greetings. Au revoir.
20 March 1917

KARL RADEK
Revolutionary activist, associate of Lenin

There was a constant conflict between the smokers and the non-smokers about a particular location in the carriage. We didn't smoke in the compartment because of little Robert and Ilyich, who couldn't bear it. The smokers therefore tried to make a smoking room in the place normally reserved for functions of a different kind. As a result a constant crowd of bickering people gathered outside the place in question. Ilyich then tore up some paper and handed out passes. For every three tickets of Category A, for those using the place for its intended functions, there was one ticket for smokers. This gave rise to arguments about which human needs were of greater value, and we were very sorry that we didn't have Comrade Bukharin with us, who is in an expert in Böhm von Bawerk's theory of marginal utility.

DAVID SULIASHVILI
Georgian communist writer; travelled on the train to Petrograd with Lenin

We stopped in Zurich for a few hours. The city's émigrés met us with hostility. They shouted at us from the platform: 'Turncoats! Traitors!'

We stayed away from the windows and did not respond. That was Lenin's advice.

SIR HORACE RUMBOLD
British ambassador to Switzerland; letter to his stepmother

[The Germans] are banking on coming to an arrangement with Russia and are moving heaven and earth to bring this about. Amongst other things they have collected a good number of Russian extremists, nihilists, etc., who were living in exile in this country and have shipped these gentry off to Stockholm via Germany in order to work on the Russian socialists in favour of peace.
17 April 1917

KARL RADEK
Revolutionary activist, associate of Lenin

In Berlin, the platform at which the train stopped was cordoned off by plain-clothes agents. We travelled like this as far as Sassnitz, where we boarded a steamer. There, we were given instructions to carry out the usual formalities and fill out forms. Lenin saw this as a cunning ruse by the enemy, and ordered us to sign our names using various pseudonyms, which later led to a comical misunderstanding.

The radio on the steamer received a query from Trelleborg, enquiring if there was a Mr Ulyanov on board. It was our comrade Hanecki, who had been waiting for us at a port in Sweden for several days, and who had managed to get permission to use the government radio by impersonating a representative of the Russian Red Cross. The captain knew from the forms that there was no Ulyanov on board, but asked in any case if, by chance, there was a Mr Ulyanov among us. Lenin looked uncomfortably about him for some time, and eventually admitted that he was Ulyanov. As a result of this, Hanecki had notification that we were on our way. *30 March 1917*

NEW YORK TIMES
American newspaper; report

The fact that Russian peace agitators, chiefly extreme socialists, have been permitted to cross Germany from Switzerland seems to indicate that the German Government at least does not desire to throw any obstacles in the way of such a movement.

A party of Russians, which [...] is now on its way to Petrograd, included thirty who came through Germany in a sealed coach. Among the principal members of the party were Nikolai Lenin, radical socialist leader, and Zinovyof, another radical and peace advocate.* Both are members of their party's Central Committee and editors of party newspapers in Geneva, as well as prominent figures in the Zimmerwald Congress [...] While in Stockholm the Russians issued a statement attacking England and accusing it of trying to 'destroy one of the Russian Revolution's results – political amnesty', and of refusing to permit Russian revolutionists abroad, who opposed the war, to return to Russia.
2 April 1917

NIKOLAI SUKHANOV
Member of the Executive Committee of the Petrograd Soviet, writer and editor

Lenin was travelling to Russia via Germany, in a sealed train, by the special favour of the enemy government. Even though this was the only way for Lenin to return to his country, it was clear that the bourgeoisie and all its hangers-on would make appropriate use of it. [...]

Everyone understood that in meeting the interests of these Russian citizens halfway the Germans were pursuing their own interests exclusively: they were, of course, gambling on the Russian internationalists' undermining the foundations of Russian imperialism, wrenching Russia away from the Allied pirates and pushing her into a separate peace. The Russian émigré internationalists were fully aware of the intentions of the German authorities.

Grigory Zinoviev

GRIGORY ZINOVIEV
Leading Bolshevik; in Tornio, Swedish–Russian border

Tornio – night time. We travelled on sledges over the frozen gulf. A long narrow ribbon of sledges. Two people to a sledge. The tension reached its peak. The most effusive of our younger comrades (such as Usievich, now dead) were unusually nervous. Soon we would see the first revolutionary Russian soldiers. Lenin was outwardly calm. He wanted most of all to know what was happening in distant Petersburg. Travelling over the frozen gulf, he looked intently into the distance, as if he could already see what was taking place in the revolutionary capital, one and a half thousand kilometres ahead of us.

We reached the Russian side of the border (today's border between Finland and Sweden). Our younger compatriots rushed towards the Russian border soldiers (there were probably only a few dozen of them) and struck up conversations to find out what was happening. Vladimir Ilyich immediately seized on the Russian newspapers. Several editions of *Pravda*, our *Pravda*, were there. Vladimir Ilyich pored over the columns and then, shaking his head, held up his hands reproachfully: he had read the news that Malinovsky had indeed turned out to be a spy. On he read. [...]

We had our first encounters with the 'Kerensky' lieutenants – the 'revolutionary democrats'. Then we came across Russian revolutionary soldiers; after an hour of conversation Vladimir Ilyich christened them 'sincere defenders of the fatherland' in need of particularly 'patient education'. Following orders from the authorities, a group of soldiers accompanied us to the capital. We got onto the train.

Vladimir Ilyich really got stuck into these men; they talked about the nation, war and the new Russia. Vladimir Ilyich's particular way of conversing with workers and peasants ensured that he quickly established an excellent, comradely relationship with the soldiers. The discussions continued throughout the night without interruption. But the soldiers, these 'defenders of the fatherland', stood their ground. The first conclusion Vladimir Ilyich drew from this exchange was that the ideology of defencism remained a powerful force. To combat it we would need to be stubborn and unyielding, but patience and shrewdness were equally necessary.

The closer we got to Beloostrov, the more anxious we became. But when we arrived we were received with a degree of civility by the authorities. One of the Kerensky officers, who was commander of Beloostrov, even 'reported' to Vladimir Ilyich.

In Beloostrov we were met by our dear friends – among them Kamenev, Stalin and many others. In a dim, narrow third-class carriage, illuminated solely by a candle stub, the first exchange of opinions occurred. Vladimir Ilyich hurled a series of questions at our comrades.

'Will we be arrested in Petrograd?'

Our friends did not give a direct answer, but just smiled enigmatically.

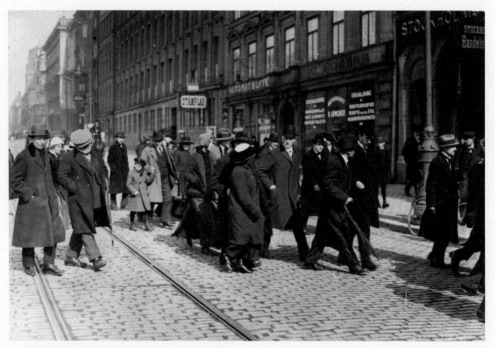

Russian revolutionaries in Stockholm during their journey back to Russia;
Lenin is leading the group, holding an umbrella

NIKOLAI SUKHANOV
Member of the Executive Committee of the Petrograd Soviet, writer and editor

When the reports about the first emigrant train through Germany reached the Ex. Com., it caused great regret; many thought the step a mistake, but only a few individuals condemned it. In spite of the fact that only Lenin (odious to the majority) was involved for the time being, the Ex. Com., though aware of all the ticklishness of the situation, nevertheless did not hesitate to cover the sealed train with its authority, and turned its weapons against the policies of the government, the bourgeoisie bristling with malice, and the rabble.

WINSTON CHURCHILL
British politician; from his history of the First World War, *The World Crisis*

In the middle of April the Germans took a sombre decision. Ludendorff refers to it with bated breath.* Full allowance must be made for the desperate stakes to which the German war leaders were already committed. They were in the mood which had opened unlimited submarine warfare with the certainty of bringing the United States into the war against them. Upon the Western front they had from the beginning used the most terrible means of offence at their disposal. They had employed poison gas on the largest scale and had invented the 'Flammenwerfer'. Nevertheless it was with a sense of awe that they turned upon Russia the most grisly of all weapons. They transported Lenin in a sealed truck like a plague bacillus from Switzerland into Russia. Lenin arrived at Petrograd on April 3. Who was this being in whom there resided these dire potentialities?

GRIGORY ZINOVIEV
Leading Bolshevik; in Petrograd

We were all firmly convinced that Milyukov and Lvov would arrest us on our arrival in Petrograd. Vladimir Ilyich was more sure of this than anyone, and he prepared the group of comrades travelling with him for this eventuality. [...]

The platform of the Finland Station in Petrograd. Night-time. Only now do we understand our friends' cryptic smiles: it's not imprisonment that awaits Vladimir Ilyich, but triumph. The station and adjacent square are awash with floodlights. A guard of honour of men armed with all kinds of weapons greets us on the platform. The station, the square and adjoining streets are thronged with tens of thousands of workers rapturously greeting their leader. A thunderous Internationale. Thousands upon thousands of workers and soldiers delirious with enthusiasm.

NIKOLAI SUKHANOV
Member of the Executive Committee of the Petrograd Soviet, writer and editor

Lenin's train was expected around eleven. There was a crush around the station – more delegations, more flags, and sentries at every step demanding special authority for going any further [...] I made my way right through the station to a platform, and towards the tsar's waiting-room, where a dejected Chkheidze sat, weary of the long wait and reacting sluggishly to Skobelev's witticisms. [...]

The Bolsheviks, who shone at organisation, and always aimed at emphasising externals and putting on a good show, had dispensed with any superfluous modesty and were plainly preparing a real triumphal entry.

NIKOLAI CHKHEIDZE
Menshevik chairman of the Petrograd Soviet; greeting Lenin at the Finland Station, Petrograd

Comrade Lenin, in the name of the Petersburg Soviet and the whole revolution we welcome you to Russia [...] We think that the principal task now facing revolutionary democracy is the defence of the revolution from any encroachments either from within or from without [...] We hope you will pursue these goals together with us. *3 April 1917*

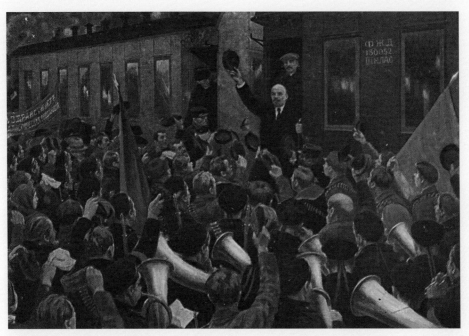

Postcard reproduction of Mikhail Sokolov's c. 1930 painting Lenin's Arrival in Petrograd; *Stalin is shown standing behind Lenin*

VLADIMIR LENIN
Bolshevik leader; speech on arrival at the
Finland Station, Petrograd

Dear Comrades, soldiers, sailors and
workers! I am happy to greet the
victorious Russian Revolution that you
represent, and greet you as the vanguard
of the worldwide proletarian army. The
predatory imperialist war is the begin-
ning of a civil war throughout Europe.
The hour is not far off when at the call
of our comrade, Karl Liebknecht, the
peoples will turn their arms against
their own capitalist exploiters.* The
worldwide socialist revolution has
already dawned. Germany is coming
to the boil. Any day now the whole of
European imperialism may come
crashing down. The Russian Revolution
accomplished by you has prepared the
way and opened a new epoch. Long live
the worldwide socialist revolution!
3 April 1917

NIKOLAI SUKHANOV
Member of the Executive Committee of
the Petrograd Soviet, writer and editor

I reached the Kshesinskaya Mansion,
which was ablaze with lights, decorated
with red banners, even, it seemed,
illuminated.

A crowd stood in front of the house
and was not dispersing, while from the
balcony of the second floor Lenin, by now
already hoarse, was making a speech. I
stopped near a detachment of soldiers
with rifles, who had accompanied the
procession to its very end.

'Thieving capitalists,' could be heard
from the balcony. 'The annihilation of
the peoples of Europe for the profit of a
handful of exploiters.' [...]

'Should stick our bayonets into someone
like that,' a soldier suddenly shouted out
in lively response to the words from the
balcony. 'Eh? The things he says! Listen to
him! If he came down here we'd show him
all right! Must be a German...'

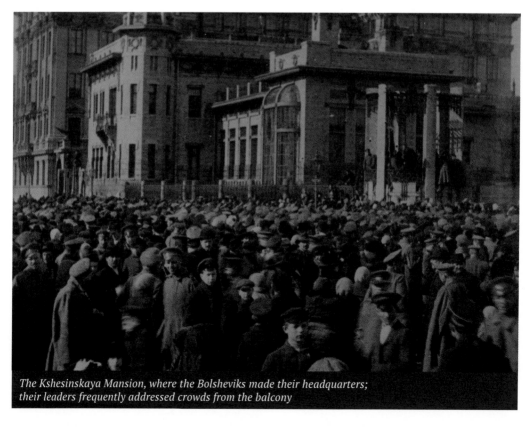

*The Kshesinskaya Mansion, where the Bolsheviks made their headquarters;
their leaders frequently addressed crowds from the balcony*

ZINAIDA GIPPIUS
Poet, novelist and journalist

So here's Lenin... Yes, it seems this 'Trishka' has arrived at last! The arrival was bombastic, with floodlights. However – he came through Germany. The Germans recruited a whole bunch of these 'dangerous' Trishkas, gave them an entire train, sealed it lest their spirit leak out onto German soil, and sent it to us: here, over to you.*

That same evening Lenin immediately sprang into action: he announced that he was renouncing Social Democracy (even Bolshevism) and now calls himself a 'Social Communist'. *5 April 1917*

OSIP BRIK
Writer and literary critic; present with Lenin at Finland Station

Seems crazy, but dreadfully convincing. *3 April 1917*

NIKOLAI NEKRASOV
Minister of transport; speech to the Kadets in Moscow

Terrifying is that prophecy of violence that now rings out from Kamenno-ostrovsky Prospect.* *9 April 1917*

VLADIMIR LENIN
Bolshevik leader; 'April Theses', first proclaimed in a speech in the Kshesinskaya Mansion

1. In our attitude towards the war, which under the new government of Lvov and Co. unquestionably remains on Russia's part a predatory imperialist war owing to the capitalist nature of that government, the slightest concession to 'revolutionary defencism' is impermissible. The class-conscious proletariat can give its consent to a revolutionary war that fully justifies revolutionary defencism only on condition: (a) that power passes to the proletariat and the poorest sections of the peasants aligned with the proletariat; (b) that all annexations are renounced in deed and not just in word; and (c) that a complete break with all capitalist interests is effected.

2. The peculiarity of Russia's current situation is that the country is in transition from the revolution's first stage – which, because of the proletariat's inadequate class-consciousness and organisation, has put power into the bourgeoisie's hands – to its second stage, when power must pass to the proletariat and the poorest peasant strata. This particular situation demands that we show ourselves capable of adapting to the special conditions of Party work among unprecedentedly large masses of the proletariat who have just awakened to political life.

3. No support for the Provisional Government; expose the utter falsity of all its promises, particularly those relating to the renunciation of annexations. This exposure must replace the impermissible, illusion-breeding 'demand' that this government, a government of capitalists, cease being an imperialist government.

4. Recognition of the fact that our party is a minority in most of the Soviets of Workers' Deputies, and so far a small minority. It faces a bloc of all petty-bourgeois opportunist elements, from the Popular-Socialists and Socialist Revolutionaries to the Executive Committee (Chkheidze, Tsereteli, Steklov, etc.) who have yielded to bourgeois influence and spread that influence to the proletariat. The masses must be made to see that the Soviets of Workers' Deputies are the only possible form of revolutionary government, and that therefore as long as this government yields to the influence of the bourgeoisie, our task is to present a patient, systematic and persistent explanation of the errors of their tactics, an explanation especially adapted to the practical needs of the masses.

5. Not a parliamentary republic – compared to the Soviets of Workers' Deputies, a parliamentary republic would be a backward step – but a Republic of Soviets of Workers', Agricultural Labourers' and Peasants' Deputies throughout the country, from top to bottom. Abolition of the police, the army and the bureaucracy. The salaries of all officials, all of whom are elective and subject to recall at any time, not to exceed the average wage of a skilled worker.

6. The agrarian programme's centre of gravity must be shifted to Soviets of Agricultural Labourers' Deputies. Confiscation of all landed estates. Nationalisation of all the country's land, which will be distributed by the local Soviets of Agricultural Labourers' and Peasants' Deputies. The selection of Soviets of Deputies from the poorest peasants. The conversion of all large estates [...] into model farmsteads under the control of the Soviets of Agricultural Labourers' Deputies and for national use.

7. The immediate consolidation of the country's banks into one general, national bank, controlled by the Soviet of Workers' Deputies. Banks are the nerve-centre of the national economy. We cannot take the banks into our own hands, but we can advocate their merger under the control of the Soviet of Workers' Deputies.

8. Instead of 'introducing' socialism as an urgent task, we must immediately put public production and distribution of goods under the control of the Soviets of Workers' Deputies. Laws are important not because they are written down, but because of who passes them. The dictatorship of the proletariat exists, but they do not know what to do with it.

9. Party tasks: (a) immediate convocation of a Party congress; (b) change the Party programme, mainly: (1) on the question of imperialism and the imperialist war; (2) on our position towards the state and our demand for a 'commune state'; (3) amend our outdated minimum programme; (c) change the Party's name.

10. Renewal of the International. We must take the initiative in creating a revolutionary International, an International that is against social chauvinists and against the 'Centre'. *4 April 1917*

NIKOLAI SUKHANOV
Member of the Executive Committee of the Petrograd Soviet, writer and editor

I cannot forget that speech, like a flash of lightning, which shook and astonished not only me, a heretic accidentally thrown into delirium, but also the true believers. I maintain that no one had expected anything like it. It seemed as if all the elemental forces had risen from their lairs and the spirit of universal destruction, which knew no obstacles, no doubts, neither human difficulties nor human calculations, circled in the hall of the Kshesinskaya Mansion above the heads of the enchanted disciples.

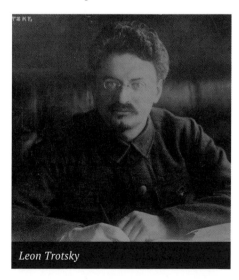

Leon Trotsky

LEON TROTSKY
Revolutionary and Marxist theorist; from
his *History of the Russian Revolution*

An hour later Lenin had to give his
speech a second time at a previously
arranged joint meeting of the Bol-
sheviks and Mensheviks, where to the
majority of listeners his words seemed
somewhere between mockery and delu-
sion. The more indulgent among them
shrugged their shoulders. Clearly this
man had come down from the moon:
no sooner had he descended the steps
of the Finland Station after ten years'
absence than he was preaching about
the seizure of power by the proletariat
[...] Stankevich testifies that Lenin's
speech delighted his opponents: 'A man
talking such nonsense was not danger-
ous. It was good that he had come, now
everyone could see him... now he would
debunk himself.'*

MAURICE PALÉOLOGUE
French ambassador

This morning Milyukov gleefully remar-
ked to me: 'Lenin was a hopeless failure
with the Soviet yesterday. He argued
the pacifist cause so heatedly, and with
such effrontery and lack of tact, that
he was compelled to stop and leave the
room amidst a storm of booing. He will
never survive it.' I answered him in Rus-
sian fashion: 'God grant it!'
 But I very much fear that once again
Milyukov will prove the dupe of his
own optimism. Lenin's arrival is in fact
represented to me as the most danger-
ous ordeal the Russian Revolution could
have to face. *5 April 1917*

EDINSTVO
'Unity', Social Democratic newspaper
edited by Georgy Plekhanov; report on
Lenin's April Theses speech

This truly delusional speech encoun-
tered a worthy rebuff from Tsereteli,
who received a loud ovation. He said
that the task of the moment was to
consolidate our gains, in other words

a democratic republic. In response to the
anarchic demagoguery just cited, he very
aptly quoted the words of Engels: 'there
is no surer road to destruction than an
early seizure of power'. *5 April 1917*

VLADIMIR LENIN
Bolshevik leader; reply to the comment
on his April Theses in *Edinstvo* newspaper

In his newspaper, Mr Plekhanov called
my speech 'delusional'. Very good, Mr
Plekhanov! But look at how clumsy,
awkward and slow-witted your own po-
lemics are. If I gave a delusional speech
for two hours, how did an audience of
hundreds of listeners tolerate these

Georgy Plekhanov

'delusions'? Further – why did your
newspaper dedicate a whole column
to an exposition of 'delusions'? Incon-
sistent! You turn out to be completely
inconsistent. Isn't it so much easier to
cry, curse and wail than it is to relate,
explain and understand how Marx and
Engels reasoned in 1871, 1872 and 1875
regarding the Paris Commune and what
kind of state the proletariat needs?
The former Marxist Mr Plekhanov in
all probability does not want to recall
Marxism. *6 April 1917*

GEORGY PLEKHANOV
Marxist theorist; article in *Edinstvo* titled 'On Lenin's theses and why delusions are sometimes interesting'

In his article on the proletariat's tasks in this revolution (*Pravda*, no. 26) Lenin, having set out his henceforth celebrated theses, considered it necessary in conclusion to launch into me as a transgressor. Why he needed to do this, I do not know. [...]

Let me say first of all that I made no comment on Lenin's speech, nor was I among his listeners. It was a comrade reporter from *Edinstvo* who called Lenin's long speech 'delusional'. It is possible that he was mistaken in his analysis. But allow me to observe that his mistake was in no way proof of the clumsiness and lack of perception of my polemics. Moreover, Lenin's speech created an impression of delusion on the vast majority of his listeners, not just on the comrade reporter from *Edinstvo*. [...]

Let us go further. My opponent is quite wrong to think that a 'delusional' speech could not attract the attention of listeners for two whole hours, or even more. And he is just as wrong to aver that newspapers would not find room to record such a speech. For delusion can sometimes be highly instructive from a psychiatric or political point of view. People who engage in psychiatry or politics purposefully devote a great deal of time and importance to it. Take Chekhov's *Ward No. 6* for example. The whole little book is taken up with it [...] When we read the work of this very great artist, we're not checking our watch and grumbling that it fills so many pages. On the contrary, we're sorry that we reach the last page too soon. [...]

Or take *The Diary of Titular Counsellor Aksenty Ivanovich Poprishchin*. In literary terms Gogol's story is weaker than *Ward No. 6*. However, we read this story, too, with great interest, and nobody complains that it takes up so many columns of text. So it is with Lenin's theses [...] This is not to say that I place Lenin on the same level as Gogol or Chekhov. No – I hope he will forgive my frankness. He himself has demanded it of me. I am just comparing his theses with the speeches of the deranged heroes of these great authors, and in a certain way I enjoy them. *9 April 1917*

LEV KAMENEV
Leading Bolshevik; article in *Pravda* titled 'Our Differences'

In yesterday's issue of *Pravda* Comrade Lenin published his 'theses'. They represent the personal opinion of Comrade Lenin and by publishing them Comrade Lenin did something which is the duty of every responsible public figure – to submit to the judgement of the revolutionary democracy of Russia his understanding of current events. Comrade Lenin did it in a very concise form, but he did it thoroughly. Having begun with a characterisation of the World War, he came to the conclusion that it is necessary to create a new, communist, party. [...]

As regards Comrade Lenin's general line, it appears to us unacceptable inasmuch as it proceeds from the assumption that the bourgeois-democratic revolution has been completed, and is aimed at the immediate transformation of this revolution into a socialist revolution. [...]

In a broad discussion we hope to carry our point of view as the only possible one for revolutionary Social-Democracy, since it wishes to be, and must remain to the very end, the one and only party of the revolutionary masses of the proletariat, and not turn into a group of communist propagandists. *8 April 1917*

NADEZHDA KRUPSKAYA
Bolshevik revolutionary and wife of Lenin; in Petrograd

Lenin's theses were printed in *Pravda*. The following day *Pravda* also published an article by Kamenev entitled 'Our Differences', in which he dissociated himself from the theses. [...]

The bourgeois and defencist newspapers started a furious campaign against

Lenin and the Bolsheviks. Kamenev's opinion meant nothing – everyone knew that within the Bolshevik organisation Lenin's point of view would prevail. Campaigning against Lenin was in fact the most effective way of popularising his theses. Lenin had called the war a predatory imperialist war, and everyone saw that he stood for peace in earnest. This stirred the sailors and soldiers, stirred all those for whom the war was an issue of life and death.

EXECUTIVE COMMITTEE OF THE SOVIET OF SOLDIERS' DEPUTIES
Resolution published in newspapers on 16 April 1917

Having discussed the dissemination of incitement propaganda veiled in a revolutionary, often even social-democratic flag, and in particular the propaganda of the so-called Leninists, and believing that this propaganda is no less harmful than any of the counter-revolutionary propaganda of the right, while at the same time acknowledging that it is impossible to take repressive measures against propaganda when it is nothing more than propaganda, the Executive Committee of the Soviet of Soldiers' Deputies therefore believes it essential to take all measures to counter this propaganda with our own propaganda and agitation.

NEW YORK TIMES
American newspaper; article titled 'Siberian Prisons give up 100,000'

Fifty thousand sledges, carrying victims of the old regime back to freedom in the new Russia from the mines and convict settlements of Siberia, are speeding in endless chain across the snows of Northern Asia toward the nearest points on the Trans-Siberian Railway. Their passengers range from members of the old Terrorist societies to exiles who were banished by administrative decree without trial, or even known offense [...] The cars were met by a vast crowd at the railroad station, which cheered them tumultuously. The exiles returned the cheers, but they were in a deplorable physical condition, shaggy, uncouth, unwashed, and extremely emaciated. Many were crippled with rheumatism, two had lost hands and feet from frost bites, and one, who attempted flight a week before the revolution, had been shot in the leg when he was captured. He was lying in a prison hospital when he learned that he was a free man. *22 March 1917*

VLADIMIR LENIN
Bolshevik leader; letter to Alexander Shlyapnikov in Petrograd

I attach receipts for our group's journey. I received a grant of 300 Swedish krona from the Russian consul in Haparanda (from the Tatyana Foundation). I paid an additional 472 roubles, 45 kopecks. I would like to receive this money, which I borrowed, from the Committee for Assistance of Exiles and Émigrés.* *5 April 1917*

VLADIMIR NABOKOV
Leading member of the Kadets, head of the Provisional Government's secretariat

I recall Kerensky saying [...] that he wanted to visit Lenin and talk with him, and in answer to some puzzled questions he explained: 'After all, he is living in complete isolation, knows nothing, sees everything through the spectacles of his fanaticism; he has nobody around him to give him the slightest help in understanding what is going on.' As far as I know, the visit did not take place. I do not know whether Lenin turned it down or whether Kerensky himself gave up on the idea.

MAURICE PALÉOLOGUE
French ambassador

When Milyukov assured me that Lenin had been hopelessly discredited in the eyes of the Soviet by the extravagance of his 'defeatism', he was once more the victim of an optimistic illusion. On the contrary, Lenin's influence seems to have

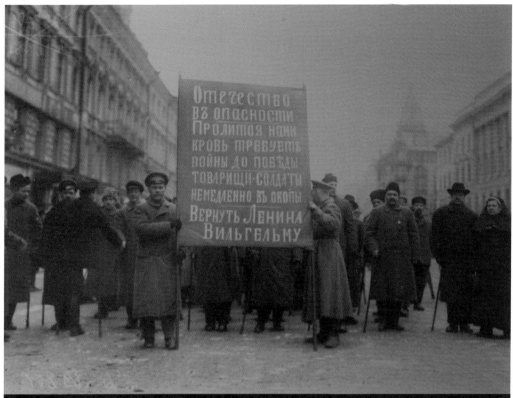

Pro-war demonstration on 29 April. The banner reads: 'The fatherland is in danger. The blood shed by us demands war until victory. Comrade soldiers to the trenches immediately. Send Lenin back to Wilhelm'

been increasing greatly in the last few days. One point of which there can be no doubt is that he has already gathered round him, or under his orders, all the hot-heads of the revolution; he is now established as a strong leader. *8 April 1917*

NIKOLAI SUKHANOV
Member of the Executive Committee of the Petrograd Soviet, writer and editor

First of all – there can be no doubt about it – Lenin is an extraordinary phenomenon, a man of absolutely exceptional intellectual power [...] He represents an unusually happy combination of theoretician and popular leader [...] The Bolshevik party was the work of his hands, and his alone. The very thought of going against Lenin was frightening

and odious, and required from the Bolshevik mass what it was incapable of giving [...] Without Lenin, there was nothing and no one in the party. *14 April 1917*

VLADIMIR LENIN
Bolshevik leader; from his speech 'On the present political situation' at the All-Russian Conference of the Russian Social Democratic Labour Party

In all countries, especially in the most advanced, Britain and Germany, hundreds of socialists who have not gone over to the side of 'their own' national bourgeoisie, have been thrown into prison by the capitalist governments. By this action the latter have clearly demonstrated their fear of the mounting proletarian revolution. In Germany the impending revolution is apparent both

in the mass strikes, which have assumed particularly large proportions in recent weeks, and in the growth of fraternisation between the German and Russian soldiers at the front.

Fraternal trust and unity are gradually being restored among the workers of different countries, the very workers who are now killing each other in the interests of the capitalists. This, in turn, will create conditions for united revolutionary action by the workers of different countries. Only such action can guarantee the most systematic development and the most likely success of the world socialist revolution. *3 May 1917*

ELENA LAKIER
Diarist, student at the Odessa Conservatoire

Today we laughed till we cried after buying *Life and Justice* and seeing that all four of our letters on the questionnaire about Lenin had been printed – with their false signatures, of course. For fun, I'll transcribe them here.

Here are the passionate words of the anti-Bolshevik: 'I am surprised that nobody has yet come forward to destroy this reptile sent to us by Wilhelm and nurtured by the secret police' (signed Benedikt Leshchinsky – Mama).

Ensign Ignatov writes no less passionately: 'I love free Russia from the bottom of my heart, and so I would feel moral satisfaction if I read that Lenin had been hanged from a lamp-post with the word "agent-provocateur" inscribed on his bald head' (signed Ensign Ignatov – that's me).

And here's the opinion of a number of women signatories: 'We are very sorry that dear Alexander Fyodorovich abolished the death penalty – otherwise Lenin should have been eradicated as harmful to the young revolution. He is either a Russian agent-provocateur or a German spy' (signed S. Sushchinskaya and 11 other invented names – this is Granny). *3 August 1917*

GERMAN AGENT
Cable from Stockholm to Berlin

Lenin's entry into Russia was successful. He is working exactly as we would wish. *4 April 1917*

Nikolaevsky Cavalry cadets;
demonstration in support of the war

6
APRIL CRISIS

"With blood pouring down my face I jumped back onto the pavement, but saw an officer running towards me, his sabre drawn."

EARLY REFORMERS

Russkie vedomosti, 'Russian Gazette', newspaper of Kadets; founded in 1863, closed down in March 1918 after publication of anti-Bolshevik article by Boris Savinkov; its last editor was sentenced to three months in prison.

Vechernee vremya, 'Evening Time', newspaper supportive of Provisional Government; ceased publication on 24 October 1917.

PROGRESSIVE REVOLUTIONARIES

All-Russian Soviet of Peasants' Deputies, Soviet of Peasants' Deputies, dominated by Socialist Revolutionaries; first congress met in May 1917; of 1,115 delegates, only nine were Bolsheviks.

Private Egorov (dates not known), soldier in 753rd Reserve Regiment.

Executive Committee of the Petrograd Soviet, leadership of the Soviet, established 28 February 1917 as rival power to Provisional Goverment (Kerensky served on both); initially fifteen members, of which two were Bolsheviks; by 25 September, when Trotsky was appointed chairman, twenty-five of its fifty members were Bolsheviks.

Izvestia, official newspaper of Petrograd Soviet, first published on 28 February 1917; reflected Menshevik and Socialist Revolutionary views until taken over by Bolsheviks after October Revolution.

Vasily Solovyov (1883–?), policeman from second Vyborg subdistrict, gave evidence to inquiry into events of 20–21 April 1917.

Irakly Tsereteli (1881–1959), leading Menshevik in Petrograd Soviet; moved to Georgia after October Revolution; represented Georgia at Paris Peace Conference in 1919; emigrated to France in 1922, then to USA in 1940; died in New York.

Vecherny kurer, 'Evening Courier', socialist newspaper published until 1918.

RADICAL REVOLUTIONARIES

Pravda, newspaper founded in 1903, taken over by Bolsheviks in 1912; edited by Stalin and Kamenev in 1917; after October Revolution became official organ of the Communist Party.

Russian Social Democratic Labour Party (Bolsheviks), Marxist party, first congress in 1898 attended by nine delegates; at second congress in 1903 party split into Menshevik and Bolshevik factions, the latter renaming it Russian Social Democratic Labour Party (Bolsheviks) in 1912; after 1918 it became the Communist Party.

OBSERVERS

Joshua Butler Wright (1877–1939), counsellor at American Embassy until February 1918; later envoy to Hungary, Uruguay and Czechoslovakia; died while serving as ambassador to Cuba.

Samuel Gompers (1850–1924), cigar maker, trade unionist, founder and president of American Federation of Labor; adviser on labour issues at Paris Peace Conference.

Razumnik Ivanov-Razumnik (1878–1946), writer and philosopher, leader of Scythians literary group with Andrei Bely; arrested several times in 1930s; interned by Germans outside Leningrad; after liberation lived in Lithuania and, later, in Munich until his death.

Vladimir Perazich (1868–1943), Serbian Marxist and revolutionary, author of *Textiles of Leningrad*, 1917.

Viktor Sereda (1877?–1920?), examining magistrate into events of 20–21 April; previously also investigator into murder of Rasputin.

Daily Telegraph, British newspaper founded in 1855.

Lev Urusov (1877–1933), Russian diplomat in Bulgaria and Japan; Russian tennis champion in 1908; member of International Olympic Committee from 1910; emigrated to France after February Revolution.

In the weeks immediately following the revolution, arguments over Russia's continued participation in the war become increasingly polarised between various elements of the Provisional Government and the Soviet. Constantinople is the symbolic vortex around which these arguments swirl back and forth. The 1915 Constantinople Agreement between the Allies has effectively promised Russia annexation rights to the Dardanelles in the event of victory. Linking the Black Sea to the Aegean, and thus giving Russia access to the Mediterranean, the Straits are seen by Foreign Minister Milyukov in particular as a crucial guarantee of Russian military security, but others in the Provisional Government are wary of seeming to perpetuate the imperial agenda of tsarist agreements.

With both army and public increasingly disillusioned with Russia's role in the war, the Soviet, too, faces a dilemma: whether to oppose the continued prosecution of this 'imperial' war or commit to it in order to shore up its wider revolutionary aims, what Lenin terms 'revolutionary defencism'. It agrees on a compromise: no separate peace and to continue the war, but to press for a general international peace on the basis of 'no annexations and indemnities'.

The Allies, struggling fully to understand the political tightrope the Provisional Government is walking, are unnerved by this seeming weakening of Russian resolve. The situation is so delicate, in fact, that towards the end of April a short note sent by Milyukov to Russia's ambassadors abroad threatens to bring this short-lived experiment in liberal-bourgeois democracy to an early end.

LEON TROTSKY
Revolutionary and Marxist theorist; from an article in *Novy Mir*, New York, titled 'War or Peace?'

By grace of a revolution that they did not want and which they fought against, Guchkov and Milyukov are today in power. They want the continuation of the war. They want victory. You bet they do! [...] 'The tsarist government is no more,' the Guchkovs and Milyukovs say. 'Now you must shed your blood for national interests.' *7 March 1917*

RUSSKIE VEDOMOSTI
'Russian Gazette', newspaper of the Kadets; editorial

The formation and strengthening of power should be the general goal of all our thoughts and all our efforts. In order to achieve this goal [...] we need to be united. We must remember that the revolution finds us at a decisive moment of a great world war. The enemy is at Russia's borders and while with one hand we rebuild our government administration, with the other we must continue to fight against the German hordes. Dissension between public authorities would now be ruinous for Russia. *2 March 1917*

PRIVATE EGOROV
Soldier in the 753rd Reserve Regiment; letter to the chairman of the Soviet of Workers' and Soldiers' Deputies

We have heard that you want war and want to support our dear allies England. Well, you can support them yourselves. Get into the trenches and fight. You are using our money to take out loans, but we are the ones who will pay. You're no sort of defenders for us. Down with the war, we want peace. Down with Milyukov. Our 753rd Regiment is now standing in reserve, but we won't go back down into the trenches any more. However, our comrades, regiments 754 and 755, need replacements, so why not send Milyukov, Guchkov, Brusilov, Kornilov, Gurko, Rodzyanko and the factory owners.

Pavel Milyukov

PAVEL MILYUKOV
Foreign minister

Inevitably I became an object of criticism for those who refused to take a realistic view of the war, or who were against it altogether. They called me 'Milyukov of the Dardanelles', an epithet of which I might justifiably have been proud, were it not for its undoubted exaggeration, the result of hostile propaganda brought about by a lack of understanding of the question.

KAZIMIR MALEVICH
Artist

At rallies it was dangerous to talk about the inviolability of the individual, about being free and not being used as a butcher of people [...] It was safer to speak in favour of loans and war. Minister Milyukov I liked least of all, although he was thinking of putting some heat on Constantinople (according to rumour the whole of the Party of People's Freedom was preparing to open a special front and start the conquest of the Dardanelles and Constantinople directly).*

PROVISIONAL GOVERNMENT

Declaration published in *Vestnik Vremennogo pravitelstva* newspaper

Citizens of the Russian State!

A great thing has happened. The old order has been overthrown by a mighty outburst by the Russian people. A new free Russia has been born. [...]

The government believes that the spirit of high patriotism evident in the struggle of the people against the old regime will also inspire our valiant soldiers on the field of battle. The government for its part will do everything in its power to ensure that our army is equipped with all that is necessary to bring the war to a victorious conclusion.

The government will preserve as sacred the alliances that bind us to other powers, and will unflinchingly implement agreements concluded with our allies.
7 March 1917

DAILY TELEGRAPH

British newspaper; report titled 'Russia's Task'

Revolutions, begun in an outburst of popular passion, very often end in despotism. The unloosening of a nation's energy gives tremendous opportunity for activities of all sorts, and among them especially the activities of extremists [...] But the sagacious men who form the new Government are in the best position to know how to deal with these and other factors of the situation. In this connection we desire to draw special attention to the Manifesto which has just been issued by the Provisional Government at Petrograd. This is a document in which M. Miliukoff's hand is clearly visible, mainly because it asseverates with such clearness the determination of our Ally to prosecute the war [...] It also undertakes to observe with absolute loyalty all the alliances with other Powers, and to help in the great struggle against Germany. *8 March 1917*

IZVESTIA

'Appeal to the Peoples of the World' by the Executive Committee of the Petrograd Soviet

Comrade-proletarians, and toilers of all countries:

We, Russian workers and soldiers, united in the Petrograd Soviet of Workers' and Soldiers' Deputies, send you warmest greetings and announce a great event. Russian democracy has shattered in the dust the age-long despotism of the tsar and enters your family of nations as an equal, and as a mighty force in the struggle for our common liberation. [...]

We appeal to our brother-proletarians of the Austro-German coalition, and, first of all, to the German proletariat. [...]

The Russian Revolution will not retreat before the bayonets of conquerors, and will not allow itself to be crushed by foreign military force. But we are calling to you: throw off the yoke of your semi-autocratic rule, as the Russian people have shaken off the tsar's autocracy [...] Toilers of all countries: we hold out to you the hand of brotherhood across the mountains of our brothers' corpses, across rivers of innocent blood and tears, over the smoking ruins of cities and villages, over the wreckage of the treasuries of civilisation; – we appeal to you for the re-establishment and strengthening of international unity. Herein lies the guarantee of our future victories and the complete liberation of humanity.

Proletarians of all countries, unite!
15 March 1917

MAURICE PALÉOLOGUE
French ambassador

There is a fresh manifesto from the Soviet, addressed this time 'to the peoples of the world'. It is a long rigmarole of emphatic statements, one long messianic dithyramb. *15 March 1917*

PAVEL MILYUKOV
Foreign minister; interview in *Rech* newspaper

Control over the straits means protection for 'the doors to our house', and clearly this protection should belong to us; making the straits neutral, particularly allowing free access of warships of all nations into the Black Sea, would be even worse for us than leaving them in the hands of the Turks. *23 March 1917*

VECHERNEE VREMYA
'Evening Time' newspaper; announcement by A.F. Kerensky

In response to the interview with Foreign Minister P.N. Milyukov, published in Petrograd newspapers on 23 March, Minister of Justice A.F. Kerensky has authorised the press office of the Ministry of Justice to announce that the foreign policy aims of Russia in the present war set out therein are the personal opinion of Mr Milyukov, and do not in any way represent the views of the Provisional Government. *25 March 1917*

JOSEPH STALIN
Leading Bolshevik; article in *Pravda* titled 'Either or'

If Kerensky is to be believed, Mr Milyukov is not expressing the view of the Provisional Government on the fundamental question of the aims of the war. In short, Minister of Foreign Affairs Milyukov, declaring the predatory aims of this war in front of the whole world, is not only contradicting the will of the Russian people, but also that of the Provisional Government of which he is a member. [...]

Or maybe Kerensky's words are not... wholly accurate? There are two possibilities: either Kerensky's statement is untrue, in which case the revolutionary people must call the Provisional Government to account and force it to admit its intentions.

Or Kerensky is right, in which case there is no place for Mr Milyukov in the government, and he must resign. There is no middle way. *26 March 1917*

PAVEL MILYUKOV
Foreign minister

Victory is Constantinople, and Constantinople is victory – for this reason it is necessary to remind the people about Constantinople constantly. *24 March 1917*

Alexander Kerensky

ALEXANDER KERENSKY
Minister of justice, member of the Petrograd Soviet

The obstinacy of Milyukov's in harping on the theme of the Dardanelles was very puzzling [...] As a historian, he must have been well acquainted with what General Kuropatkin had said as early as 1909 [...]: 'Not only would it be harmful for Russia to annex Constantinople and the Dardanelles, but such an annexation would inevitably give rise to the danger of a long-drawn-out armed struggle for the retention of this hazardous acquisition.'

PROVISIONAL GOVERNMENT
Declaration on the government's war aims

Citizens! It is the duty of the Provisional Government, having discussed the Russian State's military position, to directly and openly tell the people the entire truth. [...]

The recently deposed regime has left the defence of the country in severe crisis [...] Defending our inheritance and delivering the country from the enemy that has invaded our borders – this is the first and most vital task of our fighters, who are defending the people's freedom.

In keeping with the people's will, and in close communication with our allies regarding all issues, the Provisional Government by its rights and duty now declares that free Russia's aim is not domination over other nations, or seizure of their national property, or forcible occupation of foreign territories. Free Russia's aim is to establish a stable peace on the basis of national self-determination. The Russian people does not intend to increase its world power at other people's expense. *27 March 1917*

ALEXANDER KERENSKY
Minister of justice, member of the Petrograd Soviet

It is interesting to note that this text was entirely the work of the government except for the phrase 'or forcible occupation of foreign territories,' which was inserted at the insistence of the Soviet leaders.

PETROGRAD SOVIET
Response to the Provisional Government's declaration on war aims

On 27 March the Provisional Government published a declaration to Russia's citizens. It stated: 'Free Russia's aim is not domination over other nations, or seizure of their national property, or forcible occupation of foreign territories. Free Russia's aim is to establish a stable peace on the basis of national self-determination.' [...]

The Russian democracy considers this act by the Provisional Government extremely significant. It is an important step towards realising democratic principles in the sphere of foreign policy. The Soviets of Workers' and Soldiers' Deputies will support all the Provisional Government's steps in this direction with all their energy. *30 March 1917*

SIR GEORGE BUCHANAN
British ambassador

A battle royal is being fought between Kerensky and Miliukoff on the famous formula, 'Peace without annexations,' and as the majority of the ministers are on Kerensky's side, I should not be surprised if Miliukoff has to go. He would be a loss in many ways, as he represents the moderate element in the cabinet and he is quite sound on the subject of the war, but he has so little influence with his colleagues that one never knows whether he will be able to give effect to what he says. *17 April 1917*

LEV URUSOV
Diplomat and tennis champion

Something like a ministerial crisis is going on. The reason – disagreement over our war aims. On one side are Milyukov and, as far as one can tell, the sick Guchkov – who support taking the Dardanelles. On the other is Kerensky, who is against any kind of annexation. Yesterday evening's Council of Ministers did not resolve anything, but relations between Milyukov and Kerensky took a marked turn for the worse. It's thought that Milyukov's position is looking decidedly shaky and Plekhanov is already being named as his potential successor. *15 April 1917*

MAURICE PALÉOLOGUE
French ambassador; to Pavel Milyukov

You have ten million men under arms, [...] you are supported by eight allies, most of whom have suffered more than you but are as determined as ever to fight on until complete victory. A ninth ally is about to join you, an ally who is indeed an ally! America! This terrible war was originally a fight for a Slav cause. France rushed to your assistance without a moment's haggling over the price of her help. And you're to be the first to withdraw from the contest! *9 April 1917*

PAVEL MILYUKOV
Foreign minister; response to Paléologue

I'm so entirely in sympathy with your view that if the Soviet should get its way I should resign my office at once!

PRAVDA
Bolshevik newspaper; letter to the editor

Comrade Zinoviev!

A group of soldiers, workers and citizens of limited means ask you to respond to our question (through the newspaper *Pravda*): how and when will our Provisional Government and Soviets of Workers' and Soldiers' Deputies publish (make known) their war aims, how they plan to pursue the war?

Editor's response: the Provisional Government will never publish confidential agreements about the war and will not tell the truth about its war aims. This is because the aims of capitalists in all countries, including Russian capitalists, are larcenous. *12 April 1917*

PAVEL MILYUKOV
Foreign minister; secret note sent to Allied governments to accompany the Provisional Government's war aims published on 27 March. The note was leaked to the press on 20 April

Our enemies have been striving of late to sow discord among the Allies, disseminating absurd reports alleging that Russia is ready to conclude a separate peace with the Central Powers. [...]

The declaration [of 27 March] of the Provisional Government cannot, of course, afford the least excuse for the assumption that the revolution has entailed any slackening on the part of Russia in the common struggle of the Allies. Quite to the contrary, the aspiration of the entire nation to carry the world war to a decisive victory has grown more powerful [...] It is obvious, as stated in the communicated document, that the Provisional Government, while safeguarding the rights of our own country, will observe the obligations assumed towards our Allies in every way. *18 April 2017*

IRAKLY TSERETELI
Leading Menshevik in the Petrograd Soviet

Prince Lvov finally sent a statement to the Tauride Palace, addressed to me, saying that the note had been sent. [...]

To understand the impact this note had on us, you have to imagine the atmosphere of revolutionary Russia. In all our communications with socialist parties around the world, in our press, in our resolutions and speeches addressed to the population and to the army, we had constantly emphasised that the Provisional Government's declaration of 27 March would be the first act since the beginning of the world war that would show one of the warring nations rejecting the aims of imperialism.

Irakly Tsereteli

And now here was Milyukov's note proclaiming the slogan of the Provisional Government – the same slogan that had become so hateful to revolutionary democracy. And this note, which was nothing more than a polemic against the main policies of the Soviets, was presented as the answer to revolutionary democracy's demand.

What was even worse was that the note had already been sent to the Allies and its contents revealed to the press.

Chkheidze remained silent as he listened to the outraged protests of those present, and then, turning to me, he said in a quiet voice, revealing a long-held, deep conviction: 'Milyukov is the evil spirit of the revolution.' *19 April 1917*

RAZUMNIK IVANOV-RAZUMNIK
Writer and philosopher

What was bound to happen has happened: Milyukov, the minister of foreign affairs, has revealed his true nature. With the declaration of 27 March it remained hidden by his evasive rhetoric, but in his note to the Allied powers it is revealed in all its barefaced transparency, although again cunningly phrased. It reeks of former, pre-revolutionary, traditional, 'liberal-imperialist' times.

Such finely spun language! In fact, so finely spun that it comes apart. *20 April 1917*

NIKOLAI SUKHANOV
Member of the Executive Committee of the Petrograd Soviet, writer and editor

The new note completely annulled everything the revolution had accomplished on behalf of peace up to then. It assured the Allies that Russia's aims in the war remained as before, under the tsar, and that the revolution had changed nothing in them – just as the 27 March document had been published for domestic consumption [...] The left wing thought it an impudent and cynical mockery of the Soviet and the people. They felt that Milyukov ought to be liquidated within twenty-four hours. As for the right wing, it was rather confused; it was trying to calm us and make us believe that nothing special had happened.

MAURICE PALÉOLOGUE
French ambassador

There has been much excitement in the streets since early morning. Groups have gathered at all points to listen to impromptu speeches. At about two o'clock the character of the demonstrations became more serious. A collision between Milyukov's supporters and opponents took place in front of Our Lady of Kazan and the latter gained the day. Before long the regiments of the garrison emerged from their barracks and marched through the streets of the city, shouting: 'Down with Milyukov! Down with the war!' *20 April 1917*

NIKOLAI SUKHANOV
Member of the Executive Committee of the Petrograd Soviet, writer and editor

An immense crowd of workers, some of them armed, was moving towards Nevsky from the Vyborg side. There were also a lot of soldiers with them [...] Tremendous excitement reigned generally in the working-class districts, the factories and the barracks. Many factories were idle. Local meetings were taking place everywhere. All this on account of Milyukov's note, which had appeared that day in all the newspapers.

VASILY SOLOVYOV
Policeman from the second Vyborg subdistrict; evidence to the examining magistrate

They shouted out 'Leninists', 'Traitors', 'Provocateurs' etc. at us. We carried on ahead, threatening no one with our weapons and trying not to respond to the provocative behaviour of the crowd, which did not abate. When our front rank reached the corner of Nevsky and the Ekaterinsky Canal I saw another demonstration walking towards us by the Kazan Cathedral. They also had a red banner, which read 'Trust in the Provisional Government'. They, too, were made up of different people: officers, men in soldiers' greatcoats, volunteers and ordinary civilians and students. They ran towards us and started to tear at our banner [...] Some of them began to seize our weapons from us. At the same time the first shots rang out, I think from a revolver and from their

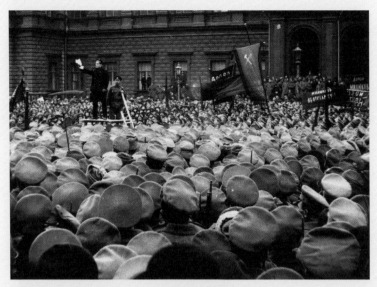

Revolutionary and soldier Fyodor Linde addressing the Finnish Regiment on 21 April 1917; the banner on the right reads 'Milyukov, resign!'

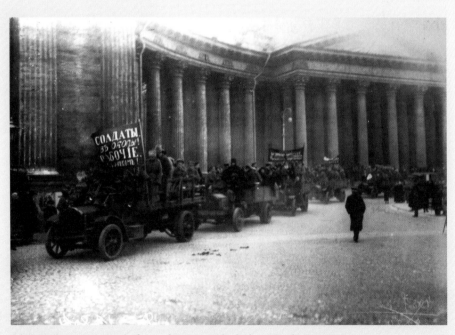

Pro-war demonstration in front of Kazan Cathedral on Nevsky Prospect; the banner reads: 'Soldiers, to the trenches! Workers, to the machines!'

side; that is, from the group demonstrating for the government. I saw that some of our number fell to the ground; whether they were wounded I cannot say. [...]

At this point a volunteer holding a rifle jumped up in front of me and struck me on the head with his butt, wounding me (*the witness pointed to a scar, still not completely healed, 2 cm long and 1 cm wide, on the left side of the hairy part of his head, between the frontal and parietal bones*). At the same time a civilian jumped at me and grabbed me around the chest, and they both took my rifle and revolver. With blood pouring down my face I jumped back onto the pavement, but saw an officer with sabre drawn running towards me.

I was pushed into the first doorway and could no longer see what was happening on the street, but soon a worker was brought into the same doorway with his head cut open, from which I concluded that he might have been slashed by the sabre of the officer I had seen.

VLADIMIR PERAZICH
Marxist, author of *Textiles of Leningrad*, 1917

On 21 April female workers were walking in demonstration down the odd-numbered side of Nevsky Prospect. Another crowd was moving in parallel down the even-numbered side – elegant ladies, officers, businessmen, lawyers and so forth. Their slogans were 'Long live the Provisional Government!', 'Long live Milyukov!', 'Put Lenin under arrest!' At Sadovaya Street there was a confrontation. A storm of insults rained down on our workers: 'Whores! Illiterate filth! Dirty scum!' Romanova did not hold back: 'The hats you are wearing were made from our blood!' A fight ensued. The woman carrying the factory banner was knocked off her feet and the flag ripped to shreds [...] In response our workers began to tear the fashionable hats off the bourgeois ladies and scratch their faces.

LOUIS DE ROBIEN
Attaché at the French Embassy

The state of anarchy is confirmed and extends further and further every day. Petrograd is no longer the only focus: it's the same everywhere, in Moscow, in Kiev, and confusion and disorder reign. The two influences of the government and of the committee cancel each other out, and the result of this double authority is chaos and anarchy. Everyone does as he pleases, and from now on it is useless to count on any concerted effort from Russia. *23 April 1917*

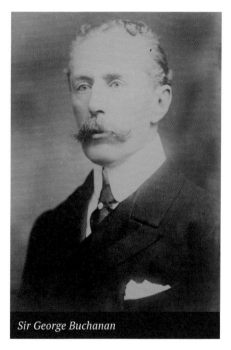

Sir George Buchanan

SIR GEORGE BUCHANAN
British ambassador

Thursday was a very critical day. In the afternoon a number of regiments marched to the space in front of the Palais Marie, where the Council of Ministers sits, and joined the crowd that had already assembled there to demonstrate against the Government.* Cries of 'Down with the Government', 'Down with Miliukoff', were raised, but eventually the troops were persuaded to return to their barracks. Later in the evening there were

counter-demonstrations directed chiefly against Lenin and his adherents, and after several Ministers had addressed the crowd from the balcony of the palace the tide turned in their favour [...] A collision took place on the Nevski between a pro-Lenin and an anti-Lenin crowd, in which several persons were killed and wounded. Between 9 and 10.30 p.m. I had to go out three times on the balcony of the Embassy to receive ovations and to address crowds who were demonstrating for the Government and the Allies. During one of them a free fight took place between the supporters of the Government and the Leninites. *20 April 1917*

SAMUEL GOMPERS
President of the American Federation of Labor; cable to the Executive Committee of the Petrograd Soviet

In view of the grave crisis through which the Russian people are passing, we assure you that you can rely absolutely upon the whole-hearted support and cooperation of the American people in the great war against our common enemy, Kaiserism. In the fulfilment of that cause, the present American Government has the support of 90 per cent of the American people, including the working classes of both the cities and agricultural sections [...] America's workers share the view of the Council of Workmen's and Soldiers' Delegates that the only way in which the German people can bring the war to an early end is by imitating the glorious example of the Russian people, compelling the abdication of the Hohenzollerns and the Hapsburgs and driving the tyrannous nobility, bureaucracy, and the military caste from power. *24 April 1917*

EXECUTIVE COMMITTEE OF THE PETROGRAD SOVIET
Appeal to the citizens of Petrograd

Citizens: at the moment when the fate of the country is being decided, every hasty step threatens us with danger. Demonstrations arising from the note

of the government regarding foreign policy have resulted in clashes on the streets. There are wounded and killed. In order to save the revolution from the chaos that threatens to engulf it, we are making a passionate appeal to you: maintain peace, order and discipline. *21 April 1917*

RUSSIAN SOCIAL DEMOCRATIC LABOUR PARTY (BOLSHEVIKS)
Resolution of the Central Committee

The political crisis that developed between April 19 and 21 must be regarded, at least in its initial stage, as having passed. [...]

The slogan 'Down with the Provisional Government!' is an incorrect one at the present moment because, in the absence of a solid (i.e. a class-conscious and organised) majority of the people on the side of the revolutionary proletariat, such a slogan is either an empty phrase, or, objectively, amounts to attempts of an adventurist character. [...]

The resolution of the Petrograd Soviet of 21 April banning all street meetings and demonstrations for two days must be unconditionally obeyed by every member of our Party. *22 April 1917*

VIKTOR SEREDA
Examining magistrate; report on the events of 20–21 April

The groups of factory workers that participated in the street demonstrations in the day and in the evening of 21 April had undoubtedly been organised in advance: their numerous banners and placards (some with printed inscriptions or occasionally artistic drawings) were prepared beforehand. [...]

By contrast, the demonstrations in favour of the Provisional Government, and, in particular, the group of these demonstrators that clashed during the day near the Kazan Cathedral with the workmen of the Vyborg district, were not organised in advance, but formed spontaneously. [...]

The workers demonstrating against the Provisional Government were amply equipped with firearms, and are to be held responsible for the firing in the area of Nevsky Prospect and Sadovaya Street during the afternoon and evening of 21 April; in mitigation, during both afternoon and evening clashes, a few individual soldiers and members of the public, indignant at the inscriptions on some of the placards of the demonstrating workmen, attempted to remove them and destroy them.

VECHERNY KURER
'Evening Courier', socialist newspaper; article titled 'Peace in Petrograd'

The conflict between the Provisional Government and the Soviet of Workers' and Soldiers' Deputies can now be said to be fully resolved. [...]

This morning complete calm reigns on the streets of Petrograd. Work is going on as normal in all the factories and plants. There are neither meetings nor demonstrations.

Full agreement has been reached between the Provisional Government and the Soviet of Workers' and Soldiers' Deputies on matters of foreign policy and, in particular, on the war aims. The Provisional Government has once more confirmed its complete readiness to co-ordinate its actions with the resolutions of the Soviet of Workers' and Soldiers' Deputies. *22 April 1917*

ALEXANDER GUCHKOV
Minister of war

Milyukov and Shingaryov went to the front. While they were gone, a Provisional Government meeting was unexpectedly called late one evening in Prince Lvov's apartment. Kerensky and Tereshchenko took it upon themselves to launch a sharp attack on the point about the Straits and on Milyukov's entire role in the Provisional Government.* I was the only one to stand up for him.

The rest were silent or criticised Milyukov and his policy and the question of the Straits was given no support.

It was suggested that we should remove Milyukov. He does, however, head a large group in society. You can't just throw him out. It was said that Milyukov could be given the Ministry of Education, but everyone supported the decision to remove him from the Ministry of Foreign Affairs. I saw that the Provisional Government was descending into demagoguery, and I concluded definitively that the only way out was finally to break the great compromise and go into battle, if necessary taking harsh measures. I then returned home and wrote Lvov a letter.

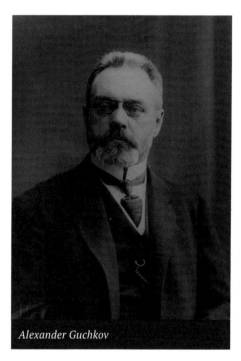
Alexander Guchkov

ALEXANDER GUCHKOV
Minister of war; letter of resignation to Prime Minister Lvov

In view of the condition in which the power of the government is now placed, and particularly the authority of the minister of war and navy over the army and fleet, conditions which I am powerless to alter and which threaten the defence, freedom, and even the existence of Russia with fatal consequences, I can no longer conscientiously continue my duties as minister of war and navy and shoulder responsibility for the grievous sin being committed against

the motherland. I therefore request the Provisional Government to release me from these duties. *1 May 1917*

IRAKLY TSERETELI
Leading Menshevik in the Petrograd Soviet

Guchkov's resignation was a sensational one. Sensational not in itself, but in the manner in which it occurred: without issuing any warning to the government, without engaging in any preliminary discussions of the matter with his ministerial colleagues, the minister of war quit his post even as the war raged on, declaring that the government lacked the capacity to fulfil its functions and that he, the minister of war, could 'no longer shoulder responsibility for the grievous sin being committed against the motherland'. This act signified an emphatic break between Guchkov and the bourgeois rightists ranged behind him, and the Provisional Government.

PRINCE GEORGY LVOV
Prime minister; conversation with Kerensky

In the view of all the commanders-in-chief, you are the only possible candidate. [...] They know that we need a man of your stature who enjoys the confidence of the country and army as you do. It is your duty to accept the post, and you must not refuse.

ALEXANDER KERENSKY
Minister of justice

I was reaching for the telephone to refuse the nomination when I was struck with the sudden realisation of what would happen to my work, to the government and to Russia if the 'truce' were allowed to drag on. In two or three months the Russian front would disintegrate completely. [...]

This had to be prevented at all cost! No one in Russia was going to conclude a separate peace with Germany [...] Hindenburg's plan had to be foiled, and for that purpose military operations must be resumed on the Russian front.

After several hours of agonising inner struggle I finally realised that there was no alternative for the government, the supreme command or myself, and I telephoned Lvov that I would accept the post.

JOSHUA BUTLER WRIGHT
Counsellor at the American Embassy

The situation changes so quickly that it is almost impossible to keep pace with it. Today we learn that the minister of foreign affairs has resigned – that a general shift in the cabinet has taken place and that Brusilov and two other generals have also resigned. The brightest spot is that the Soviet of Soldiers' and Workmen's Deputies, apparently realising that they have forced the country into an utterly untenable position in the eyes of its allies, has issued a most vigorous statement reconsidering its decision not to form a coalition government and combat the enemy. It may – by the extraordinary psychology of races and nations – clarify the situation. If an offensive can only be waged the whole sentiment would improve. Anti-British feelings run high. *2 May 1917*

PROVISIONAL GOVERNMENT
Declaration calling for the support of the nation's vital forces

Before Russia rises the terrible apparition of civil war and anarchy, bringing destruction to freedom. There is a sombre and grievous course of peoples, a course well known in history, leading from freedom through civil war and anarchy to reaction and the return of despotism. This course must not be the course of the Russian people. [...]

Let everyone who values the freedom of Russia support the state power by obedience and cooperation, by setting an example and by conviction, by participating personally in the common work and the sacrifices, and by appealing to others for the same. The government, for its part, will be particularly persistent in renewing its efforts to draw into responsible

government representatives of those active creative forces of the country who have not previously taken direct [...] part in the government of the state. *26 April 1917*

ALEXANDER KERENSKY
Minister of justice, member of the Petrograd Soviet; declaration sent to the Petrograd Soviet

Comrades! [...] I now regard the situation as radically changed. On the one hand, the general state of affairs in the country is becoming increasingly more complicated. On the other hand, the strength of the organised toiling democracy has also increased. And perhaps it can no longer stand aside from responsible participation in ruling the state. This participation would bring new strength to the order born of revolution, and the necessary authority to consolidate all the vital forces of the country in order to surmount the barriers that prevent Russia from entering upon a broad path of historic development. *26 April 1917*

PRINCE GEORGY LVOV
Prime minister; letter to Nikolai Chkheidze, chairman of the Petrograd Soviet

Dear Nikolai Semyonovich,
 In the statement published by the Provisional Government on 26 April, it is pointed out, among other things, that the Government will renew its efforts to widen its circle by asking for the participation in the responsible work of government of those actively creative elements of the country who until now have had no direct role in the government of the state.
 In view of this statement, I ask you, in the name of the Provisional Government, to be good enough to bring this matter to the attention of the Executive Committee of the parties represented in the Soviet of Workers' and Soldiers' Deputies, of which you are president. *27 April 1917*

IRAKLY TSERETELI
Leading Menshevik in the Petrograd Soviet, minister of post and telegraph

When I was heading for the exit, one worker approached from the group of workers and soldiers who were bidding me farewell with shouts of approval, and said: 'Comrade Tsereteli, rest assured. The Bolsheviks have only a small clique behind them. We, the workers, are uneducated but we can sense when we're being told the truth. Join the new government. We will stand behind you with the whole nation, with the whole of democracy. It is difficult for us, but demagoguery and empty promises will not deceive us. We must work together, without anarchy, maintaining order. That's what our workers in the factories think.' *2 May 1917*

VLADIMIR LENIN
Bolshevik leader; article in *Pravda*

The 'conciliation' machine is working at full speed [...] The government of the capitalists will have a few petty-bourgeois ministers tacked on to it in the shape of Narodniks and Mensheviks who have allowed themselves to be lured to the support of the imperialist war. We shall have more phrase-mongering, more fireworks, more lavish promises and bombast about 'peace without annexations' – but no desire whatsoever to even enumerate frankly, precisely and truthfully the actual annexations effected, say, by three countries: Germany, Russia and England. How long, gentlemen of the old and the new cabinets, can one deceive oneself with the utopia that the peasants will support the capitalists (the well-to-do peasants are not the whole of the peasantry), with the utopia of an 'offensive' at the front (in the name of 'peace without annexations')? *5 May 1917*

Первое коалиціонное министерство съ участіемъ соціалистовъ.

First Coalition Ministry involving socialists

1 Alexander Kerensky, minister of war
2 Prince Georgy Lvov, prime minister and minister of the interior
3 Andrei Shingaryov, minister of finance
4 Alexander Konovalov, minister of trade and industry
5 Irakly Tsereteli, minister of post and telegraph
6 Vladimir Lvov, chief procurator of the Holy Synod
7 Alexander Manuilov, minister of national education
8 Alexei Peshekhonov, minister of food supply
9 Viktor Chernov, minister of agriculture
10 Mikhail Skobelev, minister of labour
11 Ivan Godnev, state controller
12 Pavel Pereverzev, minister of justice
13 Nikolai Nekrasov, minister of transport
14 Mikhail Tereshchenko, minister of foreign affairs
15 Prince Dmitry Shakhovskoi, minister of state aid

ALL-RUSSIAN SOVIET OF PEASANTS' DEPUTIES
Resolution on the Provisional Government

The country is in danger. The defence and expansion of the gains made by the revolution call for vigorous measures. One of the conditions for the consolidation of freedom is a stable government that commands the confidence of the working people.

Therefore, fully aware of the responsibility which the present situation imposes upon it, the All-Russian Soviet of Peasants' Deputies believes that the entrance of socialists into the Provisional Government on the basis of the guarantees given by the latter to the country in the declaration of 5 May is entirely correct and necessary. It appeals to the country to have implicit confidence in and render full support to the reorganised Provisional Government, bearing in mind that only with this support and the participation of all the working people can it, while enjoying full power, consolidate the freedom gained and assure the further success of the revolution. *8 May 1917*

Nikolai Sukhanov

NIKOLAI SUKHANOV
Member of the Executive Committee of the Petrograd Soviet, writer and editor

By 2 o'clock in the morning of 5 May everything was ready. The portfolios had been quickly assigned, and all the doubtful points settled in this way: Kerensky got the War Ministry and the Admiralty, Pereverzev the Ministry of Justice, Peshekhonov Supply, Skobelev Labour, Tsereteli Posts and Telegraphs. The coalition had been created. The formal union of the Soviet petty-bourgeois majority with the big bourgeoisie had been ratified in a written constitution.

LOUIS DE ROBIEN
Attaché at the French Embassy

A government has been formed... young Tereschenko is minister of foreign affairs [...] The only public position he has ever occupied is that of attaché to the imperial theatres; it was to him that one telephoned via the messenger boy when one wanted a box for the ballet. In charge of agriculture there is a citizen who is in favour of the confiscation of all private estates for the benefit of the state. At the War Ministry there is Kerensky, who has declared in his proclamation that he is going to re-establish iron discipline in the army, [...] whereas a little further on he admits that he himself has never submitted to any discipline. *6 May 1917*

VLADIMIR NABOKOV
Leading member of the Kadets

The socialists realised that another rejection could be used as a powerful weapon against them and would put them in the position of 'irresponsible critics' and 'watchdogs', an extremely difficult role. They entered the cabinet. One could say, in point of fact, that from that moment the days of the Provisional Government, which had been put in power by the 'victorious revolution', were numbered.

Alexander Kerensky

7
WAR

"The offensive movement proved abortive.
The Germans reoccupied, without opposition,
all the ground and trenches we had won at
such high cost."

EARLY REFORMERS

Maria Bochkaryova (1889–1920), founder of Women's Battalion of Death; arrested after October Revolution; allowed to leave Russia in April 1918, met Woodrow Wilson and George V on trips to USA and UK, returned to Russia in August 1918 to fight for Whites; arrested by Bolsheviks in 1919 and executed the following year.

General Anton Denikin (1872–1947), commander, Western front, dismissed for support of Kornilov rebellion; later general in White Volunteer Army; emigrated to Paris in 1920 and then to USA in 1945.

General Vladimir Dzhunkovsky (1865–1938), commander of 3rd Siberian Army Corps; arrested in 1918, released in 1921; believed to have advised Dzerzhinsky on security matters for new secret service OGPU; arrested in 1937, executed in 1938.

Yakov Kalnitsky (1895–1949), Ukrainian writer; fought in Red Army during civil war; arrested in 1938, released in 1941; died after choking on his pipe.

Vasily Kravkov (1859–1920), army doctor and diarist; worked for Bolshevik government after October Revolution; convicted of falsifying exemptions from conscription and executed.

Sergei Markov (1878–1918), chief of staff on Western and South-Western fronts; arrested for supporting Kornilov rebellion; fought for White Army; died in battle near Stavropol.

Colonel Vasily Pronin (1882–1965), founder member of Union of Officers of Army and Fleet, participated in Kornilov rebellion; active in White Army; settled in Belgrade where he edited émigré newspapers; emigrated to Brazil in 1950.

Rech, 'Speech', newspaper of the Kadets; editorials in 1917 often written by Pavel Milyukov; shut down by Bolsheviks the day after October Revolution.

Boris Savinkov (1879–1925), writer and terrorist, Socialist Revolutionary; involved in murder of interior minister von Plehve and Grand Duke Sergei Alexandrovich; deputy war minister under Kerensky, formed anti-Bolshevik 'Union for Defence of Motherland and Freedom'; emigrated to Poland; lured back to USSR by Soviet agents; died after jumping or being pushed from window of Lubyanka.

Svobodny narod, 'Free People', newspaper of the Kadets, conceived as more accessible, cheaper alternative to Rech.

PROGRESSIVE REVOLUTIONARIES

Ekaterina Breshko-Breshkovskaya (1844–1934), leading Socialist Revolutionary, exiled to Siberia from 1878 to 1896 and again from 1907 to 1917; strongly supported Provisional Government, opposed Bolsheviks; fled to USA after October Revolution; settled in Czechoslovakia.

Yosif Dashevsky (1891–1937), Socialist Revolutionary, chairman of Executive Committee, South-Western front; sentenced to three years for anti-Bolshevik activities in 1921; rearrested in 1937 and shot.

Valentin Malakhovsky (1894–1971), member of his regiment's Soldiers' Committee; fought in First World War, civil war and Second World War; military commissar of Latvian Soviet Republic from 1944, where he remained until his death.

RADICAL REVOLUTIONARIES

Flavian Khaustov (dates not known), lieutenant in Novoladozhsky Regiment, founding editor of Bolshevik newspaper *Trench Pravda*; after October Revolution worked on various Soviet military newspapers.

OBSERVERS

Robert Bruce Lockhart (1887–1970), unofficial British envoy to Russia after October Revolution; accused of plot to assassinate Lenin in 1918, released in exchange for Maxim Litvinov, sentenced to death in absentia; later career as journalist and writer; member of Morozov football team, winners of Moscow league in 1912.

Vladimir Chertkov (1854–1936), Tolstoy's editor and publisher, lived in exile in England 1897–1908; editor-in-chief of Tolstoy's 90-volume complete works.

Florence Farmborough (1887–1978), English nurse serving with Russian army on Romanian front, which she recorded in diaries and photographs; later worked as newsreader for Franco's National Radio during Spanish Civil War.

General Max Hoffmann (1869–1927), German chief of staff on Eastern front; senior German representative at Brest-Litovsk.

Alfred Knox (1870–1964), British military attaché in Petrograd, liaison officer on Western front; attached to White Army under Admiral Kolchak in 1919; Conservative Member of Parliament 1924–45.

Nikita Okunev (1864?–?), diarist, employee of the Samolyot Shipping Line, author of *Diary of a Muscovite, 1917–1920*.

Anna Stravinskaya (1854–1939), pianist, wife of Fyodor Stravinsky, leading bass at Mariinsky Theatre in St Petersburg, mother of composer Igor Stravinsky; left Russia in 1922 to join her son in France.

Alexandra Tolstaya (1884–1979), youngest of Leo Tolstoy's thirteen children, nurse on North-Western front; arrested in 1920, released to work as head of museum at Yasnaya Polyana; emigrated in 1929, settled in USA, established Tolstoy Foundation to assist Russian refugees.

Kerensky, now minister of war, sees himself as the great galvaniser, his aim being to reinvigorate Russia's fighting capacity and launch a new offensive against the Austro-German forces in June. The battleworn generals, struggling to command their increasingly truculent troops, refer to him sardonically as the 'persuader-in-chief', as Kerensky tours the front exhorting the soldiers to one more decisive effort. Enthusiasm generated by the minister's rousing rhetoric quickly dissipates. The government's position is further weakened by their coalition partners from the Petrograd Soviet, who urge the army to continue whilst condemning the war as 'imperialist'.

For soldiers at the front, news from the capital is unsettling and exciting: why risk their lives in a campaign of confused allegiances when back home a new, freer life is beginning? The pressure from Russia's allies continues. In early June Emmeline Pankhurst arrives in Petrograd 'with a prayer from the English nation to the Russian nation that you may continue the war on which depends the fate of civilisation and freedom'. At the same time Kerensky, encouraged by General Kornilov in particular, is considering measures to tackle the growing insubordination in the ranks by curtailing some of the freedoms the Russian troops have only recently acquired.

SOLDIER OF THE 21ST MUROMSKY INFANTRY REGIMENT
Letter home from the Western front

The Germans are all cleanly dressed, while our soldiers have no shoes or clothes and are hungry. On 18 April we hoisted a white flag and a red flag, the red one saying in large letters: 'The interests of the fighting men of all nations' [...] The Germans started to shout: 'Mister, come out into the middle...' They began walking towards us, we came together, started to exchange a few words, and they said, 'Rus, there's no need to shoot, we need peace.' And our side replied: 'Absolutely right, we need peace' [...] They gave us a pack of cigarettes, and then our officers weren't pleased about this, and they told the artillery to start firing to disperse us. Well, we still got together again with the Germans and soon began to get friendly: now they come to our trenches and we go to theirs; and for about a month now not a single shot has been fired. They just shout, 'Rus, don't shoot...' and they throw leaflets over at us which say, 'if you shoot, then I'll shoot back with interest, and then who do you think's going to suffer – the whole infantry, yours and ours.' *18 April 1917*

FLAVIAN KHAUSTOV
Lieutenant in the Novoladozhsky Regiment; a founding editor of the Bolshevik newspaper *Trench Pravda*

From the very first the Bolshevik committee of the 436th Novoladozhsky Regiment established links with the Central and Petersburg committees of the Bolsheviks through Comrade A. Vasiliev, and received literature and leadership from there [...] At the beginning of March the committee, against the orders of the commander of the Northern front, organised fraternisation with the Germans over an area of no less than 25 miles. At this time I was chairman of the corps' Bolshevik committee. The fraternisation took place in an orderly way... The result of the fraternisation was effectively the end of military action on the territory of the corps.

RUSSKIE VEDOMOSTI
'Russian Gazette', newspaper of the Kadets; editorial titled 'On the need for an offensive'

From a military point of view, there can be only one opinion in this case. We must undertake an offensive, and only in that way can we bring the end of the war closer, only in that way can we guarantee a peace that is quick and, at the same time, without shame. We may be waging a defensive war, but the defensive aims of the war do not preclude the possibility of a strategic offensive [...] One cannot defend oneself standing in one spot. In order to defend oneself, one has to move and move forward, not backward. The principles of the [Socialist] International and of the universal peace are all well and good, but they cannot stand up against German cannons. *30 April 1917*

YAKOV KALNITSKY
Corporal in the reconnaissance unit, 138th Volkhovsky Infantry Regiment

By day we would watch through binoculars, or in clear weather with the naked eye, as grey-blue and grey-green forage caps emerged between the two opposing lines, walking arm-in-arm, gathering in groups, stepping into each other's trenches... Sometimes a camera would appear from the other side, and our soldiers would huddle around it trying to get their images preserved on paper. Usually the strolling between the trenches would stop when a couple of artillery shells went off, shrapnel exploding high in the sky. Then the soldiers from both sides would run quickly into the nearest trench, and almost always our soldiers would end up in the Austrian trenches and the Austrians in ours. When the panic subsided the soldiers would bid each other a friendly farewell and return to their trenches. After such fraternisation our soldiers might have chocolate, Austrian coffee mixed with sugar, rum, biscuits and, sometimes, heavy yellow boots or grey puttees. Occasionally photographs would appear of Russian and Austrian soldiers together.

In the Austrian trenches, meanwhile, they would be enjoying Russian black bread and strong sugar, and trying on tall Russian sheepskin hats. [...]

Did the Austro-Germans really not want war with us, or was it all a deception – we couldn't tell. The most contradictory signals confused and misled us. On the one hand a local offensive by the Austrians would start suddenly, while on the other we all remember an occasion when the Austrians threw a bottle into our trenches with a message warning us that our front line would be bombarded at dawn. We passed this on to the command and the first battalion was withdrawn to the second line, and then at 5 o'clock that morning the Golden Mount and the first line of trenches really did get blown up. It was only thanks to the warning that our first battalion was saved from likely slaughter.

All the same it was impossible to be certain. The usual artillery fire went on from both sides. Heavy mines would explode in our trenches, while all sorts of hand and rifle grenades would fly through the air as before, straight into our lookout posts and trenches, killing and maiming people. And no sooner had the wounded and dead been gathered up than the Austrians would come visiting and the fraternisation would begin again. In response to mutual recriminations both sides would reply, 'But why were yours first?!'

VLADIMIR LENIN
Bolshevik leader

This is the sum and substance of the new government's 'programme'. An offensive, an offensive, an offensive! [...]

Minister Lvov in tones of deepest moral indignation fulminates against the 'virtual armistice that has been established at the front'! [...]

What is wrong with a virtual armistice? What is wrong with having the slaughter stopped? What is wrong with the soldiers getting at least a brief respite? [...]

Fraternisation on one front can and should lead to fraternisation on all fronts. A virtual armistice on one front can and should lead to a virtual armistice on all fronts. [...]

The Russian people have two programmes to choose from. One is the programme of the capitalists [...] This is the programme of offensive, the programme for dragging out the imperialist war, dragging out the carnage.

The other programme is that of the world's revolutionary workers, advocated in Russia by our party. This programme says: stimulate fraternisation (but do not permit the Germans to deceive the Russians); fraternise by means of proclamations; extend fraternisation and a virtual armistice to all fronts; help to spread these in every possible way, thereby hastening the proletarian revolution in all the countries, giving at least a temporary respite to the soldiers of all the belligerent countries; hasten in Russia the transfer of power to the Soviets of Workers', Soldiers' and Peasants' Deputies, and thereby hasten the conclusion of a truly just, truly universal peace in the interests of the working people, and not in the interests of the capitalists. *9 May 1917*

SVOBODNY NAROD
'Free People', newspaper of the Kadets

When the Bolshevik-Leninists say that there should be no regular armies and that a law should be introduced abolishing them, they are not transgressing legal freedoms. But when these same Leninists [...] say to the soldiers: do not obey your officers, fraternise with the Germans even if your commanding officers forbid it, do not acknowledge your appointed superiors but choose your own; when the Leninists say all this, they are committing a grave crime and should be brought to justice. *3 June 1917*

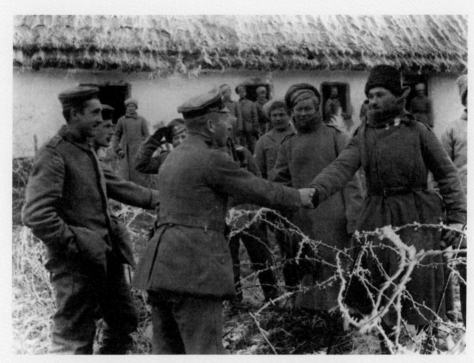

Austro-German and Russian soldiers greeting each other in Spring 1917

ALFRED KNOX
Military attaché at the British Embassy

The German propaganda department soon changed its line of attack. A proclamation distributed on the Western front stated:

'Comrades! In December last year the German emperor offered you peace. This offer was made voluntarily, without any compulsion, solely for the love of peace and in the interests of suffering humanity. It was refused by your tsar. Now you have chosen your own government. And you imagine that our emperor could help your overturned tsar to seize the throne once more! What madness is this! None of us dreams of interfering in Russian internal affairs [...] Germany is ready to make peace, though peace is not necessary for her. She will wait patiently to see if the new and free Russia will start peace negotiations with us in the holy holidays of Christ's resurrection.'

ALEXANDRA TOLSTAYA
Daughter of Leo Tolstoy, nurse on the North-Western front

The entire front was awash with the most desperate propaganda. There were endless meetings. This propaganda, of course, had its desired effect. Which was hardly surprising: the soldiers had spent months in the trenches, hungry and exhausted, and then along came someone saying, 'Go home, the land will be yours, the factories will be yours. A new life is beginning.'

NIKOLAI SUKHANOV
Member of the Executive Committee of the Petrograd Soviet, writer and editor

On 14 May Kerensky published an order to the army concerning an offensive [...] 'In the name of the salvation of free Russia, you will go where your commanders and your government send you. On your bayonet-points you will be bearing peace, truth and justice. You will go forward in serried ranks, kept firm by the discipline of your duty and your supreme love for the revolution and your country.' The proclamation was written with verve and breathed sincere 'heroic' emotion. Kerensky undoubtedly felt himself to be a hero of 1793. And he was of course equal to the heroes of the great French Revolution – but not of the Russian. *14 May 1917*

ROBERT BRUCE LOCKHART
Diplomat, journalist and secret agent

How well I remember his first visit to Moscow. It was, I think, soon after he had been made minister of war. He had just returned from a visit to the front. He spoke in the Big Theatre, [...] the first politician to speak from that famous stage [...] On this occasion the huge amphitheatre was packed from top to bottom.* In Moscow the embers of Russian patriotism were still warm, and Kerensky had come to stir them into flame again. Generals, high officials, bankers, great industrialists, merchants, accompanied by their wives, occupied the parterre and first balcony boxes [...] The audience rose to him. Kerensky held up his hand and plunged straight into his speech. He looked ill and tired. He drew himself up to his full height, as if calling up his last reserves of energy. Then, with an ever-increasing flow of words, he began to expound his gospel of suffering. Nothing that was worth having could be achieved without suffering. Man himself was born into this world in suffering. The greatest of all revolutions in history had begun on the Cross of Calvary. [...]

As he finished his peroration, he sank back exhausted into the arms of his aide-de-camp. In the limelight his face had the pallor of death. Soldiers assisted him off the stage, while in a frenzy of hysteria the whole audience rose and cheered itself hoarse. The man with one kidney – the man who had only six weeks to live – would save Russia yet. A millionaire's wife threw her pearl necklace on to the stage. Every woman present followed her example, and a hail of jewellery descended from every tier of the huge house. In the box next

to me, General Wogak, a man who had served the tsar all his life and who hated the revolution as the pest, wept like a child. It was an epic performance [...] The speech had lasted for two hours. Its effect on Moscow and on the rest of Russia lasted exactly two days.

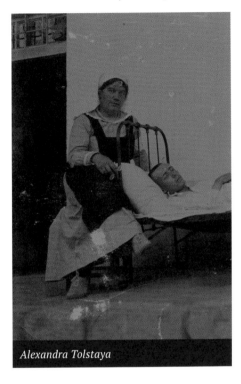

Alexandra Tolstaya

ALEXANDRA TOLSTAYA
Daughter of Leo Tolstoy, nurse on the North-Western front

Conventions and formalities between officers and their subordinates have disappeared. [The soldier] was crying, rubbing the tears from his face with his dirty fist, like a child.

'So where's the truth? The medic in the bandaging room says: "That's enough fighting the Germans, beat it, lads, go and fight the bourgeois in the rear, take the land from the landowners, the factories from the factory owners." But our platoon leader says: "You rabble, you're all cowards, handing over the motherland to the Germans. The soldier's duty to Russia is to stand firm until victory." So where's the truth?'

PETROGRAD SOVIET
'To the Socialists of all Countries'

Comrades: the Russian Revolution was born in the fire of the world war. This war is a monstrous crime on the part of the imperialists of all the countries, who, by their lust for annexations, by their mad race of armaments, have prepared and made inevitable the world conflagration [...] Let the movement for peace, started by the Russian Revolution, be brought to a conclusion by the efforts of the International Proletariat. *15 May 1917*

FLORENCE FARMBOROUGH
English nurse serving with the Russian army on the Romanian front

During breakfast the order was brought to us: Kerensky was coming to Podgaitsy! He would come and harangue our soldiers with heartening words. Pray Heaven that his influence would succeed in reorganising the already disorganised front line troops [...] At first glance, he looked small and insignificant. He wore a darkish uniform and there was nothing about him to indicate the magnetic power he was able to wield. I remember clearly a feeling of disappointment. Was this man really *the* Kerensky? He looked less than his 36 years and his beardless face made him even younger. For a while he stood in silence; then he began to speak, slowly at first and very clearly. As he spoke, one realised immediately the source of his power. His sincerity was unquestionable; and his eloquence literally hypnotised us. *13 May 1917*

LEV URUSOV
Diplomat and tennis champion

Kerensky issued an order for the troops to go on the offensive. The order wasn't particularly well formulated – in any case it was difficult to do it well, and by far the most important thing was that the order was given. I haven't met a single person who believes that the order will be executed – some say that at best a few divisions will go on the attack, others are convinced that if troops are

moved into battle and have a notable success, that this in itself will act like an avalanche. Kerensky's trip to the front has been a resounding triumph but once again it's just words, words and more words. Our allies are still our allies and they still hope that we'll work something out and that the nation will come to its senses. *14 May 1917*

VALENTIN MALAKHOVSKY
Member of the Soldiers' Committee of the 6th Finland Rifles Regiment

The 6th Finland Rifles Regiment was the first in the division to fraternise with the Germans, and stubbornly refused calls to go on the offensive. The officers of the regiment and numerous delegations – from the State Duma, from Minister of War Kerensky and, finally, from the workers of Europe [...] – tried by all means possible to raise the offensive spirit in the soldiers. It was as if the eloquence of the orators would hypnotise the riflemen. Outbursts of 'Too right!' and applause would sometimes ring out in response to the silken words of the Allies' representatives about freedom, equality and brotherhood. But no sooner had the flunky of the bourgeoisie left the stage than the hypnosis dissipated, and the great soldierly mass, covered in the mud of the trenches, would cry out, 'Down with the war! We won't attack!'

VLADIMIR CHERTKOV
Tolstoy's editor and publisher

The socialist minister, worshipped by the mob, and who signifies in its eyes the liberation of Russia from monarchical oppression, rides around the army, passionately appealing to the troops to go on the offensive. Everywhere he is met with the usual expressions of mass excitement by the very people who several months ago greeted Nicholas II in the same way.

RECH
'Speech', newspaper of the Kadets, supportive of the Provisional Government

Our country is definitely turning into some sort of madhouse with lunatics in command, while people who have not yet lost their reason huddle fearfully against the walls. *17 May 1917*

VLADIMIR CHERTKOV
Tolstoy's editor and publisher

There can be no doubt that the war has become hateful to the Russian soldier, who hadn't the least desire to be involved in the first place, despite all the assurances of those who want to view it as a demonstration of the people's will. The fact that the military leadership is never going to tell their soldiers that participation in the war is voluntary, that whoever wants to can head home, is clear evidence of this.

They would never do so because they, like all of us, know perfectly well this would make the continuation of the war impossible. Given all this, why is it that millions of Russian peasants and workers who detest a fratricidal war already in its fourth year nonetheless continue to fight in it? After all, they are many and their commanding officers relatively few. What power is it that compels them to fall into line?

GENERAL VLADIMIR DZHUNKOVSKY
Commander of the 3rd Siberian Army Corps; in Pavlovshchina, Belarus

In an attempt to raise the fighting capacity of the army, an order was received for every regiment to form a company of shock troops, in accordance with certain new regulations, and as a result I ordered that such a company should be formed. A huge number of soldiers wanted to join these companies, so a stringent selection process had to take place. *26 May 1917*

LOUIS DE ROBIEN
Attaché at the French Embassy

Kerensky has occasional bursts of energy and is trying to take the army in hand again: he has reorganised the courts martial and ordered them to punish all attempts at desertion severely. All requests by officers to resign are refused, and General Gurko, who had asked to be relieved of his command of the central group of armies due to the growing lack of discipline, has been put at the head of a mere division. Generalissimo Alexeev has been replaced by General Brusilov, the victor of Galicia. But what can all these measures accomplish against the forces of anarchy which are causing the army to disintegrate, and against which all words are useless? *24 May 1917*

VASILY KRAVKOV
Army doctor and diarist

Improbable – but true! Kerensky, with his 'iron discipline', has ordered that all mutineers (and they probably number hundreds of thousands!) should be put on trial and deprived of their right to vote, and their divisions disbanded. Some are even tentatively suggesting that a decent fist might be formed from our Cossacks, who would soon whip some sense into our excessively 'self-determining' citizens. *28 May 1917*

RUSSKOE SLOVO
'Russian Word', newspaper supportive of the Provisional Government

Reports have come from the front of several incidents of the gravest military crimes, perpetrated by individuals, groups and entire divisions: acts of insubordination that include rebellion and outright revolt, unauthorised desertion of one's post or location, refusal to obey battle instructions and to engage in battle, and also incitement to commit these crimes.

All these acts are a serious violation of the soldier's duty. Such violations are punishable by penal servitude and the loss of all personal rights. These include the right to employment and public work, the right to vote, the right to own property, both personal and real estate,

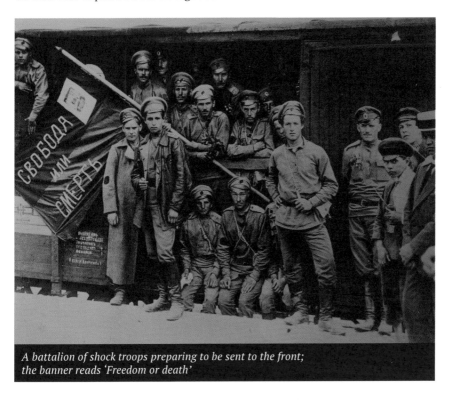

A battalion of shock troops preparing to be sent to the front; the banner reads 'Freedom or death'

and the right to own land. The families of those convicted will lose their right to rations and benefits. *1 June 1917*

MARIA BOCHKARYOVA
Founder of the Women's Battalion of Death

Then suddenly an idea dawned upon me. It was the idea of a Women's Battalion of Death.

'You have heard of what I have done and endured as a soldier,' I said, rising to my feet and turning to the audience. 'Now, how would it do to organise three hundred women like myself to serve as an example to the army and lead the men into battle?'

Rodzyanko approved of my idea. 'Provided,' he added, 'we could find hundreds more like Maria Bochkaryova, which I greatly doubt.'

To this objection I replied that numbers were immaterial, that what was important was to shame the men, and that a few women at one place could serve as an example to the entire front. 'It would be necessary that the women's organisation should have no committees and be run on the regular army basis in order to enable it to help towards the restoration of discipline,' I further explained.

Rodzyanko thought my suggestion splendid and dwelt upon the enthusiasm that would inevitably be kindled among the men if women should occupy some of the trenches and take the lead in an offensive.

ALFRED KNOX
Military attaché at the British Embassy

After supper, General Kornilov asked me to come into his study for a talk. The room, which also served as a bedroom for the general, was in the palace of the Austrian viceroys of the Bukovina, and looked out on a garden with a beautiful statue of the murdered Austrian empress [...] Poor Kornilov was very pessimistic. He said that the way Gurko had been treated showed clearly that the present government was determined to remove everyone who had decision of character and possessed some influence with the troops, and to keep only such men as Brusilov, who agreed to any madness they proposed. He agreed with me that, if the coming offensive failed, the Allies would have nothing more to hope for from Russia, and he said: 'If Russia stops fighting, I hope you will take me as a private soldier in the British army, for I will never make peace with the Germans.' *29 May 1917*

COLONEL VASILY PRONIN
Founder member of the Union of Officers of the Army and Fleet

Stepping out of the carriage to the strains of a welcoming march, General Brusilov, having received a report from the officer, greeted the guard: 'Greetings, comrades!' 'We wish you health, Mr General,' replied the Muscovites in the new fashion.

General Brusilov passed along the guard and walked up to an orderly, and [...] held out his hand.

The soldier was not expecting such a gesture from the commander-in-chief; he looked in confusion at the proffered hand and did not know how to behave. First he trailed arms, then he presented arms, and then, holding his rifle in his left hand, he shook General Brusilov's hand with his right.

ELIZAVETA NARYSHKINA
Lady-in-waiting to former Empress Alexandra

It seems that everything's going from bad to worse. Some army divisions want to remain loyal but they are too few to start the offensive. *30 May 1917*

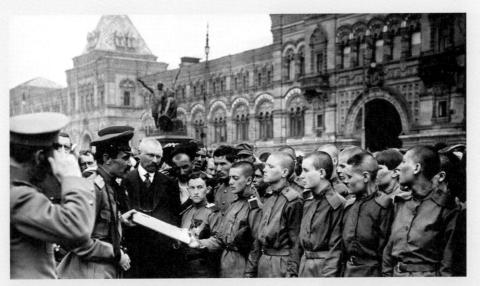

*Presentation of the colours to the Women's Battalion
of Death on Red Square*

Members of the Women's Battalion of Death in camp

Ekaterina Breshko-Breshkovskaya

EKATERINA BRESHKO-BRESHKOVSKAYA

Leading Socialist Revolutionary; letter from the South-Western front to American suffragist Alice Stone Blackwell

The old girl is busy, and often very preoccupied with the state of affairs throughout the country. Not the country, no, but the front, which has been going mad with the sole idea of liberty. Young people without education and knowledge imagine that the war must be abandoned, since the people were not asked to begin it. Some ignorant and some bad individuals are spreading these ideas among the recruits, and it takes time and efforts to convince the soldiers that they ought to begin again to do their duty. *9 June 1917*

LOUIS DE ROBIEN

Attaché at the French Embassy

Lubersac, who has just returned from the front, is more pessimistic than ever; anarchy is gaining ground and the artillery, which up till now had resisted the infection better than anyone, is beginning to be contaminated [...]* He

mentioned the names of several officers who have been murdered by their men. One of them was buried with great pomp by the very men who had killed him. They had invited the Germans, and it is said that a German band marched at the head of the funeral procession. There are many cases of Russians fraternising with Germans. Sometimes it ends badly: in one village the Russian troops had invited the Germans to a big banquet, but the German officers who came refused to sit down at the same table as their men and the Russian soldiers. The comrades were offended, and it ended in a battle [...] I do not know whether it is one which is mentioned in despatches. *9 June 1917*

ALEXANDER KERENSKY

Minister of war; speech to the army on the Romanian front

Forward, in the fight for freedom! I call you not to feast, but to die! *16 June 1917*

BORIS SAVINKOV

Deputy minister of war

'Thank you, guardsmen!'
'At your command, Mr Minister!'

The first battalion turned to the right and immediately vanished out of sight. And at that same moment we could hear the tramping of a thousand feet as row upon row of guards began approaching in steady formation, slowly and ponderously. I remember one officer. Turning to the minister and touching the peak of his cap with his hand, he looked at Kerensky with an ecstatic look in his eyes, and although not audible we could see that he shouted something. Was it maybe 'Long live Land and Liberty'? And the soldiers shouted the same.

Their voices were drowned out by the strains of the Marseillaise. And on this joyful summer's day, with its bright blue sky, the corn already grown and rippling in the fields, the larks singing above our heads, it was impossible to believe that the following day all these tall men, all these young peasants in their soldiers' uniforms, would go off to die.

It was impossible to believe that within a day there would be corpses, crippling injuries, screams and blood. There was no presentiment of death. Neither in the elderly general, who marched at the head of his regiment and smiled at the minister from afar; nor in the musicians with their trumpets glistening in the sun; nor in the steady procession and constant regularity of the ceremonial march; nor even in the distant, ominous rumble of cannons. It felt not like war, but a parade. Not a parting, but a coming together. Not destruction, but on the contrary: a wonderful celebration of enduring strength. *17 June 1917*

ZINAIDA GIPPIUS
Poet, novelist and journalist

Now all our energies must be given over to the war in an effort to shoulder its burden and determinedly bring it to an end. War is the only possible means of redeeming the past. Of preserving the future. Of coming to our senses. The ultimate trial. *18 June 1917*

GENERAL ANTON DENIKIN
Commander, Western front, Minsk

The Russian forces on the South-Western front today broke through enemy lines and inflicted a defeat. A decisive battle, on which hangs the fate of the Russian people and its freedoms, has begun. Our brothers on the South-Western front are moving forward victoriously, without regard for their own lives, and they need emergency aid from us. We will not betray them. Soon the enemy will hear the thunder of our cannons. I call on the forces of the Western front to strain every sinew and prepare as soon as possible for the offensive, otherwise we will be condemned by the Russian people who put their trust in us to defend their freedom, honour and heritage. *18 June 1917*

FORMER EMPEROR NICHOLAS II
Diary entry, Tsarskoe Selo

Just before lunch we received the good news that the offensive on the South-Western front has started. After two days of artillery fire our troops have broken through enemy positions on the Zolochev line and taken prisoner around 170 officers and 10,000 men, as well as six heavy artillery and 24 machine guns. Thank the Lord! God speed! Felt completely different after this joyous news. *19 June 1917*

ALEXANDER KERENSKY
Minister of war; telegram to Prime Minister Lvov

Today is a great triumph for the revolution. On 18 June the Russian revolutionary army began an offensive with great enthusiasm, and proved to Russia and to the whole world its supreme fidelity to the revolution and its love of liberty and the motherland.

Ignoring small groups of the faint-hearted in a few regiments, and leaving them contemptuously in the rear, with this offensive the free Russian soldiers have asserted their new-found discipline, based on a sense of civic duty.

Whatever happens later, today has put an end to the malicious, smearing attacks on the organisation of the Russian army, which is built on democratic principles. *18 June 1917*

ALEXANDER BENOIS
Artist, writer and journalist

The newspapers brought news of the offensive that's begun. My reaction to this monstrous news was one of dull indifference, not anger or despair. Over the past few weeks I feel as if everything in me has somehow worn out, changed, become numb. You want to die – well go on, die then! Want to destroy – go and destroy! [...] A hopeless, idiotic abomination, and we should have turned our back on this abomination, since there is nothing we can do to stop it. *21 June 1917*

General Max Hoffmann

GENERAL MAX HOFFMANN
German chief of staff on the Eastern front

The Russians are really remarkable people. At the bottom of my heart my only anxiety was that they might not be induced to attack in Galicia, and would thus prevent us carrying out a very neat counter-operation. Instead of which they have been attacking for the last few days with such fury and with such a concentration of troops as we have never seen in the east: seven to eight Russian divisions against one of ours. Which is rather more than I like... In any case the position here is, at the moment, very interesting. I am not anxious in the least, but we must be very careful, because even a trifling Russian victory would, of course, influence public opinion among all classes in favour of the war. *19 June 1917*

LEV URUSOV
Diplomat and tennis champion

Kornilov's army has gone on the offensive and has made a significant breakthrough at the front – our cavalry is operating in the enemy rear, has taken 7,000 prisoners and 48 weapons including twelve heavy artillery. Morale is improving – a planned approach to Lvov is being drawn up – and the Bolsheviks are inexorably losing ground. Glory to Kerensky – raised up on the crest of the revolutionary wave, he's found himself on top of the situation. He's transformed himself into a statesman and without abandoning democracy he has become an autocrat. *26 June 1917*

LEON TROTSKY
Revolutionary and Marxist theorist

Mr Tsereteli [...] declared at the Congress of Soviets that the offensive is a powerful blow to Russian, Allied and German imperialism, and as such should be welcomed by all Internationalists, including German [...] But when Tsereteli says that the Russian forces are fighting against imperialism, we ask this: how exactly are they doing so when fighting alongside the imperial governments of England, America, Italy and France? After all, Lloyd-George, Ribot and Wilson, who till now no one thought of as sworn enemies of imperialism, fervently welcomed the Russian offensive, not supposing in the least that it was aimed [...] at them.* *28 June 1917*

ANNA STRAVINSKAYA
Pianist; letter to her son Igor Stravinsky

These past few days everyone's mood has been lifted by the offensive we've now begun and which has been so successful; God grant that it may continue to be so. With the concerted efforts of our Allies may we finally defeat this cruel and stubborn enemy and let this terrible nightmare of a war be over by Christmas, please God! *28 June 1917*

LOUIS DE ROBIEN
Attaché at the French Embassy

Russia is definitely the land of surprise. At the moment when everybody believed the army to be completely breaking up, every day brings news of fresh victories [...] There is something immoral about the victory of this disorganised, louse-ridden army, led by a petty little socialist lawyer. All our ideas about discipline [...] are contradicted by this herd, in which each man does as he pleases, where officers are murdered, where each company has a soviet of delegates, and where even the plans of campaign are argued about [...] But this can hardly last, and we shall have a terrible awakening when the comrades have to face the Germans, with their machine guns and their heavy cannon, instead of the Austrians who have decidedly 'had enough of it'. *28 June 1917*

TO 'COMRADE PATRIOTS'
Letter from soldiers in the trenches

Certain Bolshevik anarchists from the Petrograd garrison [...] are now travelling up and down the front with the following slogans: 'Down with the war', 'Down with the offensive'. And they are running to the ignorant mass of soldiers with these false words: 'You should trust and believe only us and, generally, all the Bolsheviks and their parties – we alone will save you, we will lead you out onto the true path without bloodshed or carnage!' and instead of leading us out onto the path of salvation, they send us into anarchy; they want us to become anarchists [...] But no, Comrades! We are not anarchists or monarchists, not Nicholas II or Grishka Rasputin [...] We are position soldiers, trench rats! We do not recognise Bolshevik anarchists or their henchmen, but we have always and only trusted the socialist minister Kerensky and the Soviet of Workers', Soldiers' and Peasants' Deputies. *27 June 1917*

ELIZAVETA NARYSHKINA
Lady-in-waiting to former Empress Alexandra

The offensive appears to have stopped. So many hostile forces are acting against honour and duty. A kingdom of cowardice and backstabbing cruelty! *22 June 1917*

SERGEI MARKOV
Chief of staff on the Western and South-Western fronts; communication to General Lukomsky

The 28th Division has not left to take up its position at the front, having explained that it refuses to sustain losses in the attack. It promises to take its position tonight. The 1st Siberian Corps has categorically refused to advance, as has the entire 62nd Siberian Regiment, more than half of the 63rd Regiment, and almost 300 men in the 3rd Regiment. In the 175th Division's 689th Regiment, the mood improved after the instigators were arrested. In the 11th Siberian Division's 42nd Regiment, 246 riflemen refused to advance and have been arrested and despatched. It was decided to disband and reform the 169th Division's 673rd and 675th Regiments in light of a series of incidents and their complete refusal not only to advance, but to execute orders in general. This was done with direct participation of the front commissar, Captain Kalinin. When these measures did not help, artillery opened fire on the resistant regiments. Losses were insignificant. *8 July 1917*

YOSIF DASHEVSKY
Chairman of the Executive Committee of the South-Western front; telegram to the minister of war and the Petrograd Soviet

The German offensive begun on the Eleventh Army's front on 6 July is rapidly developing into a catastrophe beyond measure, which may threaten the destruction of revolutionary Russia.

Amongst those units who have only recently advanced through the heroic efforts of a conscientious minority, there has been a sharp and destructive break-down of morale. The momentum of the advance has quickly dissipated. The majority of units are now in a state of ever-growing disintegration [...] Some units have wilfully left their positions without even waiting for the approach of the enemy. There have been instances where an order to provide immediate support has been discussed for hours at a meeting, meaning that the support has been delayed by a day.

At the first shots fired by the enemy, units have often left their positions. Streams of deserters stretch out over hundreds of miles behind the lines, some with weapons, some without, healthy, vigorous men who have lost all shame, and consider themselves able to act entirely with impunity. [...]

Today the commander of the South-Western front and the commander of the Eleventh Army, with the agreement of the commissars and committees, have issued the command to shoot deserters. Let the whole country know the full truth about what is going on here, let the country shudder and find in itself the determination to come down ruthlessly on those who by cowardice are destroying and selling Russia and the revolution. *9 July 1917*

GENERAL MAX HOFFMANN
German chief of staff on the Eastern front

The affair is developing according to plan. I should like a few more prisoners. The fellows ran away so frantically that we could not catch any of them. Only 6,000 to date, and only 70 guns. *8 July 1917*

PETROGRAD SOVIET
Appeal to the army from the Executive Committees of the Soviet of Workers' and Soldiers' Deputies and the Soviet of Peasants' Deputies

Comrade Soldiers!

One of our armies has faltered. The regiments ran before the enemy. Part of the front has been broken through. Wilhelm's hordes are sweeping down into the country, carrying death and destruction with them.

Where does the responsibility fall for this disgrace?

The responsibility falls on those who were disorganising the ranks of the army, who were undermining its discipline. The responsibility falls on those who, in a moment of danger, disobeyed the battle orders, who wasted time on fruitless discussions and arguments. [...]

Enough words! The time has come to act without hesitation.

We have recognised the Provisional Government as the Government to Save the Revolution. We have recognised its unlimited authority and unlimited powers.

Let its orders be law for everyone!

He who disobeys in battle the order of the Provisional Government – he is a traitor. And there will be no mercy shown to traitors and cowards. [...]

Soldiers at the front!

Let there be neither traitors nor cowards in your midst! Let not a single one of you retreat a single step before the enemy! There is only one road open to you – the road ahead.

Soldiers in the rear!

Be prepared, everyone, to go to the front in support of your brothers, forsaken and betrayed by regiments who fled from their positions. [...]

Comrade soldiers!

The workers of Russia and of the whole world are looking to you with hope.

The destruction of the Russian Revolution spells destruction for everyone.

Gather all your courage, perseverance and discipline.

Save our native land!

Save the revolution! *11 July 1917*

Maria Bochkaryova

MARIA BOCHKARYOVA
Founder of the Women's Battalion
of Death

Our condition grew desperate. We sent an urgent appeal for help to Headquarters. From the other end of the wire came the appalling answer:

'The 9th Corps has been holding a meeting. It arrived from the reserve billets and went forward till it came to the trenches we had held before the attack. There it stopped, wavered, and began to debate whether to advance or not.'

We were struck by the news as if by some terrific blow. It was crushing, unimaginable, unbelievable.

Here we were, a few hundred women, officers, men – all on the brink of a precipice, in imminent danger of being surrounded and wiped out of existence. And there, within a mile or two, were they, thousands of them, with the fate of our lives, the fate of this whole movement, nay, the fate, perhaps, of all Russia, in their hands. And they were debating!

Where was justice? Where was brotherhood? Where was manhood and decency? [...]

The officers begged and implored their men to go forward as our calls for help grew more and more insistent. There was no response. The men said they would defend their positions in case of a German attack, but would not take part in any offensive.

It was in these desperate circumstances, as I was rushing about from position to position, exposing myself to bullets in the hope that I might be struck dead rather than see the collapse of the whole enterprise, that I came across a couple hiding behind the trunk of a tree. One of the pair was a girl belonging to the Battalion, the other a soldier. They were making love!

This was even more overpowering than the deliberations of the 9th Corps, which were sentencing us to annihilation. I was almost out of my senses. My mind failed to grasp that such a thing could really be happening at a moment when we were trapped like rats at the enemy's mercy. My heart turned into a raging cauldron. In an instant I flung myself upon the couple.

I ran my bayonet through the girl. The man took to his heels before I could strike him, and escaped.

NIKITA OKUNEV
Diarist, employee of the Samolyot
Shipping Line

Kornilov has telegraphed Kerensky and Brusilov: 'In the field, which can no longer even be called the field of battle, there is sheer horror, disgrace and shame... I demand the offensive's immediate cessation on all fronts to preserve and save the army so that it can be reorganised on the basis of firm discipline... The introduction of the death penalty and establishment of military courts in the theatre of war... Death not just from enemy fire but at the hands of their own brothers-in-arms is a constant threat to the army... The death penalty will save many innocent lives at the cost of a few renegades, traitors and cowards... If the government does not confirm these measures, I, General Kornilov, will resign as commander.' *12 July 1917*

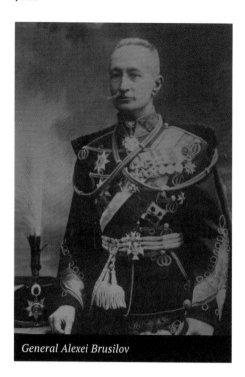

General Alexei Brusilov

GENERAL ALEXEI BRUSILOV
Supreme commander-in-chief of the Russian army; letter to Kerensky

Dear Alexander Fyodorovich,

History repeats itself. The lessons of the great French revolution, which we have partly forgotten, nevertheless come unfailingly back to mind, throwing our mistakes into even greater relief.

We have forgotten that the French, inspired like ourselves by love of their fellow men, turned the first manifestations of their revolutionary will towards the reform of the army on the principles of humanity and softheartedness. The result was the same. Both with them and with us, the army started to decay rapidly and threatened to become a dangerous crowd of armed people. [...]

Time does not wait. It is necessary to restore immediately iron discipline in all its plenitude and the death penalty for traitors.

If we do not do it at once, without delay, then the army will perish, Russia will perish, and we will sink in a dishonour created by our own hands.

In case this demand of mine is not satisfied by the government, I will relieve myself of all responsibility for the consequences, and as supreme commander I declare absolutely, definitely, and firmly that if the death penalty is not introduced in the theatre of military operations, then I will not be in a position to further direct the military operations and to remain in the post which I occupy. *11 July 1917*

PROVISIONAL GOVERNMENT
Law on the restoration of the death penalty in wartime for military personnel and the establishment of revolutionary courts martial

Fully conscious of the grave responsibility it bears for the fate of the homeland, the Provisional Government deems it necessary:
1. To restore the death penalty in wartime for military personnel convicted of certain heinous crimes;
2. To establish revolutionary courts martial consisting of soldiers and officers to try such crimes immediately.

The Provisional Government therefore decrees:

To establish the death penalty by firing squad for military personnel in the theatre of military operations, as capital punishment for the following crimes: military and state treason; [...] desertion to the enemy; flight from the battlefield; wilful desertion of one's post during battle and refusal to participate in battle; [...] incitement, instigation, or agitation to surrender; fleeing or failing to resist the enemy; [...] surrendering as a prisoner without resisting; [...] wilful absence without leave from guard duty in the face of the enemy; [...] acts of violence against persons in authority, officers, or soldiers; [...] refusal to carry out military orders and instructions of a commander; overt mutiny and instigation to such; [...] attacking a sentry or military guard; armed resistance to or wilful murder of a sentry. *12 July 1917*

FORMER EMPEROR NICHOLAS II
Diary entry, Tsarskoe Selo

For the last few days, news from the South-Western front has been bad. After our assault at Galich, many units, influenced by shameful defeatist propaganda, not only refused to advance further, but in some places even took flight without any pressure from the enemy. Taking advantage of these propitious circumstances, the Germans and Austrians managed to break through in southern Galicia with a small force, which could move the entire South-Western front back to the east. It's a shame and a disgrace! Today, at last, the Provisional Government has decreed that anyone engaging in state treason in the theatre of war will face the death penalty. Let's hope these measures are not too late. *13 July 1917*

YULY MARTOV
Leader of the Menshevik Internationalists

Using the death penalty as a deterrent for the masses does not achieve its aim. The death penalty will only serve to corrupt the army as it gets used to the murders, and then killing without trial will become the norm. The death penalty also corrupts the general population, especially children. *5 August 1917*

Crowds fleeing the violence on 4 July 1917

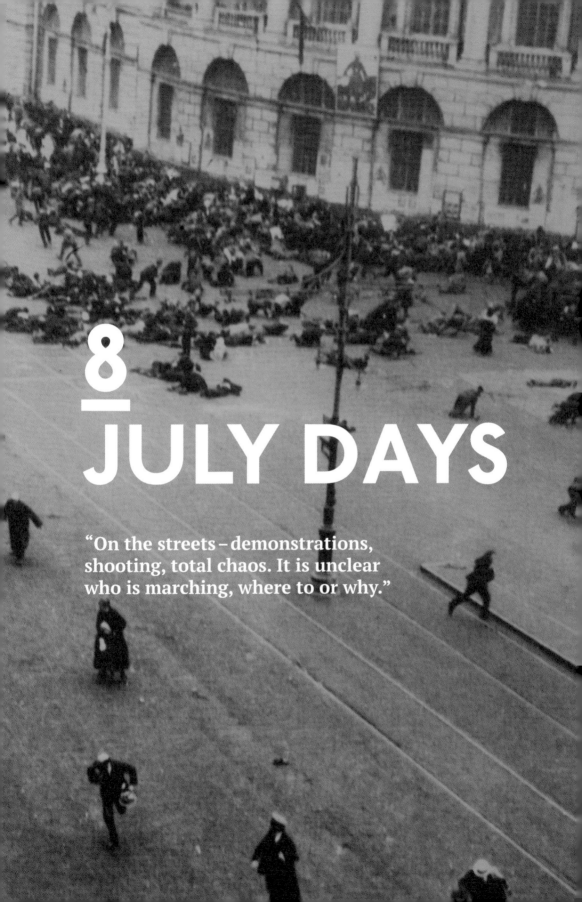

8 / JULY DAYS

"On the streets – demonstrations, shooting, total chaos. It is unclear who is marching, where to or why."

EARLY REFORMERS

Count Sergei Rebinder (1885–after 1938), colonel of the Horse Artillery, involved in suppression of the July uprising; emigrated to Germany.

PROGRESSIVE REVOLUTIONARIES

Raphael Abramovich (1880–1963), Menshevik member of Petrograd Soviet, revolutionary defencist (in favour of limited war effort to defend revolution); arrested in 1918; emigrated to Berlin in 1920; with rise of fascism moved to USA.

Grigory Alexinsky (1879–1967), elected Duma member in 1907; early Bolshevik allegiance led to exile from Russia; in Paris became involved in disclosing agents working for Germany; on return to Petrograd, along with Vasily Pankratov, made allegations against Lenin and others; emigrated in 1919, settled in Paris.

Vasily Pankratov (1864–1925), member of radical group Narodnaya volya ('People's Will') in 1880s, sentenced to 20 years' hard labour, released in 1898; joined Socialist Revolutionary Party in 1903; involved with Alexinsky in allegations against Bolsheviks in summer 1917; commissar in charge of imperial family in Tobolsk from September 1917 to January 1918; allied to anti-Soviet forces under Admiral Kolchak.

Pitirim Sorokin (1889–1968), first professor of sociology at Petrograd University, member of Socialist Revolutionary Party; secretary to Kerensky; expelled from Soviet Union in 1923 for anti-Bolshevism; founded department of sociology at Harvard in 1930 and worked at University of Minnesota.

Grigory Torsky (1887–?), soldier in 1st Infantry Reserve Regiment, Petrograd; gave evidence to Special Commission of Inquiry into July Events.

RADICAL REVOLUTIONARIES

Listok Pravdy, 'Sheet of Truth', two-page newspaper issued after the forced closure of *Pravda* office on 5 July.

Fyodor Raskolnikov (1892–1939), sailors' leader and deputy chairman of Kronstadt Soviet; Bolshevik member of Constituent Assembly; later fought against the Whites, was captured by British and imprisoned in Brixton jail, exchanged for British hostages; served as diplomat until 1937; recalled to Moscow from Bulgaria but refused to go; in 1939 addressed open letter to Stalin, 'How I was made an enemy of the people'; died soon after.

OBSERVERS

Anna Allilueva (1896–1964), Stalin's sister-in-law, married to Cheka officer Stanislav Redens; memoirs published in 1946 infuriated Stalin; sentenced to 10 years' solitary confinement in 1948, released 1954.

Alexander Amfiteatrov (1862–1938), writer, critic and satirist, prolific novelist and playwright; in exile 1904–16; anti-Bolshevik, arrested three times between 1919 and 1921, when he fled Russia; settled in Levanto.

American Mission to Russia, visited Russia for a month in June 1917, led by former US Secretary of State Elihu Root, who addressed Provisional Government on 15 June.

Meriel Buchanan (1886–1959), daughter of British ambassador, worked as nurse during the war in Petrograd hospital organised by her mother; published several books on her Russian experiences.

Phil Jordan (1868–1941), son of an emancipated slave, valet to American ambassador, David Francis; left Russia in 1918, employed by Francis family until his death.

Bernard Pares (1867–1949), historian and academic; British observer with Russian Army, later attached to British Embassy; left Russia in 1918 then posted by Foreign Office to lecture White Army forces in 1919; first director of School of East European and Slavonic Studies in London.

Teffi (1872–1952), pseudonym of writer and satirist Nadezhda Lokhvitskaya, whose works were admired by Nicholas II and Lenin; left Russia in 1919, settled in Paris.

Alexander Zhirkevich (1857–1927), poet, diarist, essayist and lawyer; after revolution lectured on literacy; collector of autographs, manuscripts, art and instruments of torture.

With the worsening situation at the front, the government sees an opportunity to purge Petrograd of troops 'contaminated' by Bolshevik propaganda, by sending units of the city's garrison to support the front-line action. This only exacerbates tensions in the capital, and by early July rumours of a decisive move against the 'bourgeois' coalition government are multiplying. The Bolsheviks urge the garrison forces to refuse to follow orders, eliciting strong support from the 1st Machine Gun Regiment, billeted near the radicalised factories in Vyborg District.

Further afield, in Kiev, the Ukrainian Rada demands and is granted autonomous rule, further weakening the coalition as three Kadet ministers resign in protest. In Petrograd people take to the streets once more; in Sukhanov's words, 'in general everyone who wasn't too lazy was demonstrating'. Public disorder and violence become daily occurrences. However, fearful of playing into the hands of those who accuse them of pro-German treachery, the Bolshevik leadership is hesitant about fomenting outright rebellion; equally indecisive, the Soviet wavers over whether to take power from the rapidly disintegrating coalition. From their naval base at Kronstadt, 20 miles west of Petrograd, the sailors – the radical 'heart of the revolution' – believe that the moment has come to make their presence felt in the capital once more.

ALEXANDER KERENSKY
Minister of war

In the first few days after the revolution I was sent by the government to the naval base at Kronstadt. An enraged mob of sailors had literally torn to pieces the commander of the Kronstadt fortress, Admiral Viren, killed a number of their officers, and thrown hundreds of others into prison after savagely beating them up. My mission was to try to obtain the release of these officers, who had suffered quite unjustly at the hands of the sailors. I had no means of persuasion except the spoken word.

I arrived there with two adjutants and, ignoring all warnings, went directly to the main square in Kronstadt, which was the meeting place for the insurgent sailors. I was met by an ominous silence, which gave way to an angry roar as soon as I began to speak. It was clear that the sailors' leaders wanted to keep me from getting a hearing. When the noise had died down a little, I said that I had come on behalf of the Provisional Government to get an explanation of what had happened. One of the leaders immediately stood up and started talking about the 'atrocities' committed against the sailors in Kronstadt.

Vasily Shulgin

VASILY SHULGIN
Member of the Duma, right-wing Progressive bloc

Imagine a concert hall, with a violinist and an audience.

If the public is only allowed to listen and not express its approval or disapproval, then this is autocracy.

If the public has the right to applaud the musician or whistle at him, thereby either encouraging him to play on or leave the stage, then this is a proper democratic system.

But if the public does not confine itself to applause or whistles, and instead climbs up onto the stage to teach the musician; if these melomaniacs grab the violin and try to run the bow over the strings, emitting a sound like a wailing cat – then this is the state of affairs we currently have. *Early June 1917*

RYURIK IVNEV
Poet, novelist and translator

It was very strange to see a drunken officer on the tram fraternising with the soldiers (who were evidently laughing at him) – a scene I found physically painful to watch. *30 May 1917*

ALFRED KNOX
Military attaché at the British Embassy

In Petrograd, children have been seen parading with banners inscribed: 'Down with the parental yoke!' *28 April 1917*

BARON NIKOLAI WRANGEL
Businessman and memoirist

During these days, for some reason the 'people of the revolution' began endlessly chewing on sunflower seeds, and as the streets had been virtually unswept since the time of 'freedoms', the pavements and roads were completely covered with husks.

Teffi

TEFFI
Writer and satirist

Chewing sunflower seeds! The whole of Russia has been taken over by this stupid and dangerous affliction. They're all at it – women, children, young lads and soldiers – always the soldiers [...] So-called impartial historians will call this period of the Russian Revolution the sunflower-seed-chewing period.

Psychiatrists will study it as an illness and probably categorise it along with other nervous diseases like nail-biting, various tics, involuntary grimaces and obsessive gestures. We need to fight this affliction and take decisive and urgent measures against it. *7 June 1917*

ALEXANDER ZHIRKEVICH
Poet, essayist and lawyer

Under the command of an officer, soldiers were leading a half-dead thief in a bloodied military uniform through the city; he'd been beaten up by the mob and had a lock fixed to his mouth. A monstrosity, carried out – so people were saying – to deter other thieves. It's as if we're living in the Middle Ages rather than these days of freedoms. *24 May 1917*

ALEXANDER BLOK
Poet

I will not be at all surprised if (though not immediately) the people, who are clever, calm and understand what the intelligentsia cannot understand (because of the socialist mindset which is totally and diametrically opposite), will also begin calmly and majestically to hang and rob the intelligentsia – to establish order and clean out the rubbish from the country's brain. *19 June 1917*

AMERICAN MISSION TO RUSSIA
Report

The Mission has accomplished what it came here to do, and we are greatly encouraged. We found no organic or incurable malady in the Russian democracy [...] The solid admirable traits in the Russian character will pull the nation through the present crisis. Natural love of law and order and capacity for local self-government have been demonstrated every day since the revolution. *27 June 1917*

GRIGORY TORSKY
Soldier in the 1st Infantry Reserve Regiment; evidence to the Special Commission of Inquiry into the July Events

On 3 July at about 5 p.m. soldiers calling themselves a delegation of the 1st Machine Gun Regiment came to see me as chairman of the regimental committee; several workers from the Lessner, the Metallichesky and other plants came with them [...] The delegation declared that it had been sent by the Machine Gun Regiment to demand that we should immediately demonstrate, arms in hand, in the streets of Petrograd for the purpose of overthrowing the capitalist ministers and of transferring all power into the hands of the Soviets of Workers', Soldiers' and Peasants' Deputies. [...]

To the demands of the delegation I replied that the 1st Regiment did not sympathise with anarchists and their affiliates, and that we recognised the resolutions of the central democratic bodies.

RUSSKIE VEDOMOSTI
'Russian Gazette', newspaper of the Kadets; account of the events of 3 July titled 'Events in Petrograd. An armed insurrection'

At about 6 o'clock in the evening rumours spread through the city that the workers, with the participation of some army units, planned to stage an uprising. Automobiles bearing unknown people appeared on the streets. They stopped in front of the army barracks, informing the soldiers of the forthcoming armed uprising of the people and inviting them to join the rebellion [...] At about 7 o'clock in the evening a proclamation appeared from the All-Russian Executive Committee of the Soviet of Workers' and Peasants' Deputies, addressed to all soldiers and workers and warning them against the armed rebellion.

However, the rebellion did begin. The signal for it was given on the Vyborg side [...] At about 7 o'clock in the evening, hundreds of workers from the Vyborg area began to gather near the Liteiny Bridge. Separate groups of the so-called 'Red Guard' appeared, and among them, engaging in intensive propaganda, were Bolsheviks and anarchists from the Durnovo villa.* Shortly afterwards rows of soldiers appeared, who had arrived in several trucks, bearing red posters. The Machine Gun Regiment also arrived. The soldiers who gathered near the machine gunners proceeded to drag passengers off the trams and send the trams back to the depot. Tram movement stopped. Young people appeared on the streets distributing bullets, procured no one knows where, to persons who had arms [...] The mob carried placards with slogans: 'All power to the Soviets of Workers', Peasants' and Soldiers' Deputies'. *4 July 1917*

RYURIK IVNEV
Poet, novelist and translator

Another political crisis. On the streets – demonstrations, shooting, total chaos. It is unclear who is marching, where to or why. Vehicles hurtle by with armed soldiers and machine guns. Who knows what tomorrow will bring. The Provisional Government is impotent. I am not afraid for Russia. I have suddenly sensed that all will be well. The thing is, before, when everything was worse but somehow peaceful and all right, we kept quiet. We kept quiet, even though in Russia people were dying of hunger. Now, when we're in danger, when there are no trams (and of course that's the worst thing – that there are no 'services' such as trams, etc.) we become worked up and angry. *4 July 1917*

NIKOLAI SUKHANOV
Member of the Executive Committee of the Petrograd Soviet, writer and editor

The remnants of the government, with the 'socialist' majority, were having a meeting in the undefended apartments of Prince Lvov. Any group of ten or twelve people who wanted to could have arrested the government. But this wasn't done. The sole attempt to do so was completely futile. At around 10 o'clock a motor car with a machine gun and ten armed men dashed up to the prime minister's house, where they asked the hall porter to hand over the ministers. Tsereteli was summoned to negotiate with them, but before he got to the entrance the men in the armed motor car had vanished, contenting themselves with taking Tsereteli's own car with them.

HAROLD WILLIAMS
New Zealand journalist; article in the *New York Times* titled 'Petrograd's Night of Sudden Riots'

All night long armed soldiers and workers have marched about the streets demonstrating for or against – what, nobody could tell, least of all the demonstrators themselves [...] It was a strange sight, this great, silent, moving mass in the dusk, with the blur of guns, caps and bayonets of the men on lorries and the bent figures of soldiers on artillery horses, all silhouetted against the pale sky. *6 July 1917*

NIKOLAI SUKHANOV
Member of the Executive Committee of the Petrograd Soviet, writer and editor

The waverings of the Bolshevik Central Committee reflected the position of its individual members [...] Stalin stood inexorably for the overthrow of the Government [...] Lenin occupied an intermediate, most unstable and opportunistic position – the same as the official position of the Central Committee. Kamenev, of course, and I think Zinoviev, were against the seizure of power.

BOLSHEVIK CENTRAL COMMITTEE
Declaration drafted in the early hours of 4 July

Yesterday Petrograd's revolutionary garrison and workers proclaimed this slogan: 'All power to the Soviets.' We are asking that this movement, which burst out of the barracks and the factories, be transformed into a peaceful, organised demonstration that reflects the will of all Petrograd's workers, soldiers and peasants. *4 July 1917*

IRAKLY TSERETELI
Leading Menshevik in the Petrograd Soviet, minister of post and telegraph; address to a joint meeting of the Soviet Central Executive Committees during the night of 3–4 July

So now they are out in the streets demanding: 'All power to the Soviets of Workers', Soldiers' and Peasants' Deputies.' [...] Such slogans and actions are fatal to the cause of the revolution. This is the opinion of the All-Russian Congress [...]* Our duty is to defend the unity and integrity of the Russian Revolution. He who thinks that he is on our side when he steps out armed into the street has been deluded.

We must state that such actions conform not to the path of the revolution, but to the path of counter-revolution. We must state that the decision of the revolutionary democracy cannot be dictated by bayonets. *3 July 1917*

RAPHAEL ABRAMOVICH
Menshevik member of the Petrograd Soviet; address to a joint meeting of the Soviet Central Executive Committees during the night of 3–4 July

We are witnesses to a plot. I do not approve of it [...] I have no doubt that should power be transferred to the Soviets, the Bolsheviks would demand that it be transferred to the Central Committee of the Russian Social Democratic Labour Party. *3 July 1917*

COMMITTEE OF THE PETROGRAD SOCIALIST REVOLUTIONARIES
Declaration 'To All Petrograd Soldiers and Workers!'

Enough demonstrations! Enough wild unrest! Enough senseless parading on the streets! Enough spilling of fraternal blood! The revolution needs the disciplined and solid unity of all workers and soldiers in Petrograd. All party members – in the factories, at company and battalion meetings, at street meetings, and in separate groups – are obliged to restrain the masses from thoughtless outbursts that could otherwise lead to criminal bloodshed. *4 July 1917*

IZVESTIA
Menshevik and Socialist Revolutionary newspaper; entry in the records of the Executive Committee of the Petrograd Soviet

10.30 – the machine gunners from Oranienbaum have arrived bringing their machine guns with them [...] We have also been informed that the Kronstadt sailors have been sighted passing Peterhof aboard eight tugboats, two barges, three trawlers, three gun boats, and a torpedo boat. We are told that all are armed. *5 July 1917*

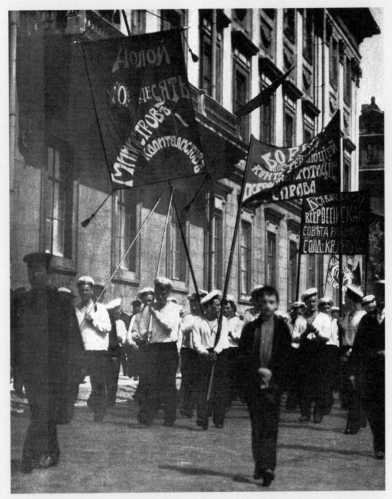

Kronstadt sailors demonstrating in central Petrograd; the banner reads 'Down with the ten capitalist ministers'

Meriel Buchanan

MERIEL BUCHANAN
Daughter of the British ambassador

A little after twelve, three thousand of the Kronstadt sailors marched past the embassy, an endless stream of evil-looking men, armed with every kind of weapon, cheered by the soldiers in the fortress, though the ordinary public in the streets shrank away at the sight of them.

Looking at them, one wondered what the fate of Petrograd would be if these ruffians with their unshaven faces, their slouching walk, their utter brutality were to have the town at their mercy.

JOSHUA BUTLER WRIGHT
Counsellor at the American Embassy

Kronstadt sent its quota of sailors, too, which made matters very ugly and at 3 p.m. as dangerous a mob as I ever hope to see – composed of half-drunken sailors, mutinous soldiers and armed civilians – paraded through our street, threatening people at the windows, and drinking openly from bottles. *4 July 1917*

PAVEL MILYUKOV
Leader of the Kadets in the Duma

Over the course of the three days (3–5 July), military units and crowds of civilians came from the Kshesinskaya Mansion and other places to the Tauride Palace, where the Soviet was in session, and kept it under permanent seige [...] Tsereteli bravely held the line: sittings continued, delegations were received, proposals listened to and discussed, papers read and decisions taken. Sometimes the crowd demanded that ministers come outside. They wanted to arrest Tsereteli, but couldn't find him. Chernov was surprised on the steps, and a strapping worker started shouting at him in a frenzy, shaking his fist in his face: 'Take power, you son of a bitch, when they offer it to you'.*

NIKOLAI SUKHANOV
Member of the Executive Committee of the Petrograd Soviet, writer and editor

It was around 5 o'clock. Someone hurried into the Ex. Com. rooms and reported that the Kronstadters had come to the palace [...] From the windows of the crowded corridor looking on to the square I saw an endless multitude packing the entire space as far as the eye could reach. Armed men were climbing through the open windows. A mass of placards and banners with the Bolshevik slogans rose above the crowd [...] Suddenly someone tugged at my sleeve. Lesha Emelyanova, an old Socialist Revolutionary friend recently back from prison and now on the staff of *Izvestia*, stood before me. She was pale and trembling violently. 'Go quickly – Chernov's been arrested.'

Fyodor Raskolnikov

FYODOR RASKOLNIKOV
Bolshevik deputy chairman of the
Kronstadt Soviet, sailors' leader

We got out at the gate and made our
way through the crowd of Kronstadters,
who allowed us passage, straight up to
the car where the arrested man, Viktor
Chernov, was sitting, without a hat. The
leader of the Socialist Revolutionaries
couldn't disguise his fear in front of the
crowd: his hands were shaking, his lop-
sided face had turned deathly pale, and
his greying hair was all dishevelled.

Trotsky and I jumped into the car and
gestured for silence so that we could
talk to our comrade Kronstadters in
friendly admonition. For several min-
utes we were unable to quieten them
down. The buzzing, clamouring crowd
was stirred up, shouting responses,
arguing with each other. [...]

It's difficult to say how long the bois-
terous excitement of the crowd would
have lasted had a trumpeter not given
a traditional bugle call summoning

the company to order. Then Comrade
Trotsky jumped onto the bonnet [...]
and with a wave of his arm gestured for
silence. [...]

'Comrade Kronstadters,' he began. 'You
are the adornment and the pride of the
Russian Revolution! I do not believe that
the decision to arrest the Socialist Revo-
lutionary minister Chernov was one that
you took consciously. I am convinced
that there is not one amongst you who is
in favour of this arrest, and that not one
hand will be raised in favour of spoiling
today's demonstration, our celebration,
our triumphant show of revolutionary
strength, with needless and uncalled-for
arrests. Whoever is in favour of violence,
raise your hand.'

Nobody even opened their mouth, not
a word was uttered in protest.

'Comrade Chernov, you are free', Com-
rade Trotsky declared triumphantly,
turning round completely to address
the minister of agriculture and, with a
gesture of his hand, invited him to get
out of the vehicle.

Viktor Chernov

COUNT SERGEI REBINDER

Colonel of the Horse Artillery; statement to the examining magistrate of the Petrograd District Court

At 8 p.m. on 4 July, the commander ordered me to take one troop each of the 1st and 4th Don Cossack Regiments along with two pieces of artillery [...] and to proceed at a trot to [...] the State Duma; and there, by all means including opening fire, to disperse the crowd which was besieging the State Duma. [...]

Seeing the vanguard platoon of my detachment, someone from the crowd [...] shouted 'Cossacks!' and at the same time a rifle shot was fired from an armoured car on Liteiny Bridge; then very strong rifle and machine-gun fire broke out against the vanguard unit of my detachment from Liteiny Prospect, the bridge, the embankment, the neighbouring houses, and even from the barges located on the Neva. It is impossible to establish precisely from which houses the shots came: the bullets literally showered from all sides [...] The force of the fire directed on the vanguard of the detachment can be judged by the losses [...]: out of 80 soldiers and 60 horses, three soldiers were killed and seventeen wounded, and 30 horses were killed, which makes 25 per cent of the soldiers and 50 per cent of the horses.

20 August 1917

PHIL JORDAN

Valet to the American ambassador, David Francis; letter to Mrs Francis in St Louis

The Cossacks and soldiers had a terrible fight just one block from the embassy. The Cossacks as you know always fight on horseback. They made a charge on the soldiers who were in the middle of the street with machine guns and cannons. My oh my what a slaughter. After 30 minutes of fighting [I] counted in half a block 28 dead horses. When the Cossacks made their charge the soldiers began to pump the machine guns and you could see men and horses falling on all sides.

PRINCE GEORGY LVOV

Prime minister; telegram to regional commissars

By that time the Tauride Palace was surrounded from all sides by dense masses of a highly excited armed mob, which was already penetrating inside the building [...] The government summoned from Pavlovsk the Horse Artillery, two troops of the 1st and 4th Don Cossack Regiments, and four companies of the Izmailovsky and two of the Semyonovsky. Immediately upon the arrival of the troops, and after receiving extremely alarming news from those members of the Provisional Government who were at the Tauride Palace, part of the troops were immediately sent to liberate the Central Committee surrounded in the Tauride Palace. On the way, the Cossacks, who were covering the artillery, were subjected near the Troitsky Bridge to cross-rifle and machine-gun fire, and suffered rather severe casualties. [...]

The rebellion has been quelled by the measures taken by the government, and towards night-time a tangible quietening was noticeable in the streets. At various places motorcars and separate groups of armed persons, who quickly discontinued resistance at the appearance of military units, were being stopped and disarmed. The government has taken all necessary measures for the prevention of similar disorders. Arrests are taking place. This morning the bridges on the Neva were raised and the streets are quiet. *5 July 1917*

PITIRIM SOROKIN

University professor, member of the Socialist Revolutionary Party

At 5 p.m. the Soviet reconvened, the Bolshevik deputies and their followers being present. They knew that the moment had arrived when they must either conquer or be conquered, and in order to conquer they were resolved to apply the utmost force. But just as one of them was roaring out a speech full of bloody

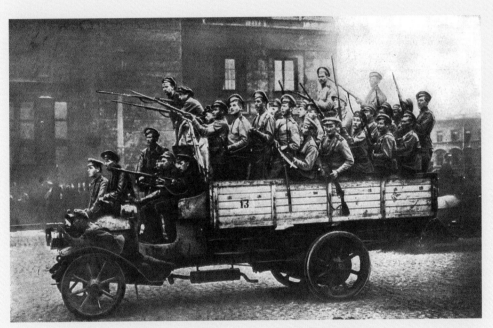

In his book From Czar to Kaiser *the American photographer Donald Thompson wrote: 'For days, trucks like this were a common sight. When the soldiers became excited, they would fire into the air, frightening the people on the streets. They were literally out of their heads'*

threats, the door was flung open and three officers, their uniforms white with dust and caked with mud, marched into the hall and advanced with rapid steps to Chkheidze's seat on the rostrum. Saluting him formally, they turned, and the ranking officer addressed the Bolshevik groups with these words:

'While the Russian army has been gathering all its forces to defend the country from the enemy, you soldiers and sailors who have never faced war, you idlers and traitors who spend your time in vicious babblings, you adventurers and turncoats – what have you been doing here? Instead of fighting like men against an invading enemy you have been murdering peaceful citizens, organising riots, encouraging the enemy, and meeting us, the soldiers of the great Russian army, with machine guns and cannon! What infamy! But all your treachery is in vain. I, commander of the Bicyclists' Regiment, inform you that my troops have entered Petrograd. Your rioters are dispersed. Your machine guns are in my hands. Your fighters, so brave in the face of unarmed citizens, when confronted with real soldiers have fled like the cowards they are. And I tell you that those who make the first attempt to continue or to repeat this uprising will be shot down like dogs.'

Turning to the chairman and saluting once more, he added: 'I have the honour to declare to the Soviet that we are at the disposal of the government and the Soviet, and that we await their orders.'

The explosion of a bomb could scarcely have produced such an effect. Wild, joyous applause on the one hand, shrieks, groans, maledictions on the other.

As for Trotsky, Lunacharsky, Gimmer, Kats and Zinoviev, as one of my colleagues expressed it, they 'shrivelled like the Devil before holy water!'* One of them did make an effort to say something, but was instantly shouted down. 'Out of here! Away!' shouted the Soviet, and with their partisans at their heels, they left. *4 July 1917*

IRAKLY TSERETELI
Leading Menshevik in the Petrograd Soviet, minister of post and telegraph

The uprising ended as suddenly as it had begun. There was a sudden change of mood, both amongst the demonstrators and amongst the units loyal to the central organs of revolutionary democracy. The Izmailovsky, Semyonovsky and Preobrazhensky Regiments came out of their garrisons in full battle readiness and headed for the Tauride Palace to the strains of the Marseillaise, in order to defend the central organs of Soviet democracy and restore order to the capital.

And the majority of the demonstrators suddenly lost the enthusiasm and will to continue their protests and dispersed back to their garrisons and workers' quarters. A decisive factor in this change of mood was the news that a senior team from the Executive Committees, with the agreement of representatives of the army committees of the Northern front, nearest to Petersburg, had summoned a joint detachment of the Fifth Army to establish order [...] Confirmation of these rumours quickly yielded results. On receiving this news, the Bolsheviks sent their official representative, Zinoviev, onto the tribune.

BOLSHEVIK CENTRAL COMMITTEE
Resolution published in *Pravda*

The demonstration's aims have been achieved. The slogans of the vanguard of the working class and army were proclaimed convincingly and with dignity. Incidental shootings by counter-revolutionaries could not detract from the demonstration's general character. Comrades! Our aims in this political crisis have been achieved. We therefore have decided to end the demonstration. Let one and all bring a peaceful, organised end to the strikes and demonstrations. We are waiting for the crisis to develop further. We will continue to prepare our forces. *5 July 1917*

Joshua Butler Wright

JOSHUA BUTLER WRIGHT
Counsellor at the American Embassy

No definite news as to casualties of last night. One hundred and eighty 'Bolsheviks' rumoured killed [...] Public sentiment is suddenly turning against these extremists. *5 July 1917*

IZVESTIA
Menshevik and Socialist Revolutionary newspaper; editorial titled 'On the "Achievements" of the Uprising'

The 5 July issue of *Pravda* carried an appeal signed by the Central Committee, the Petrograd Committee, and the Military Organisation of the Bolsheviks. Calling for an end to the demonstration and for resumption of work, the Bolsheviks say in this appeal [...] that the demonstration of 3 and 4 July achieved its aim.

What exactly did the demonstrators of 3 and 4 July and their acknowledged official leaders – the Bolsheviks – achieve?

They achieved the death of 400 workers, soldiers, sailors, women and children. [...]

They achieved the destruction and looting of private flats and shops. [...]

They achieved the insulting of a proven fighter of the revolution and recognised leader of the Socialist Revolutionary Party, V.M. Chernov, with the brazen attempt by a frenzied crowd to arrest him. [...]

The days of 3 and 4 July dealt a terrible blow to the revolution, while the counter-revolutionary cause was given powerful succour. *6 July 1917*

PROVISIONAL GOVERNMENT
Resolution on the July events

All those who have taken part in organising and leading the armed uprising against state power established by the people, as well as all those who have urged and incited such action, are to be arrested and brought to trial for treason against the motherland and betraying the revolution. *5 July 1917*

NIKOLAI SUKHANOV
Member of the Executive Committee of the Petrograd Soviet, writer and editor

An order was at once issued for the immediate arrest of Lenin, Zinoviev, Kamenev, and others. Besides this an order was drawn up and signed by Lvov for the disbanding of all army units that had taken part in the revolt and their reassignment at the discretion of the minister of war. At about two in the morning the militia came to Lenin's flat, but it was empty. Lenin, like Zinoviev, had vanished.

ANNA ALLILUEVA
Stalin's future sister-in-law

There are people sitting in the dining room. It's the first time I have seen them in our house. But I immediately recognise the one my father presents me to first. He is sitting on the sofa without a jacket, in a waistcoat and a pale shirt with a tie (it's an insufferably hot day, and very stuffy inside). He screws up his eyes at me attentively.

'Vladimir Ilyich, let me introduce my eldest daughter Nyura.'

I shake Lenin by the hand, striving to maintain a calm, completely calm, exterior.

And suddenly all those ridiculous conversations I have overheard on the train, in the tram and on the street come back to me. He's fled to Kronstadt, he's hiding on a destroyer!

And here he is, in our rooms on Rozhdestvenka, in the very centre of Petrograd. So I decide to tell Lenin all the foolish chatter that I've just heard.

'I didn't expect to meet you here. On the train they were saying that you'd fled to Kronstadt, were hiding on board a destroyer. True, true... you were seen in Kronstadt, and on a destroyer...'

'Ha, ha, ha!' Lenin laughs with infectious gaiety, his whole body leaning back. 'So that's what they're saying – on board a destroyer! Well, isn't that splendid! One more version of my flight. It's very good news that I've been seen in Kronstadt. What do you think, comrades?'

Vladimir Ilyich makes me repeat everything I've heard outside. He asks what I observed on the streets, how Petrograd is looking today. After the stress of the whole day I calm down completely, and talking to Lenin I come to life, I laugh, I forget my recent fears...

Vladimir Ilyich is so simple, so winningly attentive, and asks questions and listens to my answers with such unaffected curiosity, as if I am completely his equal.

'How wonderful he is, how wonderful!' I say to my mother as we go out into the kitchen.

LEON TROTSKY
Revolutionary and Marxist theorist

On the morning of the fifth I met Lenin. The uprising of the masses had been beaten back. 'Now they will shoot us down, one by one,' Lenin said. 'This is the right time for them.' But Lenin overestimated his opponent – not his venom, but his decisiveness and ability to act. They did not shoot us down one by one, although they were not far from it. Bolsheviks were being beaten and killed on the streets. Military cadets sacked the Kshesinskaya Mansion and the *Pravda* printing works. The entire street in front of the works was strewn with manuscripts. *5 July 1917*

SIR GEORGE BUCHANAN
British ambassador

The Government had suppressed the Bolshevik rising and seemed at last determined to act with firmness [...] Kerensky had returned from the front on the evening of 6 July, and had at once demanded, as a condition of his retaining office, that the Government should have complete executive control over the army without any interference on the part of soldiers' committees, that an end should be put to all Bolshevik agitation, and that Lenin and his associates should be arrested. The public and the majority of the troops were on the side of the government, as their indignation had been aroused by the publication of documents proving that the Bolshevik leaders were in German pay.

GRIGORY ALEXINSKY
VASILY PANKRATOV
Former Duma member (Alexinsky) and member of the Socialist Revolutionary Party (Pankratov); letter to the Committee of Journalists

We, the undersigned, [...] believe it to be our revolutionary duty to publish extracts from documents we have received, from which Russian citizens will see how and from what direction Russian liberty, the revolutionary army and the Russian people who won this liberty with their blood are endangered. [...]

Lenin was commissioned to use every means in his power to undermine the confidence of the Russian people in the Provisional Government. Money for the propaganda is being received through a certain Svendson, employed

in Stockholm at the German Embassy. Money and instructions were forwarded through trusted persons. [...]

Military censors have unearthed an uninterrupted exchange of telegrams of a political and financial nature between the German agents and Bolshevik leaders (Stockholm-Petrograd).

Owing to technical considerations the original documents will be published by us later as a supplement.

BERNARD PARES
Historian and academic, seconded to the British Embassy in Petrograd

Alexinsky, always like a little bulldog, accepted this material with relish and, going to the window of the General Staff, he at once read it out to the Preobrazhensky Regiment of the Guard, who had collected outside. Some of these went and fetched the rest of their comrades; they shouted back that now they understood that the Bolshevik attempt was a German manoeuvre, and that they would back the Provisional Government for all they were worth.

Bernard Pares

LISTOK PRAVDY
'Sheet of Truth', two-page newspaper issued after the forced closure of the *Pravda* office on 5 July

An unheard-of accusation is made against Comrade Lenin, that he apparently received or is receiving money for his propaganda from German sources. The newspapers have already publicised this monstrous slander. Underground leaflets with reference to the former deputy Alexinsky are already being printed. Calls are already heard to kill the Bolsheviks. And lists with people marked for destruction circulate among the soldiers who are being deceived.

The aim is clear. Counter-revolution wants to behead the revolution in the simplest way – by sowing discord among the masses and by baiting them against the most popular leaders, honoured warriors of the revolution.

We declare that everything that is reported about money and other connections between Comrade Lenin and the ruling circles of Germany is a lie and a slander. *6 July 1917*

RECH
'Speech', newspaper of the Kadets; article titled 'On the results of the uprising'

The capital is calming down much more quickly than could have been expected at the beginning of the revolt. [...]

Let us speak bluntly: Bolshevism is hopelessly compromised; the absurdity of its revolt, which assumed all the features of disgusting hoodlumism, seemed simply incomprehensible until the shameful accusation of being a hireling of the Germans was flung at Lenin [...] At that moment there occurred an exceptionally sharp change of feelings, and Bolshevism died, so to speak, a sudden death. [...]

Bolshevism proved to be a bluff [...] But the danger to the revolution from those who tolerate Bolshevism is much more serious, and if, at the last moment, they do not change their minds, the revolution will be threatened by a far more serious crisis. *7 July 1917*

MAXIM GORKY
Writer and political commentator

In my opinion the principal stimulus
for this drama was provided not by the
'Leninists', the Germans, the informers,
or the sinister counter-revolutionaries,
but a more evil and stronger enemy
– oppressive Russian stupidity. It is
precisely our stupidity which is more
to blame for the drama of 4 July than
all the other forces which contributed
to the drama; call it stupidity, lack of
culture, absence of a sense of history –
whatever you please. *14 July 1917*

BERNARD PARES
**Historian and academic, seconded to the
British Embassy in Petrograd**

The attempt had failed; but most of the
processionists, many of whom had come
from Kronstadt, thought they might as
well have a holiday and walk the streets
with their girls who, by the way, were
very much in evidence throughout this
period. Sailors with scantily-dressed and
high-heeled ladies were seen everywhere.

ALEXANDER AMFITEATROV
**Writer, critic and satirist; article in satirical
magazine *Bich***

The day before yesterday the idiocy on
the capital's streets began to boil up
into violent insanity. Yesterday, Tues-
day, the city reached a state of white
fever. Instead of quickly wrapping the
patient in a tunic with long sleeves,
the doctors decided to treat it with that
sentimental procedure of 'no restraint'.
The result has been several dozen peo-
ple butchered and shot, a few hundred
half-butchered and not quite finished
off, several thousand ruined in the
mayhem, and a million, maybe a million
and a half, scared nearly to death and
foaming at the mouth with fury at the
government's hopeless and cowardly
psychiatric treatment.

 In addition to all these daytime night-
mares, the night's denouement has re-
vealed what should have been revealed
long ago: according to Russian counter-
intelligence, Lenin and Co. are found
to be agents in the service of Germany.
Foul and brazen traitors, these leaders
of Bolshevism; but this government's
a fine thing too, with its ministers, and
these Soviets – octopuses with tentacles,
just without suckers.

 One thing I will say: they've certainly
brought out the thugs and roughed up
the city – and the worst is yet to come!

 As for me, I'm buying a revolver – just
in case Nicholas II or Mikhail II should
come back to Petrograd. Because that
shameful day is one I do not intend to
survive, while you, you venal hounds
in the service of the Germans, and you,
pathetic weasels in clueless power, do
everything – in one case actively, in the
other passively – to ensure that the fair
maiden Freedom dies, violated, and
the harlot of the monarchy opens her
brothel once again in the Winter Palace.
Well, to hell with the lot of you! Damn
you all! *5 July 1917*

PRINCE GEORGY LVOV
**Prime minister; from an interview with
Russkoe slovo on his resignation**

Bolshevism is buried, and this psycho-
logical break testifies to the fact that
conscience, truth and loyalty to the
state are still alive and strong among
the people. At such a time a strong
government is needed. And to bring it
about, a combination of elements of
authority, such as are embodied in the
person of Kerensky, is essential. In the
army he is a recognised leader, in the
country he is a symbol of the revolu-
tion. Actually he possesses real power,
and among the socialists he is perhaps
the only man of action. His devoted ser-
vice to the country gives him the right
and gives Russia the hope of realising
the power which the country awaits so
eagerly. *12 July 1917*

VLADIMIR NABOKOV
Leading member of the Kadets

Lvov's attitude to Kerensky depressed
me [...] It often looked like timid ingratia-
tion [...] I think he was profoundly happy
the day he was relieved of his burden.

Alexander Kerensky

PEOPLE'S MINISTER

"For all his ability to arouse strong emotions,
Kerensky has no real character at all."

ROYALISTS

Boris Nikolsky (1870–1919), journalist, lawyer, Slavophile monarchist, prominent member of extreme right Union of the Russian People; arrested in May 1919 on charges of infiltrating military affairs committee; executed the following month.

EARLY REFORMERS

General Pyotr Polovtsov (1874–1964), military commander, in the war led unit of Caucasian Mounted ('Savage') Division; replaced Kornilov as commander of Petrograd Military District in summer 1917, put down July demonstrations; from October commanded Terek-Dagestan military units; smuggled out to Persia and joined British forces in early 1918; later lived in Monaco and was director of Monte Carlo casino.

E. Vladimirovich (dates not known), social commentator, lived in Odessa, author of several pamphlets on social and financial issues.

PROGRESSIVE REVOLUTIONARIES

Vladimir Bogoraz (1865–1936), anthropologist, writer (pseudonym 'N.A. Tan') and revolutionary, exiled in 1880s; during February Revolution spent time with Kerensky and wrote sketches of events; later worked for Museum of Anthropology and Ethnography and created Institute of Peoples of the North; expert on the Chukchi people in Siberia.

OBSERVERS

L.V. Assiar (dates not known), pseudonymous journalist and critic; has been suggested that 'Assiar' was poet Raisa Blokh (1899–1943) but this is contested.

Ivan Bunin (1870–1953), poet, short-story writer and novelist, anti-Bolshevik journalist during the civil war, emigrated to Paris in 1920; first Russian winner of Nobel prize for literature in 1933.

Fyodor Chaliapin (1873–1938), opera singer; worked as shoemaker's apprentice and carpenter before joining local operetta company; studied in Tbilisi, debuted at Imperial Mariinsky Theatre in 1895 and subsequently in opera houses all over world; best know for title role in Mussorgsky's *Boris Godunov*; left Russia in 1922, resisted attempts to persuade him back; died in Paris.

Daily Times-Enterprise, American newspaper in Thomasville, Georgia, published between 1889 and 1925.

Vasily Knyazev (1887–1937), poet and satirist, published pseudonymously in satirical journals *Satirikon* and *Bich*; sided with Bolsheviks after October, during civil war worked on agit-train; one of founders of *Krasnaya gazeta* ('Red newspaper'), in which he published poems and sketches; died while being transported to prisoner camp in 1937.

W. Somerset Maugham (1874–1965), British writer; agent of British and American secret services, arrived in Petrograd in September 1917 to develop covert action aimed at keeping Kerensky in power and Russia in the war; sent back to London shortly before October Revolution; drew on his experiences in *Ashenden: Or the British Agent* (1928); later settled in France.

Konstantin Paustovsky (1892–1968), Soviet writer and journalist; worked on hospital train during war; after October Revolution moved to Odessa, then to Moscow in 1923 where he worked for Russian Telegraph Agency; first collection of stories published in 1928; nominated for Nobel prize in 1965.

Fyodor Stepun (1884–1965), philosopher and historian; worked in war ministry under Provisional Government; after October Revolution wounded while fighting in Red Army; later dismissed from Moscow theatre role for lack of 'class consciousness'; exiled in 1922 and became professor of sociology in Dresden; in 1937 banned by Nazis from teaching for 'Russophilism'; after war headed Russian culture department at Munich University, became known as bridge between Russia and Germany.

With the formation of the new coalition government, Alexander Kerensky has taken centre stage. From the start, the young human-rights lawyer who had early ambitions to be an opera singer has proved highly proficient at public performance. He is the consummate man of action. While Lenin remains cloistered in dark rooms writing lengthy theses, Kerensky dashes from meeting to demonstration, from the capital to the front, and back again – barely pausing to eat or sleep. He is widely seen not only as the personification of the revolution, but as its saviour, its only hope.

Kerensky's three ministerial positions – justice, war and finally, in July, prime minister – all play a critical role in directing the course of events between February and October 1917. The great actor receives glowing reviews – for a while at least. But before long his performances begin to grate, the mask starts to slip. The 'little Napoleon', who is rumoured to occupy the former rooms of the tsar, earning him the nickname 'Alexander IV', becomes increasingly isolated. The Bolsheviks, still licking their wounds from the abortive July coup, stay undercover – plotting, waiting for their moment. Other forces are marshalling against Kerensky, talk of counter-revolution is everywhere.

Zinaida Gippius

ZINAIDA GIPPIUS
Poet, novelist and journalist

Kerensky is restless and impatient as always. But he is profoundly right, even in his impatience and outrage.
11 February 1917

ANONYMOUS JOURNALIST

The first words I heard from A.F. Kerensky when we met for the first time after the revolution – this was 6 March – were these: 'I do not fear the right, I do not fear counter-revolution – that's not going to happen. I fear our own people: I fear the socialists – their factional disagreements, intransigence and party positions.' And A.F. was right.

ALEXANDER KERENSKY
Minister of justice in the Provisional Government

I give you my word that when I leave the post of minister of justice not one bitter enemy of the new free Russia will dare to say that during the ministry's administration by Kerensky law, legality and justice were just empty words.
4 March 1917

ANONYMOUS JOURNALIST

When I asked him what kind of issues people come to see the minister about, Kerensky's secretary V.V. Somov flung up his arms in despair and said: 'The most varied and absurd issues. Yesterday, for example, a woman came and complained that her husband wanted to leave her; so she had come to ask A.F. to intervene on her behalf.'

HAROLD WILLIAMS
New Zealand journalist; article in the *Liverpool Daily Post*

My appointment was for nine o'clock in the morning. When I arrived at the ministry there was a general air of desolation, but the hall porter said: 'The minister is here. He slept here last night. But he hardly slept at all. Yesterday he went to bed at 6.30 in the morning and was up at 8. It isn't like the old days, when hundreds of people had to wait hours to see the minister. There was Stcheglovitoff. He would go on playing with a racket and ball in the quadrangle while the crowd waited and waited in the reception-room, and if his secretaries waited for him he would say, "I must have my exercise."'

Altogether the porter was delighted with the new regime.

My companion arrived, and we went up the great stairs and, looking along the corridor, saw the minister coming to meet us, accompanied by friends. Never was there a more democratic minister. A young man in the early thirties, of

medium height, with a slight stoop, quick, alert movements, brownish hair brushed straight up the broad forehead, already lined; a sharp nose; bright, keen eyes with a certain puffiness in the lids due to want of sleep, and a pale, nervous face tapering slightly to the chin. The whole bearing was that of a man who could control masses. He was dressed in a grey, rather worn suit, with a pencil sticking out of the breast pocket. He greeted us with a very pleasant smile, and his manner was simplicity itself.

He led us into his study, and there we talked for an hour. I cannot give all the details of the conversation. He discussed the situation thoroughly, and I got the impression that M. Kerensky is not only a convinced and enthusiastic democrat, ready to sacrifice life if need be for democracy – that I already knew from previous acquaintance – but that he had a clear, broad perception of the difficulties and danger of the situation, and was preparing to meet them. [...]

We talked of England, and M. Kerensky expressed an ardent desire that the democracies of England and Russia should be linked by close bonds of sympathy and common effort. [...]

We both went away hopeful, and personally I thought, as I walked down the Nevsky through a snowstorm, that if all went well Russia might actually prove to be an even freer country than England. *9 March 1917*

ZINAIDA GIPPIUS
Poet, novelist and journalist

Kerensky is now the only person who is not on either of the two sides, but exactly where one should be: with the Russian Revolution. He's the only one. Just him. And this is the terrifying thing. He is a man of brilliant intuition, but not a 'fully-rounded' character. Nobody should be alone at this time. And to be the lone voice representing the correct view is absolutely terrifying. Kerensky will either be joined by many more – and more still. Or he too will come tumbling down. *7 March 1917*

ALFRED KNOX
Military attaché at the British Embassy

There is only one man who can save the country, and that is Kerenski, for this little half-Jew lawyer of thirty-one years of age has still the confidence of the over-articulate Petrograd mob, who, being armed, are masters of the situation. *6 March 1917*

Fyodor Chaliapin

FYODOR CHALIAPIN
Opera singer

A.F. Kerensky hurtled back and forth through the long corridors of the Ministry of Justice carrying documents and dropping into various rooms [...] Hard on his heels, even more preoccupied, was a tall, thin man carrying a bottle of milk. He was evidently running after the minister in order not to miss the chance of getting him to drink at least a drop or two of milk.

ALEXANDER BENOIS
Artist, writer and journalist

Our ladies, led by my Akitsa, are in a sort of ecstasy over Kerensky, seeing him as some kind of angel that has descended from the sky – and specifically

an angel of peace.* This enthusiasm is shared by our kitchen staff.

I remember how our girls would jokingly ask Dunya, Motya, Katya, and even the cook Vera Grigorevna, 'Who is our saviour?' and with one voice they would answer excitedly, 'Kerensky!'

MAURICE PALÉOLOGUE
French ambassador

There is nothing more impressive than to see him appear on the platform with his pallid, fevered, hysterical and contorted countenance [...] But what is there behind this theatrical grandiloquence and these platform and stage triumphs? Nothing but utopian fantasies, low comedy and self-infatuation. *26 April 1917*

VLADIMIR BOGORAZ
Anthropologist, writer and revolutionary

The great Russian Revolution fell in love with this 'bright young man' from the very first, when her own young eyes were not yet clouded by cares and her path spread out in majestic celebration through the streets to the shouts of the excited people, and the red swans of newly-sewn banners fluttered in the wind. The celebration was short-lived. And now, two months later, the triumphant procession of the revolution is already turning into a Golgotha [...] We have already heard this terrible admission from Kerensky's lips: 'I regret that I did not die back then – two months ago.' *29 April 1917*

E. VLADIMIROVICH
Social commentator

On 4 May the Russian Revolution took a new turn [...] Kerensky was appointed minister of the army and navy. [...]

He rushed to the front to raise the sunken spirits of the grey mass of soldiery through the power of his oratory, to combat their fatigue, fear and shattered morale. Many thought this was futile and that Kerensky would burn up in these endless trips and fiery speeches. But a miracle occurred! Word conquered deed, and the destructive efforts of dark forces on the front were paralysed by the 'poetry in prose of Comrade Kerensky', as the naysayers and pessimists sarcastically described the war minister's speeches.

NIKITA OKUNEV
Diarist, employee of the Samolyot Shipping Line

Kerensky made an appearance at the Bolshoi Theatre to give a speech at a charitable concert rally and gained yet more laurels for his rousing oratory. His refrain was 'Do not be greedy or cowardly, do not fear freedom, believe in a better life for all'. The theatre held an auction of his signed portraits (just enlarged photographs) and one sold for 15,200 roubles, another for 8,200, a third for 5,000 and a fourth for 1,100. Chaliapin has nothing on that! *27 May 1917*

ALEXANDRA TOLSTAYA
Daughter of Leo Tolstoy, nurse on the North-Western front

A huge crowd of soldiers had gathered. On a high platform, a thin man of about average height in a soldier's overcoat was yelling hoarsely, it was difficult to make out what he was saying. It seemed to me that the orator's words lacked simplicity and conviction in his call for unity to save Russia.

When we returned to our detachment and the doctors were enthusiastically discussing and extolling Kerensky's speech, I remained silent. I felt uneasy. 'Do they really believe that this man can save Russia?' I thought.

VASILY KNYAZEV
Poet and satirist; piece for satirical magazine *Bich* titled 'How Kerensky lives and works'

Comrade Kerensky rises at four in the morning and makes his first speech, addressing the sun: 'It's time to rise up, to break through the dawn!' And so forth. He casually dashes off 224 circulars and 348 decrees, reads through and signs 496 documents, knocks backs several cups of strong coffee and eats three sandwiches. With butter. Ten minutes later Comrade Kerensky is hurtling towards Helsingfors – a Finnish language textbook on his knee. Five minutes more and Comrade Kerensky is beginning to chat fairly fluently in Finnish. Another ten minutes and he gives a speech [...]: 'Comrades in Helsingfors, [...] do you believe in me?' 'We do!' answer the comrades in Helsingfors. 'Do you know that I am prepared every minute to guarantee with my own death my allegiance to democratic ideals?' 'We know!' answer the comrades in Helsingfors. 'Are you with me?' 'We are!' 'Till death?' 'Till death!' *May 1917*

ELENA LAKIER
Diarist, student at the Odessa Conservatoire

I am overwhelmed with joy and happiness... Yesterday was one of the best, most joyful days of my life: Alexander Fyodorovich Kerensky, the hope of all Russia, came – and I saw him! Everyone was in a state of almost religious ecstasy, and the crowd went wild, everyone madly shouting 'Hurrah!' [...]

Many stood and cried, so overcome were they by rapture and adoration. I will never forget the expression on his animated face: concerned, sorrowful, but at the same time immensely kind. And what an enchanting smile he has! [...]

What incredible and totally deserved respect he enjoys. Here's someone who has earned the universal love of the people! I read in one of the papers that portraits of Kerensky can be found in every peasant family, where he's regarded as a saint, they even pray to him [...] Lenin, on the other hand, they identify with the Antichrist, an evil spirit who has sown discord and chaos throughout Russia. Kerensky is Christ, Lenin is the Antichrist: polar opposites. Kind, dear Kerensky, the genius and driving force behind the Russian Revolution. *16 May 1917*

VLADIMIR NABOKOV
Leading member of the Kadets

It is difficult to imagine the effect on Kerensky's mind of being raised to such dizzy heights in the first weeks and months of the revolution. Yet in his heart he must have realised that all the admiration, all the idolisation, was nothing but mass hysteria, that he, Kerensky, neither merited nor had the intellectual or moral qualities to justify such rapturous enthusiasm. But there is no doubt that from the first his whole being was caught up in the role that history by chance had thrust upon him.

L.V. ASSIAR
Pseudonymous journalist and critic

Kerensky was talking to the division troops, explaining to them how the army of a liberated revolutionary people needs to be more powerful than the former army of the tsars. How it should inspire the respect of friends and old enemies. One of the soldiers began to disagree with the minister, and asked him, 'Why do I need land and freedom when I will be killed? We need peace, not freedom.' The soldier's comment fired Kerensky's oratory and he started vividly to expound on the mendacity, depravity and civil irresponsibility of the Bolshevik tendency. Meanwhile the soldier, looking sullenly at the minister, kept interrupting him [...] and finally exclaimed: 'We have to finish the war peacefully!' At which point Kerensky went right up to him and shouted indignantly, 'Be quiet when the war minister is speaking!' There was a long, painful

Alexander Kerensky in the Winter Palace

pause [...] 'Regimental commander, [...] I order you to release this soldier from military service. Send him back to his village and write in the release order that there is no place for cowards in the revolutionary army.' A deathly silence ensued. The soldier went pale, then fell forward, noiselessly, in a deep faint.

ALEXANDER BENOIS
Artist, writer and journalist

Animosity towards Kerensky is growing. The incident with the fainting soldier whom Kerensky labelled a coward particularly maddens Yaremich. I also find this incident unsettling. But I still waver between approving of this talented ham and the worry that suddenly something dangerous might appear beneath the performance, that suddenly Kerensky will turn out to be a simple charlatan – the Gapon of the second revolution, a pawn in the hands of the English, a careerist or someone already corrupted by petty vanity.* *3 June 1917*

ALEXANDER KERENSKY
Minister of war

Then I decided to leave the front and dash back to Petersburg for a few days. On the way, near Polotsk, my train was lucky to avoid a collision: a railwayman had set an engine off towards us from the opposite direction. Our driver was able to slow down in time: my carriage suffered only a badly crushed front platform.

DAILY TIMES ENTERPRISE
American newspaper in Thomasville, Georgia; Associated Press report

A bold attempt to assassinate Minister of War Kerensky was made today at the small town of Polotsk.

A shot was fired at the minister but it missed him.

This information was contained in a brief telegram reaching here this afternoon. *7 July 1917*

NIKITA OKUNEV
Diarist, employee of the Samolyot Shipping Line

There has been an attempt on his life, which fortunately caused him no harm whatsoever, and if anything has wrapped Kerensky in an even greater haze of glory. *7 July 1917*

RUSSKIE VEDOMOSTI
'Russian Gazette', newspaper of the Kadets

Why do they wish to end Kerensky's life? Put this question to a child and he will answer without a moment's hesitation. Who dreams up these evil deeds against the country and against Russian freedom? Yesterday's Bolshevik banners provide an incontrovertible answer to this, with their slogan: 'The first bullet is for Kerensky'.

This time, happily, it was not for Kerensky, and we're not talking about a man's life: thankfully for Russia and for the successful outcome and triumph of that great cause to which he inspires the Russian army, this time it missed. But the same hand will fire another, and this vile intention will find its mark unless you prevent it – you who, behind the party name of socialist, liberal or conservative, have not yet abandoned your Russian identity, your blood connection with the country, your duty to it. Let every honest person in Russia, let the entire country come together in one powerful declaration: down with the Lenins and the Zinovievs, down with the conspirators in the Kshesinskaya Mansion, down with the Kronstadt rebellion, down with anarchy! *7 July 1917*

ALEXANDER AMFITEATROV
Writer, critic and satirist

Citizens, Kerensky will be eaten up here. Yes, save Kerensky! There's a good reason why so many attempts are being made to ensure his political immolation, but that ingenious chef, citizen

Alexander Amfiteatrov

Trotsky, is already in his kitchen pondering how best to prepare and serve up Kerensky: with a sauce à la Cromwell or stuffed à la Bonaparte... Save Kerensky! They'll devour him! *17 June 1917*

IVAN PAVLOV
Physiologist, Nobel prize winner

As for this rotten lawyer, this milksop at the head of state – he will ruin everything! *7 July 1917*

NIKOLAI SUKHANOV
Member of the Executive Committee of the Petrograd Soviet, writer and editor

Now the question that naturally and inevitably arose was that of a dictatorship. Indeed, three days after Kerensky's 'appointment' as prime minister, the Star Chamber appeared before the Central Executive Committee with a demand for a dictatorship. *17 July 1917*

LOUIS DE ROBIEN
Attaché at the French Embassy

I met Kerensky again today, in his khaki uniform (he still does not dare dress like a Cossack), installed like the emperor in the imperial Rolls-Royce, with an aide-de-camp covered in aiguillettes on his left, and a soldier sitting next to the chauffeur [...] The great man of the Russian Revolution is in reality nothing but an inspired fanatic, a case, and a madman: he acts through intuition and personal ambition, without reasoning and without weighing up his actions, in spite of his undoubted intelligence, his forcefulness and, above all, the eloquence with which he knows how to lead the mob. [...]

Nevertheless, for the moment he is the only man on whom we can base our hope of seeing Russia continue to fight the war, so therefore we must make use of him [...] But I fear that he has some terrible disappointments in store for us, in spite of his blustering and in spite of the draconian measures he has proclaimed. And yet, in Russia you never can tell [...] Perhaps the people will lie down like good dogs as soon as they see the stick. *18 July 1917*

FYODOR STEPUN
Philosopher and historian

I think the revolution's cause could only have benefited if Kerensky had exercised his undoubted right to more frequent rest. I am utterly convinced that most of the mistakes Kerensky made were due not to over-confidence and spinelessness, as his enemies maintain, but to a total inability to organise his working day. Anyone who cannot find a single quiet, concentrated hour in the day cannot run the country.

If Kerensky had been an enthusiastic angler he might not have lost Russia to the Bolsheviks. Being able to lead people, particularly through a revolutionary period, is a great art; like all forms of art it requires precise and objective intuition. And intuition is the younger sister of prayer: it thrives on silence and solitude.

ELENA LAKIER
Diarist, student at the Odessa
Conservatoire

I no longer have any hope that things
will end well. Just as earlier I saw
everything through rose-tinted specta-
cles and welcomed the revolution, now
those spectacles are so black that noth-
ing can be seen through them at all. It's
a terrible feeling when your beloved
idol turns out to have feet of clay and
is on the way down. I blindly believed
in Kerensky, but now he makes mis-
take after mistake and I no longer love
and admire him. Today I even wanted
to take his portrait off the wall, but I
didn't have the heart. *25 July 1917*

GENERAL PYOTR POLOVTSOV
Commander of the Petrograd
Military District

Like Boris Godunov, Kerensky has gra-
ciously returned to his subdued boyars.
It looks like he is going to follow in the
footsteps of this famous opportunist
more generally. Moving into the Winter
Palace, into the royal apartments, is
entirely characteristic, although Rago-
zin claims that I am responsible for
this, since it is thanks to me that Palace
Square became the centre of events, and
Kerensky took this into account. One
thing for sure is that he's poking fun at
his own signature, which in his haste
he has shortened to the single letter 'K'
and an illegible tail. Now he says that
'A.K.' is very similar to 'Alexander IV'.

His adjutants have started wearing
aiguillettes modelled on those of aides-
de-camp, and one of them recently
declared, à propos of the flags, that
Kerensky was so bored of 'these red rags'
that he wanted the St Andrew's flag to
be made the national one. Every time
Kerensky leaves the city the red rag
over the Winter Palace is lowered, as
was done previously with the imperial
standard, and the bare flagpole stands
as witness to the Master of the Russian
Land's absence from the capital.

The little red rag on Kerensky's car has
been replaced with a flag of the navy
minister. These are all trivial things, of
course, but trivial things are significant.
And if we are to believe the rumours,
the new Boris Godunov is looking for his
Irina.* His rash separation from his wife
is ill-considered, she apparently is curs-
ing him from the rooftops, saying that
when he was a humble lawyer, she was
good enough, but now, etc. *25 July 1917*

ALFRED KNOX
Military attaché at the British Embassy

Kerenski was still the only individual
who had any hold on the mob, and the
nation was evidently doomed if it failed
soon to produce a bigger man. He had
the theatrical qualities of a Napoleon,
but none of his moral courage or useful
ruthlessness.

E. VLADIMIROVICH
Social commentator

Someone has compared him to Napo-
leon. What an insult to the selfless ora-
tor of freedom! The puffed-up Corsican
who used freedom as a pedestal for his
own personal grandeur, the stocky, cold
book-keeper of revolution who totted it
up to his own advantage – and Kerensky!
[...] Our noble fighter for freedom does
not dream of crowns and ermine robes.

VLADIMIR LENIN
Bolshevik leader; article titled 'The Begin-
ning of Bonapartism' in *Rabochy i soldat*

Let the party tell the unvarnished truth
[...] – that we are living through the begin-
ning of Bonapartism; that the 'new' gov-
ernment of Kerensky [...] is only a screen
to hide the counter-revolutionary Kadets
and war faction; [...] that the people will
not have peace, the peasants will not
have land, the workers will not have an
eight-hour working day, the hungry will
not have bread, without the total liquida-
tion of counter-revolution. *29 July 1917*

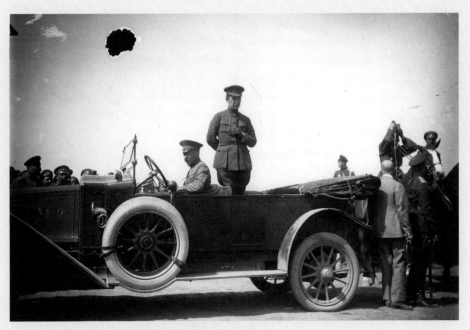

Alexander Kerensky addressing troops from his staff car

ALEXANDER ZHIRKEVICH
Poet, essayist and lawyer

Millions have been wasted reproducing the image of Kerensky and other desecrators of the country – and at a time when the Provisional Government harps on about insufficient resources for the war, and an impending financial crash at home. I can't bear the sight of Kerensky's repulsive mug stuck up in the windows of little shops and kiosks. And yet how enthused I was a while ago by the Provisional Government. I hoped for so much from it, from this new direction! And we've ended up with not just a bubble but a septic boil on the sick and scrawny body of a Russia worn out by suffering, a boil that refuses to burst and which threatens the entire organism of the Russian people with blood-poisoning, i.e. death. *28 July 1917*

ZINAIDA GIPPIUS
Poet, novelist and journalist

It's astonishing: Kerensky has apparently lost all sense of understanding. He is under competing influences. He is open to anything, almost like a woman. His domestic ways have also become corrupt. He has introduced 'courtly' practices, which smack of the worst kind of vulgarity, he's a parvenu (and living in the Winter Palace!). He was never clever, but it seems that even his brilliant intuition has abandoned him as the star-struck honeymoon days have ended, to be replaced by the severe (oh, how severe!) everyday. *9 August 1917*

IVAN BUNIN
Writer, Nobel prize winner

It seems that one of the most harmful people is Kerensky. Harmful to the right and to the left. And they've turned him into a hero. *13 August 1917*

KONSTANTIN PAUSTOVSKY
Writer

Kerensky tore around the country, trying to hammer Russia into shape with his rhapsodic rhetoric. I saw this man with his puffy lemon-coloured face, purple eyelids and crew-cut of fine greying hair on many occasions. He would walk at full pelt, so that the adjutants had to run to keep up. His injured hand, in a black sling, was tucked into the side of his creased military jacket. The jacket lay in folds on his stomach. The brown lacquered gaiters that encased his long thin legs would squeak and gleam in the light. He gave off a hint of valerian, like a hypochondriac old lady. This smell, reminiscent of the stale air of old-fashioned rented apartments, was the give-away.

I soon realised that Kerensky was just a sick man with a heavy dose of 'Dostoevskyism', an actor convinced of his own great messianic duty who was careering headlong into the abyss. He was, it seems, honest in his highly-strung convictions and his devotion to Russia – this hysteric, carried like a featherweight particle on the crest of the first revolutionary wave. *23 August 1917*

Ivan Bunin

Somerset Maugham

W. SOMERSET MAUGHAM
Writer; agent of the British and American secret services

He seemed fearfully on edge. Sitting down and talking incessantly, he took hold of a cigarette-box and played with it restlessly, locking and unlocking it [...] His speech was rapid and emphatic; and his nervousness made me nervous too [...] As the conversation proceeded – he talked on as though he were too tired to stop – something pathetic seemed to arise; I felt sorry for him and I got the idea that his power consisted perhaps in exciting a protective emotion; there was something appealing in him so that you felt inclined to help him [...] The final impression I had was of a man exhausted. He seemed broken by the burden of power. It was easy to understand that he could not bring himself to act. He was more afraid of doing the wrong thing than anxious to do the right one.

BORIS NIKOLSKY
Journalist and lawyer

Kerensky has more important things on his mind than the war. He is divorcing his wife and marrying the actress [Elizaveta] Time.* *25 August 1917*

GENERAL PYOTR POLOVTSOV
Commander of the Petrograd Military District

After his separation everyone was expecting that he would marry the actress Time, towards whom, by all accounts, he had nurtured tender feelings, but it didn't happen. On the contrary, Mme Time printed an indignant denial of such rumours in the papers. Now there are vague reports that Kerensky has consulted the chief procurator of the Holy Synod about the possibility of his marrying one of the tsar's daughters. I mention this gossip just to illustrate the general direction in which people's tongues are wagging.

LOUIS DE ROBIEN
Attaché at the French Embassy

People tell scandalous stories about him, and the latest pretext for these is his divorce, and his re-marriage to one of his sisters-in-law, who is a very young student at the conservatoire. Amongst the people, it is said that he has got divorced to marry the tsar's daughter, and that he is going to become Regent. It's the kind of story they love here, and the Slav imagination is busy embroidering on these fantastic themes [...] We shall see it all later on at the opera with some Chaliapin, or at the ballet with some Karsavina.* *23 August 1917*

ZINAIDA GIPPIUS
Poet, novelist and journalist

Kerensky is a railway car that has come off the tracks. He wobbles and sways painfully and without the slightest conviction. He is a man near the end and it looks like his end will be without honour. *14 August 1917*

General Lavr Kornilov

10
A FIRM HAND

"I have no personal ambition. I only wish to save Russia, and will gladly submit to a strong Provisional Government, purified of all undesirable elements."

EARLY REFORMERS

General Lavr Kornilov (1870–1918), early military renown in Russo-Japanese war; by July 1917 commander-in-chief; accused of attempting to overthrow Provisional Government in August; imprisoned, later escaped and formed Volunteer Army; commanded Whites in Don region; killed in battle at Ekaterinodar in April 1918.

General Alexander Krymov (1871–1917), commander of 3rd Cavalry Corps from April 1917; in August instructed by Kornilov to pacify Petrograd and arrest the Provisional Government; after Kornilov's defeat, committed suicide on 31 August.

Vladimir Lvov (1872–1930), chief procurator of Holy Synod from March 1917; dismissed in July after involvement in negotiations between Kerensky and Kornilov; emigrated in 1920; Trotsky arranged his return in 1922 to lead Bolshevik-sanctioned reforms of Russian Orthodox Church; arrested and exiled to Tomsk in 1927.

RADICAL REVOLUTIONARIES

Nikolai Bukharin (1888–1938), Marxist theorist and economist, Bolshevik Central Committee member; from March 1919 member of Comintern Executive Committee; after Lenin's death in 1924 became full member of Politburo; challenged Stalin over agricultural policy and expelled from Politburo in 1929, later partially reinstated but tried for being 'Trotskyist' and executed in 1938.

OBSERVERS

Nikolai Berdyaev (1874–1948), religious thinker, philosopher and Marxist, professor of philosophy at Moscow University; expelled from Russia in 1922, founded journal *Put* ('The Way') in Paris, and became prominent émigré in France; received honorary doctorate from Cambridge University in 1947.

Mikhail Bogoslovsky (1867–1929), historian, professor at Moscow University, member of Academy of Sciences from 1921; wrote numerous books including a diary of the years of war and revolution.

Marjorie Colt Lethbridge (1882–1957), American-born author of books on Russia including *The Soul of the Russian* and *Russian Chaps*; in 1914 undertook a journey through Russia with British husband Alan Bourchier Lethbridge.

Paul Dukes (1889–1967), studied under conductor Albert Coates at Mariinsky Theatre; asked by tsarist secret police to spy on Bolshevik leaders in summer 1917; in 1918 joined MI6 and was sent back to Petrograd in disguise; became known as 'the man of a hundred faces'; later, correspondent for *The Times*, knighted, wrote books on yoga, and moved to South Africa.

Vladimir Korolenko (1853–1921), short-story writer and journalist, exiled to Siberia for his opposition to tsarist regime; condemned both sides in the civil war; lived in Poltava from 1900 to his death.

Nikolai Punin (1888–1953), art historian, critic and curator, prominent member of pre-revolution avant-garde; became commissar of Hermitage and Russian Museum; from 1918 head of Petrograd Visual Arts department of Narkompros; arrested 1921; in 1930s poet Anna Akhmatova successfully appealed to Stalin for his release; rearrested in 1949 and died in prison camp.

Alexander Zamaraev (dates not known), peasant author of *Diary of Totma Peasant A.A. Zamaraev 1906–1922*; lived in Totma, about 530 miles east of Petrograd.

Enter a new claimant to 'save Russia' from the forces that threaten to overwhelm the country: General Lavr Kornilov, commander of the South-Western front. Kornilov sees the growing insubordination in the ranks and the continuing vacillation of the government as a potentially catastrophic combination. By the middle of July, just before Kornilov's appointment as supreme commander-in-chief of the Russian army, there is a crisis of leadership both in the army and in the government. Various ministers – including Kerensky – resign and then withdraw their resignations.

The new coalition government that emerges on 24 July is significantly more to the left than the previous one, with eleven out of eighteen portfolios held by socialists. Kerensky is perceived as increasingly in hock to the Soviets; in Zinaida Gippius's words, 'he is afraid of them'. In early August Kornilov comes to Petrograd to convince the government to accept the disciplinary measures he outlined on his appointment. A report on this encounter by British journalist Morgan Philips Price describes the general in these terms: 'A wiry little man with strong Tartar features. He wore a general's full-dress uniform with a sword and red-striped trousers. His speech was begun in a blunt soldierly manner by a declaration that he had nothing to do with politics. He had come there, he said, to tell the truth about the condition of the Russian army. Discipline had simply ceased to exist.'

As the summer nears its end, many in Russia's ruling circles are despondent about the direction the revolution has taken. Rumours of civil war and counter-revolution multiply, rumours that are readily propagated by the Bolsheviks for their own ends. Another critical moment for the Provisional Government arrives – for the first time since the revolution, there is a genuine rival to Kerensky. And it's not Lenin.

General Lavr Kornilov

GENERAL LAVR KORNILOV
Commander of the Eighth Army;
telegram to Kerensky on being appointed
commander, South-Western front

An army of ignorant men, which has
lost its mind, which was not protected
by the government from systematic
depravity and corruption, which has
lost all feeling of human dignity, is
on the run [...] This calamity can be
brought to an end and this shame wiped
out by the revolutionary government,
but if it fails to do so it will be replaced
in the inexorable march of history by
other leaders, who, whilst removing the
dishonour, will at the same time destroy
the fruits of the revolution and hence
will not bring happiness to the country.
There is no choice: the revolutionary
government must adopt a definite and
firm course. *7 July 1917*

VLADIMIR KOROLENKO
Short-story writer and journalist

Yet another monstrosity lies in wait for
us on this path, one that is designated
by another foreign word that Russia, in
its misfortune, will have to get to know.
That word is anarchy. *18 July 1917*

ZINAIDA GIPPIUS
Poet, novelist and journalist

Every day everything gets worse.
 The crisis in the government has now
reached its peak...
 The monstrosities and desertions at
the front continue [...] What an unhappy
country. God has truly punished her,
made her lose her mind. And where are
we heading? Only to starvation or into
the hands of the Germans... What a
future that is! *26 July 1917*

MIKHAIL BOGOSLOVSKY
Historian, professor at Moscow University

The ladies in the dacha next door are
starting to get anxious at night, they're
afraid of being burgled, they sleep badly.
Rumours of robberies circulate all over
the countryside. Even in Moscow, when
you go into a shop, café or bank you're
likely to witness some form of expropria-
tion. There's danger wherever you are.
This is anarchy in its purest form – and
under socialist rule! [...] The wonderful
weather continues, it's baking hot in the
sun. The Volga is still and calm as a mir-
ror. Amber leaves are already glowing on
the trees. *8 August 1917*

PROVISIONAL GOVERNMENT
Announcement in *Rech* newspaper

The commander of the South-Western
front, General Kornilov, is made supreme
commander-in-chief. War commissar of
the South-Western front, Savinkov, is
made deputy minister of war, with the
duty of standing in for Kerensky during
his absence from Petrograd. *18 July 1917*

GENERAL LAVR KORNILOV
Commander, South-Western front;
telegram to Kerensky

As a soldier, whose duty it is to set an
example of military discipline, I am
obeying the order of the Provisional
Government appointing me supreme
commander. But now, as supreme com-
mander and citizen of free Russia, I must
declare that I shall keep this office only
as long as I shall be conscious of being

useful to the fatherland and of helping to consolidate the existing order. Therefore I declare that I am accepting the command on the following conditions: (1) I shall be responsible to my own conscience and to the whole nation; (2) I shall have full freedom from interference in operational orders and hence in the appointment of senior commanders; (3) measures adopted at the front shall be extended to those regions of the rear where the army reserves are stationed; (4) the acceptance of my recommendations shall be communicated by telegraph to the supreme commander for the conference at Army Headquarters on 16 July.

General Pyotr Polovtsov

GENERAL PYOTR POLOVTSOV
Former commander of the Petrograd Military District

Internal politics remain in a state of chaos, but everyone is now looking to the front in the hope that Kornilov will save the situation.

GENERAL LAVR KORNILOV
Supreme commander-in-chief; evidence given to the Investigative Commission on 2–5 September

I declared the necessity of extending the law on the death penalty and revolutionary courts martial to the interior of the country on this basis: that no measures aimed at restoring the fighting capacity of the army could succeed while the army continued to receive reinforcements from the rear in the form of slack, uneducated, propagandised soldiers, capable of contaminating even the strongest fighting units. In the same telegraph I declared the necessity of restoring discipline among the leadership, restricting the sphere of activity of army committees, [...] banning meetings by law, banning newspapers with extreme views and, finally, banning the admission of any kind of deputations, delegations or agitators.

IZVESTIA
Menshevik and Socialist Revolutionary newspaper; article titled 'The demands of General Kornilov'

General Kornilov's report made a deep impression on the members of the government. Some of his recommendations, especially the one about capital punishment in the rear, met determined opposition from a majority of the ministers. These questions will be resolved in the near future. *5 August 1917*

ZINAIDA GIPPIUS
Poet, novelist and journalist

I can imagine how the 'comrades' will howl! (And Kerensky is afraid of them, this must be remembered.)

They will howl, because they will discover in this a fight against the Soviets – that hideous, abnormally developed phenomenon, that breeding place of Bolshevism, a phenomenon before which even now the democratic leaders and sub-leaders, non-Bolsheviks, reverently

bow [...] They will be right: it is a fight against the Soviets, although openly nothing is said in the report about the destruction of the Soviets...

And still it is (at last!) a fight against the Soviets. And what else could it be, if there is to be a real, serious fight with the Bolsheviks? *10 August 1917*

YULY MARTOV
Leader of the Menshevik Internationalists

I do not understand why shooting on the streets of Petrograd should lead to the reintroduction of the death penalty at the front. Nobody's explained that to us. But for a socialist, avoiding this question is not an option. We do not want anyone in Europe or Russia to be able to accuse Russian socialists of keeping quiet while the death penalty was being reintroduced. We need an answer to this: whether it is in the revolution's interests or for other reasons that Kornilov has called for the introduction of the death penalty at the front and behind the lines. *18 August 1917*

PETROGRADSKAYA GAZETA
Newspaper report

The Internationalists and Bolsheviks are such kindly souls: they've opposed the death penalty. Comrade Tsederbaum [Martov] has declared outright: 'The death penalty is unacceptable, not only for a socialist but for every true democrat.' It's strange, though, that many 'true democrats' continue to call for the 'slaughter of the bourgeois'. Maybe they consider this not so much an execution as a minor operation that's beneficial for the health. *20 August 1917*

BORIS SAVINKOV
Deputy minister of war

At Army Headquarters I found General Kornilov in a state of extreme irritation at Kerensky's indecisiveness and hesitant, ill-defined policies. General Kornilov told me that he can no longer serve a government headed by the 'spineless' Kerensky and whose members included the 'poorly prepared' Avksentev and the 'dubious' Chernov.

General Lavr Kornilov with Deputy Minister of War Boris Savinkov

In response I took from my briefcase the draft of a law, all prepared though not signed by Kerensky, reinstating the death penalty behind the lines, and I informed General Kornilov of Kerensky's decision to declare Petrograd and the surrounding area under martial law. I put forward the case for despatching a cavalry corps so that this might actually be implemented. General Kornilov gave these measures his full appreciation... He asked me to tell Kerensky [...] that whatever his personal relations might be with the prime minister, he, General Kornilov, was prepared to serve the Provisional Government loyally for the good of the country.

22 August 1917

VLADIMIR LVOV
Chief procurator of the Holy Synod, former member of the Duma; under interrogation on 14 September

I left for Petrograd on 22 August and went to see Kerensky. I set before him the state of affairs, and explained that in the event of an attack by the Bolsheviks the government was defenceless; in order to strengthen it he must supplement its ranks with members of groups in society that were as yet unrepresented [...] I convinced him not to turn down the opportunity to prepare the ground for negotiations. Kerensky replied that in order to negotiate it was essential to have definite demands and definite programmes, and he did not refuse my suggestion to mediate for such negotiations.

GENERAL LAVR KORNILOV
Supreme commander-in-chief; evidence given to the Investigative Commission on 2–5 September

Coming into my office, Lvov immediately declared, 'I am here on Kerensky's instructions.' I stress that it was not me who sent Lvov – for I had not seen him since April and didn't know him well enough – but Lvov who came to me from Kerensky. [...]

After outlining the general position of the country and the army [...] I told him that it was my profound belief that the only way to rescue the country from the present grievous situation was to establish a dictatorship and immediately declare the country under martial law.

I told him that I personally did not aspire to power and that I was ready to submit immediately to whoever would receive dictatorial authority, whether this was Kerensky himself, General Alexeev, General Kaledin or someone else.* Lvov replied that given the dire situation the country found itself in, it could not be discounted that the Provisional Government itself would come to see the need for establishing a dictatorship, in which case it was entirely possible they would offer me the position of dictator. I said that if this happened, having always held the view that only firm government could save the country, I would not decline the offer.

VLADIMIR LVOV
Chief procurator of the Holy Synod, former member of the Duma; under interrogation on 30 August

During our conversation Kornilov told me that the Provisional Government could always rely on his support. I asked him to set out his defined programme and demands, since I had been authorised by Kerensky to find out the mood of various groups in society. Kornilov asked me to come back before ten the following morning. When I arrived, he set out the following demands: (1) the declaration of martial law in Petrograd; (2) the transfer of all military and civil power to the supreme commander, regardless of who that might be. On this second point Kornilov added that a combination of the supreme command and the leadership of the Provisional Government might be possible.

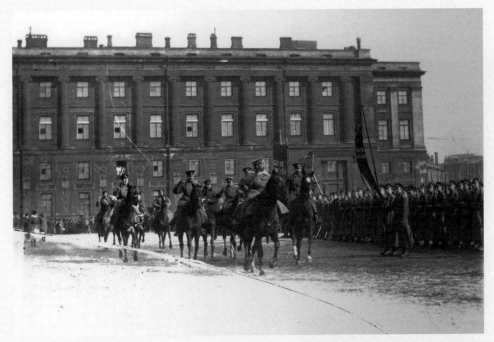

General Lavr Kornilov inspecting troops on Palace Square in Petrograd

ALEXANDER KERENSKY
Prime minister; evidence given to the
Investigative Commission on 8 October

[Lvov] told me all this orally and demanded a categorical response. I replied:
'Vladimir Nikolaevich, you must understand that if I go to the Provisional
Government and declare that this is the
state of affairs, no one will believe me:
they'll take me for a madman or they'll
send someone to check whether Kornilov really did make that declaration
or did give that order. And I'll be in
an absurd position.'

Vladimir Lvov

VLADIMIR LVOV
Chief procurator of the Holy Synod,
former member of the Duma; under
interrogation on 14 September

When Kerensky said that he was at a
loss as to what to tell the Provisional
Government, I went up to the desk,
wrote down Kornilov's three concrete
proposals on a piece of paper, signed it
and gave it to Kerensky. They were not
demands, there was no ultimatum.

VLADIMIR LVOV
Chief procurator of the Holy Synod,
former member of the Duma

General Kornilov is proposing:
1. The declaration of martial law in
 Petrograd;
2. The transfer of all power in its
 entirety, military and civil, to the
 commander-in-chief;
3. The resignation of all ministers, including the prime minister, and the
 handover of interim control of the
 ministries to deputy ministers, until
 the commander-in-chief has formed
 his cabinet. *26 August 1917*

BORIS SAVINKOV
Deputy minister of war

Without a word, Kerensky held out a
piece of paper covered in writing to me.
I read it and could not believe my eyes.
The gist of it was that the commander-
in-chief was ordering the immediate
transfer of complete military and civil
authority to himself. The signature of
V. Lvov was beneath this ultimatum.

ALEXANDER KERENSKY
Prime minister

At about 10 p.m. I had Vladimir Lvov
arrested and placed under guard in one
of the palace rooms.
 I proceeded immediately to the Malachite Chambers, where the cabinet was
in session, reported on Lvov's approach
to me, and read aloud his memorandum
and the verbatim text of my conversation with Kornilov. Then I said that the
mutiny must be crushed, and that, in
my opinion, it could only be done if I
were invested with full powers. I added
that this might necessitate some
changes in the cabinet. After a brief
discussion, it was resolved to 'transfer
all power to the prime minister in order
to put a speedy end to the anti-government movement launched by General
Kornilov, the supreme commander.'

GENERAL PYOTR POLOVTSOV
Former commander of the Petrograd Military District

Around midnight on Saturday Tumanov comes hurtling up, pulls me out of bed and tells me that Kerensky wants to see me immediately at the Winter Palace.* We get in the car. Tumanov says that Kornilov is heading for Petrograd with two cavalry corps and he asks whether I will agree to take on the command of Petrograd's forces again, to defend the capital against this counter-revolutionary incursion [...] I don't know whether the suggestion has come from Kerensky himself or the Young Turks, but I reply that whatever the situation I will under no circumstances go against Kornilov, and I add that all my work with the Petrograd armed forces has now been ruined, and they will overwhelmingly fall back into the hands of the Soviet. *26 August 1917*

ZINAIDA GIPPIUS
Poet, novelist and journalist

The boil of enmity has burst. Kerensky's enmity towards Kornilov, that is (not vice versa). The aggressor is Kerensky, not Kornilov. *26 August 1917*

ALEXANDER KERENSKY
Prime minister; radio-telegram distributed around the country and published in *Rech*

On 26 August General Kornilov sent to me State Duma deputy Vladimir Nikolaevich Lvov with a demand that the Provisional Government surrender all civil and military power so that he may, at his personal discretion, form a new government to administer the country. The authenticity of the Duma deputy's authority to make such a proposal to me was subsequently confirmed by General Kornilov in a conversation with me by direct wire. [...]

The Provisional Government has found it necessary to authorise me, for the salvation of our motherland, of liberty, and of our republican order, to take prompt and resolute measures for the purpose of uprooting any attempt to encroach upon the supreme power in the state and upon the rights which the citizens have achieved by the revolution. [...]

At the same time I order herewith:
1. That General Kornilov surrender the post of supreme commander-in-chief to General Klembovsky, commander, Northern front. [...]
2. That the city and district of Petrograd be placed under martial law, subject to all wartime regulations. *27 August 1917*

GENERAL LAVR KORNILOV
Supreme commander-in-chief; telegram transmitted across the country and as copy for newspapers

The entire first part of the prime minister's telegram no. 4663 is a lie from beginning to end. It is not I who sent V.N. Lvov, member of the Duma, to the Provisional Government, but it was the prime minister who sent him to me as his emissary [...] This has resulted in a great provocation which threatens the fate of the country.

People of Russia, our great country is dying. Her end is near. Forced to speak openly, I, General Kornilov, declare that the Provisional Government, under pressure from the Bolshevik majority in the Soviets, is acting in complete harmony with the German General Staff. *28 August 1917*

NIKOLAI SUKHANOV
Member of the Executive Committee of the Petrograd Soviet, writer and editor

Sunday 27 August marked the end of six months of revolution. It was a rather wretched anniversary [...] I went to the Petersburg side to the Cirque Moderne, where Lunacharsky was giving a lecture on Greek art. A huge working-class audience was listening with great interest to the popular speaker and his unfamiliar stories [...] We wandered about the streets and embankments for a long time, talking about aesthetics and

'culture' [...] There was already a breath of autumn in the air. An unforgettable summer was coming to an end, the sun set early beyond the sea. We could not have admired our marvellous Petersburg more... The phone rang. It was someone from Smolny [...] 'Kornilov is moving on Petersburg with troops from the front. He's got an army corps. Things are being organised here...' I dropped the receiver. In two minutes Lunacharsky and I had already left for Smolny.

ELENA LAKIER
Diarist, student at the Odessa Conservatoire

Is this really all going to end in civil war? So much for the bloodless revolution! *27 August 1917*

GENERAL LAVR KORNILOV
Supreme commander-in-chief; 'Appeal to the people to be circulated in all cities and on all railways'

I, General Kornilov, supreme commander-in-chief, declare before the whole nation that my duty as a soldier, as a self-sacrificing citizen of free Russia, and my boundless love for my country oblige me at this critical hour of the fatherland's existence to disobey the orders of the Provisional Government and to retain supreme command over the army and navy.

I am supported in this decision by all the front-line commanders, and declare to the Russian people that I prefer to die rather than give up my post of supreme commander-in-chief.

A true son of Russia remains at his post to the end and is always ready to make for his country the greatest of all sacrifices, which is his life. [...]

People of Russia, shake off your madness and blindness and look into the bottomless pit into which our country is rushing.

Desiring to avoid all collision, all shedding of Russian blood in civil war, and forgetting all insults and injuries, I, in the presence of the whole nation, say to the Provisional Government: come to Army Headquarters where your safety and freedom are guaranteed by my word of honour, and together we will work out and form a government of national defence, which by assuring victory will lead the Russian people to that great future, worthy of a free and mighty people. *28 August 1917*

GENERAL LAVR KORNILOV
Supreme commander-in-chief; telegram to the Cossack regiments

Dear Cossacks!

Was it not on the bones of your ancestors that the boundaries of the Russian state expanded and grew? Was it not through your mighty valour, your great deeds, sacrifices and heroism, that Great Russia became strong?

You, the free, liberated sons of the quiet Don, the fair Kuban, the tumultuous Terek, the migrating, powerful eagles of the Urals, the Orenburg, Astrakhan, Semireche and Siberian steppes and mountains and the ranges of Transbaikal, Amur and Ussuri – you have always guarded the honour and glory of your flags, and the Russian land is full of the legends of your fathers' and grandfathers' great deeds. [...]

I will not comply with the Provisional Government's orders, and in order to save Free Russia I am going against the government and against its unaccountable advisers who are betraying the motherland.

Cossacks, defend the honour and glory of the valiant Cossack people, which is unequalled. And by doing this you will save the motherland and the freedom won by the revolution.

So I ask you to follow my orders. Follow me now. *28 August 1917*

DEN
'Day', Menshevik newspaper

By order of the Provisional Government, special appeals have been printed in 37 Caucasian dialects in order to admonish the Caucasian division that is opposing the Provisional Government in league with Kornilov. The appeals spell out the current state of affairs and warn the

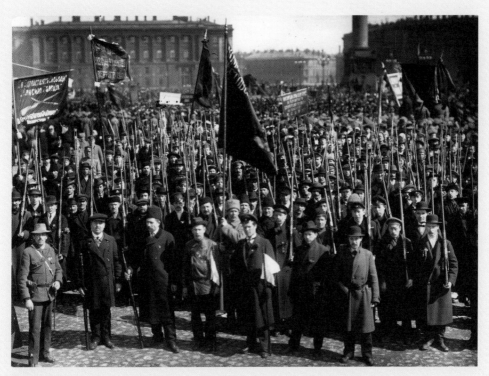

Bolshevik Red Guards, armed to face an attack by General Kornilov's troops

mountain dwellers of the consequences that could ensue from Kornilov's reckless adventure. *30 August 1917*

PITIRIM SOROKIN
University professor, member of the Socialist Revolutionary Party

There has been feverish activity in the Soviet. A Supreme Committee against Counter-revolution has been elected, made up of 22 members, and I'm of their number. It was entirely predictable that the Soviet would include several Bolsheviks on the committee, and we're faced with the awkward situation of having to work alongside the reds against the patriots. The first thing the Bolshevik members demanded was the release from prison of their comrades: Trotsky, Kollontai and others. *27 August 1917*

LOUIS DE ROBIEN
Attaché at the French Embassy

Last night I was called to the embassy by telephone, with the news that General Kornilov had announced the fall of the Provisional Government and was marching on Petrograd [...] The facts of the situation are: Kornilov had informed Kerensky through the intermediary of M. Lvov, that in view of the danger which threatened the country, he had decided to take over as dictator, and that he was offering him the office of minister of justice in the new government. Naturally, the vain and sensual petty lawyer, who believes himself to be the master of Russia because he sleeps in the emperor's bed, could not resign himself to taking his hand out of the till: he answered by having M. Lvov arrested and declaring Kornilov 'a traitor to the fatherland'. *28 August 1917*

GENERAL PYOTR POLOVTSOV
Former commander of the Petrograd Military District

Kornilov's chances of success are great. Not just the Georgievsky Regiment and the Junkers, but even the Preobrazhensky and Semyonovsky Regiments are anti-government. The hopes of the counter-revolutionaries are high, especially when artillery fire is suddenly heard, but then it transpires that the firing from the fortress is just a flood alert. *28 August 1917*

SERGEI PROKOFIEV
Composer

On the 28th, when I went out to the station for the newspapers and returned home, I disposed myself comfortably on the sofa to read them only to be stunned by the news that Commander-in-chief General Kornilov was moving up on Petrograd from the south to overthrow Kerensky, while troops loyal to Kerensky had left Petrograd to meet and crush Kornilov. Internecine war – and fate had plunged me into the epicentre of the action. What would happen next? *28 August 1917*

ALEXANDER ZAMARAEV
Peasant diarist from Totma, Vologda Province

I went into town, wanted to buy some sugar, but the town shop wouldn't sell me any, and in our peasants' store there wasn't any. At the front General Kornilov is marching on Petrograd, every day it just gets worse and worse. *30 August 1917*

NIKOLAI PUNIN
Art historian and writer

A night of deepest alarm. The city is deserted, and there's no telling what the thousand talking, newspaper-reading, whispering, but in the end mysteriously silent people are thinking. Terrifying depth. Kornilov is just outside Petrograd. With 8,000 men, 100,000 men. He's in Dno, he's in Pavlovsk. General Kornilov – in how many hearts in Petrograd is that name echoing with joy, and in how many does it evoke loathing, fear, curses? And who can tell one from the other? In the crowd on the corner of Nevsky by the newspaper sellers? Oh, how many are looking sullenly on, how many are secretly praying?

Nikolai Punin

now effectively linked [...] is equally obvious; and that the whole thing hangs on the army and the railways is certain [...] Kornilov can be assured of the officers and command, but what about the infantry? If the Bolsheviks are brought to heel, then success is possible; but the uprising has been conceived on too small a scale to hold out promise of anything permanent. *28 August 1917*

GEORGY PLEKHANOV
Marxist theorist

In the natural course of events Russia should be joyfully and noisily celebrating the six-month anniversary of its revolution now. But it is in no mood for celebration. Events are taking a truly tragic turn [...] As well as the enemy's advance towards Petrograd, we have the threat of civil war. What do I mean, threat! Civil war is already upon us. *29 August 1917*

ALEXANDER KERENSKY
Prime minister; telegram to General Alexander Krymov, commander of the cavalry advancing on Petrograd

In Petrograd complete calm. No disturbances expected. There is no need for your corps. The Provisional Government holds you personally responsible and commands you to stop the advance on Petrograd ordered by the now dismissed commander-in-chief. *29 August 1917*

ZINAIDA GIPPIUS
Poet, novelist and journalist

The 'bloodletting' did not come to pass. The divisions sent by Kornilov met the 'Petrograders' outside Luga and in some other places. They lined up tentatively on opposing sides.

Particularly unsure of themselves, the Kornilovites who had been sent 'to defend the Provisional Government' encountered an 'enemy' that had also been sent 'to defend the Provisional Government'. So they stood around and thought it over; not reaching any particular conclusion, they remembered

'Death to the traitor, the betrayer. It was not for nothing that the Germans let him out', a soldier declares suddenly and directly. The people are silent, strangely silent, won't look the soldier in the eye, still trying to guess how many troops are under General Kornilov's command.

I'm not sleeping at home with my wife, I am sleeping in my own room (Galya has left town). Getting ready for bed, I loaded my revolver. Loneliness, longing, suffering, Russia... I expect a battle on the streets in the morning, listen anxiously to even the slightest rumble – is it a cannonade? The wind howls; today there is a terrible west wind. How many days, hours will I live? *28 August 1917*

BORIS NIKOLSKY
Journalist and lawyer

The challenge is set. All the Kerenskys, Ckheidzes and others will scatter like dust, I'm sure of it. The centre of the uprising, the focus of the incursion, is undoubtedly Petrograd; that the Bolsheviks are de facto the only power in Petrograd is also clear; that they are not in a state to take any decisive action is obvious; that Kerensky and Lenin are

the lessons they'd learnt from propagandists on the front: 'fraternise with the enemy'. This they did. Avidly. *30 August 1917*

GENERAL ALEXANDER KRYMOV
Commander of the 3rd Cavalry Corps, supporter of General Kornilov; last recorded words before shooting himself

The last card for saving the motherland has been beaten – living is no longer worthwhile. *31 August 1917*

BERTIE STOPFORD
Anonymous author of *The Russian Diary of an Englishman*

It is all over! Kornilov has failed. How it happened we don't know yet, but today he is to be brought to Petrograd under arrest. If he had succeeded – as he ought to have done, once he had embarked on so important an undertaking – we should have had order restored [...] The failure of Kornilov has completely knocked me over, and yesterday I could not walk. I still foresee an ocean of blood before order comes. *31 August 1917*

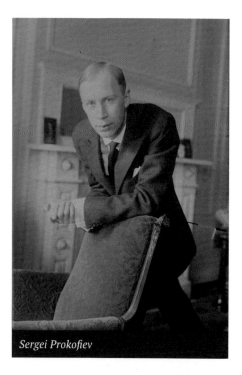

Sergei Prokofiev

SERGEI PROKOFIEV
Composer

I am neither a counter-revolutionary nor a revolutionary. I am on neither side. But I could not help regretting that Kornilov's enterprise had faded away to nothing: it had about it a whiff of romanticism.

BORIS NIKOLSKY
Journalist and lawyer

The population is entirely indifferent. There is only one phrase on anyone's lips: we don't care. We don't care whether it's Kerensky or Kornilov, as long as there is order, as long as there is calm, as long as there is food. And yet on the other hand the mood is fearful, anxious and nervous. *29 August 1917*

MARJORIE COLT LETHBRIDGE
Letter to the editor of *The Times*

Sir, As a personal friend of General Korniloff [...] may I thank you for your leading article of this morning's date? Those who label General Korniloff as a traitor to his country are traitors themselves [...] As an individual, he has a strong personality – the personality of a Cossack [...] Russia will be saved by a strong, clean, straightforward individual, unswerved by all petty, passing passions which temporarily influence the emotional mind. Such a man is General Korniloff.

Yours very truly, Marjorie Colt Lethbridge, 15 Cambridge Terrace, Hyde Park. *30 August 1917*

PAUL DUKES
Letter to the editor of *The Times*

Sir, A letter in your yesterday's issue from Mrs Lethbridge appears to suggest that General Korniloff is the sole patriot in Russia at the present moment. The fact is that so far as genuine patriotism [...] is concerned, there is absolutely no choice to be made between Korniloff and Kerensky [...] The truth is that Kerensky and Korniloff are equally

necessary for the salvation of Russia. Each is incomplete without the other. They are two utterly unselfish men both striving for the same goal, but along different paths.

Yours, Paul Dukes, 2 Bethune Avenue, Friern Barnet. *31 August 1917*

ALEXANDER KERENSKY
Prime minister

Early on 30 August, Vyrubov and I paid a visit to General Alexeev at his apartment.* We were determined to persuade him to do his duty by arresting General Kornilov and his accomplices and by assuming the supreme command. Our arrival provoked the general to a fierce emotional outburst. Finally he began to calm down, and he leaned back in his armchair and closed his eyes.

I waited a few moments and then said quietly: 'But what about Russia? We must save the country.'

He hesitated, and then replied almost inaudibly: 'I am at your disposal. I accept the post of chief of staff under your command.'

I was at a loss for an answer, but Vyrubov whispered: 'Agree.' And so I became commander-in-chief.

ANATOLY LUNACHARSKY
Leading Bolshevik; letter to his wife Anna

My dear girl,

We have won. Our victory is having an impact on everything. The whole position of our party has notably improved. The revolution is full of surprises. On this occasion the surprise was a good one. And, truth to tell, I was already prepared to 'bid farewell to precious life'. I hadn't the least intention of avoiding the battle. The political situation is uncertain, but there is a clear movement to the left. Tomorrow are the Duma elections. I'll almost certainly get in as assistant to the mayor. A new life will begin, and a totally new kind of work. I'm sending you a few cuttings and a thousand kisses. Give a kiss to Toto.

Your rested and restored Papa*
31 August 1917

RUSSKOE SLOVO
'Russian Word', newspaper supportive of the Provisional Government; article titled 'What awaits General Kornilov'

It is reported that the Provisional Government has been giving serious attention to the question of which court Generals Kornilov, Denikin, Markov, Lukomsky and others should be committed to on charges of rebellion. The argument has centred on whether the generals should be tried in a special court or the revolutionary court martial that operates at the front [...] As for what sentence might await them, I can say with certainty: the death sentence.
1 September 1917

NIKOLAI BERDYAEV
Political and religious philosopher

The tragic events linked with the name of General Kornilov suggest that we continue to live in an atmosphere of duplicity and murkiness. The forces currently ruling over the Russian state are just as incapable of enduring truth and light as those that ruled under the previous regime. The old government existed, towards the end, in constant fear of revolution; the new one lives with the equally pervasive fear of counter-revolution. Even after the upheaval that was supposed to liberate us we are still choking on murky lies. Freedom of thought and freedom of speech are suppressed. It is only too clear to honest people that the accusations against General Kornilov are built on monstrous falsehood, deceit and confusion. The whole of Russia must, before anything else, demand explanations of fact and truth, which must never be sacrificed in the name of anything on this earth.
2 September 1917

JOSHUA BUTLER WRIGHT
Counsellor at the American Embassy

There is slowly developing a most interesting story of the Kornilov-Kerensky affair which – notwithstanding apparent pressure and censorship – is also creeping into the daily papers here and especially

in Moscow. It is freely rumoured that when the truth is known the story will rival the exposé in the Dreyfus case in France and that Kerensky is purposely postponing Kornilov's trial as long as possible.* I have yet to find one sensible patriotic Russian either here or in Moscow who looks upon Kornilov as at all a traitor, rather as a man who was willing to sacrifice everything, even his reputation and perhaps his life, to save his country from a humiliating and intolerable situation. *6 October 1917*

Nikolai Bukharin

NIKOLAI BUKHARIN
Bolshevik theorist

'Kuban Cossacks put Kerensky forward for the position of Patriarch of All Russia' (*Volny Don*, no. 128). 'The News of the All-Russian Soviet of Parochial Councils' writes that in this regard 'it is not entirely clear whether the prime minister will agree to the proposal, but in all likelihood he will not refuse if it is possible to combine it with his position as supreme commander-in-chief'. This isn't, believe it or not, a story from the 'Town of Stupid' but actual present-day reality. As we know, citizen Kerensky is head of state and supreme commander-in-chief. His outrageous meddling in the judicial investigation into Kornilov, with whom he was himself in secret agreement, has shown that Kerensky is not averse to the idea of becoming chief justice. Now the role of high priest comes along to join the merry throng of titles. What is this if not caesaropapism reborn in the highest degree? What is it if not the revival of autocracy in its vilest, priestly form? *10 October 1917*

RECH
'Speech', newspaper of the Kadets, supportive of the Provisional Government

What are the probable results of the Kornilov affair? This is the question everyone is asking. It is generally agreed that the Bolsheviks will make use of it for their own ends. *31 August 1917*

VLADIMIR LENIN
Bolshevik leader; letter to the Bolshevik Central Committee

The Kornilov revolt is a most unexpected (unexpected at such a moment and in such a form) and downright unbelievably sharp turn in events.
 Like every sharp turn, it calls for a revision and change of tactics. And as with every revision, we must be extra-cautious not to become unprincipled. [...]
 What, then, constitutes our change of tactics after the Kornilov revolt?
 We are changing the form of our struggle against Kerensky. Without in the least relaxing our hostility towards him, without taking back a single word said against him, without renouncing the task of overthrowing him, we say that we must take into account the present situation. We shall not overthrow Kerensky right now. We shall approach the task of fighting against him in a different way, namely, we shall point out to the people (who are fighting against Kornilov) Kerensky's weakness and vacillation. [...]

It would be wrong to think that we have moved farther away from the task of the proletariat winning power. No. We have come very close to it, not directly, but from the side [...] Now is the time for action; the war against Kornilov must be conducted in a revolutionary way, by drawing the masses in, by arousing them, by inflaming them (Kerensky is afraid of the masses, afraid of the people). *30 August 1917*

ZINAIDA GIPPIUS
Poet, novelist and journalist

Kerensky is a mad autocrat and now also a slave of the Bolsheviks. And Bolsheviks without a single exception can be broken down into the following:
1. Witless fanatics;
2. Congenital idiots, ignoramuses and savages;
3. Certified rascals and German spies.
Nicholas II was a stubborn autocrat... Both situations have the same conclusion – fiasco. *1 September 1917*

General Lavr Kornilov and his accomplices under arrest after the failure of his rebellion; Kornilov is in the centre numbered 1

*A room in the Winter Palace after
the storming on 25 October*

11

ANATOMY OF A COUP

"Our victory is assured, for the people are now very close to desperation."

EARLY REFORMERS

General Nikolai Dukhonin (1876–1917), chief of staff, then commander-in-chief in final weeks before October Revolution; brutally killed by mob of soldiers and sailors in November 1917.

Nikolai Kishkin (1864–1930), Kadet minister of health in Provisional Government, arrested in Winter Palace on 26 October; one of the leaders of famine committee for Volga region in 1921; arrested for anti-Soviet activity but released; from 1923 worked in Commissariat of Health.

Alexander Konovalov (1875–1949), leading industrialist, minister of trade and deputy prime minister in Provisional Government; arrested in Winter Palace on 26 October; emigrated to France in 1918, prominent in several émigré organisations.

PROGRESSIVE REVOLUTIONARIES

Nikolai Avksentev (1878–1943), leading member of Socialist Revolutionary Party, minister of internal affairs in Provisional Government; president of anti-Bolshevik Ufa Directorate from September to November 1918; exiled to China, later emigrated to France and USA.

Delo naroda, 'People's Cause', newspaper of Socialist Revolutionary Party, published in Petrograd, Samara and Moscow between March 1917 and March 1919.

Captain Yakov Kharash (dates not known), Twelfth Army officer, Menshevik, Provisional Government commissar in the armies on Northern front.

Lev Khinchuk (1868–1939), Menshevik chairman of Moscow Soviet; split from Mensheviks in 1919, joined Communist Party; USSR trade representative in UK and Germany 1926–34; executed in 1939.

Alexander Liverovsky (1867–1951), engineer, minister of transport in Provisional Government, arrested in Winter Palace on 26 October; worked as lighthouse signalman in Sochi before resuming academic career.

Pavel Malyantovich (1869–1940), minister of justice in Provisional Government, arrested in Winter Palace on 26 October; prominent defence barrister in Soviet period; executed in 1940 aged 70.

Semyon Maslov (1873–1938), minister of agriculture in Provisional Government, arrested in Winter Palace on 26 October; worked as academic and economist, arrested several times (once through mistaken identity), executed in 1938.

Grigory Shreider (1860–1940), mayor of Petrograd and prominent Socialist Revolutionary; vehement opponent of Bolshevism; after Whites' defeat emigrated to Europe, remained politically active until his death.

Admiral Dmitry Verderevsky (1873–1947), minister of navy in Provisional Government, supported ending war; arrested in Winter Palace on 26 October; emigrated in 1918; lived in France, took Soviet citizenship in 1946.

Volya naroda, 'Will of the People', newspaper of right wing of Socialist Revolutionary Party, published after February Revolution; entire editorial board arrested on 2 January 1918.

RADICAL REVOLUTIONARIES

Vladimir Antonov-Ovseenko (1883–1938), secretary of Petrograd Military Revolutionary Committee, led storming of Winter Palace; Red Army commander in civil war; later, diplomat; accused of belonging to 'Trotskyist organisation' and executed in 1938.

Nikolai Podvoisky (1880–1948), chairman of Petrograd Military Revolutionary Committee, led storming of Winter Palace; people's commissar for military affairs, instrumental in creation of Red Army; played himself in Eisenstein's 1927 film *October*.

OBSERVERS

Sergei Kablukov (1881–1919), secretary of St Petersburg Religio-philosophical Society from 1909 to 1913; friend of poet Osip Mandelshtam.

Velimir Khlebnikov (1885–1922), founder of Russian Futurist movement, with fellow poet Alexei Kruchenykh created 'trans-sense' language aimed at liberating sound from meaning; in 1912 predicted collapse of empire in 1917.

Pierre Pascal (1890–1983), lieutenant in French military mission in Petrograd; welcomed Bolshevik seizure of power and became Soviet citizen; later disavowed communism and returned to France in 1933 where he became respected academic and translator.

John Reed (1887–1920), American journalist and left-wing activist, author of *Ten Days that Shook the World*; with wife Louise Bryant posted dramatic reports of the revolution; on return to New York arrested for 'anti-war' articles; later helped to form US Communist Party; returned to Russia in 1920 where he died of typhus; given state funeral and buried in Kremlin wall.

Arthur Woodhouse (1867–1961), British consul in Petrograd in 1917, remained after British ambassador's departure in January 1918; arrested during Bolshevik attack on British Embassy on 31 August 1918; imprisoned in Peter and Paul Fortress until freed in prisoner exchange in October.

'The Korniloff crisis has passed. Petrograd is enjoying a breathing space after the rush of recent events', writes *The Times* at the beginning of September. And yet it seems that Kerensky has only strengthened the Bolsheviks' hand in suppressing the revolt. Its embers are used by Lenin to relight the insurrectionist flame. The Bolshevik leader is haunted by the memory of the failed uprising in July; he argues vehemently with party colleagues that action must be taken before other events – German incursion, socialist compromise – preclude it.

Meanwhile the government lurches from crisis to irrelevance. Kerensky forms a directorate of five ministers, which offers little direction. The latest line-up of the Provisional Government, the Third Coalition, emerges towards the end of September, including ten Socialist Revolutionary and Menshevik ministers. More significantly, Trotsky becomes chairman of the increasingly Bolshevik-controlled Petrograd Soviet, and then head of its Military Revolutionary Committee.

Momentum, it seems, is all with the Bolshevik faction as reports of soldier mutinies and violent outbreaks in the provinces multiply – 'one dark picture of murders, pillages, arson and drunken debauches' writes a journalist. With trust between officers and troops utterly broken, the mood of the Petrograd garrison – the last line of defence for the government – is seen as a key litmus test. 'I don't know how we can go on', Kerensky tells British agent Somerset Maugham. Within a month the beleaguered prime minister has his answer.

LOUIS DE ROBIEN
Attaché at the French Embassy

Today the government proclaimed the Republic in order to satisfy public opinion [...] and seized the opportunity to double the price of bread. A theoretical price, in fact, because there is none to be had. *5 September 1917*

THE TIMES
London newspaper; editorial

Perhaps the advent of a Bolshevik Government is a necessary evil; it may be an indispensable ordeal through which Russia must pass before the bulk of the people realise the fact that the Bolsheviks are the real counter-revolutionaries, who are doing their best utterly to ruin the country, and working hand-in-glove with the enemies of Russia and the secret agents of the old regime. But we know enough about the Bolsheviks to realise that methods of peaceful suasion will never rid the country of their evil sway. There is only one remedy against them. M. Kerensky indicated it when he asked General Korniloff to send a cavalry division to Petrograd 'to subdue the Maximalists'.* The proverbial 'whiff of grape-shot' is the only medicine, and until it is administered in the proper dose the present situation will continue. *15 September 1917*

LEON TROTSKY
Chairman of the Petrograd Soviet

The army that rose against Kornilov was the army-to-be of the October Revolution.

VOLYA NARODA
'Will of the People', Socialist Revolutionary newspaper; editorial

Against the background of merciless foreign war and defeats of the armies of the Republic, internally the country has entered upon a period of anarchy and, virtually, a period of civil war. [...]

Grain reserve stores in Perm province are looted. Gangs of robbers appear on the roads in Pskov province. In the Caucasus there is slaughter in a number of places. Along the Volga, near Kamyshin, soldiers loot trains. In Finland the army and the fleet have dissociated themselves completely from the Provisional Government. Russia is threatened by a railway employees' strike [...] Unbridled, merciless anarchy is growing. Any cause is used. Events of colossal importance are taking place throughout the country. The Russian state is collapsing. Whole regions are seceding [...] Don't the leaders of democracy really understand, or are they unwilling to understand, that further tolerance is impossible; that the policy of compromises and agreements with Bolshevism has already led to Russia's disintegration and will eventually ruin the revolution, the country and democracy itself? *20 September 1917*

LOUIS DE ROBIEN
Attaché at the French Embassy

Bad news from Finland. The massacres of officers continue. At Vyborg half a dozen of them were thrown off the bridge into the river and finished off with gun-shots. At Helsingfors the sailors murdered several navy officers with blows from a hammer. Murders like these are said to be happening almost everywhere, but they have been kept from the public. *6 September 1917*

JOSEPH STALIN
Bolshevik Central Committee member

All power to the Soviets – such is the slogan of the new movement... All power to the imperialist bourgeoisie – such is the slogan of the Kerensky government. There is no room for doubt. We have two powers before us: the power of Kerensky and his government, and the power of the Soviets and the Committees. The fight between these two powers is the defining feature of the present moment. Either the power of the Kerensky government – and then the rule of the landlords and capitalists, war and chaos. Or the power of the Soviets – and then the rule of the workers and peasants, peace and the liquidation of chaos. *17 September 1917*

SIR GEORGE BUCHANAN
British ambassador

The Bolsheviks, who form a compact minority, have alone a definite political programme. They are more active and better organised than any other group, and until they and the ideas which they represent are finally squashed, the country will remain a prey to anarchy and disorder [...] If the government are not strong enough to put down the Bolsheviks by force, at the risk of breaking altogether with the Soviet, the only alternative will be a Bolshevik government. *21 September 1917*

LOUIS DE ROBIEN
Attaché at the French Embassy

On orders from their governments the Allied ambassadors today took steps to issue a solemn warning to Kerensky and to convey their anxiety to him. The American ambassador alone found an excuse to abstain. Kerensky received them in the Winter Palace [...] Sir George Buchanan, the doyen, read them the joint declaration. Although this was expressed in the most moderate terms – too moderate, in my opinion – it violently irritated the despot's vanity, and he walked out exclaiming: 'You forget that Russia is a great power!' The tsar also refused to listen to Sir George in similar circumstances: a few weeks later, he lost the crown! *26 September 1917*

MANCHESTER GUARDIAN
British newspaper; report

Reuter's Agency states that Commander Locker-Lampson, M.P., who has been in command of the British armoured-car unit in Russia, arrived in England yesterday [...] 'No one', said the commander, 'has any right to suppose for a moment that Russia will not remain loyal to the Allied cause. The Coalition Government now formed is a fine achievement, and many difficulties will disappear within the next few months.' *27 September 1917*

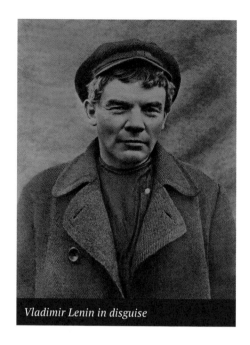

Vladimir Lenin in disguise

VLADIMIR LENIN
Bolshevik leader; letter to the Central Committee and members of the Bolshevik Party

Dear Comrades,
Events are prescribing our task so clearly for us that procrastination is becoming positively *criminal*. [...]
The Bolsheviks [...] must *take power at once*. By so doing they will save the world revolution (for otherwise there is danger of a deal between the imperialists of all countries, who, after the shootings in Germany, will be more accommodating to each other and will *unite against us*), the Russian Revolution (otherwise a wave of real anarchy may become stronger *than we are*) and the lives of hundreds of thousands of people at the front. [...]
If power cannot be achieved without insurrection, we must *resort to insurrection at once*. [...]
Victory is certain, and the chances are nine in ten that it will be a bloodless victory.
To wait would be a crime against the revolution. *1 October 1917*

ARTHUR WOODHOUSE
British consul in Petrograd; letter home

Things are coming to a pretty pass here. I confess I should like to be out of it, but this is not the time to show the white feather. I could not ask for leave now, no matter how imminent the danger. There are over 1,000 Britishers here still, and I and my staff may be of use and assistance to them in an emergency. *11 October 1917*

NIKOLAI SUKHANOV
Member of the Executive Committee of the Petrograd Soviet, writer and editor

Oh, the novel jokes of the merry muse of history! This supreme and decisive session took place in my own home [...] without my knowledge [...] For such a cardinal session not only did people come from Moscow, but the Lord of Hosts himself, with his henchman, crept out of the underground. Lenin appeared in a wig, but without his beard. Zinoviev appeared with a beard, but without his shock of hair. The meeting went on for about ten hours, until about 3 o'clock in the morning [...] However, I don't actually know much about the exact course of this meeting, or even about its outcome. It's clear that the question of an uprising was put [...] It was decided to begin the uprising as quickly as possible, depending on circumstances but not on the congress. *10 October 1917*

JOSEPH STALIN
Bolshevik Central Committee member; speech to the Central Committee

The day of the uprising needs to be chosen prudently. They say that we need to wait for an attack by the government, but we have to understand what we mean by an attack. An increase in bread prices, a despatch of Cossacks to the Donetsk region, etc. – all this constitutes an attack. How long should we wait if there is no military attack? [...] Why shouldn't we allow ourselves to choose the day of the uprising, so as not to give counter-revolution the opportunity to organise itself? *16 October 1917*

Joseph Stalin

SERGEI KABLUKOV
Secretary of the St Petersburg Religio-philosophical Society

For several days now the city has been full of blood-curdling rumours of the rabble's imminent revolt and the slaughter of the 'bourgeois'. Some are even leaving Petersburg, fleeing to the outskirts. There is no doubt that the rabble is being incited by the socialists, by German spies, and by Black Hundreds in pursuit of restoration.* What's more, there's no bread in Petersburg, which is adding to people's concerns. Nonetheless I don't think there will be any rioting, and there is almost no doubt that the government will put it down. *18 October 1917*

DELO NARODA
'People's Cause', Socialist Revolutionary newspaper; report titled 'Bolshevik Preparations for an Uprising'

The Bolsheviks are getting ready for action. This is a fact. Moreover, we have reason to assert that this action is intended to be an armed one.

'The country is ripe for a dictatorship of the proletariat and the revolutionary peasantry. The moment has arrived when the revolutionary slogan "All power to the Soviets" must finally be realised.' Thus writes *Rabochy put*. *15 October 1917*

LEV KAMENEV
Leading Bolshevik; letter printed in *Novaya zhizn*

Not only Comrade Zinoviev and I, but also a number of practical comrades, think that to assume the initiative of an armed insurrection at the present moment [...] would be an inadmissible step, ruinous to the proletariat and to the revolution [...] It is our obligation in these conditions to speak out against any attempt to take on the initiative for an armed uprising, which would be doomed to defeat and would entail the most devastating consequences for the party, for the proletariat, for the fate of the revolution. To stake everything on insurrection in the coming days would be an act of despair. And our party is too strong, it has too great a future, to take such a step. *18 October 1917*

Lev Kamenev

VLADIMIR LENIN
Bolshevik leader; letter to party members

Comrades,
 I have not yet been able to receive the Petrograd papers for Wednesday, 18 October. When the full text of Kamenev's and Zinoviev's declaration, published in *Novaya zhizn*, which is not a party paper, was transmitted to me by telephone, I refused to believe it [...] I should consider it disgraceful on my part if I were to hesitate to condemn these former comrades because of my former close relations with them. I declare outright that I no longer consider either of them comrades and that I will fight with all my might, both in the Central Committee and at the congress, to secure their expulsion from the party. *18 October 1917*

MAXIM GORKY
Writer and political commentator; editorial in *Novaya zhizn*

Rumours that the 'action of the Bolsheviks' is anticipated on 20 October are becoming more insistent. In other words, the ugly scenes of 3–5 July may be repeated...
 An unorganised mob will pour out into the streets, not knowing what it wants, and adventurers, thieves, professional murderers, using it as a shield, will begin to 'make the history of the Russian Revolution'.
 In other words, there will be a repetition of that bloody, senseless slaughter which we have already seen, and which undermined throughout the country the moral meaning of the revolution, shook its cultural import. [...]
 The Central Committee of the Bolsheviks must deny the rumours about the action of the 20th. It must do so if it is really a strong and free-acting political body, capable of guiding the masses, and not a weak-willed plaything of the wild mob's mood, not a tool in the hands of the most shameless adventurers or crazed fanatics. *18 October 1917*

JOSEPH STALIN
Bolshevik Central Committee member; response to Gorky in *Rabochy put* newspaper

As for the neurotics of *Novaya zhizn*, we have trouble working out what exactly they want from us. If they want to know about the 'day' of the uprising in order to mobilise their forces of the terrified intelligentsia in advance, for timely flight, let's say, to Finland, then we can only commend them, for we are 'generally' in favour of the mobilisation of forces. [...]

The Russian Revolution has brought a number of authorities to their knees. Indeed, its power is expressed through its refusal to bow down before 'big names'; it has taken them on board, or consigned them to oblivion if they have refused to learn from it. There is a whole legion of such 'big names' who have been cast aside by the revolution. Plekhanov, Kropotkin, Breshkovskaya, Zasulich – in fact, all those old revolutionaries who are remarkable only for the fact that they are old.* We fear that the laurels of these 'pillars' are keeping Gorky awake at night. We fear that Gorky is 'fatally' drawn to them, as to an archive.

Whatever, each to his own... the revolution knows not how to pity or to bury its corpses. *20 October 1917*

LEON TROTSKY
Chairman of the Petrograd Soviet; denial of Bolshevik plans for an armed uprising, published in *Izvestia*

Comrades, over recent days the press has been full of reports of rumours and articles concerning the coming alleged demonstrations attributed sometimes to the Bolsheviks, sometimes to the Petrograd Soviet. [...]

It was also pointed out that I, as chairman of the Soviet, had signed an order for 5,000 rifles. By virtue of the decision of the Committee for the People's Struggle against Counter-revolution, even back in the Kornilov days, it was decided to form a workers' militia and

Leon Trotsky

arm it. It was in execution of this decision that I ordered 5,000 rifles from the Sestroretsk Factory. [...]

We have still not set a date for the attack. But the opposing side evidently already has. We will meet it, we will duly repel it, and we declare that we will answer the first counter-revolutionary attempt to hamper the work of the congress with a counter-offensive which will be ruthless and which we will carry out to the end. *18 October 1917*

ALFRED KNOX
Military attaché at the British Embassy

An armed demonstration of the garrison in favour of the Bolsheviks had been openly talked of for 25 October. The Provisional Government called up two cyclist battalions from the front and expressed its confidence in its ability to quell any rising.

In fact, Kerensky and Tereshchenko pretended only to fear that the rising might not be attempted and that they might therefore be deprived of the opportunity of annihilating the movement once and for all. [...]

The Petrograd Soviet, of which Trotsky had now become chairman, proclaimed that it had no trust in the government and that it would accordingly take upon itself the defence of the capital. It formed on 20 October a 'Military Revolutionary Committee' under the Bolshevik, Antonov, to control the district staff.* This committee appointed its commissaries to all units of the garrison and to arms factories. It interfered with all orders issued by the district staff and rendered the position of the latter impossible.

ALEXANDER KERENSKY
Prime minister; in conversation with Vladimir Nabokov

I would be prepared to offer prayers to produce this uprising. I have greater forces than necessary. They will be utterly crushed. *20 October 1917*

IZVESTIA
Menshevik and Socialist Revolutionary newspaper; article titled 'The conflict between the Petrograd Soviet and the Petrograd Military District Headquarters'

A sharp conflict has developed between the Petrograd Soviet and the Petrograd Military District Headquarters on the grounds that the Petrograd Soviet organised a Military Revolutionary Committee to control the actions of the District Headquarters. [...]

On 21 October the Petrograd Soviet recognised the Military Revolutionary Committee as the body in command of the capital's troops.

On the night of 22 October, the members of the Military Revolutionary Committee presented themselves at District Headquarters and demanded that they be permitted to control the orders of the Headquarters with the right to a deciding voice.

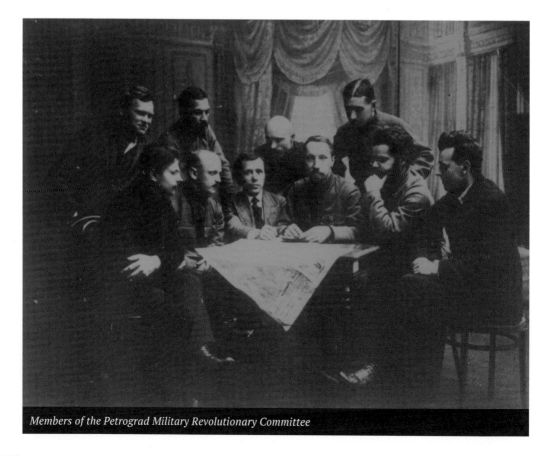

Members of the Petrograd Military Revolutionary Committee

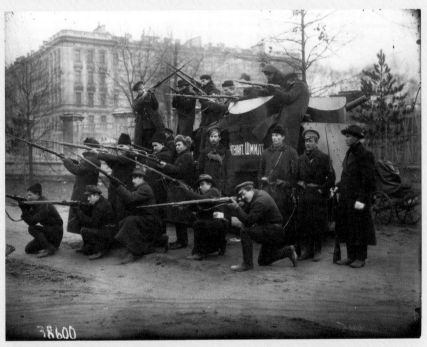

Members of the Red Guard with the armoured car Lieutenant Schmidt, *captured from officer cadets*

Colonel Polkovnikov, the commander of the troops, replied to this demand with an emphatic refusal.

The Petrograd Soviet then called a meeting of representatives of regiments, to be held at Smolny Institute. From this meeting telegrams were despatched to all units, stating that the Headquarters has refused to recognise the Military Revolutionary Committee and, by so doing, has severed relations with the revolutionary garrison and with the Petrograd Soviet of Workers' and Soldiers' Deputies, and has become a direct instrument of counter-revolutionary forces. *24 October 1917*

JOSHUA BUTLER WRIGHT
Counsellor at the American Embassy

The Petrograd situation is distinctly threatening! The Bolsheviks are well armed and the temper of the army and the fleet rapidly getting worse [...] The actions of the sailors are fearful – the subordinates of a most popular officer at Oesel raped his wife and daughter and then killed them – upon his return the officer shot himself. *19 October 1917*

LOUIS DE ROBIEN
Attaché at the French Embassy

After an excellent performance of *La Passerelle*, in which Mlle Didier was charming and Hasti screamingly funny in the part of a manservant, I went to end the evening in the house of young Countess Keller. There I heard that old Princess Urusov arrived this morning from Lapotkovo, her estate at Tula; she fled from there without being able to take anything except the clothes which she stood up in.* The peasants have burned and pillaged everything. *21 October 1917*

VLADIMIR LENIN
Bolshevik leader; letter to the party's Central Committee

Comrades, I am writing these lines on the evening of the 24th. The situation is critical in the extreme. In fact it is now absolutely clear that to delay the uprising would be fatal. With all my might I urge comrades to realise that everything now hangs by a thread; that we are confronted by problems which are not to be solved by conferences or congresses (even congresses of Soviets), but exclusively by peoples, by the masses, by the struggle of the armed people [...] We must at all costs, this very evening, this very night, arrest the government [...] We must not wait! [...] History will not forgive revolutionaries for procrastinating when they could be victorious today (and they certainly will be victorious today), while they risk losing much tomorrow; in fact, they risk losing everything. If we seize power today, we seize it not in opposition to the Soviets but on their behalf [...] The government is tottering. It must be given the deathblow at all costs. To delay action is fatal. *24 October 1917*

JOSEPH STALIN
Bolshevik Central Committee member; article in *Rabochy* put titled 'What We Need'

Do you want the present government of landlords and capitalists to be replaced by a new government, a government of workers and peasants? Do you want the new government of Russia to proclaim [...] the abolition of landlordism and to transfer all the landed estates to peasant committees without compensation? Do you want the new government of Russia to publish the tsar's secret treaties, to declare them invalid, and to propose a just peace to all belligerent nations? Do you want the new government of Russia to put a thorough curb on organisers of lockouts and profiteers who are deliberately fomenting famine and unemployment, economic disruption and high prices? If you want this, muster all your forces, rise as one man, organise meetings and elect your delegations and, through them, lay your demands before the Congress of Soviets which opens tomorrow at Smolny.* *24 October 1917*

ANATOLY LUNACHARSKY
Leading Bolshevik; letter to his wife Anna

Do the Soviets have enough strength to seize power? It is very likely that they do. Do the Soviets have enough strength to save Russia and the revolution? It is likely that they do not. *24 October 1917*

ZINAIDA GIPPIUS
Poet, novelist and journalist

A pretty scene indeed. There is as much difference between the revolution and what is going on at the moment as [...] between the glittering sky of spring and the slithering, dirty, dark grey clouds of today. *25 October 1917*

John Reed

JOHN REED
American journalist, author of *Ten Days that Shook the World*

I hurried down to the Mariinsky Palace, arriving at the end of that passionate and almost incoherent speech of Kerensky's, full of self-justification and bitter denunciation of his enemies. *24 October 1917*

NIKOLAI AVKSENTEV
Leading member of the Socialist Revolutionary Party

Kerensky's speech was extremely successful. He spoke bravely and sincerely. He warned that we could wait no longer, that the twelfth hour was upon us, when it was essential to act decisively and quickly, and he demanded support. His speech was greeted by everyone with great sympathy and great enthusiasm. *24 October 1917*

ZINAIDA GIPPIUS
Poet, novelist and journalist

Today, the unfortunate Kerensky made a speech to the Pre-parliament in which he said that all attempts and methods to resolve the conflict had been exhausted (although he was still trying to talk them round!) and that he was asking for the Soviet to grant him the power to take decisive measures and generally for their support of the government.* The very idea of asking the Soviet, and now, of all times! *24 October 1917*

ALEXANDER KERENSKY
Prime minister; speech to the Pre-parliament

At the moment when the state is in danger, because of conscious or unconscious treason, the Provisional Goverment, and myself among others, prefer to be killed rather than betray the life, the honour and the independence of Russia. *24 October 1917*

ALFRED KNOX
Military attaché at the British Embassy

About 1,000 women marched past the embassy this morning on their way to be inspected by Kerensky on Palace Square. They made the best show of any soldiers I have seen since the revolution, but it gave me a lump in the throat to see them, and the utter swine of 'men' soldiers jeering at them. *24 October 1917*

LEON TROTSKY
Chairman of the Petrograd Soviet

In the Winter Palace Kerensky has surrounded himself with officer cadets, officers and a battalion of women shock troops. I give the order to the commissars to set up reliable military blockades on the roads to Petrograd and to send out the agitators to meet the units summoned by the government [...] 'If you can't stop them with words, then bring your weapons into play. It's your heads that are on the line.' *24 October 1917*

ALEXANDRA KOLLONTAI
Bolshevik Central Committee member

A grey autumn day. The Central Committee is in session in Smolny. Resolutions adopted: all members of the Central Committee are obliged to remain in Smolny at all times. Official decision taken to break with the appeasing Central Executive Committee; to intensify patrols around Smolny; to set up machine-gun posts; to despatch

Dzerzhinsky to the post and telegraph buildings in order to secure these crucial communication centres for the revolution; to establish a reserve headquarters in the Peter and Paul Fortress in case Smolny is ransacked. That's the position. It's clear evidence that an armed insurrection in the struggle for power of the Soviets is a palpable fact. *24 October 1917*

JOHN REED
American journalist, author of *Ten Days that Shook the World*

Towards four in the morning I met Zorin in the outer hall, a rifle slung from his shoulder.*
 'We're moving!' said he, calmly, but with satisfaction. 'We pinched the assistant minister of justice and the minister of religions. They're down cellar now. One regiment is on the march to capture the Telephone Exchange, another the Telegraph Agency, another the State Bank. The Red Guard is out.' *25 October 1917*

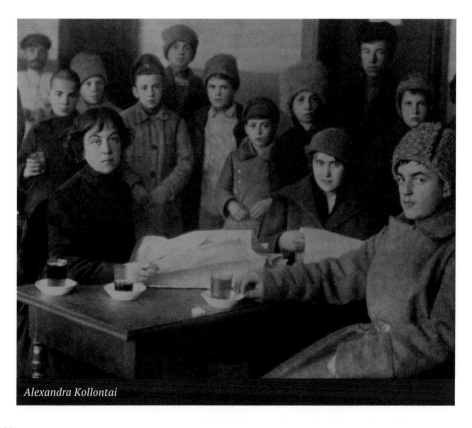

Alexandra Kollontai

PIERRE PASCAL
Lieutenant in the French military mission in Petrograd

Captain Bertrand told me of events at the Telephone Exchange. It was occupied by Bolsheviks. Junkers arrived to recapture it. The Bolsheviks looked out and said, 'We're a squadron.' The Junkers did a count and said, 'We're a platoon. There are more of you.' And they left. *25 October 1917*

NIKOLAI SUKHANOV
Member of the Executive Committee of the Petrograd Soviet, writer and editor

In general the military operations in the politically important centres of the city rather resembled a changing of the guard.

ANATOLY LUNACHARSKY
Leading Bolshevik; letter to his wife Anna

My dear girl,
 I write on the morning of the twenty-fifth. The struggle for power has now actually begun. One might even say that Kerensky has been the first to go on the attack. Politically I am, of course, in solidarity with the Bolsheviks. It is quite clear to me that there can be no salvation for Russia without the transfer of power to the Soviets. It is true that there is another way out, a purely democratic coalition formed by Lenin, Martov, Chernov, Dan and Verkhovsky.* But this would require so much good will and political wisdom on all sides that it is evidently a pipe-dream. *25 October 1917*

VLADIMIR LENIN
Bolshevik leader; proclamation 'To the citizens of Russia', published at 10 a.m. on 25 October

The Provisional Government has been deposed.
 State power has passed into the hands of the organ of the Petrograd Soviet of Workers' and Soldiers' Deputies – the Military Revolutionary Committee, which heads the Petrograd proletariat and the garrison.

What the people have been fighting for – the immediate offer of a democratic peace, revoking the landlords' ownership of the land, control by the workers over production, the creation of a Soviet government – all this has been guaranteed. Long live the revolution of workers, soldiers and peasants! *25 October 1917*

ALEXANDER KERENSKY
Prime minister; telegram to the 3rd Cavalry Corps

On receipt of this message I order all regiments of the 1st Don Cossack Division with their artillery to depart by rail for Nikolaevsky Station in Petrograd, to be under the command of Colonel Polkovnikov, commander of the Petrograd Military District. Inform me of your departure time by coded telegram. Where continued movement along the railway proves impossible, units are to continue by echelon on foot. *25 October 1917*

ALEXANDER KERENSKY
Prime minister

At the Moscow checkpoint our car was fired at, but we arrived safely at Gatchina. Despite an attempt to stop us here, we again got through unharmed.
 By night-time we had reached Pskov, headquarters of the commander-in-chief, Northern front. To be on the safe side we were lodged in a private apartment belonging to my brother-in-law, Quartermaster General Baranovsky. General Cheremisov, the commander-in-chief, came to the apartment in obedience to my summons, but it turned out that he was already 'flirting' with the Bolsheviks. The troops I had asked to have sent to Petrograd had been halted on his orders. After a very heated exchange, General Cheremisov left.

ALEXANDER LIVEROVSKY
Minister of transport

At nine in the morning, when I called headquarters about the general state of affairs, Colonel Polkovnikov informed me that he was writing a report to the

prime minister to say that the position was critical and that the Provisional Government had no soldiers at its disposal. *25 October 1917*

PAVEL MALYANTOVICH
Menshevik minister of justice

Closing the door, the Ministry of Justice messenger boy tried to wake me in a quiet, respectful but at the same time clear and insistent voice. I was fast asleep, having only gone to bed after six in the morning. 'Minister, get up. The prime minister has telephoned to ask that you go to the General Staff building without fail by ten. The samovar is ready, the tea has brewed.' *25 October 1917*

ALEXANDER LIVEROVSKY
Minister of transport

The secretary informed me that Kerensky had summoned me immediately to a meeting at the Winter Palace. Kerensky wasn't there. I asked where he was, and Konovalov replied that Kerensky had left at 11 o'clock by car and was heading towards the troops making their way to Petrograd to support the Provisional Government. *25 October 1917*

ADMIRAL DMITRY VERDEREVSKY
Minister of navy; from inside the Winter Palace

I don't understand why the assembly has been called and why we are continuing the session. We have no real power; consequently we are powerless to do anything, and it is pointless, therefore, to continue our meeting. *25 October 1917*

NIKOLAI KISHKIN
Minister of health; from inside the Winter Palace

We're not the Petrograd Provisional Government but the All-Russian Provisional Government. If we've no clout to rely on in Petrograd, this doesn't mean it's non-existent throughout Russia as a whole. And ultimately if we have no physical strength then we must try to rely on moral strength. *25 October 1917*

VLADIMIR NABOKOV
Leading member of the Kadets

The ministers were assembled in small groups. Some walked back and forth about the hall, others stood at the window. S.N. Tretyakov sat down next to me on the sofa and began to talk indignantly about how Kerensky had abandoned them all and betrayed them, and that the situation was hopeless. Others (Tereshchenko, I remember, was in a highly nervous and excited state) were saying that all we had to do was 'hang on' for another 48 hours, and troops loyal to the government would arrive in the city.

NIKOLAI PODVOISKY
Chairman of the Petrograd Military Revolutionary Committee

Lenin was prowling around the small room in Smolny like a caged lion. He needed the Winter Palace, whatever the cost: the Winter Palace was the final obstacle in the path to power for the workers. Vladimir Ilyich cursed and shouted... he was ready to shoot us. *25 October 1917*

VLADIMIR ANTONOV-OVSEENKO
Secretary of the Petrograd Military Revolutionary Committee; message to the Provisional Government inside the Winter Palace

The Winter Palace is surrounded by revolutionary forces. Cannon at the Peter and Paul Fortress and on the ships *Aurora* and *Amur* are aimed at the Winter Palace and the General Staff building. In the name of the Military Revolutionary Committee we propose that the Provisional Government and the troops loyal to it capitulate [...] You have twenty minutes to answer. Your response should be given to our messenger. This ultimatum expires at 7.10, after which we will immediately open fire. *25 October 1917*

Vladimir Antonov-Ovseenko

ALEXANDER KONOVALOV
Deputy prime minister; telegram to the supreme commander-in-chief

The Petrograd Soviet of Workers' and Soldiers' Deputies has declared the government deposed, and has demanded the transfer of power by threatening the Winter Palace with bombardment from the guns of the Peter and Paul Fortress and the cruiser *Aurora*. The government can transfer its power only to the Constituent Assembly. It has decided not to surrender, and to place itself under the protection of the people and of the army. Hasten the despatch of troops. *25 October 1917*

GENERAL NIKOLAI DUKHONIN
Supreme commander-in-chief; response to Konovalov's telegram

Measures for the earliest arrival of the troops are being taken. First Lieutenant Danilevich has been informed of the expected time of the arrival of the units, but I consider it my duty to report that in the region nearest to Petrograd, independently from us, movement is being hindered. *25 October 1917*

GRIGORY SHREIDER
Mayor of Petrograd; address to the City Duma

Citizen councillors! In a few minutes the cannons will begin to thunder, and the Provisional Government of the Russian Republic will perish beneath the ruins of the Winter Palace! Are we to remain indifferent onlookers to such criminal actions?! *25 October 1917*

SEMYON MASLOV
Minister of agriculture; telephone message relayed by Naum Bykhovsky to the City Duma

We here in the Winter Palace have been abandoned and left to ourselves. The democracy sent us into the Provisional Government; we didn't want these appointments, but we went. Yet now, when tragedy has struck, when we are being shot, we are not supported by anyone. Of course we will die. But my final words will be: 'Contempt and damnation to the democracy which knew how to appoint us but was unable to defend us!' *25 October 1917*

PITIRIM SOROKIN
University professor, member of the Socialist Revolutionary Party

At seven in the evening I went to the City Duma. With many matters before us, the immediate horror that faced us was this situation at the Winter Palace. There was a regiment of women and the military cadets were bravely resisting an overwhelming force of Bolshevik troops, and over the telephone Minister Konovalov was appealing for aid. Poor women, poor lads, their situation was desperate, for we knew that the wild sailors, after taking the palace, would probably tear them to pieces. What could we do? After breathless council it was decided that all of us, the Soviets, municipalities, committees of socialist parties, members of the Council of the Republic, should go in procession to the

Winter Palace and do our utmost to res-cue the ministers, the women soldiers, and the cadets [...] Rushing out, we formed in some kind of an orderly line and in the darkness of the unlit street we started, a few dim lanterns show-ing us our way. Never had Petrograd seen such a hopeless march. In absolute silence, like phantoms, we moved for-ward. Near Kazan Cathedral three load-ed automobiles full of sailors, machine guns and bombs, stopped us. 'Halt! Who goes there?' 'Representatives of the municipality, the Soviets, the Council of the Republic, and the socialist parties.' 'Where are you going?' 'To the Winter Palace, to end this civil war and to save the defenders of the palace.' 'Nobody can approach the palace. Turn back at once or we will fire on you.'

There was nothing to be done, so we returned in ghastly silence to the Duma. There we made one more effort to com-municate with the palace, but the wires by this time had been cut. The firing had ceased and we knew that the mas-sacre was probably in full swing.

Along pitch-black streets I staggered home, where I found my wife half-dead with anxiety for me. But I calmed her. 'My dear wife, we must now be prepared for whatever comes. The worst, in all human probability.'

ZINAIDA GIPPIUS
Poet, novelist and journalist

Now the Bolsheviks have seized the Petrograd Telegraph Agency and the telegraph. There is shooting on Nevsky. The government sent armoured cars over there, and the armoured cars have gone over to the Bolsheviks, fraternis-ing avidly. In a word, a cataclysm is imminent, the darkest, most idiotic, grubbiest social upheaval that history has ever seen. And we can expect it any minute now. *25 October 1917*

CAPTAIN YAKOV KHARASH
Twelfth Army officer, Menshevik; address to the Second All-Russian Congress of Soviets

Comrades! At the very moment that the Winter Palace is being bombarded; at the very moment that delegates of socialist parties not recalled by their parties are sitting in the Winter Palace; at this moment our congress is opening.

Behind the back of the All-Russian Con-gress, thanks to the political hypocrisy of the Bolsheviks, a criminal piece of politi-cal adventurism has been carried out.

While we are making proposals for the peaceful reconciliation of the conflict, on the streets of Petrograd a battle is underway. The spectre of civil war looms. *25 October 1917*

LEV KHINCHUK
Menshevik chairman of the Moscow Soviet; Mensheviks' declaration at the Second All-Russian Congress of Soviets

Given that a military conspiracy has been organised and carried out by the Bolshevik party in the name of the Soviets and behind the back of all the other parties and factions in the Soviets; [...] and given that this conspiracy is plunging the country into civil strife, [...] threatening military catastrophe and leading to the creation of a counter-revolution; [...] the united faction of the Russian Social Democratic Labour Party [Mensheviks] is leaving the congress and invites all other factions that share its refusal to bear responsibility for the actions of the Bolsheviks to meet immediately to discuss the situation. *25 October 1917*

LEON TROTSKY
Chairman of the Petrograd Soviet; address to the Second All-Russian Congress of Soviets

What has taken place is an uprising, not a conspiracy. A rising up of the popular masses requires no justification. We steeled the revolutionary energy of the

Petersburg workers and soldiers. We openly forged the will of the masses for insurrection, and not for conspiracy [...] Our insurrection has been victorious. And now we are told: renounce your victory, strike an agreement. With whom? With whom, I ask, are we supposed to strike an agreement? With that wretched lot who have just walked out? [...] But we've had the full measure of them. Nobody in Russia follows them any more. And the millions of workers and peasants who are represented at this congress are supposed to strike a deal, as if with equal partners, with those who not for the first or last time are ready to barter them away at the whim of the bourgeoisie! No, there's no deal to be struck here! To those who have walked out of here, and to those who make similar suggestions, we say this: you are pitifully few in number, you're bankrupt, your part is over. Go where you deserve to go: into the dustbin of history!

YULY MARTOV
Leader of the Menshevik Internationalists

Then we are leaving! *25 October 1917*

Yuly Martov

NIKOLAI SUKHANOV
Member of the Executive Committee of the Petrograd Soviet, writer and editor

By quitting the congress and leaving the Bolsheviks with only the Left Socialist Revolutionary youngsters and the feeble little *Novaya zhizn* group, we gave the Bolsheviks [...] a monopoly of the Soviet, of the masses, of the revolution. By our own irrational decision we ensured the victory of Lenin's whole 'line'.

ANATOLY LUNACHARSKY
Leading Bolshevik

The mood of those gathered is festive and celebratory. There is enormous excitement, but not the slightest panic, even though the battle is still going on around the Winter Palace, and from time to time we receive news of the most alarming nature.

When I say that there is no panic, I am talking about the communists and the vast majority of the congress who share their point of view; the hateful, confused and nervous right-wing 'socialist' elements, on the contrary, are gripped by panic. The Menshevik Bogdanov comes up, his face contorted and red, and shouts at me: 'The *Aurora* is bombarding the Winter Palace! Listen, Comrade Lunacharsky, your guns are destroying Rastrelli's palace!' Another cries, 'The Duma headed by the mayor has gone to the defence of the besieged ministers. Your gangs are shooting the representatives of the city!' *25 October 1917*

RYURIK IVNEV
Poet, novelist and translator

There's terrible machine-gun and artillery fire going on... Word is, they're firing at the Winter Palace. I've been gripped by a kind of numbness... I feel pity for no one and nothing. But surely this cannot be possible! It cannot last! Surely my heart can't be numb forever! Oh, Lord! Oh, Lord! Save Russia. *25 October 1917*

ALEXANDER BENOIS
Artist, writer and journalist

The background of gunfire was punctuated by several hollower, heavier blasts, and following the last of these came the sound of something collapsing. The *Aurora*, anchored in the middle of the Neva between the fortress and the palace, was firing on the latter at point-blank range. My heart sank. Could these really be the last moments of the Winter Palace's existence? But next door was the Hermitage, home to the Russian state's foremost treasures, home to everything I hold dearest in the world! *25 October 1917*

FYODOR CHALIAPIN
Opera singer; describing a performance of Verdi's *Don Carlo*

Dressed in my rich porphyry mantle, sceptre in hand and the crown of King Philip of Spain on my head, I come out of the cathedral onto the square. At that moment a cannon shot suddenly rings out on the Neva, not far from the theatre. As a king who does not tolerate dissent, I listen severely – is it in response to me? Another shot. From the height of the cathedral steps I notice my people tremble [...] My square begins to empty. The chorus and the extras have moved to the wings and, forgetting all the heretics, have started to discuss loudly in which direction they should flee. It is no small task for King Philip II of Spain to convince his timid subjects that there is nowhere to run, for it is completely impossible to tell where the shells are going to fall. [...]

'Why the guns?' we asked the ushers. 'It must be the *Aurora* firing on the Winter Palace, where the Provisional Government is in session.'

By the end of the performance the shooting had stopped, but my journey home was not particularly pleasant. It was sleeting, as happens in Petersburg in the middle of autumn. Slush. Emerging onto the street with Maria Valentinovna, I failed to find a cabman. So we set out on foot. We'd turned into Kamenno-ostrovsky Prospect when suddenly we heard the sound of gunfire through the damp air. There was some shooting going on. Bullets clattered. If my courage wavered in that moment, can you imagine the state of my wife? Running from porch to porch and hiding in doorways under cover of darkness – the streetlamps not having been lit – we somehow made it home. And if I slept that night, I would have to say that I awoke to a socialist fog.

PAVEL MALYANTOVICH
Menshevik minister of justice; inside the Winter Palace

And suddenly a hubbub erupted somewhere, and it immediately grew louder and drew closer. And amongst its sounds, diverse yet fused into a single wave, you could hear something else, something singular and unlike those previous noises – something final. It suddenly became apparent that the end was upon us. [...]

The door swung open... An officer cadet rushed in. He stood to attention, saluted and asked, anxious but determined: 'What are the orders? Remain steadfast to the last man? We will if that is the order of the Provisional Government.' 'No! It's pointless! That much is clear! We don't want bloodshed! We should surrender,' we all shouted without conferring, but simply by looking each other in the eye and seeing the same feeling, the same decision.

Then, like a piece of wood borne on a wave, a small man was pushed into the room by the crowd, which poured in right after him and flooded every corner of the room. *25 October 1917*

VLADIMIR ANTONOV-OVSEENKO
Secretary of the Petrograd Military Revolutionary Committee

'In the name of the Military Revolutionary Committee, I pronounce you arrested!' I said. 'Members of the Provisional Government will give way to force and surrender to avoid bloodshed', answered Konovalov.

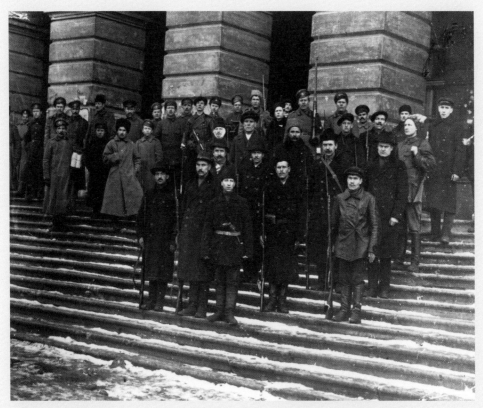

Red Guards on the steps of the Smolny Institute, venue of the Second All-Russian Congress of Soviets, and Bolshevik headquarters during the October Revolution

NIKOLAI SUKHANOV
Member of the Executive Committee of the Petrograd Soviet, writer and editor

After rather lengthy proceedings, with interrogations, roll-calls, and the making of lists, the column of prisoners moved out, in the direction of the Peter-Paul Fortress. In the darkness, between 2 and 3 o'clock in the morning, in the midst of a dense, excited mob, the column moved along Millionnaya and over Trinity Bridge. More than once the lives of the former ministers hung by a hair. But it went off without a lynching. After eight months of revolution, the Peter-Paul was receiving within its walls a third variety of prisoner: first, tsarist functionaries, then Bolsheviks, and now Kerensky's friends, the 'elite' of the Menshevik-Socialist Revolutionary democracy. What more were these impenetrable walls destined to see?

LEON TROTSKY
Chairman of the Petrograd Soviet

On behalf of the Military Revolutionary Committee I declare that the Provisional Government is no more! I know of no other example in history of a revolutionary movement involving such vast masses of people which has passed so bloodlessly. *25 October 1917*

VLADIMIR LENIN
Bolshevik leader; declaration to the Second All-Russian Congress of Soviets, read out by Anatoly Lunacharsky

To All Workers, Soldiers and Peasants:
 Supported by an overwhelming majority of the workers, soldiers and peasants, and basing itself on the victorious insurrection of the workers and the garrison of Petrograd, the congress hereby resolves to take governmental power into its own hands.
 The Provisional Government is deposed and most of its members are under arrest.
 The Soviet government will propose an immediate democratic peace to all nations and an immediate armistice on all fronts. It will safeguard the transfer without compensation of all land belonging to landowners, the crown and the monasteries to the peasant committees; it will protect soldiers' rights, introducing a complete democratisation of the army; it will establish workers' control over industry; it will ensure the convocation of the Constituent Assembly on the appointed date; it will supply the cities with bread and the villages with articles of first necessity; and it will secure to all nationalities inhabiting Russia the right of self-determination. The congress resolves that all local authority shall be transferred to the Soviets of Workers', Soldiers' and Peasants' Deputies, which are charged with the task of enforcing revolutionary order. *25 October 1917*

LEON TROTSKY
Chairman of the Petrograd Soviet

Power is taken, at least in Petrograd. Lenin hasn't even changed his collar yet. He's tired, but his eyes are wide awake. He looks at me – friendly, gentle, with an awkward shyness that indicates intimacy. 'You know,' he says hesitantly, 'to go from persecution and the underground straight to power, it's...' he searches for the right word, '*Es schwindelt,*' he suddenly switches to German and his hand circles around his head.* We look at each other and laugh a little.

VELIMIR KHLEBNIKOV
Futurist poet

Fires burned by the open bridges, guarded by sentries in sheepskin coats, their rifles stacked, while columns of sailors walked noiselessly by – dense, black and indistinguishable from the night. The only thing you noticed was the movement of the underarm gussets on their tunics. In the morning we found out that the military academies had been taken one after the other. But the population of the capital was not part of this struggle. *26 October 1917*

Velimir Khlebnikov

RECH
'Speech', newspaper of the Kadets;
editorial

Thus the die is cast. A country which
is exhausted and tormented by three
years of war, which has experienced the
convulsions of a revolution, which is
reduced to misery, which has reached
the last degree of economic and indus-
trial disintegration, a country deprived
of a firm and solid government, a
country which has become the arena of
anarchic and pogrom movements – this
unfortunate, dying country will have to
undergo a new stage on her road to Gol-
gotha. We have already entered an era of
new vivisectional experimentation over
her. As these lines are being written, we
do not as yet know whether this experi-
ment has been completed, whether
actually all the power has passed to
the Soviets – either to the Soviets or to
their candidates – or whether the reins
of government have already been seized
by Messrs Lenin and Trotsky. We do not
know whether there is still a govern-
ment in Russia. But already we know
one thing: a new, deep shock has taken
place and its consequences for the

domestic and international state of
the country are incalculable. [...]

Up to the last moment the Provisional
Government did not consider that it had
the right to throw from its shoulders the
burden of heavy historical responsibility
for the fate of the country. We welcome
its valorous firmness. In spite of all the
horrors of the insoluble situation in
which it found itself, because the units
of the Petrograd Garrison had forgotten
their duty to the country, the govern-
ment did not capitulate in the face of
violence. Up to the very last minute, it
believed in the patriotism, conscience
and wisdom of wide circles of the popu-
lation, and addressed itself to them for
support. And if these appeals prove vain,
if the legitimate government recognised
by the whole country in the first days of
the February upheaval is overthrown,
then let all responsibility for future
tragic events fall on the heads of those
who in the days of the greatest mortal
danger for their homeland threw her into
the abyss of new tempests and agitations.
26 October 1917

LEON TROTSKY
Chairman of the Petrograd Soviet

The government must be formed. We
number among us a few members of
the Central Committee. A quick session
opens in a corner of the room.

'What shall we call them?' asks Lenin,
thinking aloud. 'Anything but ministers;
that's such a vile, hackneyed word.'

'We might call them commissars,'
I suggest, 'but there are too many
commissars just now. Perhaps "supreme
commissars"? No, "supreme" doesn't
sound right. But why not "people's
commissars"?'

'People's commissars? Well, that
might do, I think,' Lenin agrees. 'And
the government as a whole?'

'A Soviet, of course, [...] the Soviet of
People's Commissars, eh?'

'The Soviet of People's Commissars?'
Lenin picks it up. 'That's splendid; it
reeks of revolution!'

SIR GEORGE BUCHANAN
British ambassador

I walked out this afternoon to see the damage that had been done to the Winter Palace by the prolonged bombardment of the previous evening, and to my surprise found that, in spite of the near range, there were on the river side but three marks where the shrapnel had struck. On the town side the walls were riddled with thousands of bullets from machine guns, but not one shot from a field gun that had been fired from the opposite side of the Palace Square had struck the building. In the interior very considerable damage was done by the soldiers and workmen, who looted or smashed whatever they could lay hands on.

In the evening two officer instructors of the women's battalion came to my wife and beseeched her to try and save the women defenders of the Winter Palace, who, after they had surrendered, had been sent to one of the barracks, where they were being most brutally treated by the soldiers. General Knox at once drove to the Bolshevik headquarters at the Smolny Institute. His demands for their immediate release were at first refused on the ground that they had resisted desperately, fighting to the last with bombs and revolvers. Thanks, however, to his firmness and persistency, the order for their release was eventually signed, and the women were saved from the fate that would inevitably have befallen them had they spent the night in the barracks.

VLADIMIR LENIN
Bolshevik leader

Comrades! The workers' and peasants' revolution, the necessity of which the Bolsheviks have always spoken about, has been accomplished. *26 October 1917*

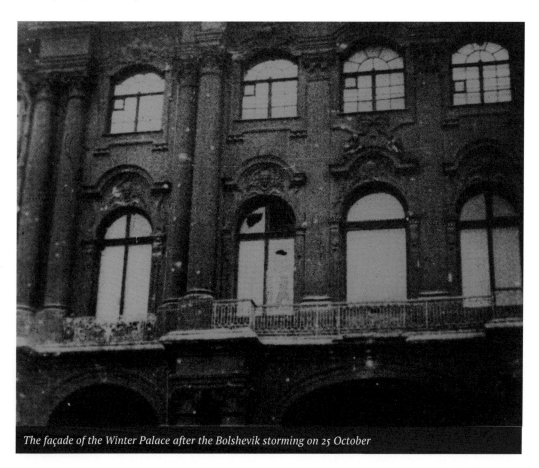

The façade of the Winter Palace after the Bolshevik storming on 25 October

*Junker officer cadets defending
the Kremlin in November 1917*

12
THIS, TOO, SHALL PASS

"Has the whole of democracy lost its senses, is there really nobody who can sense the horror of what is going on and kick out the crazy sectarians from our midst?"

REFORMERS

PROGRESSIVE REVOLUTIONARIES

Vladimir Amfiteatrov-Kadashev (1888–1942), journalist, critic, translator; son of writer Alexander Amfiteatrov; active with Whites before emigrating to Europe; wrote for pro-Nazi paper *Novoe slovo* ('New Word') in Berlin; died in Italy.

Sergei Efron (1893–1941), poet, husband of poet Marina Tsvetaeva; later served in White Army, emigrated to France but returned to USSR and executed in 1941.

General Mikhail Kaigorodov (1853–1918), governor of Irkutsk, head of Moscow Ammunition Depot inside Kremlin in 1917; believed to have been shot by the Bolsheviks in October 1918.

General Pyotr Krasnov (1869–1947), Cossack commander of 3rd Cavalry Corps; after October Revolution leading White commander; emigrated in 1919, settled in Germany in 1936; supported Nazis against USSR; handed over to Soviets in notorious post-war Cossack repatriation by the British; hanged in 1947.

Rannee utro, 'Early Morning', daily newspaper published in Moscow from 1907 to 1918, when closed down by Soviet regime.

General Vladimir Cheremisov (1871–1937), commander of Northern front September–November 1917; refused to send troops to suppress revolution; emigrated to Denmark and then France.

Lavrenty Efremov (1878–?), peasant who became Duma member in 1907, allied to Socialist Revolutionaries; later outlawed by authorities; in 1917 elected to Constituent Assembly.

Vera Figner (1852–1942), one of leaders of revolutionary Populist movement and member of Narodnaya volya ('People's Will'), group responsible for assassination of Emperor Alexander II in 1881; after revolution co-founded organisation supporting former political prisoners; never joined Communist Party.

Pyotr Palchinsky (1875–1929), mining engineer and economist, allied to Socialist Revolutionaries; worked on large industrial planning projects in USSR but was critical of regime; executed in 1929.

Sergei Shvetsov (1858–1930), imprisoned in 1880s for political activism; oldest Socialist Revolutionary member of short-lived Constituent Assembly; later active in support of former political prisoners.

RADICAL REVOLUTIONARIES

Pavel Dybenko (1889–1938), sailor and revolutionary, tried and acquitted of cowardice in 1918 court martial; married to Alexandra Kollontai; Red Army commander; executed in 1938.

Pyotr Kropotkin (1842–1921), geographer, advocate of anarcho-communism; lived in exile from 1876, returned 1917; opposed to communist dictatorship.

Nikolai Krylenko (1885–1938), Bolshevik, appointed commander-in-chief in November, took active role in preventing retaking of Petrograd by Kerensky loyalists; Red Army commander; chief prosecutor in 1920s.

Moscow Military Revolutionary Committee, Moscow branch of military organ created in run-up to October Revolution, aimed at securing power for the Bolsheviks.

Konstantin Ostrovityanov (1892–1969), Bolshevik involved in revolutionary events in Moscow; later distinguished economist and university professor.

Stanislav Pestkovsky (1882–1937), Polish-born Bolshevik, appointed director of the State Bank for three days in November 1917; USSR envoy to Mexico 1924–26, then worked in Comintern; disappeared during Stalin's 1937 purge.

Petrograd Military Revolutionary Committee, body that took control of Petrograd garrison on 21–23 October, paving way for Bolshevik seizure of power.

OBSERVERS

Kira Allendorf (1905–94), twelve-year-old diarist; later author of works on history of the French language.

Konstantin Balmont (1867–1942), Symbolist poet, lived in exile in Europe 1906–13, returned under amnesty; emigrated again to Paris in 1920.

Marina Belevskaya (?–1939), Mogilev resident, author of book about army headquarters; emigrated to Vilnius, Lithuania; active in émigré organisations and publications; killed in German air raids in 1939.

Georges Clemenceau (1841–1929), French prime minister 1906–9 and 1917–20; clashed with Woodrow Wilson and David Lloyd George at Versailles peace conference over post-war settlement.

Pauline Crosley (1871–1955), wife of American naval attaché; ordered to leave Russia with her husband in April 1918.

Yuri Gotye (1873–1943), historian, professor at Moscow University; arrested and exiled to Samara in 1930; returned to Moscow in 1934.

Igor Grabar (1871–1960), artist and art historian, head of Tretyakov Gallery 1913–20, head of art restoration workshops from 1918; later adviser to Stalin on architectural preservation.

Louise Patin (1867–?), French tutor to noble Russian families from 1900, author of *Journal d'une institutrice française en Russie pendant la Révolution, 1917-1919*.

Morgan Philips Price (1885–1973), Russian-speaking reporter for *Manchester Guardian* on Eastern front; Labour Member of Parliament 1929–31 and 1935–50.

Sergei Rachmaninov (1873–1943), composer, left Russia in December 1917, emigrated to New York; died in California.

Nadezhda Udaltsova (1886–1961), avant-garde artist; studied in Paris; professor at state art school Vkhutemas from 1924; works denounced as formalist and banned from 1934.

In the days and weeks after the October Revolution many believe that the Bolsheviks have little chance of consolidating their victory. 'These people are not going to remain in power long,' writes Butler Wright of the American Embassy. Kerensky, now outside Petrograd trying to rally Cossack support, has not given up all hope. For the Bolsheviks there are other battles to be won, notably in Moscow where the violence results in much greater loss of life than in Petrograd.

News of the coup reverberates across the country, precipitating unrest and confusion; the papers start to write of civil war. And yet there are also signs of the new regime asserting a measure of control, as the British nurse Florence Farmborough records in her diary: 'The Bolsheviki are forming councils, committees, sub-committees, courts, leagues, parties, societies; they are talented talkers and gifted orators. The masses of the people flock to their call.'

An end to the war is a particularly resonant rallying cry. Lenin's Decree on Peace is issued on 26 October and soon the Bolshevik leadership is moving towards armistice negotiations with the Central Powers. Opposition is silenced by curtailments to press freedom. Elections to the much-postponed Constituent Assembly finally take place in November. Results shore up the Bolsheviks' position in the larger cities and within the army but the Socialist Revolutionaries gain a clear majority with overwhelming support amongst the peasantry.

With the Constituent Assembly set to open on 5 January 1918, the stage is set for a symbolic manifestation of a new democratic Russia: a positive, optimistic conclusion, it would seem, to a year of almost continuous political debate and high drama. The Bolshevik leadership sees the Constituent Assembly in a rather different light. The drama, and the bloodshed, is by no means at an end.

PYOTR PALCHINSKY
Mining engineer, economist and political activist

These are historic times, but I would willingly let my father or grandson have this period, and keep for my share the February Revolution – which is more than enough for one person. *27 October 1917*

SIR GEORGE BUCHANAN
British ambassador

Avksentieff, the president of the Provisional Council, who came to see me today, assured me that, though the Bolsheviks had succeeded in overthrowing the government owing to the latter's criminal want of foresight, they would not hold out many days. At last night's meeting of the Congress of All-Russian Soviets they had found themselves completely isolated, as all the other socialist groups had denounced their methods and had refused to take any further part in the proceedings [...] The Municipal Council, he went on to say, was forming a Committee of Public Security, [...] while the troops, which were expected from Pskov, would probably arrive in a couple of days. I told him that I did not share his confidence. *27 October 1917*

GENERAL VLADIMIR CHEREMISOV
Commander, Northern front; telegram to army and navy commanders

The political struggle which is taking place in Petrograd should not involve the army, whose task remains the same as before – to keep a solid hold on positions now occupied, maintaining order and discipline. *27 October 1917*

VLADIMIR AMFITEATROV-KADASHEV
Son of the writer Alexander Amfiteatrov

Today Papa told me in strict confidence that a plot was being organised by Ellinsky. This was the plan: several pilots would take off from the Neva in seaplanes and bomb Smolny to blazes. The next morning Petrograd would wake up under a new, preassembled government [...] Ellinsky wants to go up and drop the bombs himself (just imagine!). The whole thing, of course, is childish fantasy – you don't change power like that. But Papa is very taken with the idea and I didn't argue with him. The only thing I would say, though I'm no expert, is surely it's impossible to take off in a seaplane from the Neva when it's frozen over? *31 October 1917*

PETROGRAD MILITARY REVOLUTIONARY COMMITTEE
Proclamation 'To All the People'

Former Minister Kerensky, overthrown by the people, [...] is making a criminal attempt to oppose the Soviet of People's Commissars, the legal government elected by the All-Russian Congress. [...]

Like General Kornilov, this criminal enemy of the people has mustered only a few echelons of confused Cossacks and is attempting to deceive the people of Petrograd by fraudulent manifestos.

We make a public announcement: if the Cossacks do not arrest Kerensky, who has deceived them, and if they continue to move towards Petrograd, the troops of the revolution will advance with full force in defence of the revolution's precious conquests – peace and land. [...]

Workers, soldiers, peasants, we demand of you revolutionary vigilance and revolutionary discipline. *29 October 1917*

GENERAL PYOTR KRASNOV
Cossack commander of the 3rd Cavalry Corps

Towards the evening of 27 October I had at my disposal three platoons of the 9th, two platoons of the 10th, and one platoon of the 13th Don Regiments, eight machine guns, and sixteen pieces of mounted artillery [...] There were 480 Cossacks in all [...] To go with such forces to Tsarskoe Selo, the garrison of which consisted of

General Pyotr Krasnov

some 16,000 soldiers, and then to Petrograd, which numbered 200,000, [...] was sheer madness. But civil war is not real war [...] Besides, I knew too well the habits of the Petrograd garrison. Until late at night they would be having a good time in the saloons and cinemas, with the result that you could not awaken them in the morning. We had, therefore, a good chance to take Tsarskoe Selo before dawn and before the strength of my army could be revealed.

ALFRED KNOX
Military attaché at the British Embassy

Krasnov had taken Gatchina on the 27th, and on the 28th approached Tsarskoe Selo, which was garrisoned by 20,000 men. The garrison sent delegates to ask for terms, and Krasnov demanded they should lay down their arms. Unfortunately, however, Kerenski appeared in his motor and gave vent to his usual speech about saving the revolution, etc. This resulted in the usual 'meeting'. Some of the Bolshevik soldiery gave up their arms and others did not. Krasnov fired four rounds of shrapnel and all opposition disappeared. He occupied Tsarskoe Selo by nightfall.

LEON TROTSKY
Chairman of the Petrograd Soviet; proclamation published in *Pravda* on behalf of the Soviet of Peoples' Commissars

The night of 30–31 October will go down in history. Kerensky's attempt to advance counter-revolutionary troops on the capital of the revolution has been decisively repulsed. Kerensky is retreating, we are advancing. The soldiers, sailors and workers of Petrograd have shown that they are able and willing to take up arms to validate the will and power of democracy. The bourgeoisie has tried to isolate the army of the revolution, Kerensky has attempted to break it with the might of the Cossacks. Both attempts have ended in pitiful defeat.
1 November 1917

GENERAL NIKOLAI DUKHONIN
Chief of staff; telegram from Army Headquarters

To All, All, All:
 In order to stop the bloodshed of civil war the troops of General Krasnov gathered near Gatchina today, 1 November, concluded an armistice with the Petrograd garrison. According to

General Krasnov, Supreme Commander-in-chief Kerensky has left the troops and his whereabouts are unknown. In view of this, and in conformity with the regulations of the field army administration, I have temporarily taken upon myself the duties of supreme commander-in-chief and have given orders not to send more troops against Petrograd. *1 November 1917*

GENERAL PYOTR KRASNOV
Don Cossack commander; evidence given to an investigative commission

At around 15.00 on 1 November I was summoned by the supreme commander-in-chief [Kerensky]. He was very upset and nervous.

'General,' he said, 'you have betrayed me [...] Your Cossacks here are saying that they are putting me under arrest and will hand me over to the sailors...'

'Yes', I answered. 'There are such discussions going on, and I know that there is no support for you anywhere.'

'So the officers are saying the same thing?'

'Yes, the officers are especially unhappy with you.'

'What should I do? I'll have to kill myself.'

'If you were an honourable man, you would go to Petrograd now with a white flag and appear in front of the Revolutionary Committee, and negotiate with them as the head of the government.'

'Yes, I'll do that, General.' [...]

'Go calmly and openly, so that they see you're not fleeing.'

'Yes, all right. But give me a trustworthy convoy.'

'Certainly.'

I went and summoned Rusakov [...] and ordered him to nominate eight Cossacks as the guard for the supreme commander-in-chief. Half an hour later the Cossacks came in and said that Kerensky wasn't there, that he had fled. I raised the alarm and ordered a search, assuming that he could not escape from Gatchina, but must be hiding here somewhere. *1 November 1917*

ALEXANDER KERENSKY
Former prime minister

The agreement between the Cossacks and the sailors seemed to settle the situation finally, leaving me no avenue of escape. But a miracle happened!

Two men whom I had never met or known before come into the room – a soldier and a sailor.

'There is no time to lose. Put this on.'

'This' consists of a sailor's cloak, a sailor's hat and automobile goggles. The cloak is too short for me. The hat is too small and persists in falling back on my neck. The masquerade attire appears ludicrous and dangerous. But there is nothing to be done. I have only a few minutes.

'At the gate, before the palace, an automobile awaits you.' We say goodbye.

PAVEL DYBENKO
Chairman of the Central Committee of the Baltic Fleet

Meanwhile Kerensky, having followed the course of the negotiations, is not brave enough at the last minute to appear before the Cossacks and declare that while he is ready to die at his post he does not agree to the shameful document signed by the Cossacks. Changing his clothes, he then ignominiously escapes, leaving the Cossacks he has deceived behind. The sailor Trushin, who has been keeping an eye on Kerensky, breathlessly announces: 'Kerensky, dressed as a woman, has left through the courtyard.' So be it! His flight is his political death.

MIKHAIL BOGOSLOVSKY
Historian, professor at Moscow University

A whole host of different rumours. The battle cruiser *Aurora*, it was said, was firing on the Winter Palace, firing off 1,000 shells which had destroyed the palace; moreover the women's battalion had all perished [...] At four in the morning I heard loud rifle fire which carried on till four-thirty. Then it started off again several times. By this

time I couldn't get back to sleep. So it's begun in Moscow too! Where the firing was I couldn't tell. The shots rang out deafeningly in the silence of the night. *27 October 1917*

MOSCOW MILITARY REVOLUTIONARY COMMITTEE
Order no. 1

The Military Revolutionary Committee declares:

1. The entire Moscow garrison should immediately be put on a war footing. Every troop unit should be ready to act on the first instruction of the Military Revolutionary Committee;
2. No orders or commands should be acted upon that do not issue from the Military Revolutionary Committee or are not ratified under its name. *26 October 1917*

SERGEI EFRON
Poet, officer in the 56th Reserve Infantry Regiment, husband of the poet Marina Tsvetaeva

Sitting drinking tea, I was leafing through *Russkie vedomosti* or *Russkoe slovo*, not expecting any good news after the fiasco of Kornilov's performance. Printed in bold on the front page, the following sentence caught my eye: 'Revolution in Petrograd. Arrest of members of the Provisional Government. Fighting on the city's streets.'

The blood rushed to my head. What had been likely to happen any day, and what everyone had tried so hard not to think about, had actually happened. Having warned my sister (my wife was then in Crimea), I quickly dressed, thrust my Iver Johnson revolver into the side pocket of my overcoat, and dashed off to the regiment, where the officers would, of course, be gathering to discuss the next steps. I knew for certain that Moscow would not fall to the Bolsheviks without a fight.

Sergei Rachmaninov

SERGEI RACHMANINOV
Composer

The outbreak of the Bolshevik upheaval still found me in my old flat in Moscow. I had started to rewrite my first concerto for pianoforte, which I intended to play again, and was so engrossed with my work that I did not notice what went on around me. Consequently, life during the anarchistic upheaval, which turned the existence of a non-proletarian into hell on earth, was comparatively easy for me. I sat at the writing-table or the piano all day without troubling about the rattle of machine guns and rifle shots.

SERGEI EFRON
Poet, officer in the 56th Reserve Infantry Regiment, husband of the poet Marina Tsvetaeva

The Kremlin was surrendered by the troops' commander Colonel Ryabtsov right at the start. This allowed the Red Guards to use the Kremlin arsenal. The weapons were immediately dispersed throughout Moscow. A large number fell into the hands of boys and teenagers. The crack of gunfire was heard through the deserted streets and back alleys of Moscow. People fired everywhere, and

from everywhere, often without purpose. Rooftops and attics were a favourite location. Finding the snipers, even if we could clearly identify where they were firing from, was almost impossible. As soon as we climbed to the top, they had disappeared without trace.

NIKITA OKUNEV
Diarist, employee of the Samolyot Shipping Line

Today from 5 o'clock in the morning until 6.15 I was again on duty at the main entrance to our apartment building with someone else's revolver in my pocket [...] The mornings are very uneasy on the streets. The trams and telephones aren't working, the banks and all the businesses are closed. At various points there are guards, checkpoints, patrols. Everyone looks extremely frightened and bewildered. They don't know whether to go about their business, they can't understand who is shooting, where and for what reason. School-children crowd around the gates and entrances. There's both fear of a stray bullet, and curiosity. *28 October 1917*

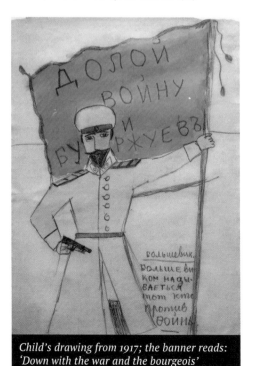

Child's drawing from 1917; the banner reads: 'Down with the war and the bourgeois'

KIRA ALLENDORF
Twelve-year-old diarist

On Monday we heard firing the whole time. Two Junker officer cadets were wounded. They started building a barricade in front of our windows, they're still building it now. Probably means there'll be a battle here – it will be interesting, but a bit frightening too.

Now there's no question of going out onto the street. The main door is boarded up, and you can't go through the courtyard gates either, that's where the barricade begins.

Our house will probably make a stand against the Bolsheviks. At first it wasn't very nice hearing the shots, but I've got used to it now and barely notice it. For days they've been firing rifles and machine guns but today they started firing shells. We've already seen several exploding in the air. At one point a bullet just missed the nursery, it hit the wall next to the window and the stucco all crumbled. *30 October 1917*

KONSTANTIN OSTROVITYANOV
Revolutionary, later economist

I was given a squadron of Red Guards and a whole tram carriage. We travelled with the lights out. I'd never conducted searches before, though I had experienced several at the hands of the tsarist police. It was hardly surprising that our first effort was a bit of a mess.

We rang the bell of the designated flat at midnight. The door was opened by the nervous, semi-dressed occupants. The Red Guards, who were no more experienced in such matters than I was, without waiting for an order pointed their guns at the owners and shouted 'Hands up!' Unimaginable panic ensued. Eventually calm was restored. We hastily searched the flat and, finding nothing, headed off shamefacedly. I carried out subsequent searches rather better and more effectively.

KONSTANTIN PAUSTOVSKY
Writer

Two little girls and their old nanny were sitting on the ground [in the courtyard]. The old woman had wrapped each of them in a warm shawl.

'It's safe here,' the landlord said. 'Bullets are hardly going to penetrate the inner walls.'

The elder girl asked from under her shawl: 'Papa, is it the Germans who have invaded Moscow?'

'There are no Germans.'

'So who's firing?'

'Be quiet!' her father shouted.

28 October 1917

NEW YORK TIMES
American newspaper; report

The commander of the garrison, Colonel Ryabtsov, at first did not believe in the seriousness of the Bolshevik rising. [...]

The Government force consisted of about 3,000 pupils of the officers' training schools, a few officers and a hastily organised White Guard of students. They had three guns and a plentiful supply of rifles and cartridges and a number of Maxims.

Of the 100,000 men of the Moscow garrison not more than 15,000 directly or indirectly supported the Bolsheviki. Most of the regiments sat tight in barracks. From Sunday on thousands of soldiers escaped from Moscow by train or on foot. The Bolsheviki Red Guard, composed mainly of boys from twelve to eighteen, and the Military Revolutionary Committee obtained the services of a few inferior officers. They had about fifteen field guns, from which they kept up a continuous bombardment from the Sparrow Hills and other points of vantage. Their firing was very bad, and for the most part the shells fell wide of their mark, smashing into private houses and killing peaceful citizens.

Up till Wednesday the number of killed and wounded was about 3,000, chiefly among the peaceful population. There was no means of collecting the dead and their bodies lay for days in doorways and on stairs. *6 November 1917*

NADEZHDA UDALTSOVA
Artist

There is every chance that in a few hours a stray shell could demolish our roof and us along with it. For three days artillery fire has been booming, machine-gun salvos chattering, it's like being in a city under siege, there's a mass of dead and wounded, and nobody knows why. [...]

Social revolution is a total farce, lie and fool's paradise. What a complete fiasco, it would be better if they were fighting at the front [...] Who gave them the right to have a say over my life, my time, my health? We're living in a kind of prehistoric age. There should be an agreement that people can't have uprisings in cities, that they have to go off and fight it out somewhere in the sticks. *29 October 1917*

LEON TROTSKY
Speech at the Petrograd Soviet

They thought that we would be passive but we have shown them that we can be merciless when it is a question of holding on to the conquests of the revolution [...] Let our enemies know that they will pay dearly for the life of every worker and soldier. *29 October 1917*

VLADIMIR CHERTKOV
Tolstoy's editor and publisher; appeal to those fighting in Moscow

Stop the fratricide!

Comrades – brothers! Let us come together as one powerful spirit and stop the mutual fratricide that has taken hold of our streets. At this terrible time, all of you who are fighting each other, on whatever side, people of all parties and classes, remember that you are all brothers, sons of a common humanity. *29 October 1917*

IVAN BUNIN
Writer, Nobel prize winner

Wake up at eight. Think it's over (it was quiet). But no, the cook says there's just been an artillery strike. Now I can hear the chatter of gunfire. The telephone

for private citizens is turned off. Electricity's working. There's nothing to buy to eat. The doorman apparently noticed that around two hundred people have gone off to the Junker Academy.

Read *Social Democrat* and *Forward*. A madhouse in hell.

Am hungry – the cook couldn't go out to get provisions (and everywhere is probably closed anyway), a pitiful lunch.

Lidia Fyodorovna is monstrously unbearable.* My god, what a life! *31 October 1917*

NIKITA OKUNEV
Diarist, employee of the Samolyot Shipping Line

The riot is in full swing. Proclamations litter Moscow's streets from two governments: Kerensky's and Lenin's. Each refers to the illegality of the other. So this is the situation for a dutiful son of Russia! Whom should he obey? The Kremlin was surrounded yesterday by Bolshevik soldiers but then later Junker officer cadets and Cossacks came along and surrounded the ring of Bolsheviks, and then they, apparently, were in turn surrounded by new Bolsheviks, and a sort of layer cake was the result.

27 October 1917

GENERAL MIKHAIL KAIGORODOV
Head of the Moscow Ammunition Depot; report of 8 November

At 8 o'clock on the morning of 28 October the Troitsky Gates were opened by Warrant Officer Berzin, and the Junker officer cadets were allowed into the Kremlin. Berzin was beaten and arrested. As soon as they occupied the Kremlin, the Junkers placed two machine guns and an armoured car by the Troitsky Gates and began to round up the men of the 56th Regiment from the barracks, herding them with rifle-butts and threats. Five hundred soldiers were lined up and disarmed in front of the gates to the Arsenal. Several cadets did a head

count. At that moment a few shots rang out from somewhere, and the cadets responded by firing from the machine guns and field gun by the Troitsky Gates. The disarmed soldiers were mown down; shouts and cries rang out as they fled towards the gates of the Arsenal. But only a narrow door was open, in front of which a mountain of bodies piled up – the dead, wounded and trampled, and those still trying to squeeze through the gate; within five minutes the shooting stopped.

The wounded were left groaning; mutilated corpses lay all around.

Vladimir Chertkov

VLADIMIR CHERTKOV
Tolstoy's editor and publisher

There is not a single bloody revolution in the world that has ever served the cause of the popular masses, rather than plunging them into even deeper horrors. This is entirely self-evident, because nothing genuinely good can be achieved through evil means.

GENERAL MIKHAIL KAIGORODOV
Head of the Moscow Ammunition Depot; report of 8 November

The next few days saw uninterrupted exchanges of gunfire between the officer cadets and the soldiers and Red Guards laying siege to the Kremlin; machine guns and artillery were used. Inside the Kremlin the field guns were positioned near the cathedrals, and were sometimes moved to the Troitsky and Borovitsky Gates. From 31 October heavy artillery began to batter the Kremlin. Part of the Small Nikolaevsky Palace and the Chudov Monastery were destroyed. The walls of the Cathedral of the Twelve Apostles were severely damaged, the Uspensky Cathedral was also damaged, as was the Bell Tower of Ivan the Great. One shell landed in the Armoury.

SERGEI EFRON
Poet, officer in the 56th Reserve Infantry Regiment, husband of the poet Marina Tsvetaeva

Colonel Ryabtsov, commander of the troops, has turned up at last. The burly colonel sits in a small room of the Alexandrovsky Academy in an unbuttoned overcoat, surrounded by a tight ring of overwrought officers. He's been given no time to take his coat off, he's boxed in. His face is pale, puffy, as if he's not slept all night. The trace of a beard, drooping moustache. He's completely limp, his pudgy face is rather feminine. Questions rain down on him one after another, each sharper than the last. I feel the string is desperately stretched to breaking point. Dozens of penetrating eyes are focused on the colonel. He sits looking down, his face a mask – no movement in his features whatsoever. 'I surrendered the Kremlin because I believed it was necessary to surrender it.'

'You want to know why? Because I consider all resistance to be the futile shedding of blood. Maybe with our forces we could have defeated the Bolsheviks. But we wouldn't have celebrated our bloody victory for

long. In a few days we'd have been swept away in any case. It's too late to say this now. With or without me, blood is already flowing.'

RANNEE UTRO
'Early Morning' newspaper; report on the Kremlin towers

On Friday morning Bolshevik soldiers blew up the Troitsky Gates with mortar fire and entered the Kremlin. The walls of the Spassky and Nikolsky Towers had been punctured with artillery fire in several places [...] The Nikolsky Gates, which housed the Icon of St Nicholas, so revered by Muscovites, were particularly badly damaged. The icon was destroyed completely. When this tower was blown up by the French in 1812 the icon survived intact. *3 November 1917*

ANATOLY LUNACHARSKY
People's commissar for enlightenment; declaration published in the press

I've just heard from eyewitnesses about what has happened in Moscow [...] The Kremlin, where all of our most important artistic treasures from Petrograd and Moscow are now being kept, is under bombardment. [...]

I am powerless to stop this horror. It's impossible to work under the weight of these maddening thoughts. That's why I'm resigning from the Soviet of People's Commissars. I understand the full weight of this decision. But I cannot do it any more. *2 November 1917*

ZINAIDA GIPPIUS
Poet, novelist and journalist

The news out of Moscow is shocking. (They say things have calmed down again, but it is difficult to believe.) The city is plunged into pitch darkness. Telephone lines are down. Lunacharsky, the 'patron of culture', has been pulling his hair out, gasping and screaming (in the papers) that if things are really so bad, he will 'leave, leave this Bolshevik government'! But he's going nowhere. *3 November 1917*

The Nikolsky Tower of the Kremlin after shelling in early November 1917

ANATOLY LUNACHARSKY
People's commissar for enlightenment

I wrote those lines [of resignation] fearful of the destruction of artistically valuable buildings which had taken place in Moscow during the battles between the revolutionary proletariat and the forces of the Provisional Government; and in this regard I was subjected to a most serious 'refinement' on the part of the great leader, when he said to me: 'How can you lend such importance to this or that old building, however fine it may be, when our task is to open the doors to a social system that will create a beauty far beyond anything dreamt of in the past?'

ANATOLY LUNACHARSKY
People's commissar for enlightenment; appeal published in *Novaya zhizn*

In these difficult days only the hope of the victory of socialism, a source of a new, higher culture, which will compensate for everything, brings consolation.

But responsibility for the protection of the people's artistic property lies on me, and I have been utterly powerless as the great heritage of history has burnt and disintegrated before us.

You cannot remain in a position where you are powerless. Therefore I submitted my resignation.

But my comrades, the people's commissars, consider my resignation inadmissable.

I will remain in my post until your will finds a more worthy representative.

But I beg you, comrades, support me, help me. Protect the beauty of our land for you and your descendents. Be guardians of the national heritage.

Soon even those who have been for so long held in the darkest vice of ignorance will be enlightened, and will understand what a source of joy, strength and wisdom works of art can be.
3 November 1917

PYOTR KROPOTKIN
Scientist, revolutionary and anarchist

The shooting has been going on in Moscow for five days. Artillery and gunfire day and night... It's all very close to us... Yesterday I got an eighth of a pound of bread per person; the day before it was a quarter. Today I got nothing: the caretaker refused to go to the Commissariat to renew the cards... There was random gunfire the whole way along Nikitskaya

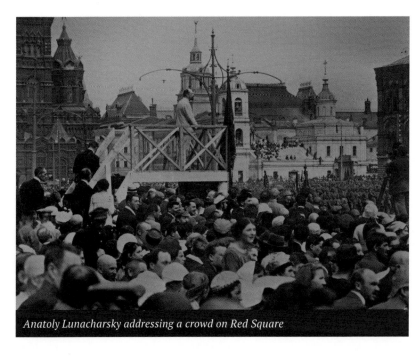

Anatoly Lunacharsky addressing a crowd on Red Square

Street... Yesterday the huge building at No. 6 Tverskoi Boulevard caught fire... And no one put it out. *1 November 1917*

Sergei Efron

SERGEI EFRON
Poet, officer in the 56th Reserve Infantry Regiment, husband of the poet Marina Tsvetaeva

Our platoon is off to General Brusilov's with a letter, inviting him to take command of all our forces. Brusilov lives in Mansurovsky Lane, on Prechistenka.

We come out onto Arbat Square. Our two cannons stand there forlornly, now almost completely silenced. Nearly all the window panes have been shattered. Here and there you see blankets in the windows instead of glass.

In Moscow the sound of artillery is deafening. Shells whistle over our heads constantly. In places, there are gaping holes in the damaged buildings [...] At Filippov and Sevastyanov, the bakers, there's a throng of housemaids and caretakers with their baskets. The housemaids cross themselves at every explosion or whistle of a shell, some

duck down. Finally the soldiers come back from Brusilov.

'So, how did it go?'

'Said he was too ill, wouldn't do it.'

A heavy silence is our only response.

GENERAL ALEXEI BRUSILOV
Former supreme commander-in-chief of the Russian army

At around 6 o'clock that evening (2 November) a grenade flew into my flat and exploded in the corridor just as I was crossing it at the other end. The floor, walls and ceiling were ripped up, fragments came hurtling towards me and struck me in the right leg below the knee. I heard Rostislav (my wife's brother) shouting, 'Get down to the flat below!' And at the same moment, feeling that my shattered leg was hanging in my boot as if in a bag, I cried out, 'I'm wounded!' And I staggered on my left leg to a chair in the nearest room. My batman Grigory, who had been sleeping in a small side room, had fortunately avoided danger; but hearing my cry and Rostislav's instructions, he seized me by the arms and with the help of Yakov's cook dragged me down to the flat of the absent owner of the house [...] They laid me on a bed and a completely untrained Bolshevik nurse tried and failed to bandage me up. My people managed to cut off my boot and the amount of blood was evidently too much for her.

MOSCOW MILITARY REVOLUTIONARY COMMITTEE
Declaration 'To All Citizens of Moscow'

Comrades, Citizens!

After five days of bloody struggle the enemies of the people who took up arms against the revolution have been routed. They have surrendered and been disarmed. Victory has been achieved at the cost of the blood of courageous warriors, both soldiers and workers. In Moscow the people's power is from now on established – the power of the Soviets of Workers' and Soldiers' Deputies.
2 November 1917

YURI GOTYE
Historian, professor at Moscow University

At two in the morning yesterday Volodya Repman dropped in to say that peace had been declared between the two warring sides; in essence it's not peace, so much as the capitulation of the so-called 'government forces' and the whole of the Socialist Revolutionary Committee of Public Security – God rest its soul! But what shame, what sorrow I feel for all those young lives, irreparably and criminally squandered. Not for the first time the matter was settled by military might – or, rather, by armed bands wearing soldiers' uniforms. Whoever has weapons has power. *4 November 1917*

NADEZHDA UDALTSOVA
Artist

What desolate and dismal days. Neither one side nor the other is in the right, and blame for the bloodshed lies on both. So much deceit, tears and grief. What have these good, peaceful people become, these peasants, and why is there such inhuman rage – no, not rage, but some kind of perversion. Ignorance? But when the cultured and educated inhabitants of a city also lose their human face [...] it is truly terrible. *9 November 1917*

ZINAIDA GIPPIUS
Poet, novelist and journalist

No change. It hurts to write. The newspapers are full of lies. In the meantime Moscow, shot to pieces, has succumbed to the Bolsheviks. The capitals have been taken by hostile – and barbarian – forces. There is nowhere to run. There is no motherland. *4 November 1917*

IGOR GRABAR
Artist and art historian; letter from Grabar and his wife Valentina to his brother Vladimir

The destruction in Moscow is terrible. I know you'll hear about it in the papers. It's eerie walking through the streets. The Kremlin's in shreds, badly damaged. The mood is such that it's hard to get on with any work. [...]

What will happen next, nobody knows. The big question is whether the revolutionary committee can keep the lower classes they've armed under control. *8 November 1917*

KONSTANTIN BALMONT
Symbolist poet; to his wife Elena Tsvetkova

I'm reading Sergei Solovyov's *History of Russia*. I've read about early times in Rus', about Stenka Razin, the Time of Troubles, the beginning of Peter's reign – Russians have always been the same, and nastiness is in the air they breathe.* *6 November 1917*

MAXIM GORKY
Writer and political commentator; article in *Novaya zhizn* titled 'In Moscow'

In essence the Moscow slaughter was a horrendously bloody massacre of the innocents. On one side – the young Red Guards who didn't know how to hold their weapons and soldiers who barely understood why or for whom they went to their deaths, why they were killing. And on the other – a numerically insignificant smattering of Junker officer cadets bravely fulfilling their 'duty' in the way they've been trained.

It's self-evidently a brazen lie to say that all Junkers are 'children of the bourgeois and landowning class' and should therefore be subject to annihilation – a lie peddled by opportunists and crazy dogmatists. In any case, if belonging to a particular class dictated a person's behaviour, then the nobleman from Simbirsk, Ulyanov-Lenin, should be standing alongside the Russian landowners, shoulder to shoulder with Purishkevich, and Bronstein-Trotsky should be working as a travelling salesman. *8 November 1917*

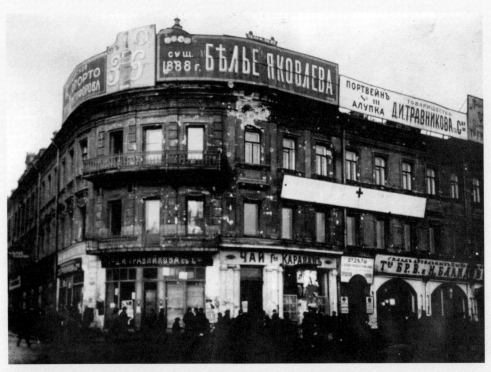

The corner of Tverskaya Street and Okhotny Ryad in the centre of Moscow after shelling in November 1917

NIKITA OKUNEV
Diarist, employee of the Samolyot
Shipping Line

Finally some real papers have come out, that is *Russkoe slovo*, *Russkie vedomosti*, *Utro Rossii* and others. The front pages are just notices announcing the death of many Moscow residents, either accidental casualties or ideological victims of these past days. May they rest in peace! The papers reveal a great deal of sorrowful and dismal things and predict yet more misery for the people. But all of them share the hope that the Bolshevik phenomenon is just an ulcer that will at some point be lanced. *8 November 1917*

RUSSKIE VEDOMOSTI
'Russian Gazette', newspaper of the
Kadets; editorial titled 'Under the burden
of violence'

Not for the first time our voice has been silenced by physical force. Over the course of half a century of struggle for freedom and justice, the hand of coarse violence has clamped shut the mouth of *Russkie vedomosti* more than once. But this is the first time in the history of Russia that those doing the clamping claim to be fighters for freedom and democracy. For the first time an autocracy that tramples on freedom is combining with a hypocritical masquerade, cynically mocking ideas that are valued by all mankind.

 The triumph of this faux-democratic despotism, the victory which is being celebrated in Moscow and Petrograd, is the most terrible tragedy that our motherland has ever suffered [...] To Russia's shame and misfortune, a criminal act has been effected, prepared by the madness and wicked design of one side, and the dithering and duplicity of the other. [...]

 There can be no doubt that the Bolshevik experiment is destined to perish quickly. As has long been known, 'you cannot rule by bayonet', and the Bolshevik quasi-government has no moral authority. *8 November 1917*

VLADIMIR CHERTKOV
Tolstoy's editor and publisher

For the moment the armed conflict in Moscow has stopped. But in various regions of Russia fratricide is continuing or starting and the papers have already introduced a special section headed 'Civil War'. *7 November 1917*

VLADIMIR LENIN
Chairman of the Soviet of People's
Commissars; decree 'On peace'

The workers' and peasants' government, created by the revolution of 24 and 25 October, [...] proposes to all warring peoples and their governments to begin negotiations for a just and democratic peace immediately. An overwhelming majority of the exhausted, wearied and war-tortured workers, and the labouring classes of all the warring countries, are longing for a just and democratic peace. *26 October 1917*

GEORGES CLEMENCEAU
French President of the Council of
Ministers; telegram to the chief of the
French Military Mission to Russia, General
Berthelot

I request you to inform the Russian supreme command to which you are attached that France does not recognise the government of the Soviet of People's Commissars, and, believing in the loyalty of the Russian Supreme Command, expects that the latter will categorically repudiate all criminal negotiations, and will hold the Russian army at the front facing the common enemy. *12 November 1917*

IZVESTIA
Bolshevik newspaper; editorial

The threats of the Allied diplomats are not going to change our policy [...] We are on the path to peace, and we will reach our goal in spite of all obstacles. *14 November 1917*

General Nikolai Dukhonin

GENERAL NIKOLAI DUKHONIN
Acting supreme commander-in-chief;
conversation by direct wire with Lenin,
Stalin and Krylenko

COMMISSARS: The telegram which
was sent to you was absolutely clear
and precise. It said to begin immediate
negotiations with all belligerents. [...]
DUKHONIN: I understand that it is dif-
ficult for you to carry on direct negotia-
tions with the Central Powers. It is even
more difficult for me to do so in your
name. Only a government [...] supported
by the army and the country can have
sufficient weight to impress the enemy
[...] and to get any results. I too am of
the opinion that an early general peace
is in the best interests of Russia.
COMM: Do you refuse to give us a
straight answer and to carry out our
orders?
ND: [...] I repeat again that the peace
which Russia needs can be achieved
only by a central government.
COMM: In the name of the government
of the Russian Republic [...] we dismiss
you from your post for refusing to carry
out the orders of the government and
for pursuing a course that will bring
incredible misery to the toilers of all
countries, especially for the armies [...]
Ensign Krylenko is appointed com-
mander-in-chief. *9 November 1917*

GENERAL NIKOLAI DUKHONIN
Former supreme commander-in-chief;
appeal to the people and the army

Soldier-Citizens!
 You are troubled because you desire
peace and our Allies do not. For that
reason you have been advised to break
the treaties made with them in the time
of the tsar. Those who would lead you
to peace with the imperialistic govern-
ment of Germany fail to tell you that it
is almost the same kind of autocratic
government as that from which the
revolution has freed Russia [...] Rappro-
chement with the Germans means a new
war in the near future. The Germans will
not endure a free democratic Russian
people on their borders. *12 November 1917*

Nikolai Krylenko

NIKOLAI KRYLENKO
Supreme commander-in-chief; Order
no. 2, published in *Izvestia*

The plenipotentiaries crossed the Ger-
man trenches in the region of the Fifth
Army. An answer is expected tomorrow,
the 14th, at 20.00. Comrades, peace is
at hand and in our hands. Stand firm in

these last days [...] Treat with contempt the lies and the false appeals of General Dukhonin's gang, and of his bourgeois pseudo-socialist flunkies who are gathered at headquarters [...] I pronounce the former supreme commander-in-chief, General Dukhonin, an enemy of the people, for his stubborn refusal to obey the order of dismissal and for his criminal acts which have given a new impetus to civil war. All those who support Dukhonin are to be arrested regardless of their social position, party affiliations or past record. *13 November 1917*

LEON TROTSKY
VLADIMIR LENIN
Radiogram to countries at war, published in *Pravda*

The Russian army and the Russian people cannot and will not wait any longer [...] We want a general peace, but if the bourgeoisie of the Allied countries force us to conclude a separate peace, the responsibility will be theirs. *15 November 1917*

LOUIS DE ROBIEN
Attaché at the French Embassy

Whoever they may be, it is the men who end the war who will be masters of Russia for a long time. *24 November 1917*

MARINA BELEVSKAYA
Mogilev resident, author of a book about the Army Headquarters

At the station, despite the efforts of Krylenko, a crowd of Red Army men hoisted General Dukhonin on their bayonets. His mutilated body was crucified in the goods wagon, pinned up with nails. A fag-end was stuffed in the corpse's mouth, and the whole crowd went to look at the general's desecrated body, spitting in his face and hurling abuse at him. It was in this state that his wife, who had heard of her husband's murder, found him at the station. *20 November 1917*

VLADIMIR KOROLENKO
Short-story writer and journalist

Sad news from headquarters. Ensign Krylenko has taken over with the Red Guards and sailors. Dukhonin has been killed. Krylenko is 'outraged' and shedding crocodile tears. *23 November 1917*

MAXIM GORKY
Writer and political commentator

Now, when a certain part of the working masses, stirred up by its fanatical overlords, displays the spirit and methods of a caste by employing terror and coercion – the very coercion against which its best leaders and most perceptive comrades fought so long and courageously – now, clearly, I cannot march in rank with this section of the working class. [...]

To intimidate by terror and violence those who do not wish to participate in Mr Trotsky's frenzied dance on the ruins of Russia is disgraceful and criminal.

All this is unnecessary and will only increase the hatred for the working class. It will have to pay for the mistakes and crimes of its leaders with thousands of lives and torrents of blood. *12 November 1917*

FLORENCE FARMBOROUGH
English nurse serving with the Russian army

The Bolsheviki are forming councils, committees, sub-committees, courts, leagues, parties, societies; they are talented talkers and gifted orators. The masses of the people flock to their call. Already they have established the nucleus of the proletarian republic and drawn up their political programme; and, what is more surprising, they have successfully organised the Red Army – in great part drawn from the disloyal soldiers of the imperial army. One and all wage war against the 'intelligentsia' and the 'bourgeoisie' – nicknames given to the educated people and to the middle-class or 'idle rich'. There is no doubt that Lenin and Trotsky are intent on exterminating the Russian intellectual classes. *12 November 1917*

LOUIS DE ROBIEN
Attaché at the French Embassy

I went to see Grand Duke Paul and Princess Paley in Countess Kreutz's apartment, where they have taken refuge while waiting to be allowed to go back to Tsarskoe Selo.* I found the grand duke wonderfully courageous, relating the details of his arrest and of his detention at Smolny with great good humour. But they went through some terrible hours after the fall of Kerensky, when they were at the mercy of the red hordes [...] The grand duke has no complaints about his guards: some of them even addressed him as 'Comrade Highness'! They found an armchair for him and settled him into it; one of them then begged him to read the newspaper to them and explain it, and they asked his permission to smoke while listening. The grand duke naturally agreed, and it must have been strange to see this Romanov in general's uniform and wearing the order of Saint George, with his majestic look and superb presence, reading *Pravda* to a group of four dishevelled sailors. *11 November 1917*

STANISLAV PESTKOVSKY
Polish-born Bolshevik, director of the State Bank from 11 to 13 November

I opened the door into a room opposite Lenin's office and entered... Comrade Menzhinsky was reclining on a sofa looking exhausted.* There was a sign above the sofa which read 'People's Commissariat of Finance'. I sat down next to him and we started to talk. With an entirely innocent look Menzhinsky began to ask me about my past, and was curious as to where I had studied.

I replied that I had studied at London University, where, as it happened, my subjects included finance. Menzhinsky suddenly got up, fixed his eyes on me and declared categorically: 'In that case we'll make you director of the State Bank.' I was frightened and answered [...] that I had no desire to hold this position, since it was entirely 'outside my line'. Saying nothing, Menzhinsky asked me to wait, and left the room.

A short time later he returned with a paper signed by Lenin confirming that I was indeed director of the State Bank.

PAULINE CROSLEY
Wife of the American naval attaché; letter home

In general the news is: Petrograd is still here; a part of Moscow is no longer there; many handsome estates are no longer anywhere; the Bolsheviki are everywhere. *16 November 1917*

KADET PARTY
List no. 2 for elections to the Constituent Assembly

Citizens of Petrograd!
The day of the election to the Constituent Assembly is approaching.* This body is the only true Lord of Russia. By its powerful voice, the voice of the many millions of Russians, it can determine the form of government, the organisation of power, and whether we should have peace or go on with the war. Not the users of force and the grabbers of power, not the murderers, not the destroyers of the freedom of speech and the press, not the 'Soviet of People's Commissars' or any other such self-appointed organisations, but the Constituent Assembly alone has the right to issue decrees on land and peace. To its decisions all the peoples of Russia must submit [...] Remember that the failure to vote helps the Bolsheviks and is therefore a serious sin against the country!

LOUISE PATIN
Author of *Diary of a French Tutor in Russia during the Revolution*

It is obvious that these posters, with their huge letters indicating what list to vote for, are intended for an uneducated population. The Bolsheviks' posters are red: 'Vote for list 4! You will get bread! Land! Peace!'
The pale blue posters of the Kadets are more moderate. The Cossacks have white signs with the number 1. On every street corner, in the squares and in the

park, one can see Bolshevik soldiers screaming in angry voices and giving pretentious speeches. Men and women of all classes are voting.

TEFFI
Writer and satirist

It seems that the elections have gone smoothly. The papers make no mention of outrages or excesses or any of the other modish phrases that seem to encompass anything from a street brawl to mass slaughter. The excesses will probably start once the count is in. Voting confidentiality remains sacrosanct but – alas! – nothing is so secret that it cannot be disclosed!

This is probably why, in one of the regiments of the Petrograd garrison, the regimental committees, with an elegant transparency, only distributed list number 4 to the soldiers. Why beat about the bush, everyone knows what's going on. *17 November 1917*

MORGAN PHILIPS PRICE
Journalist and British Labour Party politician; letter to his aunt Anna Maria Philips

The elections for the Constituent Assembly have just taken place here. The polling was very high. Every man and woman votes all over this vast territory, even the Lapp in Siberia and the Tartar of Central Asia. Russia is now the greatest and most democratic country in the world. There are several women candidates for the Constituent Assembly and some are said to have a good chance of election. The one thing that troubles us all and hangs like a cloud over our heads is the fear of famine. *17 November 1917*

ZINAIDA GIPPIUS
Poet, novelist and journalist

Something has happened to me. I can't write. 'Russia has been sold on the cheap.' After various attempts at 'peace-making' by the military high command, after the disgraceful elections to the Constituent Assembly, elections held under the bullets and bayonets of our new thugocracy, after all the decrees of madmen calling to dissolve the City Duma as 'bulwark of the counter-revolution', what is there to say? Speaking the truth feels as shameful as lying.

When they dissolve the Constituent Assembly (and they will dissolve it!), I think I will fall silent forever. From shame. It is a shame which is difficult to adjust to and heavy to bear. *18 November 1917*

PITIRIM SOROKIN
University professor, member of the Socialist Revolutionary Party

The Bolsheviki are decisively beaten. Yet we know that they have no intention of accepting the verdict. As long as they had hopes of gaining a favourable vote they were willing for the Constituent Assembly to meet. Now they will try to prevent its meeting. *18 November 1917*

EDITORIAL STAFF OF DELO NARODA
'People's Cause', Socialist Revolutionary newspaper

In May 1906 *Delo naroda*, the organ of the Central Committee of the Socialist Revolutionaries, was closed by the tsar's government. History repeats itself [...] autocracy has come back and is trying to suppress freedom of speech. On the night of 23 November an armed gang of Red Guards came to our printing office and ordered us to close *Delo naroda* because it did not submit to the authority of the people's commissars. Force had its way. *Delo naroda* did not appear on 23 November. What does this prove? That we are broken, that we submit? Not in the least. We did not recognise, do not recognise and will not recognise authority seized by force. *24 November 1917*

VLADIMIR NABOKOV
Leading member of the Kadets

On the 23rd, about two hours after the commission had started its business, the commandant of the Tauride Palace, a Bolshevik ensign whose name I have

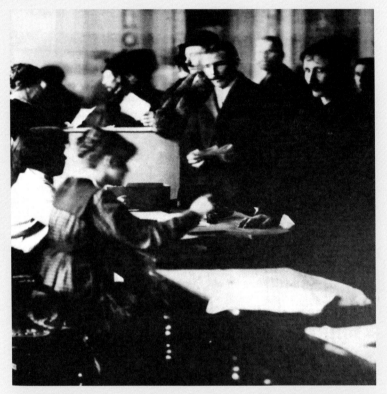

Electors casting their votes for the Constituent Assembly in November 1917

forgotten, appeared and in the name of the Soviet of People's Commissars ordered the commission to disband. N.N. Avinov was in the chair, and his reply, on behalf of the whole commission, was a categorical refusal. The officer left, went to the Smolny for instructions, and came back with a document signed by Lenin and containing an order – very badly worded – to arrest the Kadet Electoral Commission and send its members to Smolny Prison. [...]

We were interrogated on the very first evening; the interrogation was conducted by a certain Krasikov, a barrister of the worst type, and invariably included the following question, to which we invariably answered 'no': 'Do you recognise the authority of the Soviet of People's Commissars?' At the end of the interrogation I asked directly: 'What is the reason for our arrest?' Back came the reply: 'Refusal to recognise the authority of the people's commissars.' *23 November 1917*

NIKITA OKUNEV
Diarist, employee of the Samolyot Shipping Line

The main Electoral Commission of the Constituent Assembly has been arrested. The reasons are fairly mysterious but it looks as though the Constituent Assembly will be broken up by the Bolsheviks. They're already saying that given the existence of the Soviets there's nothing for the Constituent Assembly to do, particularly in its current composition, with Socialist Revolutionaries and Kadets outnumbering the Bolsheviks. *27 November 1917*

ZINAIDA GIPPIUS
Poet, novelist and journalist

Manukhin turned up, all shaken and distraught: he's quit the prisoners in the Trubetskoi Rampart. Today they arrested the Investigative Commission he served on under the Provisional Government, when he was working as doctor to the tsarist ministers being held there. Now, in order to continue visiting the prisoners, he has to be in the employ of the Bolsheviks. They had no objection to this, and even asked him to stay 'with them'. This is actually one of their remarkable characteristics: first and foremost they demand 'recognition'. And they'll bestow any favour 'if you fall down and worship them'. Manukhin is an incredibly good person. And it was desperately painful to see how torn he was. He knows what his leaving means for the unfortunate captives: 'Today Konovalov and I were in tears together. Because, you see, they all understand perfectly well that it's no longer a prison, it's a torture chamber! I'd have to constantly beat them up! If I'd stayed (as indeed I said to those who suggested it), I'd have started yelling that it was a torture chamber! Today, with their cheerful faces, they were banging up members of the Constituent Assembly and saying, these are just the first, we're clearing the cells, getting them ready for the socialists. If only we could get Tsereteli [...] All these "enemies of the people". Kokoshkin, who is seriously ill with tuberculosis, has been put in a damp cell (though I managed to reclaim him a dry one).* They have nothing, no candles, no clothing...

We're in the clutches of a gorilla, whose owner is a villain.' *30 November 1917*

THE TIMES
London newspaper; report titled 'Trotsky against the Cadets'

Replying to some speakers who disapproved of violence being offered to members of the Constituent Assembly, Trotsky said: 'You are shocked at the mild form of terror we exercise against our class enemies, but take notice that not more than a month hence that terror will assume a more terrible form, on the model of that of the great French Revolution. No prison but the guillotine for our enemies. It is not immoral for a democracy to crush another class. That is its right.' *5 December 1917*

VLADIMIR LENIN

Chairman of the Soviet of People's Commissars; decree 'On the Establishment of the Extraordinary Commission to Fight Counter-revolution'

The duties of the commission will be:

1. To persecute and break up all acts of counter-revolution and sabotage all over Russia, no matter what their origin.
2. To bring before the revolutionary tribunal all counter-revolutionaries and saboteurs and to draw up measures for fighting them.
3. To make preliminary investigation only – enough to break up activities. [...]

First and foremost, the Commission is to watch the press, sabotage, Kadets, Right Socialist Revolutionaries, saboteurs and strikers. Measures: confiscation, confinement, deprivation of ration cards, publication of the names of the enemies of the people, etc.

The commission is to be named the All-Russian Extraordinary Commission to Fight Counter-revolution and Sabotage under the Soviet of People's Commissars (CHEKA). *7 December 1917*

FLORENCE FARMBOROUGH

English nurse serving with the Russian army

The Bolsheviki in Petrograd and Moscow have proclaimed that all aristocratic, wealthy, cultured, religious and educated people are to be classed as bourgeoisie and denounced as enemies of the New Proletarian State of Russia. If they show resistance to the laws laid down by the Bolsheviki, they will be considered counter-revolutionaries and their lives forfeited [...] We have been thinking well and deeply about the situation and the longer that we ponder over it the more grievous does it become. *10 December 1917*

ALEXANDER BLOK

Poet; interview in *Petrogradskoe ekho* newspaper

Can the intelligentsia work with the Bolsheviks? It can, and it must. I am not well-informed about politics and do not presume to make judgements about how the intelligentsia and the Bolsheviks may reach an agreement. But the deep impetus driving this agreement will be musical.

Personality aside, the same music is playing among the intelligentsia and the Bolsheviks. The intelligentsia has always been revolutionary. The decrees of the Bolsheviks are emblems of the intelligentsia [...] The intelligentsia's bitter resentment of the Bolsheviks is superficial. It seems that it is already passing. People think differently from the way they speak. A sense of agreement is beginning to appear – a musical agreement. *1 January 1918*

HAROLD WILLIAMS

New Zealand journalist; article in the *New York Times* titled 'The Russian Despotism'

The Bolsheviki have determined, evidently, that the Constituent Assembly shall not meet unless they can control it. The elections went against them. At first their intention was to set the elections aside in those districts where they had been defeated and order new ones, presumably under the auspices of the Red Guard. But a simpler method has been employed. They have adopted Cromwell's old method of a 'purge'. When anti-Bolshevik delegates show up, they are arrested. The news may be expected to deter other anti-Bolshevik delegates from taking the risk and trouble of coming to Petrograd. Whether they come or stay, the weeding is satisfactorily done; arrest disposes of them in the one case, absence in the other. Meanwhile headquarters at Petrograd sends out an urgent appeal to the Bolshevik delegates to hurry to Petrograd. [...]

The idea of abiding by the voice of the people, of accepting the verdict of the polls, even when it is against you, does not seem ever to have penetrated the Russian radical mind. *2 December 1917*

PITIRIM SOROKIN
University professor, member of the Socialist Revolutionary Party

I've been caught! The Bolshevik cat has finally got its mouse, and now I have plenty of spare time. After a meeting of the Committee of the Constituent Assembly, Argunov and I went along to the editorial office of *Volya naroda*. We climbed to the second floor, where the office was, and didn't notice anything out of the ordinary. But when we opened the door, we found five or six people pointing revolvers at us.

'Hands up!' they cried.

'What is the matter?'

'You're both under arrest.'

'Members of the Constituent Assembly are not subject to arrest,' I said, perfectly aware of the futility of my words.

'You can forget about that. Our order is to arrest you. That's all there is to it.'

An hour later we were delivered by car to our destination, and found ourselves behind the walls of the Peter and Paul Fortress, Petrograd's Bastille.

In the governor's office we saw six or seven Bolshevik soldiers engaging in idle chat. For a while they ignored us completely, although one fellow, playing around with his revolver, aimed it in our direction a couple of times. In the end we broke our silence.

'Are prisoners allowed to see their family and receive food, bedding, books and clothes?'

'Generally speaking, yes. You, no.'

'Why?'

'Because you deserve not just imprisonment but immediate execution.'

'For what crimes?'

'For trying to kill Lenin.'

This news was indeed very interesting. While we were digesting it, governor Pavlov, famous for his pathological cruelty, came into the room, coldly looked us over, and ordered the soldiers to escort us to cell no. 63. A few minutes later the doors of the cell in the Trubetskoi Rampart clanked shut behind us. And so now we are prisoners of Peter and Paul. *2 January 1918*

NADEZHDA UDALTSOVA
Artist

I'm fed up with it all, I only want to work, eat and sleep; I don't want to go anywhere or see anyone. A demonstration in support of the Constituent Assembly is expected on the 5th. The Bolsheviks are getting ready to disperse it with armed force, what a vile business. *3 January 1918*

PETROGRAD SOVIET
Resolution on the demonstrations of 5 January 1918

This will be a demonstration of enemies of the people. [...]

On 5 January saboteurs, the bourgeoisie and their lapdogs will demonstrate on the streets of Petrograd [...] Not a single honest worker nor a single conscientious soldier will take part in this demonstration of enemies of the people. [...]

The Petrograd Soviet authorises Commissar Blagonravov to take all measures to ensure that order is maintained on the streets of Petrograd on 5 January. Seizure of any public institutions by counter-revolutionary demonstrators will not be permitted and will be met with the most ruthless rebuff. *4 January 1918*

MAXIM GORKY
Writer and political commentator; article in *Novaya zhizn*

For almost a hundred years the finest Russians have lived by the idea of a Constituent Assembly [...] In the struggle for this idea, thousands of the intelligentsia and tens of thousands of workers and peasants have perished in prisons, in exile and at hard labour, on the gallows, and by soldiers' bullets. Rivers of blood have been spilled on the sacrificial altar of this sacred idea, and now the 'People's Commissars' have given orders to shoot the democracy which demonstrated in honour of this [...] *Pravda* lies when it writes that the demonstration of 5 January was organised by the bourgeois, the bankers [...] *Pravda* lies, it knows full well that the 'bourgeois' have no reason to rejoice over

the opening of the Constituent Assembly, they can do nothing among 246 socialists of one party and 140 Bolsheviks. *Pravda* knows that the workers of the Obukhov, Patronny and other factories took part in the demonstration [...] It was precisely these workers who were shot, and however much *Pravda* lies, it cannot hide this shameful fact. *9 January 1918*

Harold Williams

HAROLD WILLIAMS
New Zealand journalist; article in the British *Daily Chronicle*

From various quarters of the town processions, carrying red flags with inscriptions for the Constituent Assembly, marched towards the centre and one by one were fired on and dispersed by Red Guards and sailors. [...]

Most of the shooting took place on Liteiny Prospect. The number of killed and wounded apparently was not large, considering the amount of ammunition expended. Among those killed and wounded were several workmen and students and one member of the Constituent, the peasant Loginov. Indignation is intense.

When the assembly was opened the galleries were crowded, mostly with Bolshevik supporters. Sailors and Red Guards, with their bayonets hanging at various angles, stood on the floor of the House. To right and left of the Speaker's tribune sat the people's commissars and their assistants. Lenin was there, bald, red-bearded, short and rather stout. He was apparently in good spirits, and chattered merrily with Krylenko (commander-in-chief of the army). There were Lunacharsky and Mme Kollontai, and a number of dark young men who now stand at the head of the various government departments and devise schemes for the imposition of unalloyed socialism on Russia.

After a long wait a Socialist Revolutionary proposed that the senior deputy, Shvetsov, should open the proceedings. The Bolsheviks in the House and galleries raised a howl of indignation, banged the desks, and with whistles and catcalls accompanied the slow, heavy tread of an elderly gentleman with long hair towards the tribune. Shvetsov rang the bell, but the din continued. *6 January 1918*

SERGEI SHVETSOV
Oldest Socialist Revolutionary member of the Constituent Assembly; excerpt from the stenographic record of proceedings

(*Rings a bell.*) I declare the session of the Constituent Assembly open. (*Noises to the left. Voices: 'Down with the imposter!' Prolonged noise and whistling to the left; applause to the right.*) I declare an adjournment. *5 January 1918*

FYODOR RASKOLNIKOV
Bolshevik member of the Constituent Assembly; excerpt from the stenographic record of proceedings

Since we do not for one minute intend to provide cover for the crimes of enemies of the people, we declare that we are leaving this Constituent Assembly (*wild applause in the crowd*); we propose handing over to the Soviet the final decision on relations with the counter-revolutionary part of the Constituent Assembly. (*Cries of 'Pogromists!' Applause in the crowd.*) *5 January 1918*

LAVRENTY EFREMOV
Socialist Revolutionary member of the Constituent Assembly; excerpt from the stenographic record of proceedings

Citizens, members of the Constituent Assembly, before saying what is tearing at my heart and my soul, I would like... (*Voice: 'There'll be a murder!' A revolver is seized from member of the Constituent Assembly Feofilaktov.*) *5 January 1918*

VERA FIGNER
Revolutionary, participant in 1880–81 plots to assassinate Emperor Alexander II

I felt deeply humiliated and was amongst the minority who voted not to disperse and to be expelled by force. The dissolution of the Constituent Assembly was a new humiliation for the cherished dream of many generations and the naive reverence of the masses who believed in it. And at the same time I realised that we, the revolutionaries of the older generation – we were the begetters of these events. *5 January 1918*

VLADIMIR LENIN
Chairman of the Soviet of People's Commissars; draft decree 'On the Dissolution of the Constituent Assembly'

The Constituent Assembly, elected on the basis of lists drawn up prior to the October Revolution, was an expression of the old relation of political forces which existed when power was held by the compromisers and the Kadets. When the people at that time voted for the candidates of the Socialist Revolutionary Party, they were not in a position to choose between the Right Socialist Revolutionaries, the supporters of the bourgeoisie, and the Left Socialist Revolutionaries, the supporters of socialism. The Constituent Assembly, therefore, which was to have crowned the bourgeois parliamentary republic, was bound to become an obstacle in the path of the October Revolution and Soviet power. [...]

Accordingly, the Central Executive Committee resolves that the Constituent Assembly is hereby dissolved.
6 January 1918

MAXIM GORKY
Writer and political commentator

Recently the sailor Zheleznyakov, translating the ferocious speeches of his leaders into the crudely elementary language of the masses, said that for the good of the Russian people even a million people could be killed.*

I do not consider this statement to be exaggeration and, though I resolutely refuse to recognise any circumstances that might justify mass murder, I still believe that a million 'free citizens' could be killed in our country. Even more could be killed. Why shouldn't they be killed?

There are many people in Russia and there are plenty of murderers [...] From Ivan the Terrible to Nicholas II, this simple and convenient method of combating sedition was freely and widely used by all our political leaders; why, then, should Vladimir Lenin renounce such a simple method? *17 January 1918*

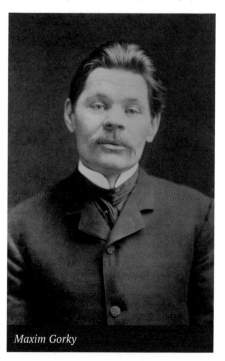

Maxim Gorky

References to bibliographical sources use the Library of Congress transliteration system with diacritics omitted.

Extracts are numbered as follows: the first number refers to the page, the second to the extract on that page, so 21.3 is the third extract on page 21.

Abbreviated works

Benua
Aleksandr Benua, *Dnevnik 1916–1918 godov*, Moscow, 2006

Browder
The Russian Provisional Government 1917: Documents, ed. Robert Paul Browder and Alexander F. Kerensky, vols 2–3, Stanford, 1961

Buchanan
Sir George Buchanan, *My Mission to Russia and Other Diplomatic Memories*, vol. 2, London, 1923

Bunyan
The Bolshevik Revolution 1917–1918: Documents and Materials, ed. James Bunyan and H.H. Fisher, Stanford, 1965 (Hoover War Library Publications no. 3)

Complete Correspondence
The Complete Correspondence of Tsar Nicholas II and the Empress Alexandra: April 1914 – March 1917, ed. Joseph T. Furmann, Westport-London, 1999

Gippius
Zinaida Gippius, *Sobranie sochinenii*, 15 vols, Moscow, 2001–13; vol. 8: *Dnevniki 1893–1919*, Moscow, 2003

Houghteling
James L. Houghteling, Jr, *A Diary of the Russian Revolution*, New York, 1918

Kerensky
Alexander Kerensky, *The Kerensky Memoirs: Russia and History's Turning Point*, London, 1966

Knox
Major-General Sir Alfred Knox, *With the Russian Army 1914–1917*, vol. 2, London, 1921

Lenin Collected Works
V.I. Lenin, *Collected Works*, Institute of Marxism-Leninism, Moscow (Progress Publishers), 45 vols, 1960–70

Lenin Polnoe sobranie
V.I. Lenin, *Polnoe sobranie sochinenii*, Institute of Marxism-Leninism, Moscow, 55 vols, 1967–1975

Mensheviki
Mensheviki v 1917 godu, ed. Z. Galili, A. Nenarokov, vol. 2, Moscow, 1995

Nabokov
V.D. Nabokov, *The Provisional Government*, Brisbane, 1970

Padenie tsarskogo rezhima
Padenie tsarskogo rezhima: Stenograficheskie otchety doprosov i pokazanii, dannykh v 1917 g. v Chrezvychainoi Sledstvennoi Komissii Vremennogo Pravitel'stva, ed. P.E. Shchegolev, vols 1–5, Moscow-Leningrad, 1924–26

Paléologue
Maurice Paléologue, *An Ambassador's Memoirs 1914–1917*, trans. Frederick A. Holt, London, 1973

Robien
Louis de Robien, *The Diary of a Diplomat in Russia, 1917–1918*, trans. Camilla Sykes, London, 1969

Sukhanov
Nik. Sukhanov, *Zapiski o revoliutsii*, books 1–7, Moscow-St Petersburg-Berlin, 1919–23

Trotskii
L. Trotskii, *Moia zhizn': Opyt avtobiografii*, vols 1–2, Berlin, 1930

Chapter 1

17.1 *Dnevnik L.A. Tikhomirova 1915–1917 gg.*, ed. A.V. Repnikov, Moscow, 2008, p. 304

17.2 *Izbrannye vystupleniia deputatov Gosudarstvennoi Dumy s 1906 do nashikh dnei*, ed. S.E. Naryshkin, Moscow, 2013, p. 109

17.3 Gippius, p. 194
Boris Stürmer, who became prime minister in January 1916, and Metropolitan Pitirim owed their influence within royal circles to Rasputin, who is quoted as saying, 'I begat Pitirim and Pitirim begat Stürmer'. Journalist and spy Ivan Manasevich-Manuilov was another close associate of Rasputin.

17.4 State Archive of the Russian Federation, *fond 612, opis' 1, delo 8*

18.1 Letter to M.N. Pokrovsky, in M. Gor'kii, *Polnoe sobranie sochinenii*, vol. 12, Moscow, 1997, p. 84

18.2 Complete Correspondence, no. 1587 (AF's no. 629), 11 November 1916, p. 651
Alexandra and Nicholas wrote to each other primarily in English. Alexandra's erratic spelling and punctuation are reproduced here without correction. Rasputin is often referred to as 'our Friend' or just 'He'. 'Baby' is Tsarevich Alexei.

18.3 State Archive of the Russian Federation, *fond 612, opis' 1, delo 8*

18.4 Kniaz' Feliks Iusupov, *Memuary v dvukh knigakh*, Moscow, 2011, p. 194

18.5 Paléologue, p. 708

18.6 S.I. Vavilov, *Dnevniki. 1909–1951*, Moscow, 2016, p. 58
Count Frederiks is the elder statesman who served as minister of the imperial household for twenty years, from 1897 to 1917; he would refer to Nicholas and Alexandra as 'mes enfants'.

20.1 Douglas Smith, *Rasputin*, London, 2016, p. 573
Grand Duke Dmitry Pavlovich, a first cousin of both Nicholas II and the Duke of Edinburgh, was a co-conspirator in the murder of Rasputin.

20.2 Ibid.

20.3 Complete Correspondence, no. 1620 (AF's no. 636), 9 December 1916, pp. 664–5
Nicholas and Alexandra had nicknames for several members of the government, including 'Kalinin' for Minister of Internal Affairs Protopopov.

20.4 *Dnevnik L.A. Tikhomirova*, p. 315

20.5 Complete Correspondence, no. 1637 (AF's no. 639), 13 December 1916, p. 672
'Ania' is Anna Vyrubova, lady-in-waiting and confidante of Empress Alexandra; Alexander Trepov ('Tr.') became prime minister in November 1916 after Stürmer was dismissed. The empress's antipathy towards Trepov was fuelled by his attempts to distance Rasputin from the court.

21.1 Ibid., no. 1642 (AF's no. 640), 14 December 1916, pp. 674–5

21.2 Ibid., no. 1644, 14 December, pp. 676–7

21.3 '"Mad monk" repeats suppressed story', *New York Times*, 27 December 1916, p. 4

21.4 Vladimir Purishkevich, Feliks Iusupov, *Poslednie dni Rasputina*, Moscow, 2005, p. 205

21.5 Iusupov, *Memuary*, p. 204

22.1 Ibid., p. 208
Accounts of Rasputin's death became quickly mythologised and increasingly lurid, with the 'mad monk' displaying a remarkable ability to come back from the dead. The veracity of Yusupov's memoir has been questioned.

22.2 Purishkevich, Iusupov, *Poslednie dni Rasputina*, pp. 98–9

22.3 Iusupov, *Memuary*, p. 212

22.4 State Archive of the Russian Federation, *fond 685, opis' 1, delo 10*

22.5 R. Ivnev, *Dnevnik, 1906–1980*, Moscow, 2012, p. 196

23.1 *Voennyi dnevnik Velikogo Kniazia Andreia Vladimirovicha (1914–1917)*, Moscow, 2008, p. 210

23.2 Maksim Gor'kii, *M. Gor'kii i syn: pis'ma, vospominaniia*, Moscow, 1971, p. 160

23.3 Paléologue, p. 766

23.4 M.V. Rodzianko, *Krushenie imperii*, Leningrad, 1929, pp. 208–9

24.1 P.N. Miliukov, *Vospominaniia, 1859–1917*, Moscow, 1990, p. 247

24.2 A.A. Brusilov, *Moi vospominaniia*, Riga, 1924, p. 228

24.3 Gippius, p. 201

24.4 Complete Correspondence, no. 1677 (AF's no. 648), 26 February 1917, p. 695

24.5 V.V. Shul'gin, *Dni: Rossiia v revoliutsii 1917*, St Petersburg, 2014, p. 110

24.6 A. Taneeva (Vyrubova), *Stranitsy moei zhizni*, Berlin, 1923, p. 96
At this stage in the war Nicholas was commander-in-chief of the Russian armies and spent long periods at army headquarters (Stavka) at Mogilev in Belarus, some 500 miles from Petrograd.

24.7 Complete Correspondence, no. 1668 (AF's no. 645), 23 February 1917, p. 688

26.1 Ibid., no. 1665 (AF's no. 644), 22 February 1917, p. 687

26.2 *Dnevnik L.A. Tikhomirova*, p. 346

26.3 Complete Correspondence, no. 1665 (AF's no. 644), 26 February 1917, pp. 686–7

26.4 Ibid., no. 1665 (AF's no. 644), 22 February 1917, p. 687

26.5 V. Lenin, 'Doklad o revoliutsii 1905 goda' (http://libelli.ru/works/30-2.htm)

26.6 Lili Dehn, *Podlinnaia tsaritsa*, St Petersburg, 2003, p. 94
Veronal was a barbiturate prescribed for anxiety and sleep disorders, first made available in 1903, and named after the Italian city Verona. It was said to be highly addictive.

Chapter 2

29.1 Nikolai Egorovich, Baron Vrangel', *Vospominaniia: ot krepostnogo prava do Bol'shevikov*, Moscow, 2003, p. 361

33.1 Paléologue, p. 813

33.2 *Dnevnik Filosofova*, Russian National Library, Manuscripts Department, *fond* 813, *opis'* 1, *delo* 1

33.3 State Archive of the Russian Federation, *fond* 601, *opis'* 1, *delo* 2090, *list* 1; *Krasnyi arkhiv*, 1927, no. 2 (21), pp. 6–7 (telegram sent 12.40 p.m.)

33.4 Padenie tsarskogo rezhima, vol. 5, 1926, p. 38 (interrogation of Count Frederiks, 2 June 1917)

33.5 *Krasnyi arkhiv*, 1927, no. 2 (21), p. 8

33.6 A.I. Spiridovich, *Velikaia Voina i Fevral'skaia Revoliutsiia 1914–1917 godov*, Moscow, 2017, p. 167

33.7 Princess Paley, *Memories of Russia, 1916–1919*, London, 1924, pp. 46–7

34.1 N.N. Pokrovskii, *Poslednii v Mariinskom dvortse: Vospominaniia ministra inostrannykh del*, Moscow, 2015, p. 217
Prince Nikolai Golitsyn reluctantly succeeded Alexander Trepov as prime minister in January 1917 and was thus the last of Russia's imperial prime ministers. Under the Bolsheviks he earned his living repairing shoes, before being executed on trumped-up charges in 1925.

34.2 *Krasnyi arkhiv*, 1925, no. 3 (10), p. 178

34.3 *Krasnyi arkhiv*, 1927, no. 2 (21), p. 8

34.4 Benua, p. 102
Ivan Manasevich-Manuilov was a journalist and police agent who was close to the royal circle and Rasputin; he was shot in 1918 attempting to cross the Finnish border with contraband.

34.5 P.N. Miliukov, *Vospominaniia (1859–1917)*, vol. 2, New York, 1955, pp. 292–3

35.1 K.I. Globachev, *Pravda o russkoi revoliutsii*, Moscow, 2009, p. 124

35.2 A.P. Kutepov, *Pervye dni revoliutsii v Petrograde*, Moscow, 2014, p. 15

35.3 Sergei Prokofiev, *Diaries 1915–1923: Behind the Mask*, trans. Anthony Phillips, London, 2008, p. 179

35.4 Spiridovich, *Velikaia Voina i Fevral'skaia Revoliutsiia*, p. 174

35.5 Padenie tsarskogo rezhima, vol. 5, 1926, p. 314 (interrogation of Ivanov, 28 June 1917)

35.6 *Krasnyi arkhiv*, 1927, no. 2 (21), p. 11 (direct wire conversation with Alexeev, 10.30 p.m.)

36.1 Ibid., p. 12 (direct wire conversation with Grand Duke Mikhail Alexandrovich, 10.30 p.m.)

36.2 *Dnevnik i Perepiska Velikogo Kniazia Mikhaila Aleksandrovicha: 1915–1918*, ed. V.M. Khrustalev, Moscow, 2012, p. 396

36.3 Gippius, p. 212

36.4 State Archive of the Russian Federation, *fond* 1834, *opis'* 2, *delo* 21, *list* 1

36.5 *A Lifelong Passion: Nicholas and Alexandra, Their Own Story*, ed. Andrei Maylunas & Sergei Mironenko, London, 1996, p. 550

36.6 Pokrovskii, *Poslednii v Mariinskom dvortse*, p. 219
> Eduard Kriger-Voinovsky was the last minister of transport under the tsar, a post he held for just two months before the revolution.

37.1 Prokofiev, *Diaries 1915–1923*, p. 183

37.2 V.V. Shul'gin, *Dni: Rossiia v revoliutsii 1917*, St Petersburg, 2014, p. 263

37.3 Benua, p. 104

37.4 *Krasnyi arkhiv*, 1927, no. 2 (21), p. 19

37.5 *Krasnyi arkhiv*, 1930, no. 45 (41–42), p. 97

37.6 Pavel Shchegolev, *Otrechenie Nikolaia II: vospominaniia ochevidtsev, dokumenty*, Leningrad, 1927, p. 93

38.1 Nabokov, p. 9

38.2 'Ivan P. Pavlov: A Biographical Sketch', in Ivan Petrovitch Pavlov, *Lectures on Conditioned Reflexes*, ed. W. Horsley Gantt, vol. 1, London, 1928, p. 25

38.3 Benua, p. 104

38.4 Liudmila Korotkina, *Konstantin Andreevich Somov*, 2004, St Petersburg, p. 74

38.5 Paléologue, pp. 821, 822
> The mansion of ballerina and rumoured mistress of the tsar, Matilda Kshesinskaya, became the Bolsheviks' headquarters and played a crucial part in the events leading up to the October Revolution.

38.6 Shul'gin, *Dni: Rossiia v revoliutsii 1917*, p. 153

40.1 M.M. Prishvin, *Dnevniki. 1914–1917*, Moscow, 1991, p. 245

40.2 Buchanan, pp. 65–6

40.3 *Krasnyi arkhiv*, 1927, no. 21, p. 36

40.4 *Dnevniki imperatora Nikolaia II (1894–1918)*, ed. S.V. Mironenko, vol. 2, part 2 (1914–18), Moscow, 2013, p. 295

40.5 Lili Dehn, *Podlinnaia tsaritsa*, St Petersburg, 2003, p. 108

40.6 'Velikie kniaz'ia v Gosud. Dume', *Russkoe slovo*, 2 March 1917

40.7 Gippius, p. 220

41.1 *An Illustrated History of the Great October Socialist Revolution: 1917*, Moscow, 1988 (https://www.marxists.org/history/ussr/government/1917/03/01.htm)

42.1 Gippius, p. 224

42.2 P.L. Bark, *Vospominaniia poslednego ministra finansov Rossiiskoi imperii. 1914–1917*, vol. 2, Moscow, 2017, p. 341

42.3 Sukhanov, book 1, 1919, p. 205

42.4 Prokofiev, *Diaries 1915–1923*, p. 184

42.5 Maksim Gorky, *Selected Letters*, ed. Andrew Barratt and Barry P. Scherr, Oxford, 1997, pp. 198–9

44.1 Baron Vrangel', *Vospominaniia*, p. 358

44.2 *Padenie tsarskogo rezhima*, vol. 5, 1926, p. 320 (interrogation of Ivanov, 28 June 1917)

44.3 *Krasnyi arkhiv*, 1927, no. 2 (21), p. 40

45.1 'General-ad'iutant N.V. Ruzskii. Beseda s gen. S.N. Vil'chkovskim o prebyvanii Nikolaia II vo Pskove 1 i 2 marta 1917 goda', in *Otrechenie Nikolaia II. Vospominaniia ochevidtsev, dokumenty*, ed. P.E. Shchegolev, Moscow, 1990, p. 147

45.2 Complete Correspondence, no. 1687 (AF's no. 651), 2 March 1917, p. 700
> 'Otvetstvennoe ministerstvo' (otv. min. in Alexandra's abbreviation), meaning literally 'responsible government', refers to the Duma's ill-fated attempts to persuade the tsar to move towards a more parliamentary government within a constitutional monarchy.

45.3 *Krasnyi arkhiv*, 1927, no. 2 (21), pp. 56–9

45.4 Ibid., p. 67

46.1 Ibid., p. 69

46.2 Ibid., p. 70

46.3 Complete Correspondence, no. 1665 (AF's no. 644), 2 March 1917, p. 699

46.4 *Krasnyi arkhiv*, 1927, no. 2 (21), p. 73

46.5 E.I. Martynov, *Tsarskaia armiia v fevral'skom perevorote*, Leningrad, 1927, pp. 158–9

46.6 V.N. Voeikov, *S tsarem i bez tsaria: vospominaniia poslednego dvortsovogo komendanta gosudaria imperatora Nikolaia II*, Minsk, 2002, p. 193
'Nikolasha' is Grand Duke Nikolai Nikolaevich, uncle of Nicholas II and his predecessor as commander-in-chief of the imperial armies.

47.1 Iu.N. Danilov, *Velikii kniaz' Nikolai Nikolaevich*, Paris, 1930, p. 306

47.2 Voeikov, *S tsarem i bez tsaria*, p. 193

47.3 Pierre Gilliard, *Thirteen Years at the Russian Court*, London, 1921, p. 195

47.4 *Dvorianskoe Sobranie. Istoriko-publitsisticheskii i literaturno-khudozhestvennyi al'manakh*, no. 5, Moscow, 1996, p. 31

47.5 *Dnevniki imperatora Nikolaia II (1894–1918)*, p. 296

47.6 *Izvestiia Petrogradskogo Soveta rabochikh i soldatskikh deputatov*, 3 March 1917, no. 4

48.1 *Krasnyi arkhiv*, 1927, no. 3 (22), p. 9

48.2 *Manifest ob otrechenii gosudaria imperatora Nikolaia II i o slozhenii s sebia verkhovnoi vlasti*, 2 March 1917 (see Voeikov, *S tsarem i bez tsaria*, pp. 205–6)

48.3 *A Lifelong Passion*, p. 558

48.4 *Krasnyi arkhiv*, 1927, no. 2 (22), pp. 27–8

50.1 *The Times*, Friday 16 March 1917, p. 6, issue 41428

50.2 *Dnevnik i Perepiska Velikogo Kniazia Mikhaila Aleksandrovicha*, p. 398

50.3 Miliukov, *Vospominaniia (1859–1917)*, vol. 2, p. 278

50.4 Gippius, p. 228

50.5 *Dnevniki imperatora Nikolaia II (1894–1918)*, p. 296

50.6 *Dnevnik i Perepiska Velikogo Kniazia Mikhaila Aleksandrovicha*, p. 399

50.7 *Russkoe slovo*, no. 51, 5 March 1917

51.1 Baron Vrangel', *Vospominaniia*, p. 361

51.2 A.F. Kerensky, *Dnevnik politika*, Moscow, 2007, p. 88

Chapter 3

53.1 L. Andreev, *S.O.S.: Dnevnik (1914–1919), pis'ma (1917–1919), vospominaniia sovremennikov (1918–1919)*, Moscow-St Petersburg, 1994, p. 30

57.1 T.I. Polner, *Zhiznennyi put' kniazia G.E. L'vova*, Moscow, 2001, p. 353

57.2 Houghteling, p. 137

57.3 Complete Correspondence, no. 1688 (AF's no. 652), 3 March 1917, pp. 701–2
'Paul' is Count Paul Benckendorff, who was Grand Marshal of the Russian Imperial Court and was imprisoned with the imperial family after the abdication.

57.4 Lili Dehn, *Podlinnaia tsaritsa*, St Petersburg, 2003, p. 111

57.5 *The Times*, Friday 16 March 1917, p. 10, issue 41428

58.1 A.F. Kerensky, *Dnevnik politika*, Moscow, 2007, p. 86

58.2 Pavel Nikolaevich Miliukov, *Istoriia vtoroi russkoi revoliutsii*, St Petersburg, 2014, p. 60

58.3 Marc Chagall, *Angel nad kryshami*, Moscow, 1989 (http://m-chagall.ru/library/Angel-nad-kryshami40.html)

58.4 I.F. Stravinskii, *Perepiska s russkimi korrespondentami. Materialy k biografii, 1913–1922*, vol. 2, Moscow, 2000

58.5 Albert Stopford [Anonymous], *The Russian Diary of an Englishman*, New York, 1919, pp. 137–8

59.1 Kerensky, *Dnevnik politika*, p. 87

59.2 Paléologue, pp. 856–7
A 'verst' is approximately a kilometre; the original meaning of 'muzhik' as male peasant or villager later became generalised as someone of the lower classes; 'starets' is similarly untranslatable, with origins in the Russian Orthodox monastic tradition – venerated adviser, spiritual leader.

59.3 Houghteling, pp. 136–7
Dr Walter Pettit was special assistant in relief work at the American Embassy in Petrograd 1916–17 and subsequently attaché to the American Commission to Negotiate Peace in 1918–19.

59.4 E. Naryshkina, Diary manuscript, State Archive of the Russian Federation, *fond 6501, opis' 1, delo 595*

60.1 Robien, p. 21

60.2 Nabokov, pp. 34–5
In a later footnote of 29 July 1918 Nabokov wrote, 'On 16 June in Ekaterinburg this knot was finally severed.'

60.3 'Russian Democrats and Britain', *Manchester Guardian*, 22 March 1917, p. 8

60.4 Princesse Paley, *Souvenirs de Russie, 1916–1919*, Paris, 1923, p. 33
Vasily Maklakov was one of the leaders of the Kadets, not to be confused with his brother Nikolai Maklakov, who was interior minister under the tsar and close to the imperial family. At the time of the October Revolution Vasily was ambassador in France, where he remained for seven years.

60.5 Buchanan, pp. 95, 96, 99–100

61.1 'Great Britain to Free Russia: Mr Lloyd George's Message', *The Times*, 23 March 1917, p. 7, issue 4134

61.2 L. Trotskii, 'Revoliutsiia v Rossii', *Novyi mir*, no. 937, 16 March 1917

61.3 'Obrashchenie Sv. Sinoda ko vsem chadam Pravoslavnoi Rossiiskoi Tserkvi po povodu otrecheniia Nikolaia II...', *Tserkovnye vedomosti*, 1917, no. 9–15, p. 57

61.4 Houghteling, pp. 149–50

61.5 Paléologue, p. 839

62.1 'Otmena smertnoi kazni', *Niva*, March 1917, no. 12, p. 180

62.2 Aleksandr Blok, *Zapisnye knizhki 1901–1920*, Moscow, 1965, p. 318

62.3 *Zhurnal dlia khoziaek* (Housewife Magazine), no. 7, 2 March 1917

62.4 Donald C. Thompson, *Donald Thompson in Russia*, New York, 1918, p. 125

62.5 Sukhanov, book 2, 1922, pp. 32–3

62.6 Robien, p. 22

65.1 Paléologue, pp. 875, 876

65.2 Sukhanov, book 2, 1922, p. 348

65.3 *Voices of Revolution, 1917*, ed. Mark D. Steinberg, New Haven and London, 2001, pp. 115–16

65.4 Harvey J. Pitcher, *Witnesses of the Russian Revolution*, London, 1994, pp. 51, 52

66.1 Thompson, *Donald Thompson in Russia*, p. 103

66.2 Houghteling, pp. 190–1
Admiral Robert Viren, commander of Kronstadt naval base, was bayoneted to death on 1 March by pro-Bolshevik sailors. Over subsequent days many of his fellow officers were also killed.

66.3 Harold Williams, 'War Council Runs Russia's Army', *New York Times*, 28 March 1917, pp. 1–2

66.4 Hansard: HC Deb (22 March 1917), vol. 91, cc. 2085–6

66.5 'Exiles sail for Russia', *New York Times*, 28 March 1917, p. 2

67.1 Miliukov, *Istoriia vtoroi russkoi revoliutsii*, p. 102

67.2 Richard Pipes, *The Russian Revolution 1899–1919*, London, 1990, p. 323

67.3 'The Russian Revolution', *The Times*, 16 March 1917, p. 7, issue 41428

67.4 Lenin Collected Works, vol. 35, 1976, pp. 295–6

67.5 Stinton Jones, *Russia in Revolution: Being the Experiences of an Englishman in Petrograd During the Upheaval*, New York, 1917, p. 278

67.6 *Dnevnik A.L. Bloka 1917–1921*, ed. P.N. Medvedev, Leningrad, 1928, p. 12

Chapter 4

69.1 I.I. Manukhin, 'Vospominaniia o 1917–18 gg. Moia deiatel'nost' pomoshchi zakliuchennym vo vremia revoliutsii', *Novyi zhurnal*, no. 54, New York, 1958

73.1 K. Malevich, 'Chto bylo v fevrale 1917 goda i marte', archive of Khardzhiev-Chaga Art Foundation, Amsterdam (http://kazimir-malevich.ru/t5_1_1_10/)

73.2 Donald C. Thompson, *Donald Thompson in Russia*, New York, 1918, p. 99

73.3 *Krasnyi arkhiv*, 1925, no. 3 (10), pp. 179–80

73.4 Paléologue, p. 845

74.1 Nabokov, p. 34

74.2 Public Record Office, London, FO 371–3008, p. 1, Reel 22, Doc. 196482 (cited in Richard Pipes, *The Russian Revolution 1899–1919*, London, 1990, p. 332)

74.3 'V.V. Shul'gin 1917–1919', *Litsa: Biograficheskii al'manakh*, vol. 5, Moscow-St Petersburg, 1994, p. 134

74.4 Lili Dehn, *Podlinnaia tsaritsa*, St Petersburg, 2003, p. 138

74.5 David Lloyd George, *War Memoirs*, vol. 3, London, 1933, p. 1642

75.1 Kenneth Rose, *King George V*, London, 1983, p. 213

75.2 H.G. Wells, 'A Republican Society for Great Britain', *The Times*, Letters to the Editor, 21 April 1917, p. 7, issue 41458

75.3 Rose, *King George V*, pp. 212–13

76.1 'Romanoff Family's Fortune: The Tsar a Poor Man', *The Times*, 5 April 1917, p. 5, issue 41445

76.2 Alexander F. Kerensky, *The Catastrophe: Kerensky's Own Story of the Russian Revolution*, New York-London, 1927, p. 264

76.3 Pierre Gilliard, *Thirteen Years at the Russian Court*, London, 1921, p. 227

76.4 Mariia Romanova, *Vospominaniia velikoi kniazhny: stranitsy zhizni kuziny Nikolaia II, 1890–1918*, Moscow, 2006, p. 306
Maria Pavlovna's father was Grand Duke Pavel Alexandrovich, youngest child of Alexander II. After the February Revolution he remained with his family at Tsarskoe Selo. He was shot by the Bolsheviks along with other Romanov relatives at the Peter and Paul Fortress in January 1919.

77.1 Albert Stopford [Anonymous], *The Russian Diary of an Englishman*, New York, 1919, p. 162
Countess Elizaveta (Betsy) Shuvalov and Grand Duchess Vladimir ('the grandest of the grand duchesses'), widow of one of Alexander II's sons, were at the heart of Petrograd's pre-revolution beau monde. Both emigrated to France.

77.2 'How Tsardom Fell', *The Times*, 21 April 1917, p. 5, issue 41458

77.3 Robien, pp. 54–5
Countess Maria Kleinmichel eventually settled in France where she wrote her memoir, Memories of a Shipwrecked World. *She lived to 85.*

78.1 Thompson, *Donald Thompson in Russia*, pp. 99–100
Admiral Alexander Giers, commander of the battleship Emperor Alexander II, *was killed at Kronstadt a few days after Admiral Viren. Rear Admiral Viktor Kartsev was director of the naval college; he was later released and worked in Leningrad till 1930 when he was rearrested and sent to Archangelsk.*

78.2 A. Taneeva (Vyrubova), *Stranitsy moei zhizni*, Berlin, 1923, p. 109

78.3 Padenie tsarskogo rezhima, vol. 1, 1924, pp. 221–38 (interrogation of Stürmer, 22 and 31 March 1917)
A 'volost' is an administrative district.

81.1 M.A. Beketova, *Aleksandr Blok: biograficheskii ocherk*, Leningrad, 1922, p. 236
Lawyer and friend of Tolstoy, Nikolai Muravyov was chairman of the Investigative Commission that cross-examined those arrested after the February Revolution. Ivan Lodyzhensky was overall head of the commission. Ivan Goremykin was a reactionary minister of internal affairs from 1895 to 1899 and prime minister for just three months in 1906; in 1914 Nicholas II reappointed him prime minister but by 1916 he had lost the support of the empress and was replaced; he was murdered on his country estate in December 1917.

82.1 V.N. Voeikov, *S tsarem i bez tsaria: vospominaniia poslednego dvortsovogo komendanta gosudaria imperatora Nikolaia II*, Minsk, 2002, pp. 270–1

82.2 Padenie tsarskogo rezhima, vol. 3, 1925, pp. 250, 251 (interrogation of Vyrubova, 6 May 1917)

83.1 Manukhin, 'Vospominaniia o 1917–18 gg.', *Novyi zhurnal*, no. 54, New York, 1958

Ekaterina Viktorovna Sukhomlinova was the third, much younger, wife of Vladimir Sukhomlinov, the former minister of war who was imprisoned before the revolution (as well as after) on charges of treason.

83.2 Taneeva (Vyrubova), *Stranitsy moei zhizni*, p. 110

83.3 From the manuscript of forthcoming publication *Dnevniki Direktora Imperatorskikh teatrov V.A. Teliakovskogo. 1913–1917*, vol. 6 (ART publishers)

83.4 *Dnevniki imperatora Nikolaia II (1894–1918)*, ed. S.V. Mironenko, vol. 2, part 2 (1914–18), Moscow, 2013, p. 302

83.5 *Krasnyi arkhiv*, 1926, no. 1 (14), pp. 247–8

84.1 Beketova, *Aleksandr Blok: biograficheskii ocherk*, pp. 238–40

Stepan Beletsky was director of the police department and deputy minister of the interior; he was publicly executed by the Bolsheviks in Moscow in August 1918. Prince Mikhail Andronikov was an associate of Rasputin and political insider who was accused of espionage by the Bolsheviks and shot in 1919. Konstantin Kafafov was a high-ranking and notoriously anti-semitic official in the police department. General Evgeny Klimovich was head of the police under the tsar and later fought with the Whites against the Bolsheviks.

85.1 Manukhin, 'Vospominaniia o 1917–18 gg.', *Novyi zhurnal*, no. 54, New York, 1958

Ivan Shcheglovitov was minister of justice from 1906 to 1915; like Beletsky and Nikolai Maklakov, he was publicly executed in Moscow in August 1918.

85.2 Taneeva (Vyrubova), *Stranitsy moei zhizni*, p. 115

85.3 Manukhin, 'Vospominaniia o 1917–18 gg.', *Novyi zhurnal*, no. 54, New York, 1958

85.4 *Dnevniki imperatora Nikolaia II (1894–1918)*, p. 308

86.1 *A Lifelong Passion: Nicholas and Alexandra, Their Own Story*, ed. Andrei Maylunas & Sergei Mironenko, London, 1996, p. 598

86.2 Rose, *King George V*, p. 216

86.3 State Archive of the Russian Federation, *fond* R-1235, *opis'* 53, *delo* 10

86.4 Sukhanov, book 4, 1922, pp. 324, 325, 326, 328, 329–30

88.1 Taneeva (Vyrubova), *Stranitsy moei zhizni*, pp. 123–4

88.2 Beketova, *Aleksandr Blok: biograficheskii ocherk*, pp. 242–3

89.1 Gilliard, *Thirteen Years at the Russian Court*, pp. 231–2

89.2 *Dnevniki imperatora Nikolaia II (1894–1918)*, p. 324

89.3 *Dnevnik i perepiska velikogo kniazia Mikhaila Aleksandrovicha: 1915–1918*, ed. V.M. Khrustalev, Moscow, 2012, pp. 445–6

89.4 Kerensky, p. 337

89.5 *Dnevniki imperatora Nikolaia II (1894–1918)*, p. 326

'Valya' is Prince Vasily Dolgorukov who was marshal of the imperial court and one of Nicholas II's closest confidants; he voluntarily accompanied the family to Tobolsk and was killed in Ekaterinburg in July 1918, just a week before the Romanov family shared the same fate.

90.1 Diary manuscript, State Archive of the Russian Federation, *fond* 6501, *opis'* 1, *delo* 595

90.2 *Russkoe slovo*, no. 191, 20 August 1917

90.3 Taneeva (Vyrubova), *Stranitsy moei zhizni*, p. 129

90.4 Manukhin, 'Vospominaniia o 1917–18 gg.', *Novyi zhurnal*, no. 54, New York, 1958

90.5 *Kievlianin*, no. 243, 17 October 1917

91.1 *Zapretnoe slovo*, no. 1, 24 November 1917

After several months in the Peter and Paul Fortress, Protopopov was released and then rearrested; he began to suffer from hallucinations and was transferred to the Nikolaevsky Military Hospital; in 1918 he was shot by the Cheka.

91.2 *Petrogradskaia gazeta*, no. 235, 6 October 1917

91.3 *The Letters of Tsar Nicholas and Empress Marie*, ed. Edward J. Bing, London, 1937, p. 301 (State Archive of the Russian Federation, *fond* 601, *opis'* 1, *delo* 1297, *listy* 131–5)

Chapter 5

93.1 Osip Brik, quoted in Bengt Iangfel'dt, *Stavka – zhizn': Vladimir Maiakovskii i ego krug*, Moscow, 2009, p. 112

97.1 N.K. Krupskaia, *Vospominaniia o Lenine*, Moscow, 1933, p. 260
Lenin was commonly referred to as 'Ilyich'. 'V.I.' are the initials of his name and patronymic: Vladimir Ilyich. Mieczyslaw Bronski was a Polish Bolshevik studying in Zurich who accompanied Lenin on the sealed train. Alexander Parvus (born Israel Gelfand in Belarus) was a Marxist ally of the Bolsheviks who negotiated with the Germans for Lenin's return to Russia.

97.2 Nadezhda K. Krupskaya, *Memories of Lenin*, London, 1942, p. 288

97.3 Ia. Ganetskii, *O Lenine: otryvki iz vospominanii*, Moscow, 1933, p. 59

98.1 Lenin Collected Works, vol. 35, 1976, p. 300
Vyacheslav Karpinsky, member of the Communist Party since 1898, was a leading Bolshevik; in exile in Geneva he worked on various newspapers and corresponded with Lenin; after the October Revolution he was on the editorial board of Pravda *and subsequently wrote many works on Lenin and communism.*

98.2 Krupskaya, *Memories of Lenin*, p. 288
Swiss socialist Robert Grimm was the organiser of the Zimmerwald Conference, a gathering of the world socialist movement held in Switzerland in September 1915; he later became embroiled in controversial negotiations to end hostilities between Germany and Russia.

98.3 A.M. Kollontai, 'Skoree v Rossiiu! Vospominaniia A.M. Kollontai', *Sovetskie arkhivy*, 1967, no. 2, p. 17

99.1 *Leninskii sbornik*, Moscow-Leningrad, 1930, vol. 13, p. 262

99.2 Lenin Polnoe sobranie, vol. 49, 1970, p. 428

99.3 Trotskii, vol. 1, p. 318

99.4 D.N. Shub, *Politicheskie deiateli Rossii (1850–1920): Sbornik statei*, New York, 1969, pp. 245–6

99.5 Lenin Collected Works, vol. 35, 1973, pp. 306–7
Born in Paris, Inessa Armand moved to Moscow with her husband, joining the SDLP in 1903; she was arrested in 1907 but fled abroad. She met Lenin in Paris in 1910 and became his lover. He was devastated by her death from cholera in 1920.

99.6 Lenin Collected Works, vol. 43, 1977, pp. 622–3
Swiss communist Fritz Platten was the main organiser of Lenin's return; he was also in the car with Lenin when the Bolshevik leader survived an assassination attempt in January 1918.

100.1 *Revoliutsonnaia Rossiia. 1917 god v pis'makh A. Lunacharskogo i Iu. Martova*, ed. G.A. Bordiugov, Moscow, 2007, p. 147

100.2 D.S. Suliashvili, 'Iz Shveitsarii v Petrograd – vmeste s Leninym', *Zaria Vostoka*, Tiflis, no. 781, 17 January 1925

101.1 Fritz Platten, *Die Reise Lenins durch Deutschland im plombierten Wagen*, Berlin, 1924, p. 62 (English translation by Ian Birchall: https://www.marxists.org/archive/radek/1924/xx/train.htm)

101.2 Ganetskii, *O Lenine*, p. 60

101.3 K.B. Radek, 'V "plombirovannom vagone"', *Pravda*, 20 April 1924

101.4 Romain Rolland, *Journal des années de guerre 1914–1919*, Paris, 1952, pp. 1129–30

102.1 Lenin Collected Works, vol. 36, 1977, p. 427

102.2 A.V. Lunacharskii to A.A. Lunacharskaia, Russian State Archive of Socio-Political History, *fond* 142, *opis'* 1, *delo* 12, *listy* 1–2

102.3 Lenin Collected Works, vol. 43, 1977, pp. 623–4

102.4 K.B. Radek, 'Shveitsarskii period', *Vospominaniia o V.I. Lenine*, vol. 4, Moscow, 1984, p. 110

102.5 Suliashvili, 'Iz Shveitsarii v Petrograd – vmeste s Leninym', 17 January 1925

103.1 Martin Gilbert, *Sir Horace Rumbold: Portrait of a Diplomat 1869–1941*, London, 1973, p. 148

103.2 Radek, 'V "plombirovannom vagone"', *Pravda*, 20 April 1924

103.3 'Russian Radicals Allowed to Cross from Berne on Way to Petrograd', *New York Times*, 15 April 1917, p. 1
An early pseudonym used by Lenin was 'N. Lenin', which the foreign press deciphered as 'Nikolai'.

103.4 Sukhanov, book 3, 1922, pp. 10, 11–12

104.1 Grigorii Zinov'ev, 'Priezd Lenina v Rossiiu', *Pravda*, 16 April 1924 (English translation by Ben Lewis: https://weeklyworker.co.uk/worker/1149/lenins-arrival-in-russia/)

106.1 Sukhanov, book 3, 1922, p. 13

106.2 Winston S. Churchill, *The World Crisis: The Aftermath*, London, 1929, pp. 72–3
Erich Ludendorff was the Prussian general primarily responsible for German military strategy in the final years of the First World War; he later joined the Nazi party.

106.3 'Priezd Lenina v Rossiiu', *Pravda*, 16 April 1924 (English translation by Ben Lewis: https://weeklyworker.co.uk/worker/1149/lenins-arrival-in-russia/)

106.4 Sukhanov, book 3, 1922, pp. 8, 9

106.5 Ibid., p. 14

108.1 Ibid., p. 15
Karl Liebknecht was a German Social Democrat who, with Rosa Luxemburg and others, founded the Spartakusbund, a Berlin underground group that became the Communist Party of Germany; he and Luxemburg were murdered by the proto-Nazi freikorps on the same day in January 1919.

108.2 Ibid., pp. 20–1

109.1 Zinaida Gippius, *Siniaia kniga: Peterburgskii dnevnik (1914–1918)*, Belgrade, 1929, p. 256
The moral of Krylov's fable 'Triskha's Caftan' is that however much you might try to make do and mend, or borrow from Peter to pay Paul, ultimately you will be found out.

109.2 Iangfel'dt, *Stavka – zhizn'*, p. 112

109.3 Lenin Polnoe sobranie, vol. 31, 1969, p. 207
Kamenoostrovsky Prospect is the street on which the Kshesinskaya Mansion – by this time Bolshevik HQ – is situated.

109.4 V.I. Lenin, 'O zadachakh proletariata v dannoi revoliutsii: Tezisy', ibid., pp. 113–16

110.1 Sukhanov, book 3, 1922, pp. 26–7

111.1 Leon Trotsky, *The History of the Russian Revolution*, trans. Max Eastman, London, 1936, pp. 232–3
Vladimir Stankevich was a member of the editorial board of Sovremennik *('Contemporary') and military commissar of the Provisional Government.*

111.2 Paléologue, p. 890

111.3 'Soveshchanie predstavitelei s.-d partii po voprosu ob ob''edinenii', *Edinstvo*, no. 5, 5 April 1917

111.4 V.I. Lenin, 'O zadachakh proletariata v dannoi revoliutsii', *Pravda*, no. 26, 7 April 1917

112.1 G.V. Plekhanov, 'O tezisakh Lenina i o tom, pochemu bred byvaet podchas interesen', *Edinstvo*, no. 9/10, 9–12 April 1917 (G.V. Plekhanov, *God na rodine: Polnoe sobranie statei i rechei 1917–1918 g. v dvukh tomakh*, vol. 1, Paris, 1921, pp. 19–21)

112.2 L. Kamenev, 'Nashi raznoglasiia', in *The Russian Revolution and the Soviet State 1917–1921: Documents*, ed. Martin McCauley, London, 1980, pp. 54–5

112.3 Krupskaia, *Vospominaniia o Lenine*, pp. 282–3

113.1 Lenin Polnoe sobranie, vol. 31, 1969, p. 278 ('Nashi vzgliady: Otvet na resoliutsiiu ispolnitel'noi komissii Soveta soldatskikh deputatov')

113.2 'Siberian Prisons give up 100,000', *New York Times*, 4 April 1917, p. 8

113.3 Lenin Polnoe sobranie, vol. 49, 1970, p. 435
At the time of the February Revolution, Alexander Shlyapnikov was the only member of the Russian Social Democratic Labour Party (Bolsheviks) to be based in Russia, from where he helped to organise Lenin's return. Prominent in the early years of Soviet rule, he later fell out with Stalin and was executed in 1936.

113.4 Nabokov, p. 94

113.5 Paléologue, pp. 891–2

114.1 Sukhanov, book 3, 1922, p. 53

114.2 V.I. Lenin, 'Resolution on the Current Situation', *Soldatskaia Pravda*, no. 13, 3 May 1917

115.1 From E.I. Lakier, 'Otryvki iz dnevnika – 1917–1920', 'Preterpevshii do kontsa spasen budet': zhenskie ispovedal'nye teksty o revoliutsii i grazhdanskoi voine v Rossii, St Petersburg, 2013, pp. 133–179

115.2 Richard Pipes, *The Russian Revolution 1899–1919*, London, 1990, p. 394

Chapter 6

117.1 *Krasnyi arkhiv*, vol. 33, 1929, p. 50

121.1 L. Trotskii, 'Voina ili mir', *Novyi mir*, no. 941, 7 March 1917

121.2 *Russkie vedomosti*, no. 48, 2 March 1917

121.3 *Voices of Revolution, 1917*, ed. Mark D. Steinberg, New Haven and London, 2001, p. 119

121.4 P.N. Miliukov, *Vospominaniia, 1859–1917*, Moscow, 1990, p. 164

121.5 K. Malevich, 'Chto bylo v fevrale 1917 goda i marte', archive of Khardzhiev-Chaga Art Foundation, Amsterdam (http://kazimir-malevich.ru/t5_1_1_10/)
> *The Party of People's Freedom was also known as the Constitutional Democratic Party, or Kadets.*

122.1 *Vestnik Vremennogo pravitel'stva*, 7 March 1917, no. 2 (47), p. 1

122.2 'Russia's Task', *Daily Telegraph*, 21 March 1917

122.3 Sukhanov, book 2, 1922, pp. 234–5

122.4 Paléologue, p. 865

123.1 'Beseda s ministrom inostrannykh del', *Rech'*, 23 March 1917, no. 70

123.2 *Vechernee vremia*, no. 1779, 25 March 1917, p. 2

123.3 I.V. Stalin, 'Ili – ili', *Pravda*, no. 13, 26 March 1917, p. 1

123.4 Kerensky, p. 244

123.5 Ibid.

123.6 'Obrashchenie Vremennogo pravitel'stva k rossiiskim grazhdanam', *Vestnik Vremennogo pravitel'stva*, 28 March 1917, no. 18, p. 4

124.1 Kerensky, p. 245

124.2 *Izvestiia Petrogradskogo Soveta*, 31 March 1917, p. 3; 2 April 1917, p. 2

124.3 Buchanan, pp. 119–20

124.4 *Ministerstvo inostrannykh del Rossii v gody pervoi mirovoi voiny: sbornik dokumentov*, Tula, 2014, p. 816

124.5 Paléologue, p. 883

125.1 P.N. Miliukov, *Vospominaniia (1859–1917)*, vol. 2, New York, 1955, p. 352

125.2 *Pravda*, no. 30, 12 April 1917, p. 7

125.3 *Vestnik Vremennogo pravitel'stva*, 20 April 1917, no. 35, p. 2

125.4 I.G. Tsereteli, *Krizis vlasti*, Moscow, 2007, p. 19

126.1 Ivanov-Razumnik, *God revoliutsii. Stat'i 1917 goda*, St Petersburg, 1918, p. 13

126.2 Sukhanov, book 3, 1922, pp. 251, 252

126.3 Paléologue, pp. 914–15

126.4 Sukhanov, book 3, 1922, p. 259

126.5 *Krasnyi arkhiv*, vol. 33, 1929, p. 50

128.1 V. Perazich, *Tekstili Leningrada v 1917 g.*, Leningrad, 1927, p. 44

128.2 Robien, p. 51

128.3 Buchanan, pp. 123, 124
> *The Palais Marie, or Mariinsky Palace, became the seat of the Provisional Government after the February Revolution.*

129.1 *Russian-American Relations: March 1917 – March 1920*, ed. C.K. Cumming and Walter W. Pettit, New York, 1920, p. 14

129.2 Ibid., p. 13

129.3 *Pravda*, 23 April 1917, no. 39 (Lenin Collected Works, vol. 24, 1964, pp. 210–12)

129.4 *Krasnyi arkhiv*, vol. 33, 1929, p. 79

130.1 *Vechernii kur'er*, 22 April 1917

130.2 A.I. Guchkov, *Aleksandr Guchkov rasskazyvaet: Vospominaniia predsedatelia Gosudarstvennoi dumy i voennogo ministra vremennogo pravitel'stva. Voprosy Istorii*, 1993; conversation with Nicolas de Bailly on 5 January 1933
> *A former doctor and close ally of Milyukov, Andrei Shingaryov was one of the leaders of the Kadets and minister of finance in the first coalition government. Mikhail Tereshchenko, son of a sugar factory owner, was minister of foreign affairs in the same government, replacing Milyukov.*

130.3 *Rech'*, no. 101, 2 May 1917, p. 3

131.1 I.G. Tsereteli, *Vospominaniia o fevral'skoi revoliutsii*, Paris, 1963, p. 134

131.2 Kerensky, p. 266

131.3 Ibid., p. 267

131.4 *Witness to Revolution: The Russian Revolution Diary and Letters of J. Butler Wright*, ed. William Thomas Allison, Westport-London, 2002, p. 76

131.5 *Vestnik Vremennogo pravitel'stva*, 26 April 1917, no. 40, p. 1

132.1 *Delo naroda*, 26 April 1917, no. 33, p. 2

132.2 *Izvestiia*, 11 May 1917, no. 52

132.3 Tsereteli, *Vospominaniia o fevral'skoi revoliutsii*, p. 149

132.4 Lenin Polnoe sobranie, vol. 32, 1969, p. 22 (*Pravda*, 5 May 1917, no. 49)

134.1 *Delo naroda*, 10 May 1917, no. 45, p. 2

134.2 Sukhanov, book 3, 1922, p. 439

134.3 Robien, p. 59

134.4 Nabokov, p. 79

Chapter 7

137.1 Maria Botchkareva, *Yashka: My Life as Peasant, Officer and Exile* (as set down by Isaac Don Levine), New York, 1919, pp. 217–18

141.1 *Antivoennye vystupleniia na russkom fronte v 1917 godu glazami sovremennikov (vospominaniia, dokumenty, kommentarii)*, ed. S.N. Bazanov, Moscow, 2010, pp. 48–9

141.2 F.P. Khaustov, 'Okopnaia pravda', *Krasnaia Letopis'*, Leningrad, 1927, no. 3 (24), p. 109

141.3 *Russkie vedomosti*, no. 96, 30 April 1917, p. 3

141.4 *Antivoennye vystupleniia*, ed. S.N. Bazanov, pp. 112–13

142.1 'The Virtual Armistice', *Pravda*, 9 May 1917

142.2 *Svobodnyi narod*, 3 June 1917

144.1 Knox, p. 601

144.2 A.L. Tolstaia, interview on Radio Svoboda, 1965, published in *Russkaia zhizn'*, 2007, no. 9

144.3 Sukhanov, book 4, 1922, p. 68

144.4 R.H. Bruce Lockhart, *Memoirs of a British Agent*, London and New York, 1932, pp. 178–80
The 'Big Theatre' in Moscow is now better known untranslated – the Bolshoi.

145.1 Aleksandra Tolstaia, *Doch'*, London, Ontario, 1979, p. 73

145.2 *Russian-American Relations: March 1917 – March 1920*, ed. C.K. Cumming and Walter W. Pettit, New York, 1920, pp. 17, 18

145.3 Florence Farmborough, *Nurse at the Russian Front: A Diary 1914–18*, London, 1974, p. 269

145.4 *Ministerstvo inostrannykh del Rossii v gody pervoi mirovoi voiny: sbornik dokumentov*, Tula, 2014, p. 826

146.1 *Antivoennye vystupleniia*, ed. S.N. Bazanov, p. 111

146.2 V.G. Chertkov, 'O prekrashchenii voiny', *Golos Tolstogo i Edinenie*, Moscow, 1917, no. 4, p. 6

146.3 *Rech'*, 17 May 1917 (see Sukhanov, book 4, 1922, p. 135)

146.4 Chertkov, 'O prekrashchenii voiny', *Edinenie*, Moscow, July – August 1917, no. 2, p. 9

146.5 V. Dzhunkovskii, *Vospominaniia (1915–1917)*, vol. 3, Moscow, 2015

147.1 Robien, p. 68
General Vasily Gurko was the last chief of staff under the tsar, and commander, Western front, from March to June 1917. Dismissed by Kerensky, he was arrested in July for corresponding with Nicholas II. He was exiled and went to England, later settling in Italy.

147.2 V.P. Kravkov, *Velikaia voina bez retushi: Zapiski korpusnogo vracha*, Moscow, 2016

147.3 *Russkoe slovo*, 1 June 1917, no. 122, p. 4

148.1 Botchkareva, *Yashka*, p. 157

148.2 Knox, pp. 631–2

148.3 V. Pronin, 'Miting gen. Brusilova', *Voennyi sbornik Obshchestva revnitelei voennykh znanii*, Belgrade, 1921, book 1, pp. 162–4, 168

148.4 E. Naryshkina, Diary manuscript, State Archive of the Russian Federation, *fond* 6501, *opis'* 1, *delo* 595

150.1 *The Little Grandmother of the Russian Revolution: Reminiscences and Letters of Catherine Breshkovsky*, ed. Alice Stone Blackwell, London, 1919, pp. 322–3

150.2 Robien, pp. 73–4
Lieutenant Jean de Lubersac was a member of the French military mission to Russia and was mentioned by Lenin in his 'Letter to American Workers' in August 1918.

150.3 Aleksandr Fedorovich Kerenskii, *Russkaia Revoliutsiia, 1917*, Moscow, 2005, p. 183

150.4 B. Savinkov, *Iz deistvuiushchei armii (leto 1917 g.)*, Moscow, 1918, pp. 221–2

151.1 Gippius, p. 263

151.2 A.I. Denikin, *Ocherki russkoi smuty*, vol. 1, ch. 31, Paris, 1921 (http://militera.lib.ru/memo/russian/denikin_ai2/1_31.html)

151.3 *Dnevniki imperatora Nikolaia II (1894–1918)*, ed. S.V. Mironenko, vol. 2, part 2 (1914–18), Moscow, 2013, p. 317

151.4 *Rech'*, no. 142, 20 June 1917, p. 2

151.5 Benua, p. 397

152.1 Major-General Max Hoffmann, *War Diaries and Other Papers*, vol. 1, trans. (from German) Eric Sutton, London, 1929, p. 188

152.2 *Ministerstvo inostrannykh del Rossii v gody pervoi mirovoi voiny: sbornik dokumentov*, Tula, 2014, p. 831

152.3 L.D. Trotskii, *Vpered*, no. 5, 28 June 1917 (*Sochineniia*, vol. 3, Moscow-Leningrad, 1924, pp. 138–40)

> As prime ministers of Great Britain and France and president of the United States, respectively, David Lloyd George, Alexandre Ribot and Woodrow Wilson were united in their desire to keep their ally Russia in the war.

152.4 Igor' Stravinskii, *Pis'ma 1917–22*, part 1

153.1 Robien, pp. 80–1

153.2 *Voices of Revolution, 1917*, ed. Mark D. Steinberg, New Haven and London, 2001, p. 126

153.3 E. Naryshkina, Diary manuscript, State Archive of the Russian Federation, *fond* 6501, *opis'* 1, *delo* 595

153.4 *Competing Voices from the Russian Revolution*, ed. Michael C. Hickey, Westport, 2010, p. 248

153.5 Pavel Nikolaevich Miliukov, *Istoriia vtoroi russkoi revoliutsii*, St Petersburg, 2014, pp. 66–7

154.1 Hoffmann, *War Diaries and Other Papers*, pp. 189–90

154.2 Browder, vol. 2, pp. 970–1 (*Izvestiia*, no. 114, 11 July 1917, pp. 1–2)

155.1 Botchkareva, *Yashka*, pp. 214–15

155.2 Nikita Okunev, *Dnevnik moskvicha, 1917–1924*, Moscow, 1997, p. 57

156.1 *Krasnaia Letopis'*, Moscow-Leningrad, 1923, no. 6, pp. 10, 11, 16

156.2 Browder, p. 982

157.1 *Dnevniki imperatora Nikolaia II (1894–1918)*, p. 321

157.2 Mensheviki, p. 299

Chapter 8

159.1 R. Ivnev, *Dnevnik, 1906–1980*, Moscow, 2012, p. 228

163.1 Kerensky, pp. 229–30

163.2 V.V. Shul'gin, 'Pusti, ia sam!', *Russkaia svoboda*, 1917, no. 7, p. 10 (cited in *Revoliutsiia 1917 goda glazami sovremennikov*, ed. A.P. Nenarokov, vol. 2 (June–September), Moscow, 2017, p. 24)

163.3 Ivnev, *Dnevnik*, p. 223

163.4 Knox, p. 610

163.5 V.G. Krasnov, *Vrangel'. Tragicheskii triumf barona: Dokumenty. Mneniia. Razmyshleniia*, Moscow, 2006, p. 90

164.1 Teffi, *Russkoe slovo*, no. 127, 7 June 1917

164.2 A.V. Zhirkevich, *Vstrechi s Tolstym: dnevniki, pis'ma*, Iasnaia Poliana, 2009, pp. 378–9

164.3 M.A. Beketova, *Aleksandr Blok: biograficheskii ocherk*, Leningrad, 1922, p. 244

164.4 *Russian-American Relations: March 1917–March 1920*, ed. C.K. Cumming and Walter W. Pettit, New York, 1920, p. 32

164.5 *Krasnyi arkhiv*, 1927, no. 4 (23), p. 58

165.1 *Russkie vedomosti*, no. 150, 4 July 1917, p. 4

> The Petersburg-side villa of Pyotr Durnovo, governor of Moscow during the 1905 Revolution, was occupied by anarchists and other militants after the February Revolution and converted into a revolutionary commune and 'house of rest'; the government's attempt to expel them from the building in June led to the most serious violence in the city since February.

165.2 Ivnev, *Dnevnik*, p. 228

165.3 Sukhanov, book 4, 1922, p. 399

165.4 Harold Williams, 'Petrograd's Night of Sudden Riots', *New York Times*, 19 July 1917, p. 3

166.1 Sukhanov, book 4, 1922, p. 322

166.2 *Competing Voices from the Russian Revolution*, ed. Michael C. Hickey, Westport, 2010, p. 249

166.3 'Iz protokola ob''edinennogo zasedaniia tsentral'nogo ispolnitel'nogo komiteta sovetov rabochikh i soldatskikh deputatov...', Mensheviki, pp. 92–3
 The First All-Russian Congress of Soviets of Workers' and Soldiers' Deputies took place from 3 to 24 June in the building of the 1ˢᵗ Cadet Corps on Vasilievsky Island.

166.4 'Vystuplenie R.A. Abramovicha na ob''edinennom zasedanii...', Mensheviki, p. 94 (State Archive of the Russian Federation, *fond* 6978, *opis'* 1, *delo* 153, *listy* 1–10b)

166.5 *Competing Voices*, ed. Michael C. Hickey, p. 254

166.6 *Izvestiia*, 5 July 1917, p. 2 (cited in Alexander Rabinowitch, *Prelude to Revolution: The Petrograd Bolsheviks and the July 1917 Uprising*, Bloomington, 1991, p. 181)

168.1 Meriel Buchanan, *The City of Trouble*, New York, 1918, p. 129

168.2 *Witness to Revolution: The Russian Revolution Diary and Letters of J. Butler Wright*, ed. William Thomas Allison, Westport-London, 2002, p. 101

168.3 P.N. Miliukov, *Vospominaniia, 1859–1917*, Moscow, 1990, pp. 388–9
 Viktor Chernov was a founder and leader of the Socialist Revolutionary Party (SRs); he edited Delo naroda *and was elected president of the short-lived Constituent Assembly. He later emigrated, first to Paris and eventually to the United States.*

168.4 Sukhanov, book 4, 1922, p. 422

169.1 F.F. Raskol'nikov, *Kronstadt i Piter v 1917 godu*, Moscow, 1990, pp. 137–9

170.1 Browder, vol. 3, pp. 1344–5

170.2 Helen Rappaport, *Caught in the Revolution: Petrograd 1917*, London, 2016, p. 218

170.3 Browder, vol. 3, pp. 1336–7

170.4 *A Long Journey: The Autobiography of Pitirim A. Sorokin*, Lanham, 1963, pp. 130–1
 'Gimmer' is Nikolai Sukhanov's real name. Like many Bolsheviks (Lenin-Ulyanov, Trotsky-Bronstein), he used a pseudonym. Boris Kats was a leader of the Left SRs, and was generally known as 'Kamkov'.

172.1 I.G. Tsereteli, *Vospominaniia o fevral'skoi revoliutsii*, Paris, 1963, p. 328

172.2 *Competing Voices*, ed. Michael C. Hickey, p. 255

173.1 *Witness to Revolution*, p. 101

173.2 Browder, vol. 3, pp. 1363–4

173.3 Pavel Nikolaevich Miliukov, *Istoriia vtoroi russkoi revoliutsii*, St Petersburg, 2014, p. 223

173.4 Sukhanov, book 4, 1922, p. 480

173.5 Anna Sergeevna Allilueva, *Vospominaniia*, Moscow, 1946, p. 175

174.1 Trotskii, vol. 2, p. 34

174.2 Buchanan, p. 156

174.3 Browder, vol. 3, p. 1365

175.1 Bernard Pares, *My Russian Memoirs*, London, 1931, pp. 464–5

175.2 Browder, vol. 3, p. 1366

175.3 Ibid., p. 1362

176.1 Maxim Gorky, *Untimely Thoughts: Essays on Revolution, Culture and the Bolsheviks, 1917–1918*, ed. Mark D. Steinberg, New Haven, 1995, p. 75

176.2 Pares, *My Russian Memoirs*, p. 465

176.3 Aleksandr Amfiteatrov, *Bich*, no. 26, Petrograd, 1917

176.4 Browder, vol. 3, p. 1389 (*Russkoe slovo*, no. 157, 12 July 1917, p. 3)

176.5 Nabokov, p. 46

Chapter 9

179.1 *Dnevnik L.A. Tikhomirova, 1915–1917 gg.*, ed. A.V. Repnikov, Moscow, 2008, p. 360

183.1 Gippius, p. 202

183.2 V.V-ii (anonymous journalist), 'A.F. Kerenskii', *A.F. Kerenskii: Pro et Contra*, St Petersburg, 2016, p. 123 (originally published in *Narodnaia vlast'*, Petrograd, 1917, pp. 3, 21–39, 44–55)

183.3 Ibid., p. 130

183.4 Ibid., p. 134

183.5 Harold Williams, 'Russian Leader Interviewed', *Liverpool Daily Post and Mercury*, 22 March 1917, p. 4

184.1 Gippius, p. 235

184.2 Knox, p. 576

184.3 F.I. Shaliapin, *Stranitsy iz moei zhizni: Povesti*, Moscow, 1990, p. 354

184.4 Benua, pp. 176–7
'Akitsa' is Benois's wife, Anna Karlovna Benois.

185.1 Paléologue, p. 922

185.2 Vladimir Bogoraz (Tan), 'A.F. Kerenskii. Liubov' russkoi revoliutsii', *Geroi dnia. Biograficheskie etiudy*, 1917, no. 1, p. 2

185.3 E. Vladimirovich, 'A.F. Kerenskii – narodnyi ministr', *A.F. Kerenskii: Pro et Contra*, p. 161 (originally published as *A.F. Kerenskii – narodnyi ministr*, Odessa, 1917, pp. 3, 14–32)

185.4 Nikita Okunev, *Dnevnik moskvicha, 1917–1924*, Moscow, 1997, p. 45

185.5 Aleksandra Tolstaia, *Doch'*, London, Ontario, 1979, p. 76

186.1 V. Kniazev, 'Kak zhivet i rabotaet tovarishch Kerenskii', *A.F. Kerenskii: Pro et Contra*, pp. 184–5 (originally published in *Bich*, no. 20, May 1917, pp. 9–11)

186.2 From E.I. Lakier, 'Otryvki iz dnevnika – 1917–1920', *'Preterpevshii do kontsa spasen budet': zhenskie ispovedal'nye teksty o revoliutsii i grazhdanskoi voine v Rossii*, St Petersburg, 2013, pp. 133–179

186.3 Nabokov, p. 39

186.4 L.V. Assiar, *Siluety revoliutsii. Kerenskii na fronte*, Moscow, 1917, pp. 3, 5–6, 16–28

188.1 Benua, p. 366
Stepan Yaremich was a Ukrainian-born artist and friend of Benois. Father Georgy Gapon was the priest and political activist who on 9 January 1905 led unarmed demonstrators towards the Winter Palace to present a petition to Nicholas II; the massacre that ensued became known as Bloody Sunday.

188.2 Aleksandr Fedorovich Kerenskii, Timofei Fedorovich Prokopov, *Poteriannaia Rossiia*, Moscow, 2007, p. 40

188.3 'Russian War Minister Victim of an Attempted Assassination', *Daily Times Enterprise*, 20 July 1917, p. 1

188.4 Okunev, *Dnevnik moskvicha*, p. 55

188.5 *Russkie vedomosti*, no. 153, 7 July 1917, p. 3

188.6 Aleksandr Amfiteatrov, *Bich*, no. 21, Petrograd, 1917, p. 3

189.1 N.A. Grigor'ian, *Ivan Petrovich Pavlov. Uchenyi. Grazhdanin. Gumanist*, Moscow, 1999, p. 146

189.2 Sukhanov, book 5, 1922, pp. 16, 18

189.3 Robien, p. 91

189.4 F.A. Stepun, *Byvshee i nesbyvsheesia*, St Petersburg, 2000, p. 376

190.1 Lakier, 'Otryvki iz dnevnika – 1917–1920', pp. 133–179

190.2 P.A. Polovtsov, *Dni zatmeniia (zapiski glavnokomanduiushchego voiskami Petrogradskogo voennogo okruga generala P.A. Polovtsova v 1917 godu)*, Paris, 1927, pp. 173–4
Boris Godunov was tsar of Muscovy from 1598 to 1605, the so-called Time of Troubles. His sister Irina was the wife of his predecessor as tsar, Fyodor I.

190.3 Knox, p. 671

190.4 Vladimirovich, 'A.F. Kerenskii – narodnyi ministr', *A.F. Kerenskii: Pro et Contra*, pp. 171, 172

190.5 'Nachalo bonapartizma', Lenin Polnoe sobranie, vol. 34, 1969, p. 51 (*Rabochii i Soldat*, 29 July 1917, no. 6)

192.1 A.V. Zhirkevich, *Vstrechi s Tolstym: dnevniki, pis'ma*, Iasnaia Poliana, 2009, pp. 381–2

192.2 Gippius, pp. 270–1

192.3 Ivan Bunin, *Okaiannye dni. Vospominaniia. Stat'i i vystupleniia 1918–1953*, Moscow, 2000, p. 32

192.4 Konstantin Paustovskii, *Povest' o zhizni*, vol. 1, Moscow, 1993, pp. 378 9

193.1 W. Somerset Maugham, *A Writer's Notebook*, London, 1949, pp. 187–8

193.2 B.V. Nikol'skii, *Dnevnik 1896–1918*, vol. 2, St Petersburg, 2015, p. 311
Elizaveta Time was an actress at the Alexandrinsky Theatre in Petrograd. Although rumours of an affair with Kerensky were rife, they were firmly denied by Time and her husband in 1918.

193.3 Polovtsov, *Dni zatmeniia*, p. 174

193.4 Robien, p. 102
Tamara Karsavina was a prima ballerina with the Imperial Russian Ballet and then with Diaghilev's Ballets Russes.

193.5 Gippius, pp. 278

Chapter 10

195.1 Browder, vol. 3, p. 1548

199.1 P.N. Miliukov, *Istoriia vtoroi russkoi revoliutsii*, vol. 1, pt. 2, Sofia, 1921, p. 58

199.2 V.G. Korolenko, *Byla by zhiva Rossiia! Neizvestnaia publitsistika. 1917–1921*, Moscow, 2002, p. 146

199.3 Gippius, p. 266

199.4 M.M. Bogoslovskii, *Dnevniki (1913–1919)*, State Historical Museum, Moscow 2011 (http://az.lib.ru/b/bogoslowskij_m_m/text_1919_dnevniki.shtml)

199.5 'Peremeny v vysshem komandovanii', *Rech'*, no. 168, 20 July 1917, p. 2

199.6 Miliukov, *Istoriia vtoroi russkoi revoliutsii*, p. 69

200.1 P.A. Polovtsov, *Dni zatmeniia (zapiski glavnokomanduiushchego voiskami Petrogradskogo voennogo okruga generala P.A. Polovtsova v 1917 godu)*, Paris, 1927, p. 175

200.2 Record of interrogation, 2–5 September 1917; State Archive of the Russian Federation, *fond* 1780, *opis'* 1, *delo* 14

200.3 *Izvestiia*, no. 136, 5 August 1917 (in *Documents of Russian History 1914–17*, ed. F.A. Golder, Stanford, 1927, p. 517)

200.4 Gippius, pp. 272–3

201.1 Mensheviki, pp. 301–2 (*Den'*, no. 140, 19 August 1917)

201.2 *Petrogradskaia gazeta*, 20 August 1917

201.3 B. Savinkov, *K delu Kornilova*, Paris, 1919, pp. 20–1

202.1 *Delo generala L.G. Kornilova*, vol. 2, Moscow, 2003, p. 216

202.2 Ibid., pp. 195–6
 General Alexei Kaledin, imperial army officer and Cossack commander, was one of the first to organise resistance against the Bolsheviks after the October Revolution from his stronghold in the Don region.

202.3 Ibid., p. 213

204.1 Ibid., p. 156

204.2 Ibid., p. 219

204.3 N. Avdeev, *Revoliutsiia 1917 goda: khronika sobytii*, vol. 4 (August–September), Moscow, 1924, p. 95

204.4 Savinkov, *K delu Kornilova*, p. 24

204.5 Kerensky, pp. 348–9

205.1 Polovtsov, *Dni zatmeniia*, pp. 183–4
 Prince Georgy Tumanov served as a special assistant to War Minister Kerensky from May 1917 and was made major general in August. He was murdered during the October Revolution by soldiers of the Volynsky Regiment.

205.2 Gippius, p. 289

205.3 *Rech'*, no. 202, 29 August 1917 (in *Documents of Russian History 1914–17*, p. 520)

205.4 *Novoe vremia*, no. 14866, 29 August 1917 (in *Documents of Russian History 1914–17*, p. 521)

205.5 Sukhanov, book 5, 1922, pp. 216, 217

206.1 From E.I. Lakier, 'Otryvki iz dnevnika – 1917–1920', *'Preterpevshii do kontsa spasen budet': zhenskie ispovedal'nye teksty o revoliutsii i grazhdanskoi voine v Rossii*, St Petersburg, 2013, pp. 133–179

206.2 *Novoe vremia*, no. 14866, 29 August 1917 (in *Documents of Russian History 1914–17*, p. 522)

206.3 State Archive of the Russian Federation, *fond* 1780, *opis'* 1, *delo* 27, *list* 40

206.4 'Vozzvanie k gortsam', *Den'*, no. 150, 30 August 1917, p. 2

208.1 *A Long Journey: The Autobiography of Pitirim A. Sorokin*, Lanham, 1963, p. 134

208.2 Robien, pp. 106–7

208.3 Polovtsov, *Dni zatmeniia*, pp. 186–7

208.4 Sergei Prokofiev, *Diaries 1915–1923: Behind the Mask*, trans. Anthony Phillips, London, 2008, p. 226

208.5 A.A. Zamaraev, V.V. Morozov, N.I. Reshetnikov, *Dnevnik totemskogo krest'ianina A.A. Zamaraeva (1906–1922)*, Moscow, 1995, p. 422

208.6 *The Diaries of Nikolay Punin 1904–1953*, ed. Sidney Monas and Jennifer Greene Krupala, Austin, 1999, p. 51

209.1 B.V. Nikol'skii, *Dnevnik 1896–1918*, vol. 2, St Petersburg, 2015, p. 312

209.2 Georgii Plekhanov, 'Chto delat'?', *Edinstvo*, no. 127, 29 August 1917 (G.V. Plekhanov, *God na rodine: Polnoe sobranie statei i rechei 1917–1918 g. v dvukh tomakh*, vol. 1, Paris, 1921, p. 124)

209.3 N. Avdeev, *Revoliutsiia 1917 goda: khronika sobytii*, vol. 4 (August–September), Moscow, 1924, p. 125

209.4 Gippius, p. 293

210.1 Browder, vol. 3, p. 1589

210.2 Albert Stopford [Anonymous], *The Russian Diary of an Englishman*, New York, 1919, pp. 203–4, 205–6

210.3 Prokofiev, *Diaries 1915–1923*, pp. 226–7

210.4 Nikol'skii, *Dnevnik 1896–1918*, vol. 2, pp. 312–13

210.5 Marjorie Colt Lethbridge, 'General Korniloff', *The Times*, Letters to the Editor, 12 September 1917, p. 8, issue 41581

210.6 Paul Dukes, 'General Korniloff', *The Times*, Letters to the Editor, 13 September 1917, p. 8, issue 41582

211.1 Kerensky, p. 354
After the February Revolution Vasily Vyrubov became assistant minister of the interior and a close colleague of Kerensky, which led to jokes about Kerensky sharing the Winter Palace with Vyrubov, as the former empress had with (Anna) Vyrubova. From 1918 he lived in Paris.

211.2 A.V. Lunacharskii to A.A. Lunacharskaia, Russian State Archive of Socio-Political History, *fond* 142, *opis'* 1, *delo* 12, *listy* 85–6
Although signed 'Papa', the letter is to Lunacharsky's wife, Anna. Toto is their son Anatoly.

211.3 *Russkoe slovo*, no. 199, 31 August 1917

211.4 Nikolai Berdiaev, *Dukhovnye osnovy russkoi revoliutsii*, ed. E.V. Bronikova, RGALI, 1998, p. 230

211.5 *Witness to Revolution: The Russian Revolution Diary and Letters of J. Butler Wright*, ed. William Thomas Allison, Westport-London, 2002, p. 137

The Dreyfus affair, a political scandal that rocked France in the 1890s and early 1900s, revealed the deep anti-Semitism in French society. The comparison made here seems to be more one of political connivance and deceit.

212.1 N. Bukharin, *Na podstupakh k Oktiabriu. Stat'i i rechi, mai–dekabr' 1917*, Moscow-Leningrad, 1926, p. 125

212.2 *Rech'*, no. 204, 31 August 1917 (in *Documents of Russian History 1914–17*, p. 532)

212.3 Lenin Collected Works, vol. 25, 1964, pp. 289, 290, 293

213.1 Gippius, p. 295

Chapter 11

215.1 Lenin Collected Works, vol. 26, 1972, pp. 22–7

219.1 Robien, p. 114

219.2 'The Struggle with Bolshevism', *The Times*, 28 September 1917, p. 7, issue 41595
The term 'Maximalists', used here apparently synonymously with 'Bolsheviks', is somewhat confusing. Maximalism was a separate movement that arose from the Socialist Revolutionary Party, proclaiming the need for the suppression of the state as a whole – a 'maximum' programme for complete socialism that differed from Bolshevism and was crushed by it after October 1917.

219.3 Trotskii, vol. 2, p. 39

219.4 *Volia naroda*, no. 123, 20 September 1917, p. 1

219.5 Robien, p. 114

219.6 *Rabochii put'*, no. 13, 17 September 1917

220.1 Buchanan, p. 217

220.2 Robien, p. 121

220.3 'The Russian Outlook', *Manchester Guardian*, 10 October 1917, p. 5

220.4 Lenin Collected Works, vol. 26, 1972, pp. 140–1

221.1 Helen Rappaport, *Caught in the Revolution: Petrograd 1917*, London, 2016, p. 274

221.2 Sukhanov, book 7, 1923, pp. 33–4

221.3 I.V. Stalin, *Sochineniia*, vol. 3, Moscow, 1946, p. 382

221.4 'Dnevnik Sergeia Platonovicha Kablukova. God 1917', *Literaturovedcheskii zhurnal*, 2009, no. 24, pp. 138–234

The 'Chernosotentsy', or 'Black Hundreds', were violent reactionary, anti-Semitic groups that formed after the 1905 Revolution, composed mostly of landowners, rich peasants, merchants, police officials and clergymen who clung to ideas of Orthodoxy, autocracy and Russian nationalism.

221.5 *Delo naroda*, no. 181, 15 October 1917, p. 1

222.1 *Novaia zhizn'*, no. 156, 18 October 1917

222.2 Lenin Collected Works, vol. 26, 1972, pp. 216–19

222.3 *Novaia zhizn'*, no. 156, 18 October 1917, p. 1

223.1 I.V. Stalin, 'Okruzhili mia tel'tsy mnozi tuchny', *Rabochii put'*, no. 41, 20 October 1917

Vera Zasulich became a revolutionary in the 1860s and was a founding member, with Plekhanov and others, of the first Russian Marxist organisation, the Liberation of Labour. As a member of the Russian Social Democratic Workers' Party, she sided with the Mensheviks after the 1903 split and opposed the Bolshevik coup in 1917.

223.2 *Izvestiia*, no. 201, 18 October 1917

223.3 Knox, pp. 703–4
'Antonov' is Vladimir Antonov-Ovseenko.

224.1 Cited in *V.D. Nabokov and the Russian Provisional Government 1917*, ed. Virgil D. Medlin and Stephen L. Parsons, New Haven and London, 1976, p. 78

224.2 *Izvestiia*, no. 205, 24 October 1917

226.1 *Witness to Revolution: The Russian Revolution Diary and Letters of J. Butler Wright*, ed. William Thomas Allison, Westport-London, 2002, pp. 141, 142

226.2 Robien, pp. 128–9
Countess Keller, born Irina Skariatina, was maid to Empress Alexandra and imprisoned by the Bolsheviks but later emigrated to the USA where she wrote her memoir, A World Can End. *Princess Vera Urusov was one of Russia's wealthiest landowners; her husband was shot by the Bolsheviks in 1918 and she escaped to Italy in 1924.*

226.3 Lenin Polnoe sobranie, vol. 34, 1969, pp. 435–6

226.4 *Rabochii put'*, no. 44, 24 October 1917
The Second All-Russian Congress of Soviets met on 25–26 October in the Smolny Institute. Of the 649 delegates, 390 were Bolsheviks, 160 Socialist Revolutionaries, 72 Mensheviks, 14 Menshevik-Internationalists and 13 others.

227.1 A.V. Lunacharskii to A.A. Lunacharskaia, Russian State Archive of Socio-Political History, *fond* 142, *opis'* 1, *delo* 12, *listy* 135–6

227.2 Gippius, p. 319

227.3 John Reed, *Ten Days that Shook the World*, New York, 1960, p. 91

227.4 *Otechestvennaia istoriia*, Institute of Russian History, 1992, issues 5–6, p. 151

227.5 Gippius, p. 316
The Pre-parliament, or Provisional Council of the Russian Republic, was convened at the Mariinsky Palace on 7 October as a representative body to which the Provisional Government would be answerable until the election of the Constituent Assembly; it was dissolved by the Petrograd Revolutionary Committee on 25 October.

227.6 Reed, *Ten Days that Shook the World*, p. 93

227.7 Knox, p. 705

228.1 Trotskii, vol. 2, p. 45

228.2 A.M. Kollontai, *Iz moei zhizni i raboty: vospominaniia i dnevniki* (series *Gody i liudi*), Moscow, 1974, p. 315

228.3 Reed, *Ten Days that Shook the World*, p. 101
Sergei Zorin emigrated to the United States in 1911 but returned to Russia with Trotsky in 1917. Politically active in the Communist Party, he was purged by Stalin in September 1937.

229.1 Pierre Pascal, *Mon Journal de Russie: A la mission militaire française 1916–1918*, vol. 1, Lausanne, 1975, p. 238

229.2 Sukhanov, book 7, 1923, p. 160

229.3 A.V. Lunacharskii to A.A. Lunacharskaia, Russian State Archive of Socio-Political History, *fond* 142, *opis'* 1, *delo* 12, *listy* 137–8
> *Fyodor Dan was a leading Menshevik. Socialist Revolutionary Alexander Verkhovsky was minister of war in the Third Coalition Government in the final weeks before the October Revolution.*

229.4 'K grazhdanam Rossii!', *Rabochii i soldat*, no. 8, 25 October 1917 (Lenin Polnoe sobranie, vol. 35, p. 1)

229.5 *Krasnyi arkhiv*, 1927, no. 5 (24), p. 204

229.6 Kerensky, p. 439

229.7 'Poslednie chasy vremennogo pravitel'stva (Dnevniki ministra Liverovskogo)', *Istoricheskii arkhiv*, issues 4–6, Institute of History, Moscow, 1960, p. 40

230.1 *Oktiabr'skoe vooruzhennoe vosstanie v Petrograde: vospominaniia aktivnykh uchastnikov revoliutsii*, ed. S.P. Kniazev, A.P. Konstantinov, Leningrad, 1956, p. 399

230.2 'Poslednie chasy vremennogo pravitel'stva', p. 40

230.3 *Oktiabr'skoe vooruzhennoe vosstanie: semnadtsatyi god v Petrograde*, vol. 2: *Vooruzhennoe vosstanie. Pobeda sotsialisticheskoi revoliutsii*, 1967, p. 339

230.4 'Poslednie chasy vremennogo pravitel'stva', p. 43

230.5 Nabokov, p. 109

230.6 Nikolai Podvoiskii, 'V.I. Lenin v 1917 godu', *Istoricheskii arkhiv*, issue 6, Institute of History, Moscow, 1960, p. 132

230.7 *Istoricheskii arkhiv*, issues 4–6, 1960, p. 45

231.1 Browder, vol. 3, p. 1786

231.2 Ibid., pp. 1786–7

231.3 Alexander Rabinowitch, *The Bolsheviks Come to Power*, New York, 1976, p. 288

231.4 *Oktiabr'skoe vooruzhennoe vosstanie v Petrograde*, ed. E.F. Erykalov, Leningrad, 1966, p. 451

231.5 Pitirim Sorokin, *Leaves from a Russian Diary*, New York, 1924, pp. 101–2

232.1 Gippius, p. 317

232.2 *Vtoroi vserossiiskii s''ezd Sovetov rabochikh i soldatskikh deputatov: 1917 god v dokumentakh i materialiakh*, Moscow, 1928, p. 35

232.3 Ibid., p. 37

232.4 Trotskii, vol. 2, p. 49

233.1 Sukhanov, book 7, 1923, p. 203

233.2 Ibid., pp. 219–20

233.3 A.V. Lunacharskii, *Vospominaniia i vpechatleniia*, Moscow, 1968, p. 172

233.4 R. Ivnev, *Dnevnik, 1906–1980*, Moscow, 2012, p. 266

234.1 A.N. Benua, diary entry for 25 October 1917 (http://www.fedy-diary.ru/html/042011/24042011-03a.html)

234.2 F.I. Shaliapin, *Maska i dusha*, Moscow, pp. 211–12

234.3 *Oktiabr'skoe vooruzhennoe vosstanie v Petrograde*, 1956, p. 414

234.4 Ibid., p. 106

236.1 Sukhanov, book 7, 1923, p. 214

236.2 *Vtoroi vserossiiskii s''ezd Sovetov rabochikh i soldatskikh deputatov*, p. 164

236.3 'Rabochim, soldatam i krest'ianam!', Lenin Polnoe sobranie, vol. 35, 1974, p. 11

236.4 Trotskii, vol. 2, p. 59
> *'Es schwindelt' means 'it's dizzying'.*

236.5 Velimir Khlebnikov, *Sobranie sochinenii v trekh tomakh*, vol. 3, St Petersburg, 2001, p. 98

237.1 *Rech'*, no. 252, 26 October 1917, p. 1

237.2 Trotskii, vol. 2, pp. 59–60

238.1 Buchanan, pp. 207–8

238.2 'Doklad o zadachakh vlasti sovetov', Lenin Polnoe sobranie, vol. 35, 1974, p. 2

Chapter 12

241.1 Maksim Gor'kii, 'V Moskve', *Novaia zhizn'*, no. 175, 8 November 1917

245.1 State Archive of the Russian Federation, *fond* R3348, *opis'* 1, *delo* 830

245.2 Buchanan, pp. 208–9

245.3 *Krasnyi arkhiv*, 1927, no. 4 (23), p. 176

245.4 Vladimir Amfiteatrov-Kadashev, 'Stranitsy iz dnevnika', *Minuvshee: Istoricheskii al'manakh*, no. 20, Moscow-St Petersburg, 1996, p. 502

245.5 'To All the People', Browder, vol. 3, p. 1805 (*Izvestiia*, no. 210, 29 October 1917, p. 2)

245.6 Bunyan, p. 150

246.1 Knox, p. 717

246.2 *Pravda*, no. 175, 1 November 1917

246.3 Bunyan, p. 173

247.1 'Pokazaniia generala P.N. Krasnova voenno-sledstvennoi komissii Petrogradskogo voenno-revoliutsionnogo komiteta', *Oktiabr'skoe vooruzhennoe vosstanie v Petrograde. Dokumenty i materialy*, Moscow, 1957, pp. 803, 804

247.2 Alexander F. Kerensky, *The Catastrophe: Kerensky's Own Story of the Russian Revolution*, New York-London, 1927, pp. 366–7

247.3 P.E. Dybenko, *Revoliutsionnye baltiitsy*, Moscow, 1959, p. 93

247.4 M.M. Bogoslovskii, *Dnevniki (1913–1919)*, State Historical Museum, Moscow 2011 (http://az.lib.ru/b/bogoslowskij_m_m/text_1919_dnevniki.shtml)

248.1 P.N. Miliukov, *Istoriia vtoroi russkoi revoliutsii*, vol. 1, pt. 3, Sofia, 1923, p. 291

248.2 Sergei Efron, *Zapiski dobrovol'tsa*, Moscow, 1998, pp. 53–4

248.3 *Rachmaninoff's Recollections told to Oskar von Riesemann*, London, 1934, p. 185

248.4 Efron, *Zapiski dobrovol'tsa*, pp. 80–1

249.1 Nikita Okunev, *Dnevnik moskvicha, 1917–1924*, Moscow, 1997, p. 100

249.2 Kira Allendorf, unpublished diary (http://olifantoff.ru/allendorf-k/)

249.3 K.V. Ostrovitianov, *Dumy o proshlom*, Moscow, 1967, p. 253

250.1 K.G. Paustovskii, *Sobranie sochinenii*, vol. 4: *Povest' o zhizni*, book 1–3, Moscow, 1982, p. 525

250.2 Harold Williams, 'Rebels Destroy Shrines of Moscow', *New York Times*, 19 November 1917, p. 2

250.3 Nadezhda Udal'tsova, *Zhizn' russkoi kubistki*, ed. E. Drevina, V. Rakitin, A. Sarab'ianov, Moscow, 1994, p. 38

250.4 *Izvestiia*, no. 211, 30 October 1917

250.5 Friends of Lev Tolstoi, *Golos Tolstogo i Edinenie*, Moscow, 1917, no. 4, p. 12

250.6 Ivan Bunin, *Polnoe sobranie sochinenii v XIII tomakh*, vol. 9: *Vospominaniia. Dnevnik (1917–1918)*, Moscow, 2006, p. 222
 Lidia Fyodorovna Muromtseva, Bunin's mother-in-law, was described by those who knew her as 'storm and tempest'.

251.1 Okunev, *Dnevnik moskvicha*, p. 99

251.2 M. Kaigorodov, *Bor'ba klassov*, 1931, no. 6–7, pp. 99–100

251.3 Friends of Lev Tolstoi, *Golos Tolstogo i Edinenie*, p. 12

252.1 Kaigorodov, *Bor'ba klassov*, pp. 99–100

252.2 Efron, *Zapiski dobrovol'tsa*, pp. 87–8

252.3 *Rannee utro*, no. 245, 8 November 1917

252.4 *Literaturnoe nasledstvo*, no. 80: *V. I. Lenin i A. V. Lunacharskii: Perepiska, doklady, dokumenty*, Moscow, 1971, p. 46

252.5 Gippius, p. 331

254.1 A.V. Lunacharskii, 'Lenin i literaturovedenie', *Literaturnaia entsiklopediia*, vol. 6, Moscow, 1932, pp. 211–12

254.2 'Otstavka A.V. Lunacharskogo', *Novaia zhizn'*, no. 171, 3 November 1917

254.3 N.M. Pirumova, *Petr Alekseevich Kropotkin*, Moscow, 1972, pp. 194–5

255.1 Efron, *Zapiski dobrovol'tsa*, pp. 92–3, 94

255.2 A.A. Brusilov, *Moi vospominaniia. Brusilovskii proryv* (online only: https://www.litres.ru/aleksey-brusilov/moi-vospominaniya-brusilovskiy-proryv/chitat-onlayn/)

255.3 G.D. Kostomarov, *Oktiabr' v Moskve: Materialy i dokumenty*, Moscow-Leningrad, 1932, p. 156

256.1 Iu.V. Got'e, 'Moi zametki', *Voprosy istorii*, no. 6–12, 1991

256.2 Udal'tsova, *Zhizn' russkoi kubistki*, p. 39

256.3 Gippius, p. 331

256.4 Russian National Library, Manuscripts Department, *fond* 376, book 2, *Ed. khr.* 41

256.5 Pavel Kuprianovskii, *Bal'mont*, Moscow, 2014, ch. 8
Stepan (Stenka) Razin was a Cossack leader who led a Cossack and peasant rebellion on Russia's south-eastern border in 1670–71. The Time of Troubles was a period of political crisis between the end of the Rurik dynasty in 1598 and the beginning of the Romanov dynasty in 1613.

256.6 Maksim Gor'kii, 'V Moskve', *Novaia zhizn'*, no. 175, 8 November 1917

258.1 Okunev, *Dnevnik moskvicha*, p. 107

258.2 *Russkie vedomosti*, no. 245, 8 November 1917

258.3 *Golos Tolstogo i Edinenie*, Moscow, 1917, no. 6

258.4 'Decret o mire', *Dekrety Sovetskoi vlasti*, vol. 1, Moscow, 1957, p. 12

258.5 *Russian-American Relations: March 1917 – March 1920*, ed. C.K. Cumming and Walter W. Pettit, New York, 1920, p. 50

258.6 *Izvestiia*, no. 225, 14 November 1917, p. 2

259.1 Bunyan, p. 235

259.2 Ibid., p. 253

259.3 *Izvestiia*, no. 226, 15 November 1917, pp. 2–3

260.1 *Pravda*, no. 190, 15 November 1917, p. 2

260.2 Robien, p. 163

260.3 M. Belevskaia, *Stavka verkhovnogo glavnokomanduiushchego v Mogileve 1915–1918*, Vilno, 1932, p. 41

260.4 Vladimir Korolenko, *Dnevnik, pis'ma (1917–1921)*, Moscow, 2001

260.5 Maxim Gorky, *Untimely Thoughts: Essays on Revolution, Culture and the Bolsheviks, 1917–1918*, ed. Mark D. Steinberg, New Haven, 1995, pp. 92, 93 (*Novaia zhizn'*, no. 179, 12 November 1917)

260.6 Florence Farmborough, *Nurse at the Russian Front: A Diary 1914–18*, London, 1974, p. 354

261.1 Robien, pp. 153–4
Grand Duke Pavel (Paul) Alexandrovich and his morganatic wife, Princess Olga Paley, were kept under house arrest at Tsarskoe Selo for several months. After the grand duke's murder in January 1919 Princess Paley escaped to Finland and from there to France.

261.2 Stanislav Pestkovskii, 'Ob oktiabr'skikh dniakh v Pitere', *Proletarskaia Revoliutsiia*, 1922, no. 10, pp. 99–100
Vyacheslav Menzhinsky was a member of the Military Revolutionary Committee and commissar of the State Bank. He succeeded Dzerzhinsky as head of OGPU, the secret police department, in 1926.

261.3 Pauline S. Crosley, *Intimate Letters from Petrograd*, New York, 1920, p. 231

261.4 Bunyan, p. 345
Nineteen parties stood for the Constituent Assembly in Petrograd. The number of candidates on each ticket ranged from four to eighteen.

261.5 Elizabeth Heresch, *Blood on the Snow: Eyewitness Accounts of the Russian Revolution*, New York, 1990, p. 143

262.1 Teffi, *V strane vospominanii. Rasskazy i fel'etony 1917–1919*, ed. S.I. Kniazev and M.A. Rybakov, Kiev, 2011

262.2 Morgan Philips Price, *Dispatches from the Revolution: Russia 1916–18*, ed. Tania Rose, London-Chicago, 1997, p. 103

262.3 Gippius, p. 338

262.4 *A Long Journey: The Autobiography of Pitirim A. Sorokin*, Lanham, 1963, p. 138

262.5 *Delo naroda*, no. 218, 24 November 1917, p. 4

262.6 Nabokov, pp. 119, 120

264.1 Okunev, *Dnevnik moskvicha*, p. 114

264.2 Gippius, pp. 344–5, 346
Fyodor Kokoshkin was a Kadet lawyer and chairman of the Special Council drafting the electoral law for the Constituent Assembly. He was arrested by the Bolsheviks on arrival in Petrograd for the opening of the Assembly and imprisoned in the Peter and Paul Fortress. After he was transferred to hospital suffering from tuberculosis, Kokoshkin was murdered by Baltic sailors, along with fellow Kadet Andrei Shingaryov.

264.3 'Trotsky against the Cadets', *The Times*, 18 December 1917, p. 6, issue 41664

265.1 'Postanovlenie SNK o sozdanii Vserossiiskoi chrezvychainoi komissii', 7 December 1917, typescript in State Archive of the Russian Federation, *fond* R-130, *opis'* 23, *delo* 2, *listy* 159, 161–2

265.2 Farmborough, *Nurse at the Russian Front*, pp. 359, 360

265.3 A. Blok, 'Mozhet li intelligentsiia rabotat' s bol'shevikami?', *Petrogradskoe ekho*, 1 January 1918

265.4 Harold Williams, 'The Russian Despotism', *New York Times*, 15 December 1917, p. 12

266.1 *A Long Journey: The Autobiography of Pitirim A. Sorokin*, pp. 141–2

266.2 Udal'tsova, *Zhizn' russkoi kubistki*, p. 41

266.3 *Pravda*, 4 January 1918

266.4 Gorky, *Untimely Thoughts*, pp. 124–5 (*Novaia zhizn'*, no. 6, 9 January 1918)

267.1 Harvey J. Pitcher, *Witnesses of the Russian Revolution*, London, 1994, pp. 273, 275

267.2 *Pervyi Den' Vserossiiskogo Uchreditel'nogo Sobraniia: Stenograficheskii otchet*, Petrograd, 1918, p. 1

267.3 Ibid., p. 79

268.1 Ibid.

268.2 Vera Figner, 'Avtobiografiia', *Deiateli SSSR i revoliutsionnogo dvizheniia Rossii: Entsiklopedicheskii slovar'*, Moscow, 1989, pp. 253–4

268.3 *Izvestiia*, no. 5, 7 January 1918

268.4 Gorky, *Untimely Thoughts*, p. 131 (*Novaia zhizn'*, no. 11, 17 January 1918)
The young anarchist Anatoly Zheleznyakov was the Kronstadt sailor who dispersed the Constituent Assembly after one day with the words 'The guard is tired'. In June he had been arrested defending the Durnovo villa and imprisoned but escaped a few weeks later. He fought with the Red Army against the Whites and was killed in July 1919. The Soviet government embraced him as one of its heroes and a bust was erected in his honour in Kronstadt.

Images are listed by page number and, where relevant, by sequence on the page.

Every effort has been made to trace the copyright holders of the images used in this publication and obtain permission to reproduce this material. Images in the public domain have been identified as copyright-free; other sources are listed individually below. Please contact the publisher with any enquiries or information relating to images or rights holders; agreed omissions or errors will be corrected in subsequent editions.

The following images are published under license from the Central State Archive of Documentary Films, Photographs and Sound Recordings of St Petersburg (Tsentral'nyi gosudarstvennyi arkhiv kinofotofonodokumentov Sankt-Peterburga):

> 17.1, 29, 53, 82, 104, 114, 117, 125, 127.2, 156, 163, 169.1, 169.2, 200, 203, 204, 215, 231, 233, 246

The following images are reproduced under license from the Multimedia Art Museum, Moscow / Moscow House of Photographs (Mul'timedia art muzei, Moskva / Moskovskii dom fotografii); further attributions where relevant are given in brackets:

> 39 (Yakov Steinberg); 41; 58; 63 (Viktor Bulla); 79.1; 105 (Russian State Archive of Socio-Political History); 108; 127.1; 130; 134 (Sergej Lobovikov); 143; 147; 149.2; 159; 191; 207; 224; 225; 235; 238 (Pyotr Novitsky); 241

Individual rights holders in the following images are given in brackets:

> 13 (De Agostini Picture Library / G. Dagli Orti / Bridgeman Images / FOTODOM. RU); 25 (K. Sinyavsky, © The State Hermitage Museum, St. Petersburg, 2019); 26 (TASS); 49 (SPUTNIK); 64 (SPUTNIK); 98 (SPUTNIK); 107 (Chelyabinsk State Museum of Local History); 133 (State Historic Public Library of Russia); 145 (The Leo Tolstoy State Museum); 187 (Keystone Pictures USA / Alamy Stock Photo); 195 (TASS); 199 (Russian State Archive of Socio-Political History); 228 (SPUTNIK); 254 (SPUTNIK); 255 (The Marina Tsvetaeva Museum, Moscow); 263 (World History Archive / Alamy Stock Photo)

The following images are reproduced under license from DIOMEDIA. Further attributions where relevant are given in brackets:

> 40 (Fine Art Images, State History Museum); 75 (Heritage Images); 81 (Heritage Images / Fine Art Images, State Museum of AS Pushkin, Moscow); 88 (Musée de l'Elysée, Lausanne); 101 (The History Collection / Alamy); 149.1; 167; 168 (Design Pics Historical / John Short); 183 (Fine Art Images); 184 (Fine Art Images); 189; 193 (Granger); 209 (Fine Art Images); 212; 220 (TASS Archive); 221 (TASS Archive); 249 (Azoor Photo / Alamy); 253 (James Maxwell Pringle); 257 (James Maxwell Pringle); 259.1 (Universal Images Group); 259.2 (TASS Archive)

The following images are reproduced from works published before 1923:

> 19.1 (Donald C. Thompson, From Czar to Kaiser, New York 1918); 33 (Stinton Jones, Russia in Revolution, London 1917, p. iv); 43 (Donald C. Thompson, From Czar to Kaiser, New York 1918); 59 (Letopis' voiny 1914 goda, no. 2, p. 31); 150 (The Little Grandmother of the Russian Revolution: Reminiscences and Letters of Catherine Breshkovsky, ed. Alice Stone Blackwell, London, 1919, p. iii); 171 (Donald C. Thompson, From Czar to Kaiser, New York 1918, p. 38); 175 (Bernard Pares, Day by Day with the Russian Army 1914–15, London, 1915, p. ii); 192 (Iskry no. 42, 28 October 1912); 237 (Sobraniie proizvedenii Velimira Khlebnikova, vol. 4, p. ii)

The following images are in the Bain Collection, Library of Congress, Prints & Photographs Division, and there are no known restrictions on publication. The reproduction number is given after each image:

> 6 (LC-DIG-ggbain-25191)
> 19.2 (LC-DIG-ggbain-20942)
> 84 (LC-DIG-ggbain-15471)
> 93 (LC-DIG-ggbain-34971)
> 97.2 (LC-DIG-ggbain-30798)
> 110 (LC-DIG-ggbain-35130)
> 128 (LC-DIG-ggbain-20054)
> 137 (LC-DIG-ggbain-24971)
> 155 (LC-DIG-ggbain-26866)
> 173 (LC-DIG-ggbain-28195)
> 179 (LC-DIG-ggbain-24416)
> 210 (LC-DIG-ggbain-28258)
> 227 (LC-DIG-ggbain-19363)
> 248 (LC-DIG-ggbain-30158)

The following images are in the collection of the Library of Congress, Prints & Photographs Division. Every effort has been made to identify the copyright holders of the images. The reproduction number is given after each image:

20 (LC-USZ62-72743)
111 (LC-USZ62-128996)
123 (Harris and Ewing, LC-DIG-hec-09491)
222 (LC-USZ62-41709)
268 (LC-USZ62-100472)

The following images are in the public domain and there are no known restrictions on publication. Author and/or location of the image are given where known.

17.2 (R. Scharl); 21 (Romanov Collection. General Collection. Beinecke Rare Book and Manuscript Library, Yale University. Album 3, p. 57); 22; 23 (Bibliothèque nationale de France, département Estampes et photographie, EST EI-13 (385), Rol, 41924); 34 (Central State Archive of Cinema, Photographic and Phonographic Documents, St Petersburg); 35 (Central State Archive of Cinema, Photographic and Phonographic Documents, St Petersburg); 38 (U.S. National Library of Medicine, HMD Prints & Photos, Portrait no. 5255); 44 (Gallen-Kallelan Museo, no. GKM_VV_1327); 46; 57; 60 (Russian National Library, no. 010106779, K.K. Bulla, 1906); 61; 69 (GARF, fond 683 opis' 1, delo 125, list 23, foto 388); 76; 77 (K.A. Fisher); 79.2 (Central State Archive of Cinema, Photographic and Phonographic Documents, St Petersburg); 80 (Istoriko Dokumental'nyi Departament MID Rossii); 86 (Romanov Collection. General Collection. Beinecke Rare Book and Manuscript Library, Yale University); 87 (Romanov Collection. General Collection. Beinecke Rare Book and Manuscript Library, Yale University. Album 3, inside back cover); 97.1 (State Historical Museum); 99; 121 (Pierre Choumoff); 152; 164 (Pierre Choumoff); 201; 213; 223; 251; 267 (National Library of New Zealand)

COVER PORTRAITS

Front cover, left column
Grigory Rasputin
Empress Alexandra
Nicholas II
Karl Radek

Front cover, second column
Zinaida Gippius
Alexander Kerensky
Fyodor Chaliapin
Ekaterina Breskho-Breshkovskaya

Front cover, third column
General Alexei Brusilov
Alexandra Kollontai
Vladimir Lenin
Yuly Martov

Front cover, right column
Prince Georgy Lvov
Grigory Zinoviev
Maxim Gorky
Teffi

Spine
Inessa Armand
General Max Hoffmann
Nikolai Punin
Leon Trotsky

Back cover
Grand Duchess Maria Pavlovna
Joseph Stalin
Ivan Pavlov
Joshua Butler Wright